PARIS MODERNE 1914 1945

FRENCH EDITION

Editorial Director
Julie Rouart

Editor
Marion Doublet

Administration Manager
Delphine Montagne

ENGLISH EDITION

Editorial Director
Kate Mascaro

Editor
Helen Adedotun

Translation from the French
Elizabeth Heard (pp. 11–173)
and John Tittensor (pp. 176–319)

Picture Research
Marie-Catherine Audet

Copyediting
Lindsay Porter

Design and Typesetting
Amélie Boutry

Proofreading
Sarah Kane

Production
Élodie Conjat

Color Separation
Hyphen, Italy

Printed in China by C&C Offset

Simultaneously published in French
as *Paris Moderne 1914–1945*
© Éditions Flammarion, S.A., Paris, 2023

English-language edition
© Éditions Flammarion, S.A., Paris, 2023

editions.flammarion.com
@flammarioninternational

23 24 25 3 2 1
ISBN: 978-2-08-042194-4
Legal Deposit: 10/2023

This book was published on the occasion
of the exhibition *Paris Moderne 1914–1945*,
held at the Power Station of Art in Shanghai
from July 22 to October 7, 2023.

Curators
Jean-Louis Cohen, Pascal Mory

Curator for Fashion
Catherine Ormen

Associate Curator for Film
English Cook

POWER STATION OF ART, SHANGHAI

Director
Gong Yan

Project Management
Huang Mi

Exhibition Coordination
Meg Ren, Zheng Linyin

Exhibition Design
Diller Scofidio + Renfro

Elizabeth Diller, David Allin, Bryce Suite,
Alex Knezo, Rocio Brizzio, Daniel Landez

Graphic Design
PSA Graphic Team

Photographic Survey
Antonio Martinelli

Lenders
Albertina Museum, Vienna
Charlotte Perriand Archives, Paris
Ateliers-Musée Chana Orloff
L'Aventure Citroën, Aulnay-sous-Bois
Cassina SpA, Meda
Centre Pompidou, Paris
Chanel, Paris
La Cinémathèque Française, Paris
Cité de l'Architecture et du Patrimoine, Paris
Jean-Louis Cohen, Paris
Émile Hermès Collection, Paris
Conservatoire des Créations Hermès, Paris
La Contemporaine, Nanterre
Fondation Le Corbusier, Paris
Galerie Doria, Paris
Galerie Patrick Seguin, Paris
Gaumont-Pathé Archives, Saint-Ouen
Hermès, Paris
Lanvin, Paris
Pascal Mory, Paris
Médiathèque du Patrimoine et de la
 Photographie, Charenton-le-Pont
Catherine Millet, Paris
Musée de l'Air et de l'Espace, Le Bourget
Musée d'Art et d'Histoire Paul Eluard,
 Saint-Denis

Musée d'Histoire Urbaine et Sociale,
 Suresnes
Museum of Modern Art, New York
Roger-Viollet, Paris
P.J. Roodhorst and T.P. Dekker, Rotterdam
Rene Tan, RT+Q Architects, Singapore
Véronique Tessier Huort Jacopozzi, Paris
Chantal Thomass, Paris
Van Cleef & Arpels, Paris
Michel and Yves Zlotowski

Transportation
Chenue

FOR CLARISSA,
**THE CITY OF LIGHT SHINES EVER BRIGHTER
FOR THE TIME YOU SPENT HERE**

Editor's Note

French film and book titles throughout the text are
followed in parentheses by the English-language
title in italics when the film was produced or the
book was published in English. Where no English
version exists, we have provided our own translation
in roman type.

Designers in Europe worked using metric
measurements; for the ease of some readers,
we have preceded those dimensions with their
imperial equivalents.

The following exhibitions and organizations are
referred to in French throughout this book:
- Exposition Internationale des Arts Décoratifs
et Industriels Modernes (International Exhibition
of Modern Decorative and Industrial Arts), 1925
- Exposition Coloniale Internationale (International
Colonial Exhibition), 1931
- Exposition Internationale des Arts et des
Techniques Appliqués à la Vie Moderne
(International Exhibition of Arts and Technology
Applied to Modern Life), 1937
- Association des Écrivains et Artistes
Révolutionnaires (Association of Revolutionary
Writers and Artists)
- Société des Artistes Décorateurs (Society of
Decorative Artists)
- Union des Artistes Moderne (Union of Modern
Artists)

EDITORIAL DIRECTION BY
JEAN-LOUIS COHEN
GUILLEMETTE MOREL JOURNEL

PARIS MODERNE 1914 1945

ART · DESIGN · ARCHITECTURE
PHOTOGRAPHY · LITERATURE
CINEMA · FASHION

Flammarion

Thérèse and Louise
Bonney, *A Shopping
Guide to Paris*, 1929.
Book cover featuring
a map of Paris.

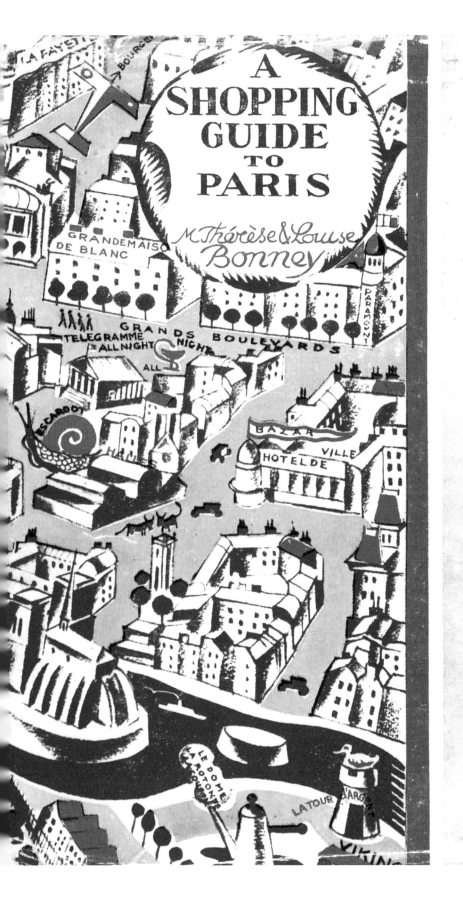

Foreword

Shanghai, the leading commercial port in the Far East, was in rapid development in the 1920s and 1930s. Urban industrialization and modernization were accompanied by the many characteristics of urban culture. Known as the "Paris of the East," Shanghai at that time was not so much an oriental projection of Paris in the same period as an urban manifesto for cities in a changing China. Modern apartments, theaters, racecourses, cafés, cinemas, salons, cheongsams (Mandarin gowns), calendars, advertising posters—being in Shanghai was like dreaming while afloat on the sea. The mixed and diversified cultural scene blurred the boundary between imagination and reality. Enchanted by this mirage of modern life, the inhabitants of Shanghai did not want to wake up. "Modern, modern," they cheered, crowding around the machines that ushered in this era of efficiency and well-being.

Following the Exposition Internationale des Arts Décoratifs et Industriels Modernes, held in Paris in 1925, Shanghai immediately put aside neoclassicism and eclecticism to fall into the embrace of art deco, combining this movement with local culture and aesthetics to create a Shanghai style of art deco. However, modernity was not limited to just one style—it sparked an awakening in all the disciplines. In 1929, Shanghai thus vigorously launched the "Greater Shanghai Plan": a bold initiative that commissioned Chinese architects who had returned from studying abroad to create a new downtown area, outside Western concessions, with a new functional division, and to establish a new urban order expressing national independence.

Unfortunately, the war put an end to this idealistic urban experiment, which failed after eight years of persistence, and the early Chinese urban planners and architects became disillusioned with their modernist city dreams. The urban history of Shanghai in this unique period was documented in the exhibition *Ordinary Metropolis—Shanghai: A Model of Urbanism* (市民都会——上海：现代城市主义的样本), held at the Power Station of Art in 2016. Six years later, the exhibition *Paris Moderne, 1914–1945* once again presents a city as an exemplar, through the prism of the French capital, to share with the Chinese public a multi-modernism, as well as the important role played by the arts in the city's transformation.

This volume could be regarded as a "parallel exhibition" on paper and an introduction to the exhibition *Paris Moderne 1914–1945*. The space is transformed into a two-dimensional plane and is ordered alphabetically, to present the protagonists of this adventure, and allow ordinary flaneurs and strangers to travel through time and discover the new spirit of the era.

Working on this publication and the related exhibition during the Covid-19 pandemic, we had never been so deeply and urgently eager to examine the role and function of a city and to touch upon its soul. Thanks again to Jean-Louis Cohen, Guillemette Morel Journel, Pascal Mory, Antonio Martinelli, and all the contributors, as well as the institutions and the collectors, for making this encounter and dialogue possible between modern Paris and the magical city of Shanghai, in a changing historical context.

Gong Yan
Director of Power Station of Art, Shanghai

Preface

This book accompanies the exhibition *Paris Moderne, 1914–1945*, held in the summer of 2023 at the Power Station of Art in Shanghai. It eloquently portrays historic landmarks and areas of artistic invention over a period encompassing four decades, placing them within the context of political and cultural life as it evolved in Europe's foremost metropolis.

To recount the transformations that occurred during this period, we decided to present the era's principal protagonists and list them alphabetically, as a kind of encyclopedia: an alternative approach to a collection of analytical essays focused on these domains of creation, or on narrowly defined disciplines.

The eighty-eight concise biographies featured in this book are the result of a rigorous selection process—an endeavor that has inevitably been subject to omissions or repetitions. The entries record the interactions between leading figures in the fields of the arts, literature, politics, haute couture, architecture, and film. The reader will encounter sequences that have elements of Dadaist absurdity, such as the juxtaposition, among the letters "N," "O," and "P," of the sophisticated patron of the arts Marie-Laure de Noailles, the sculptor Chana Orloff, the couturier Jean Patou, the typographer Charles Peignot, and the architect Auguste Perret.

The reader will also discover the many interlocking connections among these personalities. Asterisks in each entry provide cross-references to individuals who are discussed in their own separate biographies. The individual entries are accompanied by six essays, each focused on an important theme—cinema, fashion, graphic design, housing, painting, and urban planning—written by experts whose works are featured in the bibliography at the end of the volume.

Contemporary Paris retains many vestiges of this intensely creative period. Traces of the entire era still mark the capital, from the historical center to its outlying areas. These extant sites have been explored by Antonio Martinelli with his camera: his original photographs, grouped together into two portfolios at the beginning and end of the book, reveal several dozen constructions throughout the city, as well as their interiors, many of which are not accessible to the general public.

It would be overly ambitious for a single volume to address the infinite complexity of so many transformations in Parisian society. This mosaic attempts to sketch the outlines of a vast human adventure. We hope it will inspire readers to embark on their own exploration of the panoramic creative landscape that Paris formed between the years 1914 and 1945.

J-L C, G MJ

Paris Moderne: An Introduction

Three scenes set in three different Parisian locales frame the events explored in this book: the rush of thousands of young recruits toward the Gare de l'Est on August 1, 1914, rallying to the cry "To Berlin!"—the opening scene of a long and bloody conflict; the parade of Nazi soldiers marching down the deserted Avenue des Champs-Élysées on June 10, 1940, after their shattering defeat of the French armed forces; and General de Gaulle forging a passage through the crowd to enter the Hôtel de Ville on August 25, 1944, following the capital's liberation. From national humiliation to joy reclaimed, these three episodes delineate a remarkable period of Parisian history.

The Dazzling City of Light

For the millions of visitors who flocked to Paris from the provinces, Europe, and all over the world in the first decades of the twentieth century, there was no doubt that the city named "Paris" and the adjective "modern" were inseparable. Still glowing in the urban splendor of Baron Haussmann and the rousing success of the Expositions Universelles of 1889 and 1900, the City of Light was a showplace for science, industry, and the arts. Indeed, the metropolis seemed to be "the capital of the world," and for the Austrian writer Hugo von Hofmannsthal its urban landscape was "composed of pure life itself."[1] Following four years of suffering, deprivation, and darkness—the city had been subjected to blackouts to elude the bombardment of German Zeppelins—Paris would see this tarnished image of the City of Light rejuvenated with enchanting illuminated displays gracing the Eiffel Tower and the façades of fashionable department stores.

Between 1918 and 1933, Paris assumed a dominance in continental Europe that only Berlin could challenge. Like its rival, Paris had become a *Weltstadt*—a "world city," engaged, according to Oswald Spengler, in a "petrification," at "the exact epoch that marks the end of organic growth and the beginning of an inorganic . . . process of massing without limit."[2] The seductive allure of Paris was far from diminished, lasting until the eve of World War II. In the eyes of the world, the city remained emblematic of the entire nation of France.

The population of Paris soared, reaching over three million inhabitants within its municipal perimeter by 1920. As its suburbs also expanded, the Paris region attracted workers, intellectuals, and artists from all over France, Europe, and the world. The Viennese architect Adolf Loos,* who spent most of the 1920s in the city, asserted, "If I thrust a stake into the intersection of the Grands Boulevards and Avenue de l'Opéra, I would say here resides the center of Western civilization."[3]

At the Crossroads of Industries and Politics

Paris was modern in every sense of the word. It remained at the forefront of

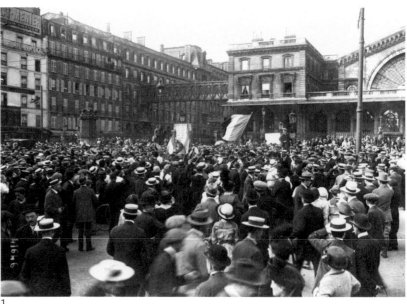

1

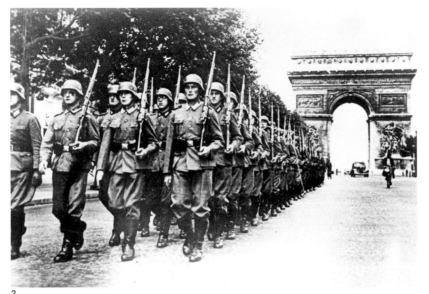

2

3

technical innovation and social change, and it was also where ideas, debates, and images were shaped, whose influence extended far beyond France's borders. Its role as the country's center of industrial activity was reinforced by the introduction of Taylorism, which spurred the war effort from 1914, followed by Fordism, of which Voisin, Renault, and Citroën* were pioneers. The country's leading automobile and aircraft factories were concentrated around the capital, and they attracted large numbers of immigrants who worked on the assembly lines, as seen in the film *À nous la liberté* (*Freedom for Us*) by René Clair.*

Parisian industry stretched all the way to the city's limits, and contingents of laborers populated several neighborhoods. National political tensions were projected onto the region's electoral map. Although, around 1930, the Chambre des Députés was dominated by moderate left-wing parties, the city of Paris remained firmly right wing, and a "red belt" of Communist municipalities representing a working class that was poorly housed and badly off enclosed the city. Populist writers such as Eugène Dabit reported on life on the edge in these outlying areas, while Louis-Ferdinand Céline lampooned the inhabitants' existence in the destitute surroundings that extended as far as the eye could see.[4]

Residents of the bourgeois areas in the west and of the working-class neighborhoods in the north and east took to the streets in turn, demonstrating on the city center's squares and boulevards—the former group during the riots of 1934, and the latter during the Popular Front marches held the following year. These periodic confrontations made a strong impact on the Parisian landscape, just as the Revolution of 1848 and the Commune had marked it in the nineteenth century. Moreover, the geography of classes and opinions corresponded to the functional divisions of the Paris region: industry occupied the east, north, and certain pockets of the west; the army remained firmly entrenched in the southwest from the École Militaire to the training camp in Satory; businesses began to migrate westwards from the neighborhood around the Bourse toward La Défense, following the axis of the Champs-Élysées.

This fractured Paris was virtually frozen in place during the four years of the Occupation. The bureaucracy of the Vichy regime administered the country as best it

1 Recruits departing from the Gare de l'Est, August 2, 1914.

2 The German army parading down the Avenue des Champs-Élysées, June 10, 1940.

3 General de Gaulle and his escort arriving at the Hôtel de Ville, August 25, 1944. Photograph by Serge de Sazo.

13

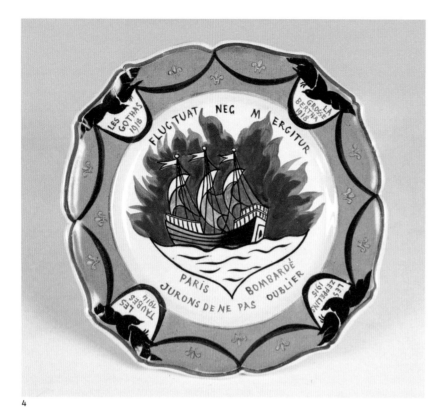

4

could. The great thoroughfares remained empty, while citizens resignedly passed their time waiting in long lines outside half-empty stores, as recorded in André Zucca's color photographs. Scarcity was evident in the attire of Parisians, who nevertheless maintained a touch of their former elegance with shoes and clothing fashioned from ersatz materials. Moving undetected through the city streets, Resistance fighters operated secretly, in basements and catacombs.

A Theater of Exhibitions

Media ranging from the illustrated press to new outlets, including radio and cinema, made Paris a spectacle that was accessible to a large, remote audience. In the city itself, movie theaters multiplied along the boulevards, projecting films in which Paris provided both the backdrop and the fictional characters who would soon enter legend, such as Madame Raymonde, played by Arletty in Marcel Carné's* Hôtel du Nord.

More concretely, the Paris region hosted three Expositions Internationales in a bid to emulate the successful shows of the previous century. Held in 1925, 1931, and 1937, they strove, each in its own distinctive way, to lend a universal dimension to a country that had been ravaged by war but was far from abandoning its imperialist ambitions. The first Exposition Internationale, which took place between the Invalides and Avenue des Champs-Élysées, emphasized the hegemony of the Parisian art industries, from fashion to interior design; these were domains that had been threatened by the growth of Germany before 1914. The second was held around the Bois de Vincennes, and was intended to dangle the lure of colonial prosperity before working-class citizens, who might otherwise be tempted by revolution. The third, installed between the Eiffel Tower and the newly built Palais de Chaillot, encouraged world powers to demonstrate their confidence in science and technology as the impact of the Crash of 1929 threatened to crush them and a new war loomed on the horizon.[5]

The optimism conveyed by these initiatives was reflected across the whole artistic spectrum, whose language was radically renewed. In 1918, Le Corbusier* had expressed the mission of his generation, attracted by "the laboratory of Paris," provoking "at any moment the temptation, the attempt to test the mechanism of mysterious tools."[6] New literary, artistic, musical,

4 Madeleine Zillhardt, plate commemorating the German bombardments of Paris, 1918.

5 The Farman airplane factory at Billancourt, July 6, 1917. Autochrome plate. Photograph by Léon Gimpel.

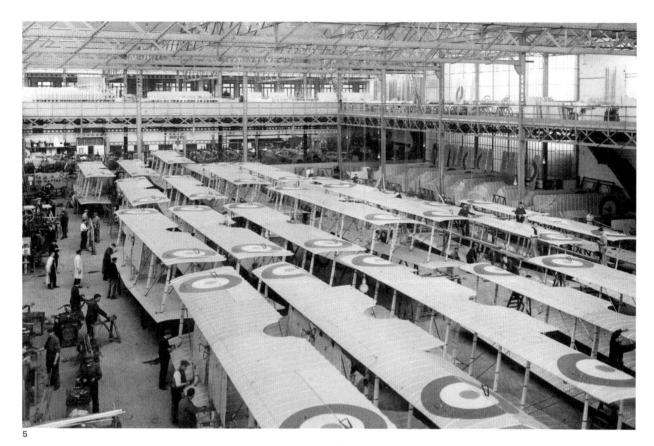

5

architectural, photographic, and cinematic forms were born, instigated by iconoclastic creators. In the realm of the arts, World War I had brought about the end of cubism's expansion, which those who advocated purism and a "return to order," such as Le Corbusier and Ozenfant, endeavored to overcome. New paths to abstraction were emerging, while figurative representation metamorphosed. In the fields of architecture and interior design, the conservatism of established institutions such as the Société des Artistes Décorateurs spurred on innovators to create new bodies. Thus, in 1929, the interior designers and architects Hélène Henry, René Herbst,* Francis Jourdain,* Robert Mallet-Stevens,* and the jeweler Jean Puiforcat formed the Union des Artistes Modernes (UAM).[7] As proof of their desire to facilitate interactions between the "fine" and "applied" arts, these founders were soon joined by, among others, the painter Sonia Delaunay,* sculptors Jan and Joël Martel,* graphic artists Jean Carlu* and Paul Colin,* metalwork craftsman Jean Prouvé,* and interior architects Eileen Gray* and Charlotte Perriand,* as well as ceramists, glassworkers, lighting engineers, and such

protean creators as Pierre Legrain—a bookbinder, illustrator (who designed the UAM logo), cabinetmaker, and decorator for Jacques Doucet,* the Rothschilds, and the Noailles.* Meanwhile, Le Corbusier, assisted by Gabriel Guevrekian,* focused on forming a Paris branch of the Congrès Internationaux d'Architecture Moderne (International Congresses of Modern Architecture), established in Switzerland a year earlier, which held their fifth meeting in Paris in 1937.

The World Comes to Paris

In opposition to the chauvinism and xenophobia of the French bourgeoisie, who had been given a strong sense of superiority by the victory over Germany, legions of creative talents flocked to Paris from far and wide. After founding Dada in Zurich, the leading proponents of the movement made the French capital their playground. Founding members Jean Arp,* Sophie Taueber-Arp,* Tristan Tzara,* and Marcel Janco recruited Francis Picabia, Marcel Duchamp,* and Man Ray,* while Salvador Dalí joined the surrealists. Americans arrived in force after the war, emulating Ernest Hemingway,

who declared that Paris was a "movable feast," and they frequented the salon of art patron Gertrude Stein.* Montparnasse attracted immigrants from all over Europe, particularly the east. As for nationals from the Republic of China, 132 came to study at the École des Beaux-Arts between 1914 and 1935,[8] and a number of architects enrolled at French and Parisian institutions, including Léon Hoa, who worked for a time with André Lurçat.

Among the Russians fleeing the Revolution of 1917 were a significant number of film directors, set designers, and actors, including the remarkable Ivan Mosjoukine, as well as two sisters: the architect Adrienne Gorska* and the painter Tamara de Lempicka.* Even before the rise of Nazism, many Jews moved their studios to Paris, including the sculptors Jacques Lipchitz* and Chana Orloff,* and the painters Sonia Delaunay and Chaïm Soutine.

There were visitors from other continents, too. Black writers of the Harlem Renaissance rubbed shoulders with pioneers of "*Négritude*," such as Aimé Césaire and Léopold Sédar Senghor, while the first movements for the independence of colonized nations appeared.[9] Represented in Parisian salons and galleries, Loos and Theo van Doesburg,* the founder of De Stijl, seized numerous opportunities to exhibit their architectural projects in Paris and, ultimately, to build them. The studios of Auguste Perret* and Le Corbusier trained students from all over the globe, who went on to disseminate the characteristics of their work worldwide. Meanwhile, the Expositions Internationales gave modernists from many countries the opportunity to build temporary models of their architectural concepts. Konstantin Melnikov's Soviet pavilion attracted attention in 1925 with the dynamism of its wood and glass spaces; twelve years later, Boris Iofan's hieratic structure was erected across from Albert Speer's edifice, in a sinister monumental duel.[10] Both stole the limelight from Junzo Sakakura's Japanese pavilion—an ingenious reinterpretation of the traditional structures of Kyoto—and the Czechoslovak pavilion—a luminous cube designed by Jaromír Krejcar. They explored the dichotomy between traditional techniques and experimental materials, while in José Luis Sert's pavilion for the Spanish Republic, Pablo Picasso* made his mark with *Guernica*: a monumental work glorifying the martyrs of the civil war. In 1930,

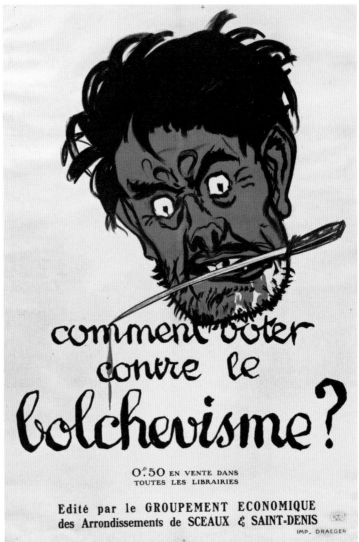

6

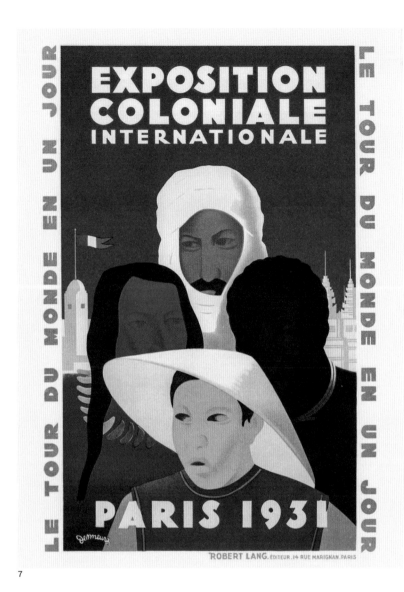

the German section of the Salon des Artistes Décorateurs had allowed Parisian audiences to discover the experimental designs of the Bauhaus in Dessau and the Deutscher Werkbund's advocacy of modern forms in residential buildings.

Beyond these public events, artists and writers encountered hospitality and inspiration in Paris; Italian antifascists and German and Austrian Jews persecuted by the Nazis took refuge there, although they were not always treated with leniency by the French authorities. The writers Alfred Döblin and Joseph Roth were joined by the critic and cultural theorist Siegfried Kracauer, while his friend Walter Benjamin* frequented the Bibliothèque Nationale to pursue his research on the distinctive features of the "capital of the nineteenth century," as he deemed Paris.[11]

Elegance and Strangeness

In a more frivolous vein, although still of great economic importance, Paris was the uncontested queen of fashion. Flamboyant couturiers were the standard-bearers, including Paul Poiret* and Jacques Doucet, while new fashion houses emerged on the scene, including Chanel,* Lanvin,* Schiaparelli,* and Patou,* whose designs created a sensation. At the intersection of art and commerce, fashion operated in numerous sectors, from clothing to jewelry to leather goods. Parisian designers became stars, comparable to those of theater and film. Their boutiques were added to those of decorators such as Francis Jourdain and Eileen Gray to become seductive microcosms that promoted the concept of a total work of art. Department stores created their own experimental design studios, which were represented at major exhibitions. Photographers, from Laure Albin-Guillot* to Man Ray to Boris Lipnitzki, published images of the collections in women's magazines such as *Le Petit Écho de la mode* and *Jardin des modes*. The latter was founded in 1922 by Lucien Vogel, a visionary newspaperman with a leftist leaning. He also established the weekly news magazine *VU*, which was founded in 1928 and largely devoted to photography, with contributions from professionals and innovative artists including Germaine Krull,* Brassaï,* and André Kertész.* The feminine face and body were transformed, which was reflected in the monthly magazine *Votre beauté* (Your

6 Adrien Barrère, "Comment voter contre le bolchevisme?" (How to vote against bolshevism) poster, 1919.

7 Poster for the Exposition Coloniale Internationale, 1931.

Beauty), launched in 1932 by Eugène Schueller, who would later found L'Oréal. The female body became the focus of new looks and elaborate beauty regimens and products—a revolution that nurtured the career of the legendary businesswoman and art collector Helena Rubinstein.*

The photographers' pictures in *VU*, however, revealed very different bodies—for Paris also inspired derision and subversion. The city became the playground of the surrealists, who delved into the mysterious world behind the scenes in their books (*Nadja* by André Breton*) and films (*Entr'acte* [*Intermission*] by René Clair*). Breton and his friends did not remain aloof from politics, as they demonstrated in the exhibition *La Vérité sur les colonies* (The Truth about the Colonies), which they organized in 1931 in opposition to Marshal Lyautey's* official event. Although their relationship with the Communist Party was a stormy one, intellectuals close to the party came together in the Association des Écrivains et Artistes Révolutionnaires. They were instrumental in the creation of the Maison de la Culture by Louis Aragon* and André Malraux in 1935; it was one of the principal venues for debate in Paris during the era of the Popular Front.[12] Following Hitler's rise to power, it was responsible for expanding the Front to support the Spanish Republic, anticipating its role in the anti-Nazi Resistance.

Capital of Myths

In 1937, the writer Roger Caillois decoded the "modern myth" of Paris, which was the product of nineteenth-century novels: "There exists a representation of the cityscape that exerts such a powerful hold on the imagination that no one has actually ever questioned its accuracy. Albeit thoroughly derived from books, it is now sufficiently widespread to be part of the collective mental atmosphere and thus have a certain constraining force."[13] This interpretation was expressed in new mediums and participated in the construction of an imaginary metropolis, superimposed on the actual city that was inhabited by its residents and visitors.[14]

Writers and artists captured shards of a mirror that reflected neighborhoods and monuments, even those described by Walter Benjamin as lacking anything that could inspire a literary masterpiece.[15] Such insights were compiled in a number of

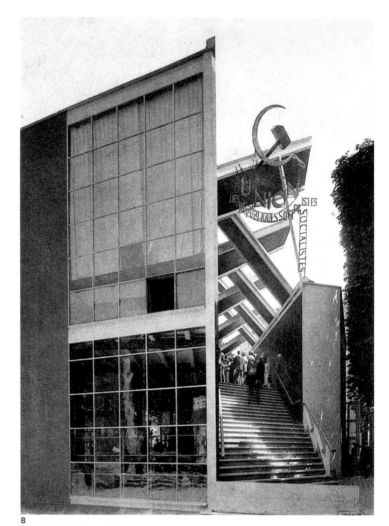

8

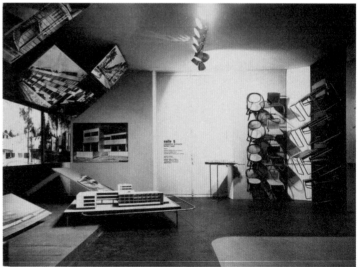

9

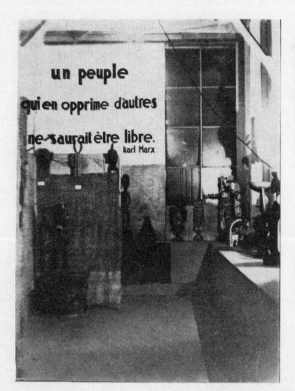
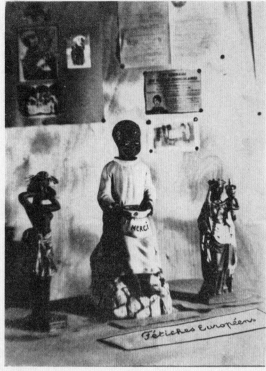

A l'Exposition LA VÉRITÉ SUR LES COLONIES, 8, avenue Mathurin-Moreau.
(Salle organisée par Aragon, Eluard et Tanguy.)

10

literary collections: Jules Romains recruited Francis Carco, Colette, Jean Giraudoux, and Paul Valéry, among other writers, and an array of artists for his volume *Paris 1937*.[16] Their accounts were not confined to fashionable neighborhoods, but delved into the faubourgs that Kracauer featured in his reporting in the *Frankfurter Zeitung*. Pursuing a very different genre, the American sisters Thérèse and Louise Bonney* wrote tour guides that revealed the secrets of Parisian boutiques to their compatriots.

Measuring Time?

The conventional temporal divisions of history—the *années folles*, or roaring twenties, which were brought to an end by the Crash of 1929, or simply "the 1920s," "the 1930s," and "the interwar period"—view the two world wars as a moment of suspension. Our assessment is different, and highlights a thirty-year "inter-peace period," extending from Germany's declaration of war on France on August 3, 1914, to the Reich's capitulation on May 8, 1945.

The two conflicts bookending this chronicle were by no means dead time. The public politics of the Union Sacrée persisted after 1918 and the artistic and literary upheavals of the 1920s began far earlier—consider cubism. The vitality of the *années folles*, with their spectacular parties and music halls where Mistinguett and Josephine Baker* reigned as queens of the night, were a repudiation of the depression and scarcity that had gone before, and that could still be felt beneath the surface. The production and management systems developed during World War I determined subsequent industrial strategies. Equally, Vichy's technocratic projects often completed undertakings that had been initiated but not realized by the Popular Front,[17] although the constantly postponed urban transformations were not achieved until after 1945.

From 1940 until 1944, the Germans strove to purge Paris of "undesirables"—Jews and democrats—converting the city into a recreational haven for Wehrmacht soldiers on leave, while enforcing strict

censorship of the press, cinema, and fashion. Hitler had declared, however, that there should be no "restriction on the liberty of French cultural life, because he had personally always admired French artistic creation, above all in the realm of architecture."[18] In this heavily patrolled and stifled city, where theaters, galleries, and cinemas nevertheless remained open, Jean-Paul Sartre proclaimed the paradox: "Never were we freer than under the German occupation,"[19] alluding to the possibility that each person had to choose between the forces of oppression and those of the Resistance.

Paris never regained its hegemony after World War II, despite the creativity that reemerged and freely found expression there.[20] The artistic scene shifted to New York[21] and Hollywood. The year 1945 marked the conclusion of an extraordinary cycle of invention and creativity set in motion in 1914. But the social challenges of the 1930s—the degradation of impoverished urban neighborhoods and rise of class tensions—did not disappear, despite the enthusiasm of the Liberation. J-L C, G MJ

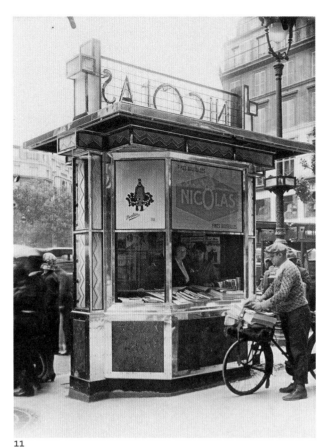

11

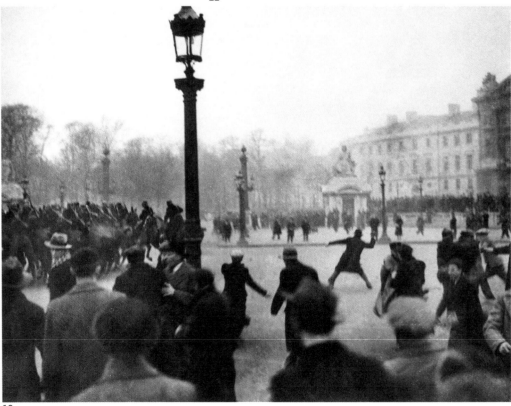

12

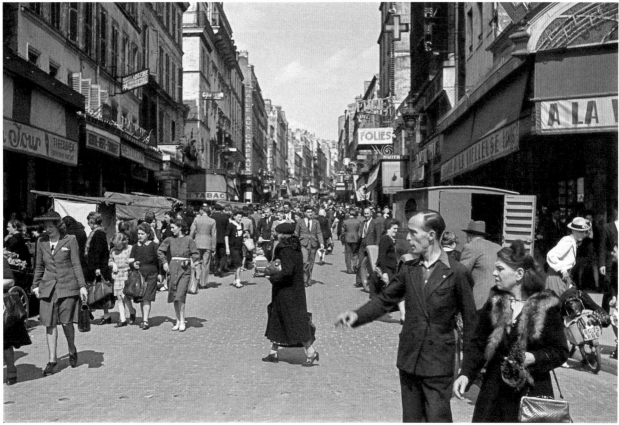

13

1. Quoted in Patrice Higonnet, *Paris: Capitale du monde, des Lumières au surréalisme* (Paris: Tallandier, 2005), 11.
2. Oswald Spengler, *The Decline of the West*, vol. 2, trans. Charles Atkinson (New York: Alfred Knopf, 1932), 100.
3. Adolf Loos, statement in "Vers un Paris nouveau," *Cahiers de la république des lettres, des sciences et des arts*, no.12 (1929): 134.
4. Eugène Dabit, *L'Hôtel du Nord*, trans. Homer P. Earle (New York: A.A. Knopf, 1931); *Faubourgs de Paris* (Paris: Gallimard, 1933). Louis-Ferdinand Céline, *Journey to the End of Night*, trans. Ralph Manheim (New York: New Directions, 2006); *Death on the Installment Plan*, trans. Ralph Manheim (New York: New Directions, 1971).
5. On these exhibitions, see Tag Gronberg, *Designs on Modernity: Exhibiting the City in 1920s Paris* (Manchester/New York: Manchester University Press, 1998); Emmanuel Bréon and Philippe Rivoirard, eds., *1925, quand l'Art déco séduit le monde* (Paris: Norma, 2013); Patricia Morton, *Hybrid Modernities: Architecture and Representation at the 1931 Colonial Exhibition* (Cambridge, MA: MIT Press, 2000); Bertrand Lemoine, ed., *Cinquantenaire de l'Exposition internationale des arts et techniques dans la vie moderne* (Paris: Institut Français d'Architecture/Paris-Musées, 1987).
6. Charles-Édouard Jeanneret [Le Corbusier], journal of March 4, attached to a letter to William Ritter, March 23, 1918, in Le Corbusier and William Ritter, *Correspondance croisée, 1910–1955*, ed. and with an introduction by Marie-Jeanne Dumont (Paris: Éditions du Linteau, 2014), 615.
7. See *UAM, une aventure moderne* (Paris: Éditions du Centre Pompidou, 2018), exhibition catalog.
8. Philippe Cinquini, *Les Artistes chinois à l'École des beaux-arts, 1900–1949* (Paris: Mare & Martin, 2022).
9. Aimé Césaire, *Cahier d'un retour au pays natal* (1939; repr., Paris: Présence Africaine, 1956). Léopold Sédar Senghor, *Liberté 1: Négritude et humanisme, discours, conférences* (Paris: Seuil, 1964).
10. Ginés Garrido, *Melnikov en Paris, 1925* (Barcelona: Fundación Caja de Arquitectos, 2011); Karen Fiss, *Grand Illusion: The Third Reich, the Paris Exposition, and the Cultural Seduction of France* (Chicago: University of Chicago Press, 2009).
11. Walter Benjamin, *The Arcades Project*, trans. Howard Eiland and Kevin McLaughlin (Cambridge, MA/London: Harvard University Press, 1999).
12. Pascal Ory, *La Belle Illusion: Culture et politique sous le signe du Front populaire (1935–1938)* (Paris: Plon, 1994).
13. Roger Caillois, "Paris, a Modern Myth," [1937] in *The Edge of Surrealism: A Roger Caillois Reader* (Durham, NC: Duke University Press, 2003), 177.
14. Évelyne Cohen, *Paris dans l'imaginaire national de l'entre-deux-guerres* (Paris: Publications de la Sorbonne, 1999).
15. Walter Benjamin, *One-Way Street*, trans. E. F. N. Jephcott (Cambridge, MA: Belknap Press of Harvard University Press, 2016).
16. Jules Romains, *Paris 1937* (Paris: J.-G. Daragnès, 1937).
17. Gérard Noiriel, *Les Origines républicaines de Vichy* (Paris: Hachette, 1999).
18. Adolf Hitler, quoted in Kathrin Engel, *Deutsche Kulturpolitik im besetzten Paris, 1940–1944: Film und Theater* (Munich: R. Oldenbourg, 2003), 121.
19. Jean-Paul Sartre, "Paris Alive: The Republic of Silence," *The Atlantic Monthly* (December 1944), 39–40.
20. Rosemary Wakeman, *The Heroic City: Paris, 1945–1958* (Chicago: University of Chicago Press, 2009).
21. Serge Guilbaut, *How New York Stole the Idea of Modern Art*, trans. Arthur Goldhammer (Chicago: University of Chicago Press, 1983).

11 Newsstand and cyclist, c. 1930. Photograph by Albert Harlingue.

12 Demonstration on February 6, 1934, Place de la Concorde.

13 Rue de Belleville, 1944. Photograph by André Zucca.

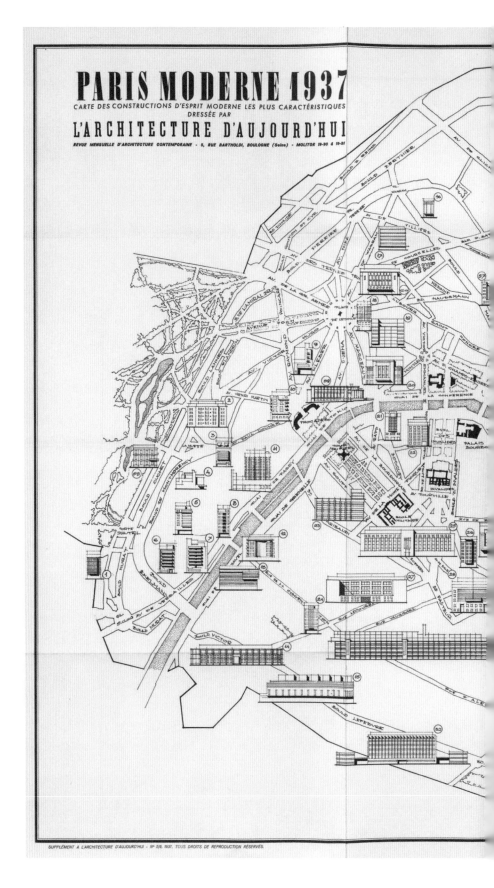

"Paris moderne 1937" map showing buildings constructed since 1918 within the municipal boundaries. Gatefold in *L'Architecture d'aujourd'hui*, 1937.

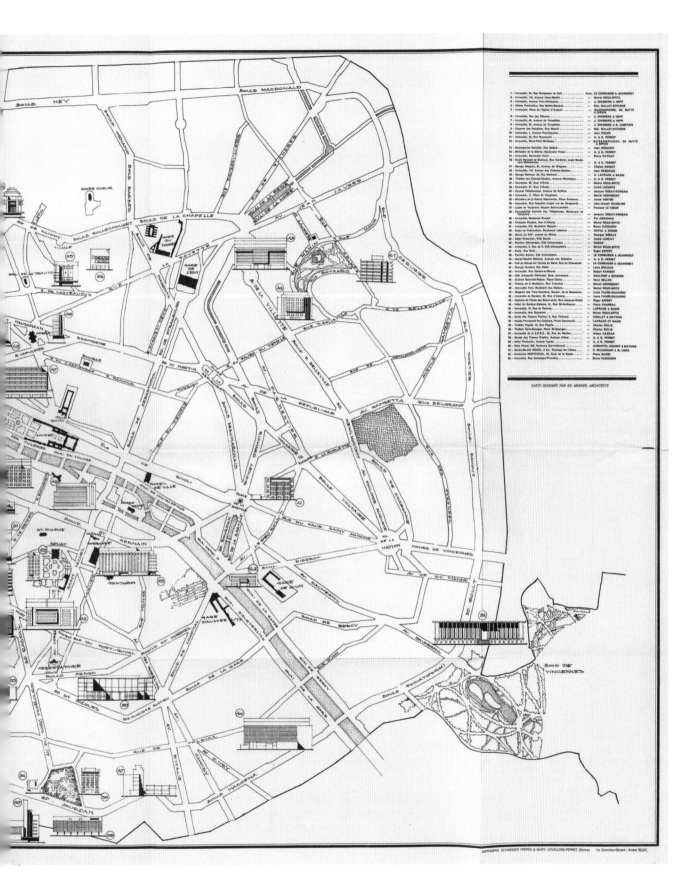

CARTE DESSINÉE PAR ED. MENKÈS, ARCHITECTE

IMPRIMERIE SCHNEIDER FRÈRES & MARY, LEVALLOIS-PERRET (Seine) Le Directeur-Gérant: André BLOC.

23

Antonio Martinelli

Contemporary Promenade

Paris *intra muros*

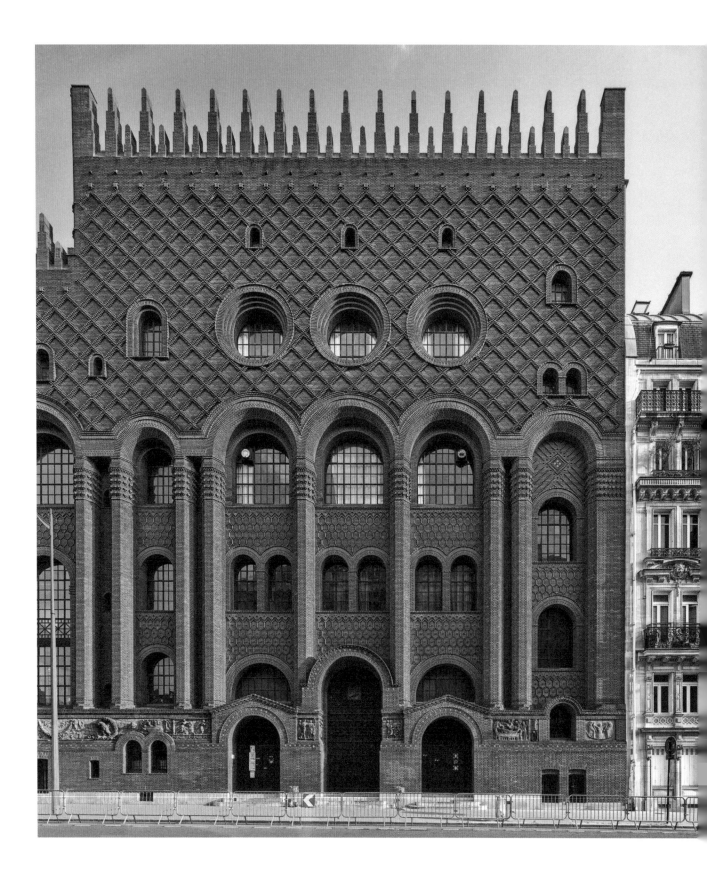

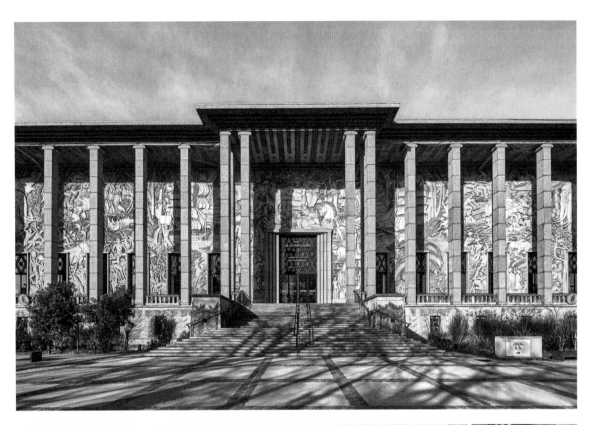

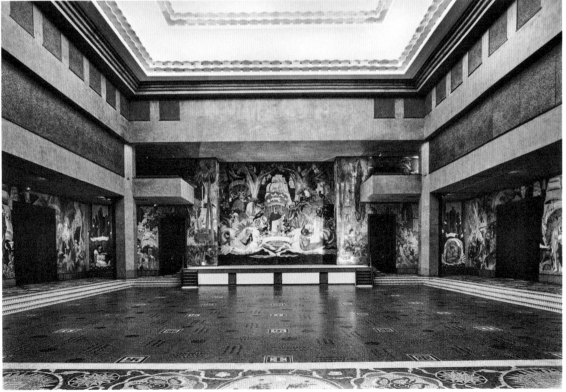

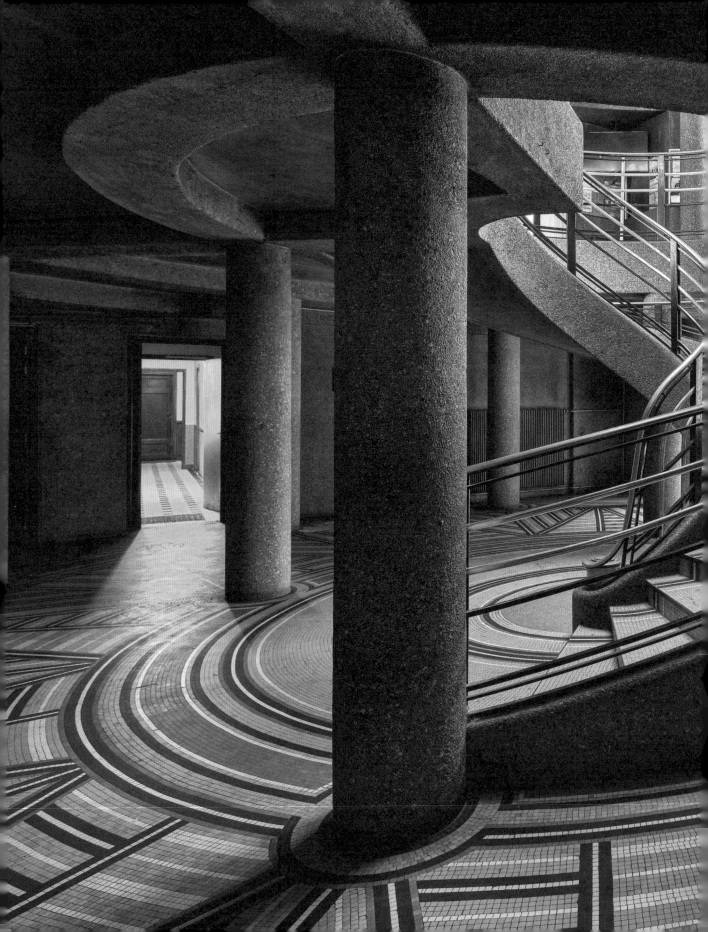

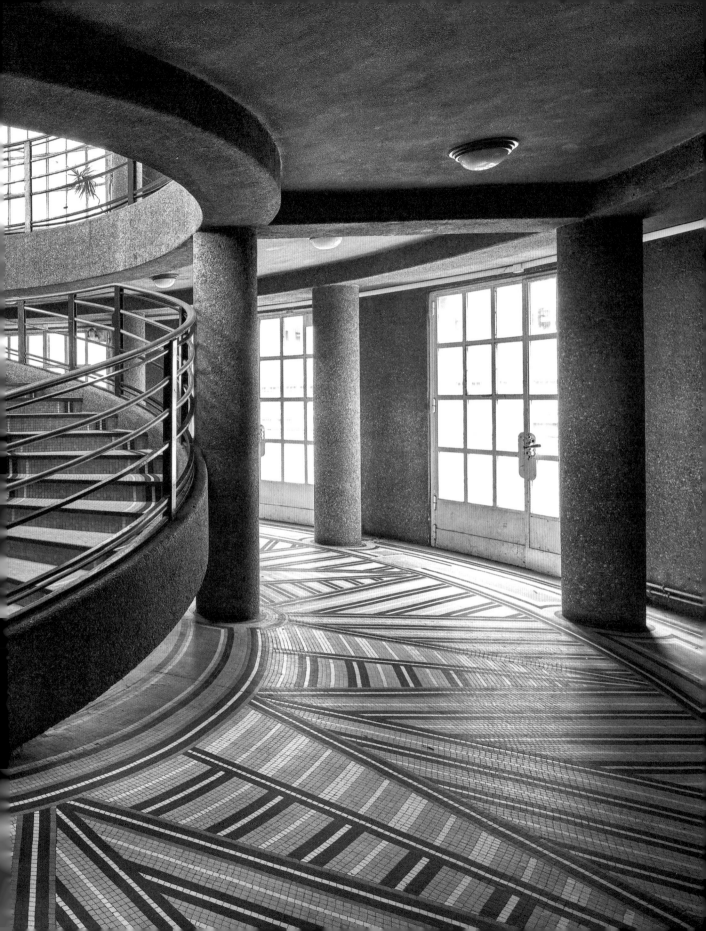

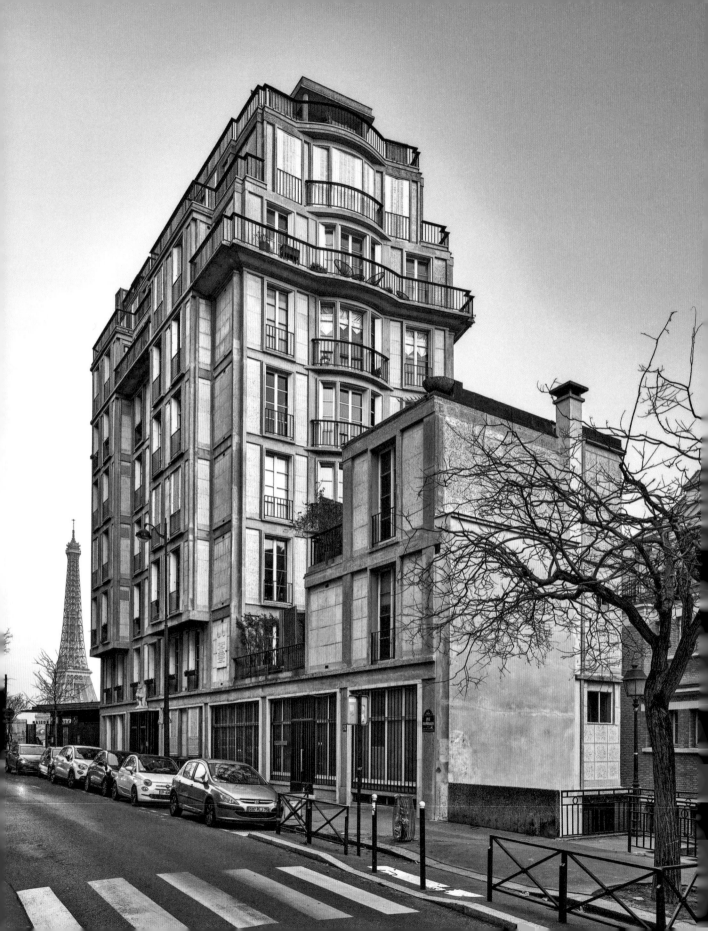

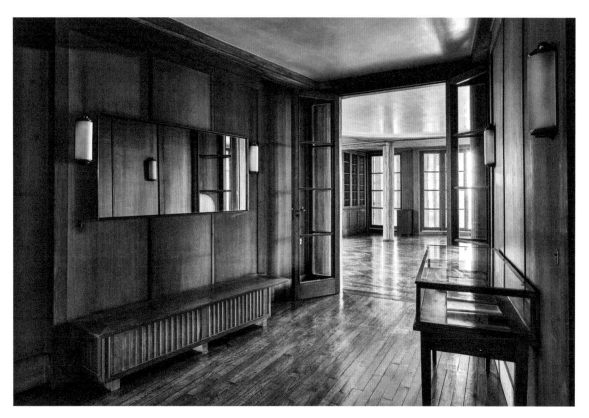

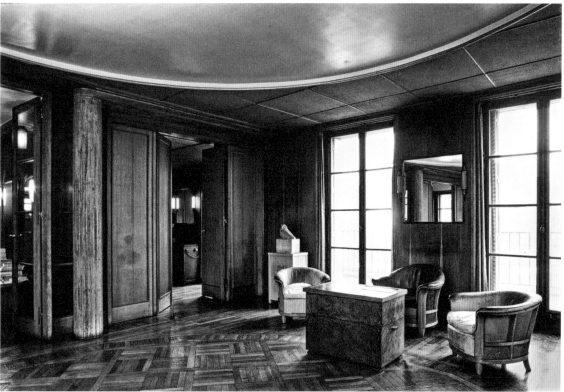

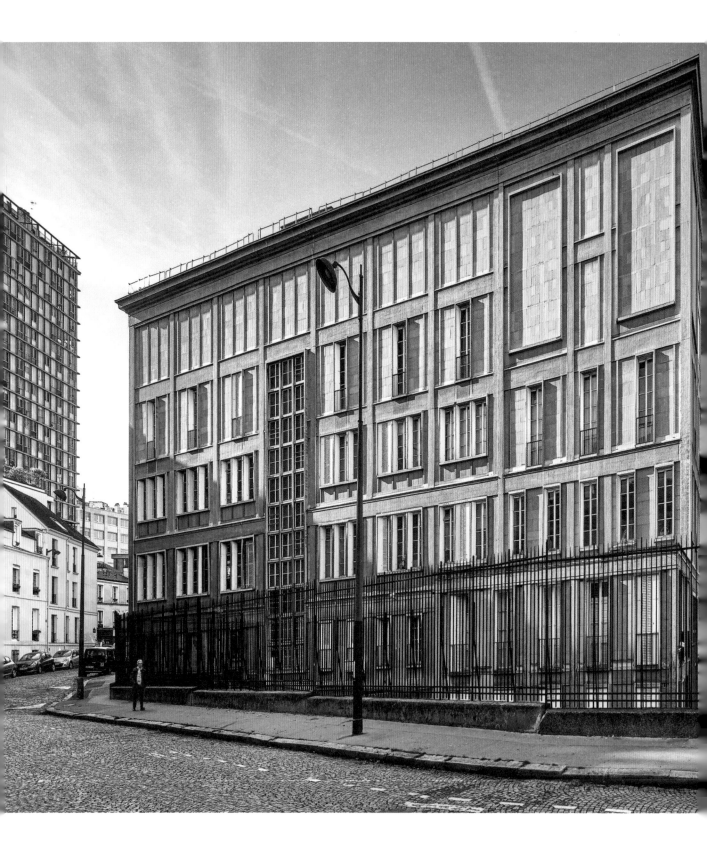

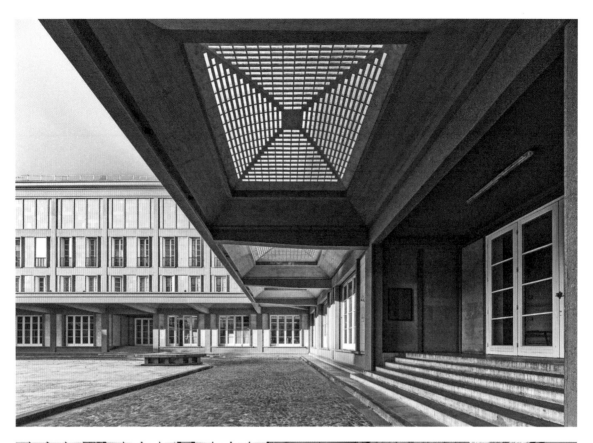

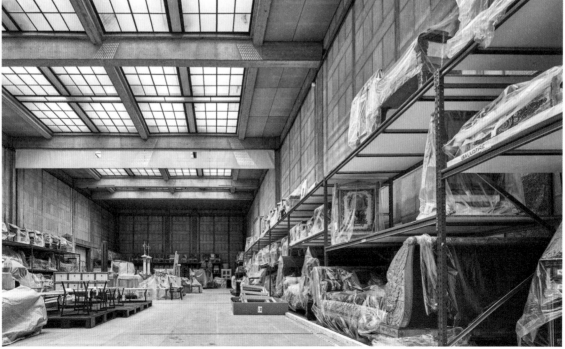

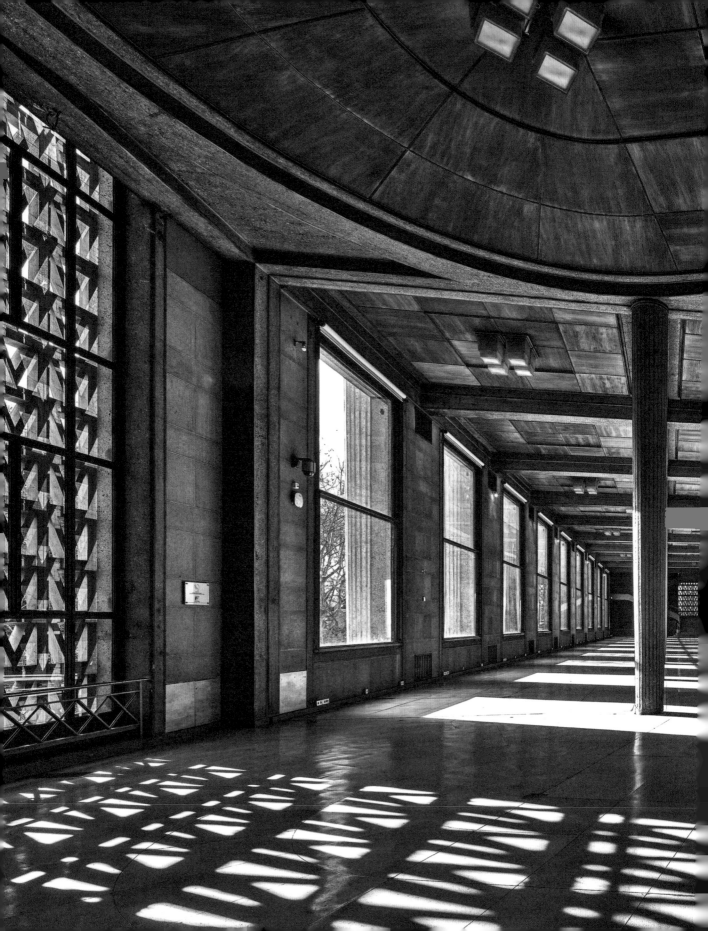

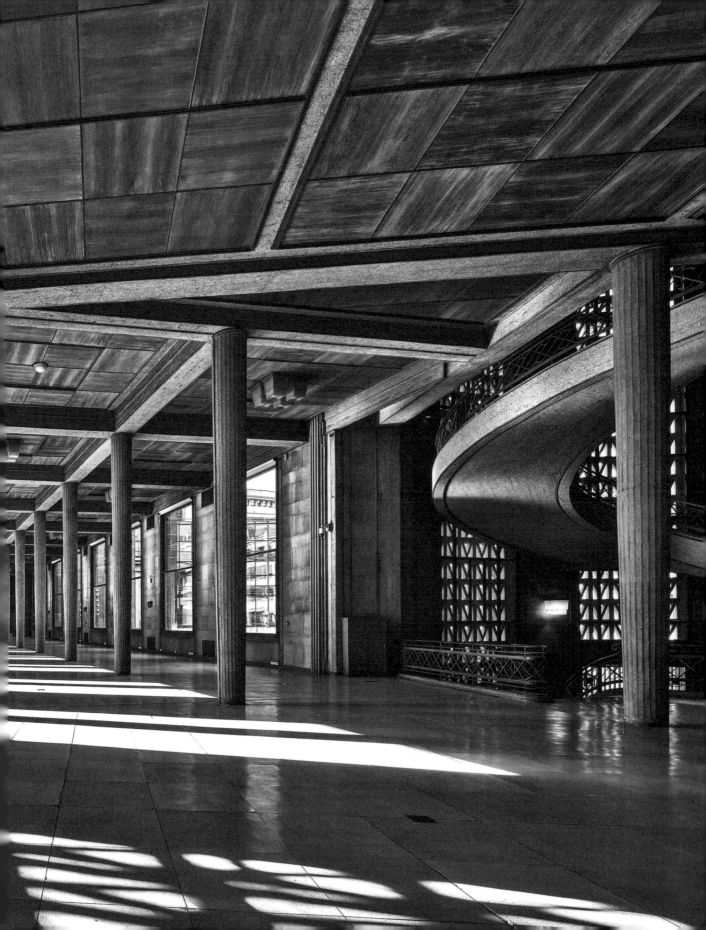

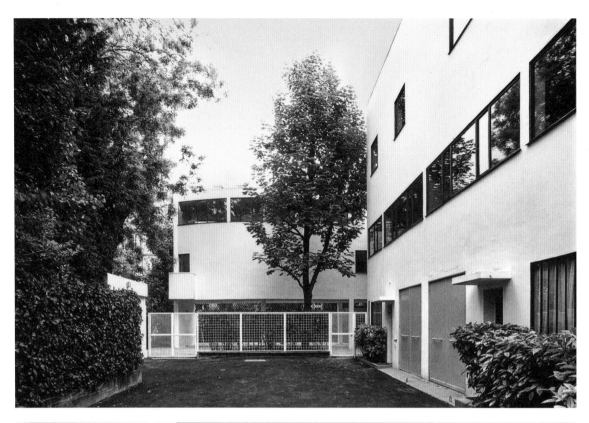

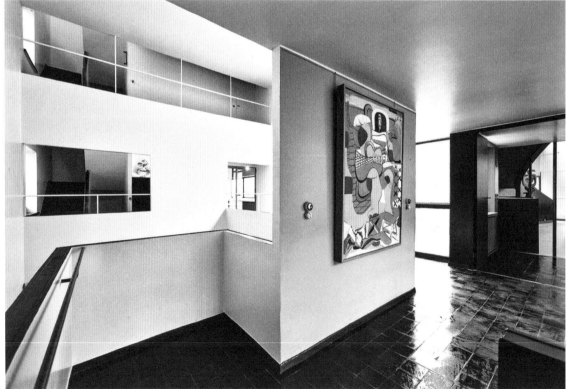

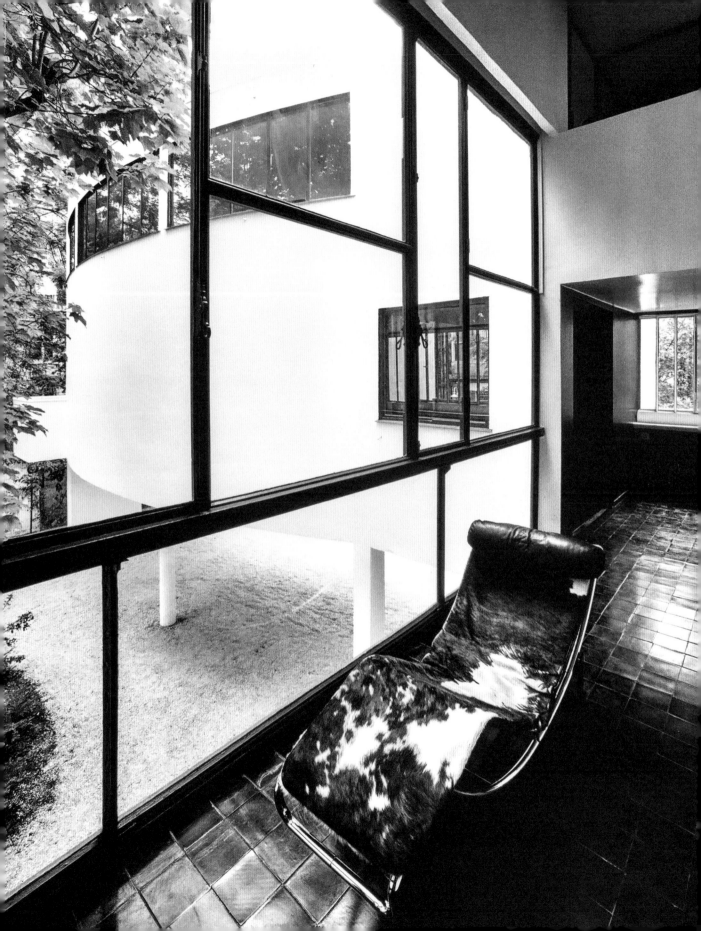

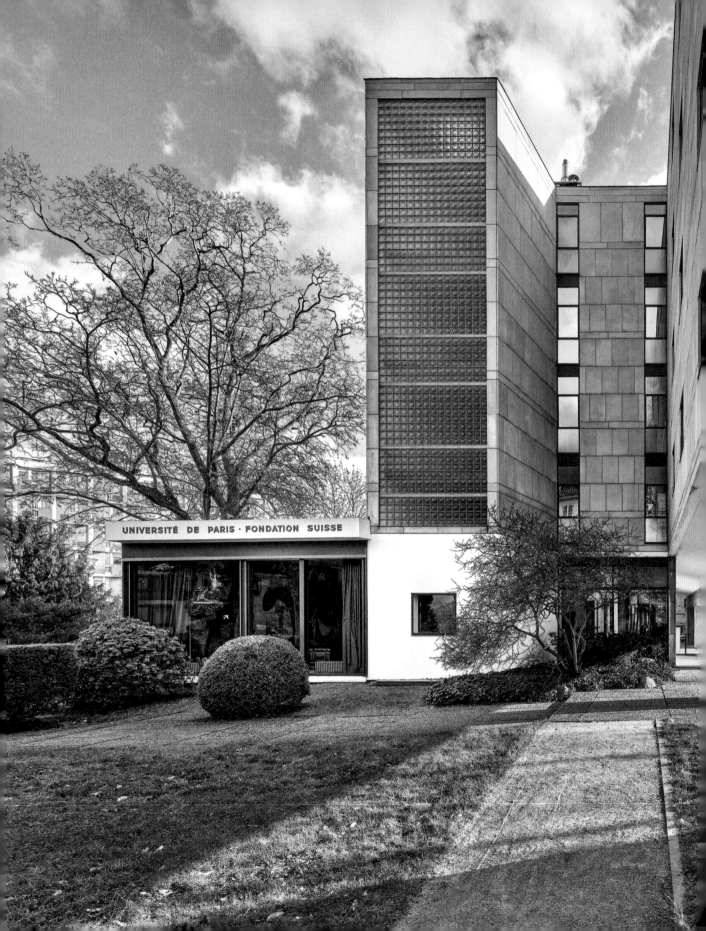

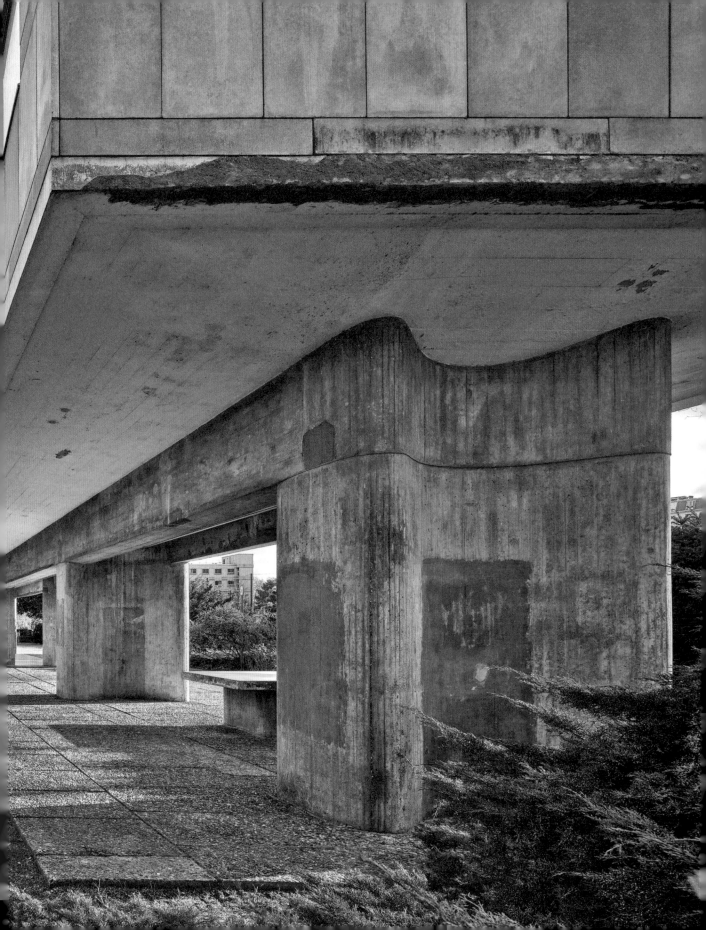

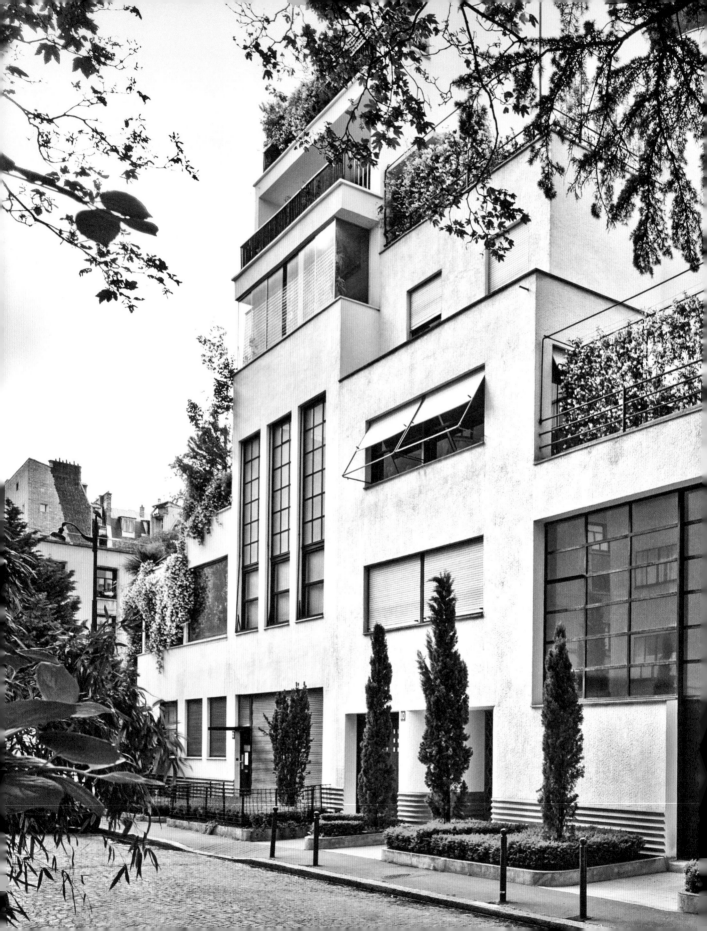

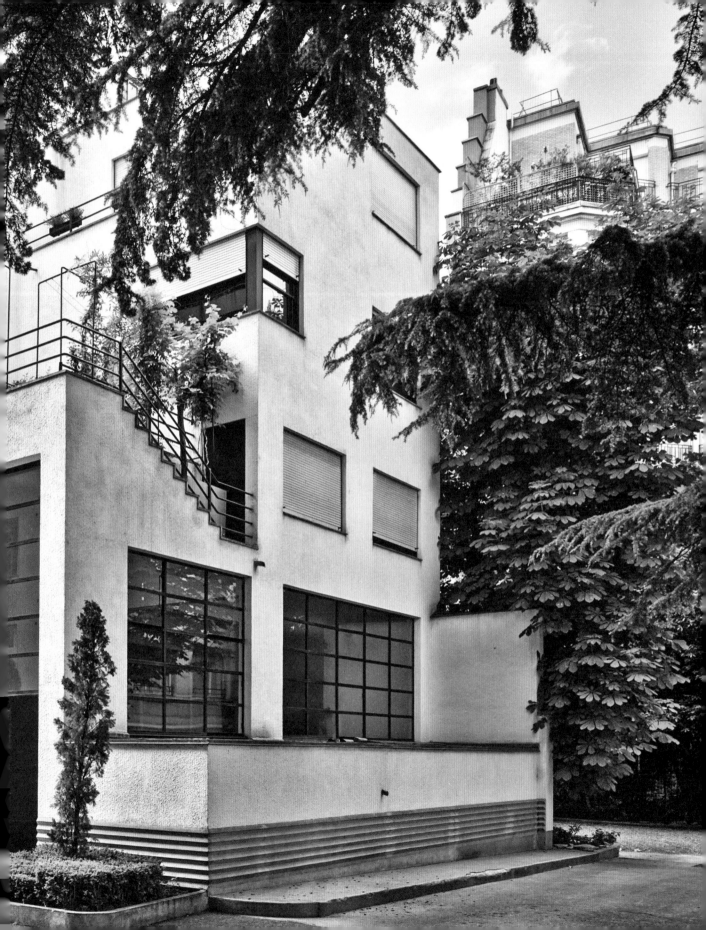

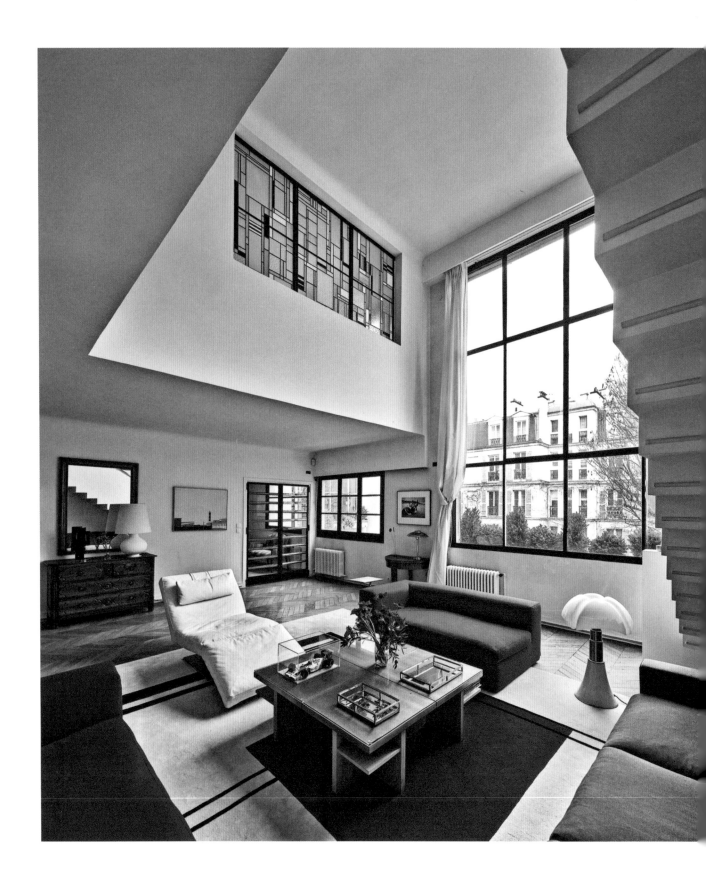

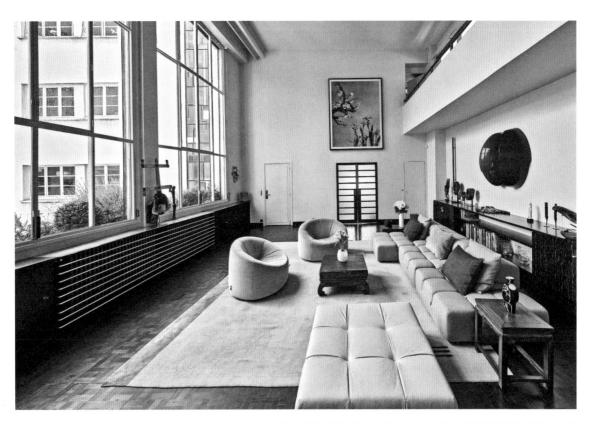

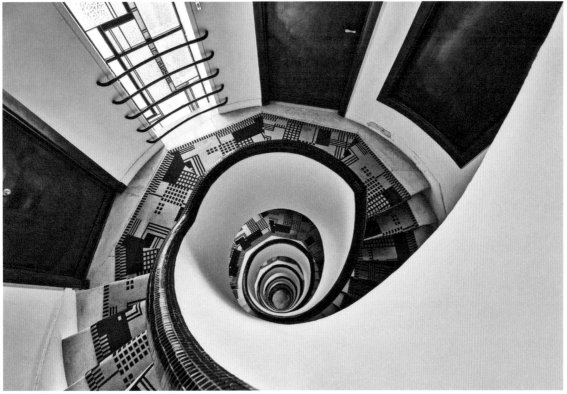

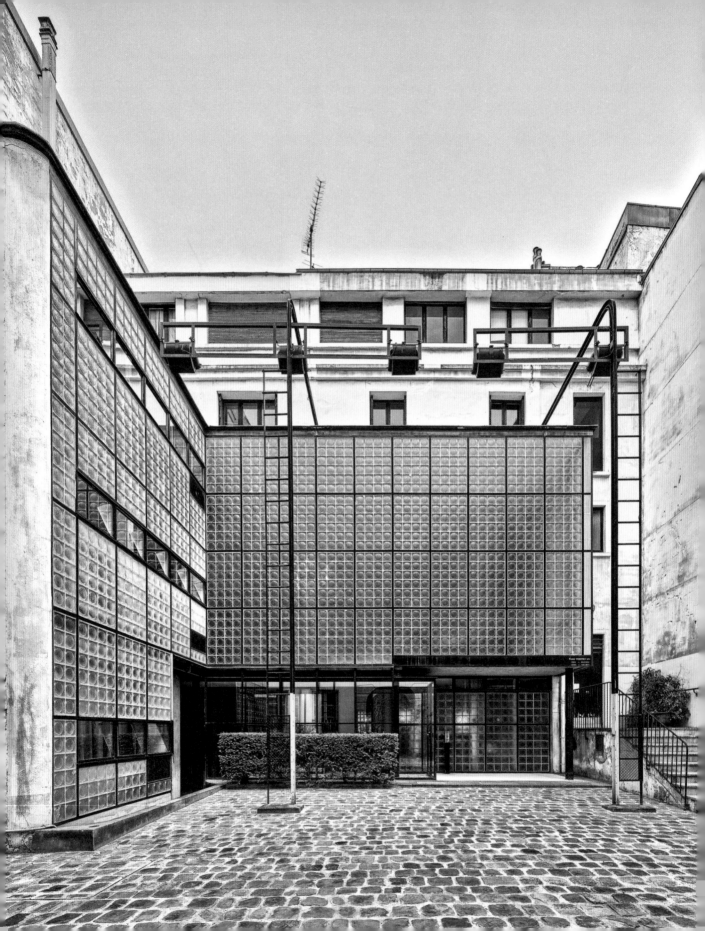

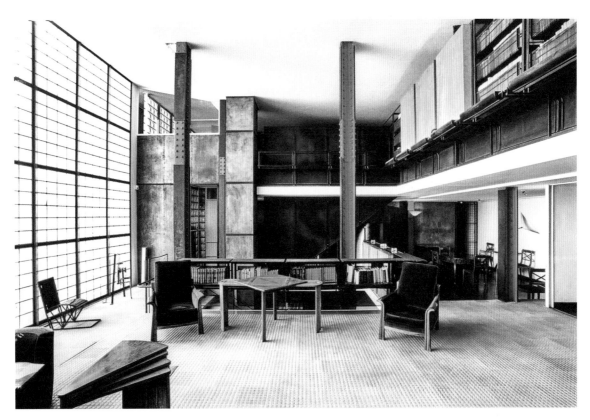

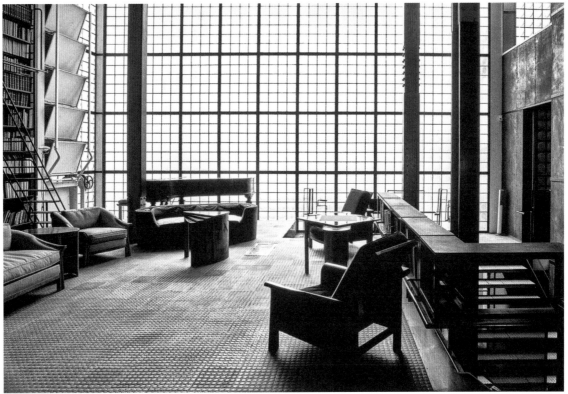

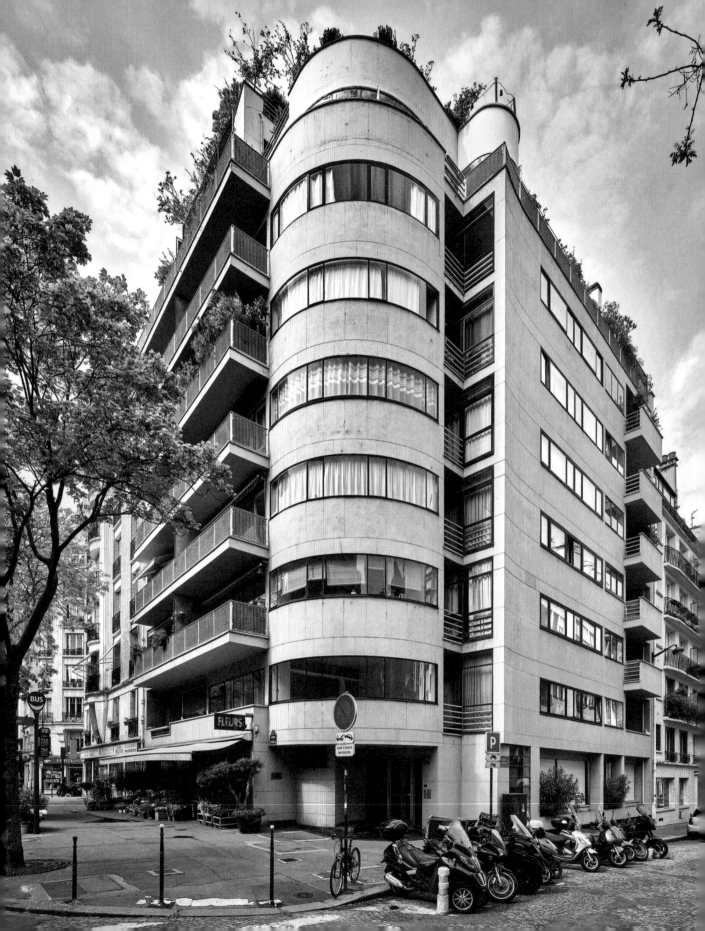

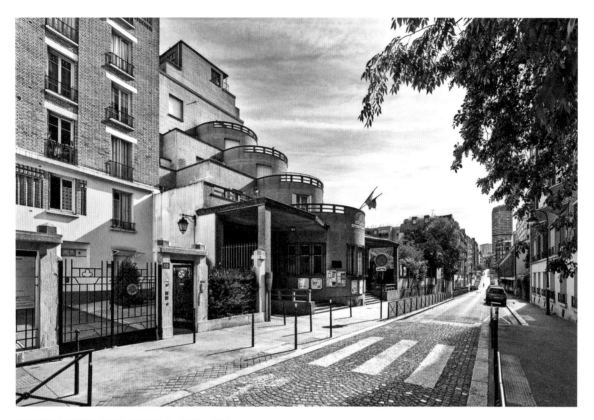

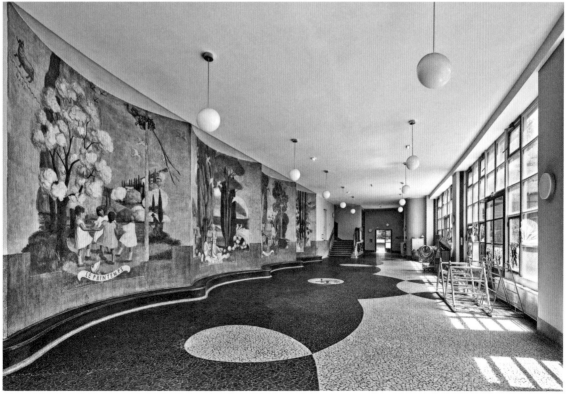

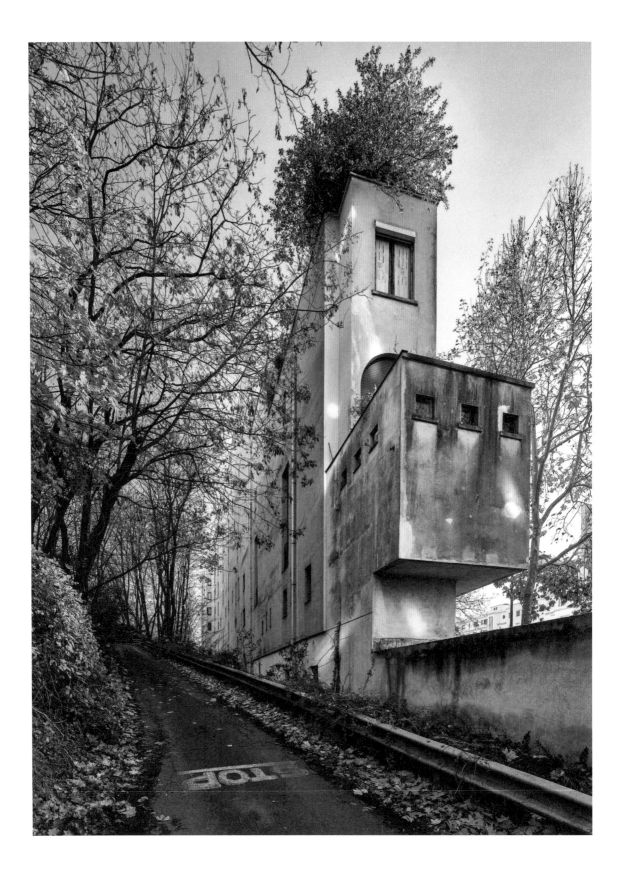

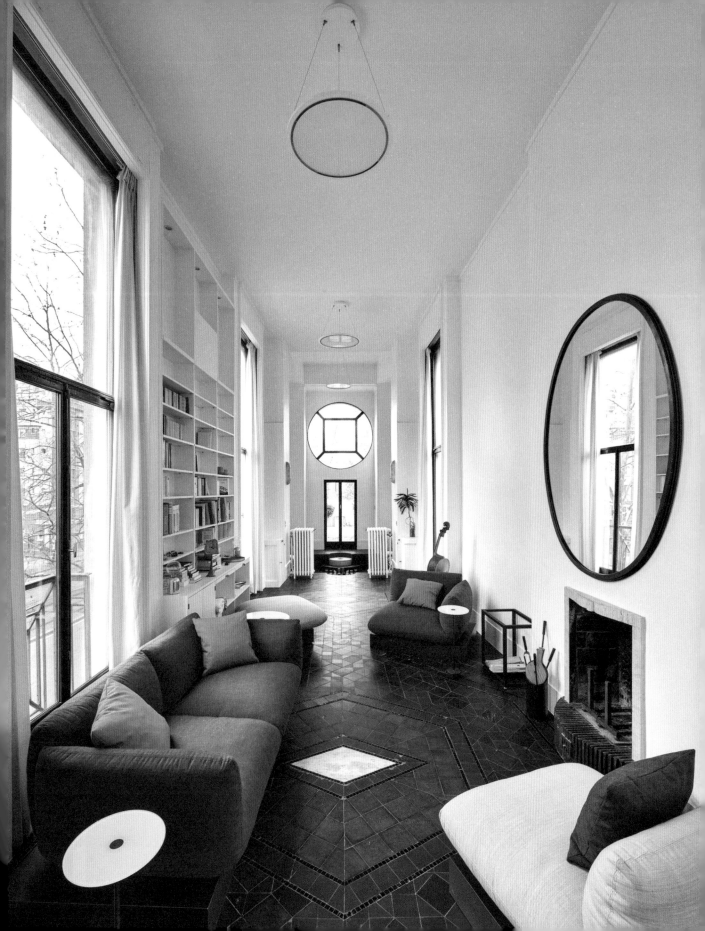

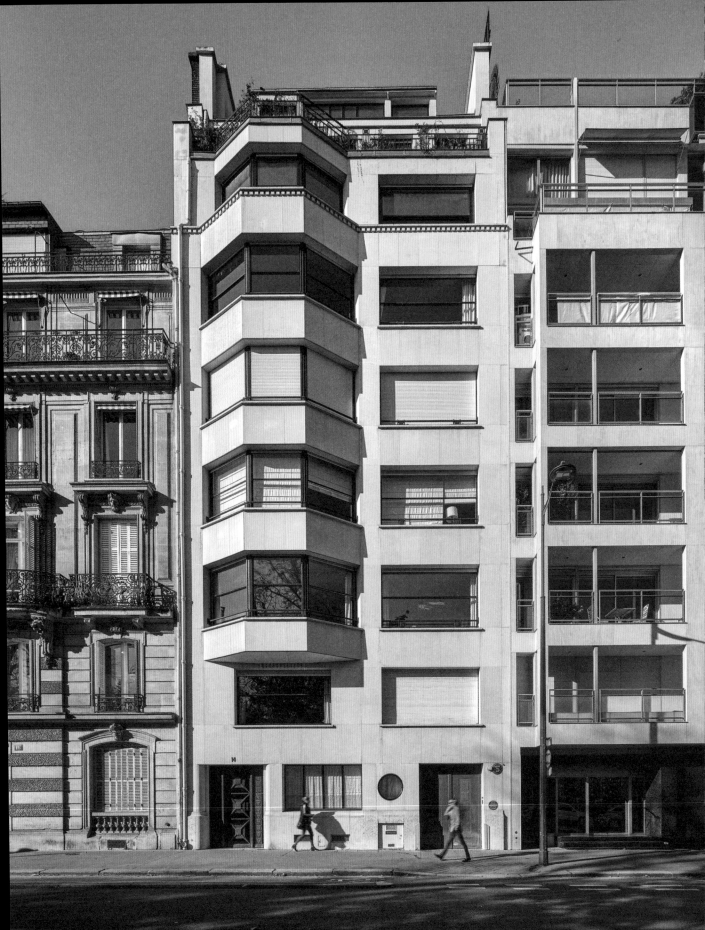

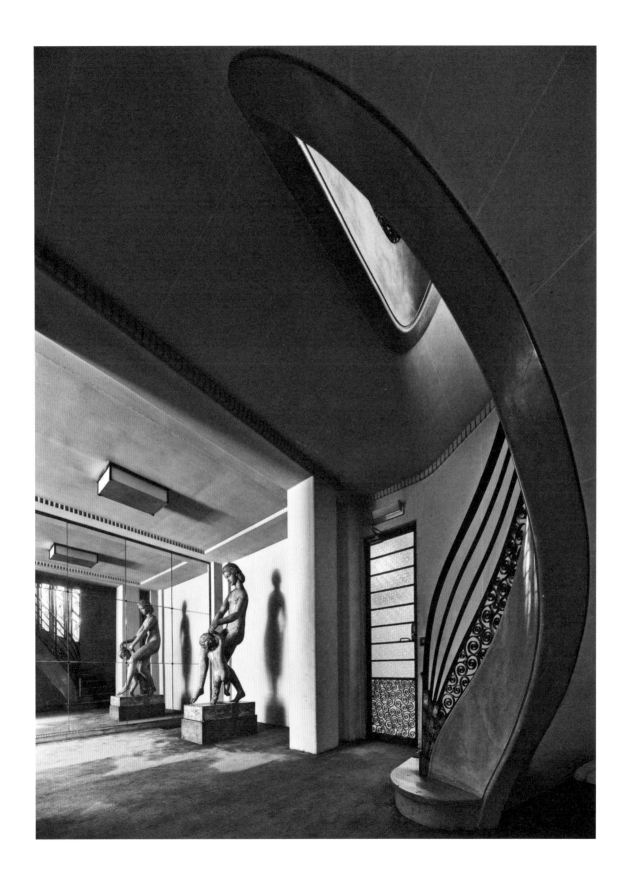

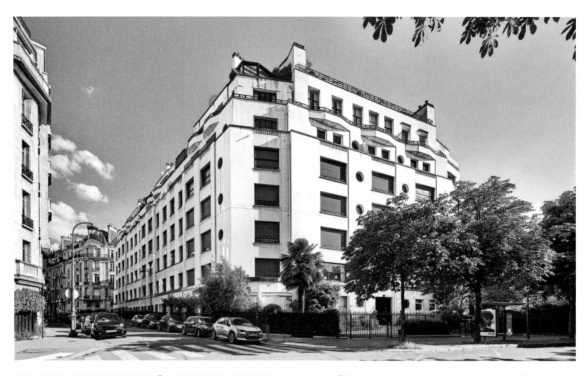

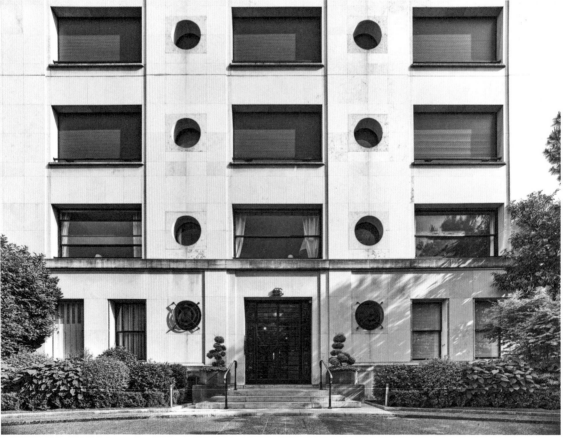

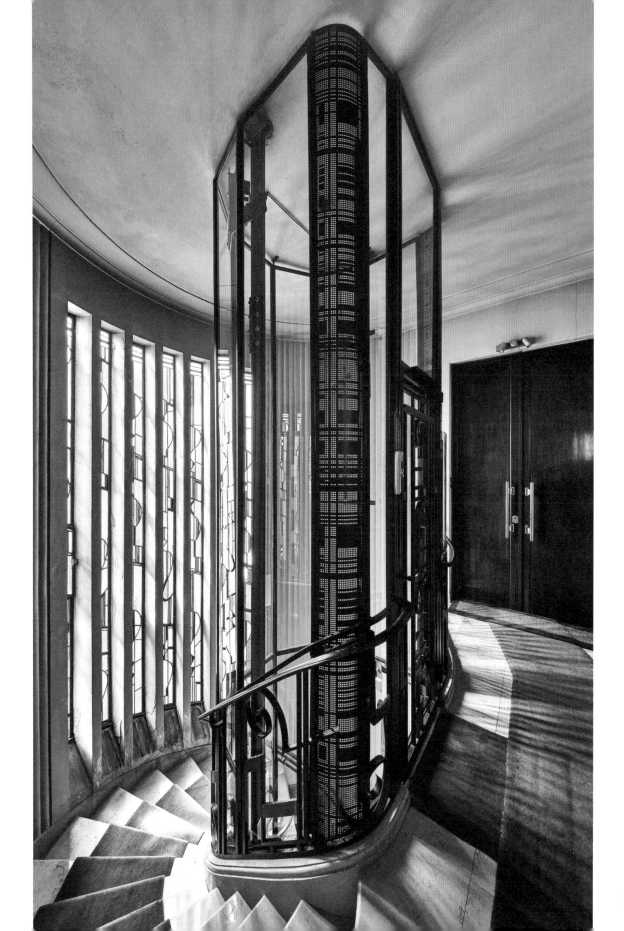

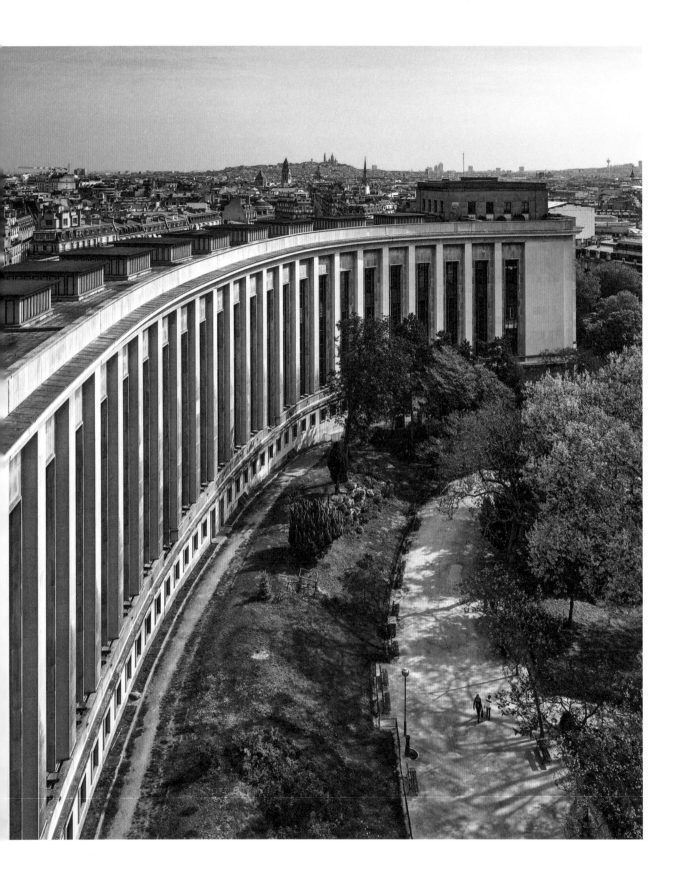

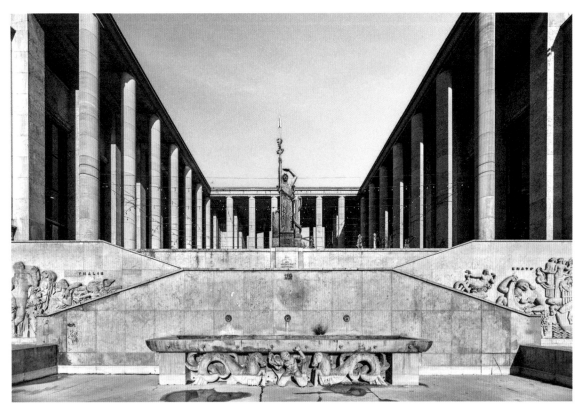

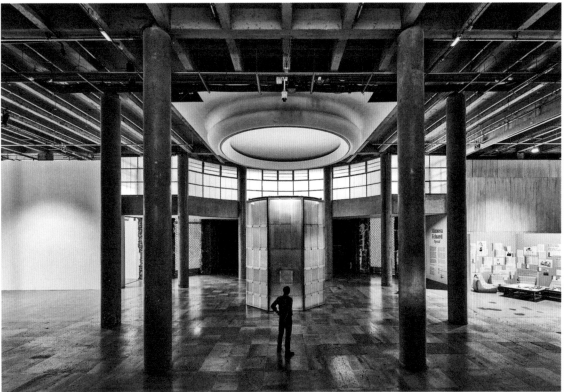

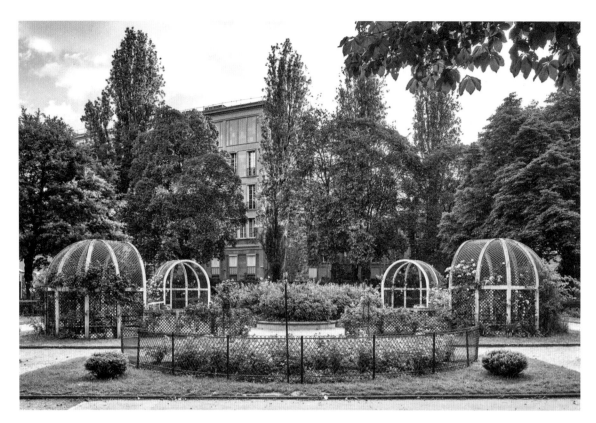

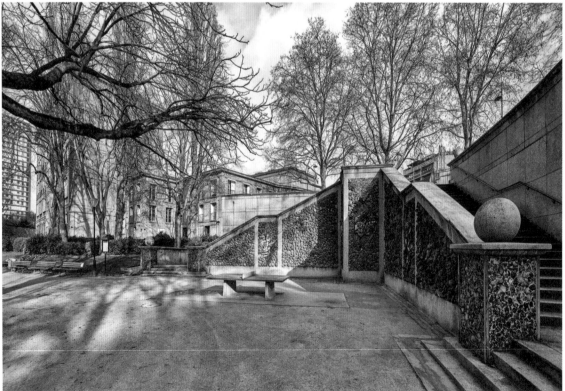

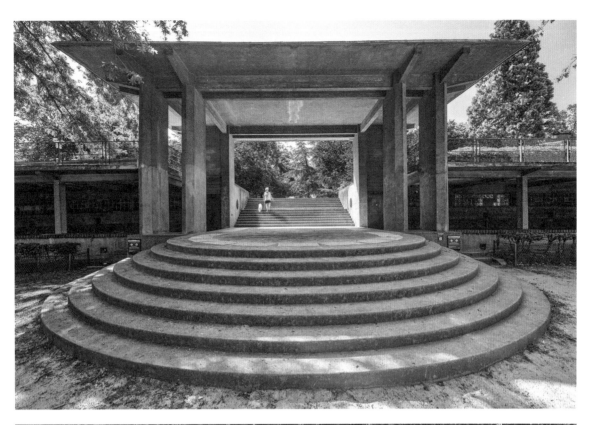

A
B

Laure Albin-Guillot

1879, Paris
1962, Paris

Laure Albin-Guillot quickly earned recognition as a photographer, with a career that oscillated between traditional pictorialism and the innovative approach characteristic of the New Vision movement. Yet she was also a businesswoman, an archivist of the photographic collections of the École des Beaux-Arts (1932), and a curator at the Cinémathèque Nationale (1933). In her studio in western Paris, which served as both an atelier and a high-society salon, she worked for a variety of fashion magazines and took portraits of the fashionable figures of "le Tout-Paris," including Suzy Solidor, Jeanne Lanvin,* André Gide,* and Émile-Jacques Ruhlmann.* She also pursued more radical endeavors, such as her studies of male and female nudes, and notably developed a new genre that she dubbed "micrography." Based on microscope slides prepared by her husband, a research scientist, she produced images of minute details that revealed extraordinary decorative qualities through their abstraction; she printed a sumptuous portfolio of these works in photogravure in 1931. She considered herself an artist and was a member of the Société des Artistes Décorateurs, creating objects such as lampshades and screens that combined traditional techniques with photography.

Albin-Guillot contributed to periodicals devoted to modern graphic arts, including *VU* and Charles Peignot's* *Arts et métiers graphiques* (Graphic Arts and Crafts), and took part in numerous exhibitions, including the Salon de l'Escalier (Salon of the Stairs)—so named because meetings were held in the stairway of the Comédie des Champs-Élysées theater—in 1928, and, ten years later, *Photography 1839–1937* at MoMA in New York.

Dedicated to her profession, and particularly committed to promoting women in the arts, she participated in the organization of a major exhibition in Paris, *Les Femmes artistes d'Europe exposent au musée du Jeu de Paume* (Women Artists of Europe Exhibit at the Jeu de Paume Museum) in 1937. G MJ, P M

Laure Albin-Guillot. *Micrographies décoratives*. Paris: Draeger, 1931.
Delphine Desveaux. *Laure Albin-Guillot: L'enjeu classique*. Paris: La Martinière, 2013. Exhibition catalog.

↓ *Study of a Nude*, 1933.

→ *Micrography*, 1931.

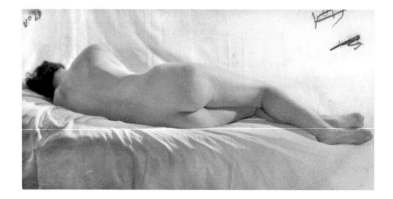

61

Guillaume Apollinaire

1880, Rome
1918, Paris

Although Guillaume Apollinaire died before his fortieth birthday, during the influenza epidemic of 1918, he had a definitive impact on the postwar Paris scene. The journal created by Le Corbusier* and Amédée Ozenfant in 1920—*L'Esprit nouveau* (The New Spirit)—was an homage to the poet, as it was named after the title of a lecture he had given in 1917.

He wrote several erotic novels and poetry collections. In his early work, he set himself apart from the conventions of symbolism and realism, deriving his inspiration from large cities and the artists of Montparnasse and Montmartre who were his friends and supporters. His book *Les Peintres cubistes* (*The Cubist Painters*) of 1913 introduced and analyzed the movement, which he had been among the first to chronicle. He called upon architects to take up the torch from artists and "build sublimely," inviting them "to raise the highest tower, to prepare for ivy and passing time a ruin more beautiful than any other," and to "span a port or a river with an arch more daring than the rainbow."[1]

He paid his own homage to the Eiffel Tower in an anti-German calligram in 1918, and made Paris the backdrop in his most compelling poems, including "Zone" and "Le Pont Mirabeau" ("The Mirabeau Bridge"). His play *Les Mamelles de Tirésias* (*The Breasts of Tiresias*) was performed in June 1917 on the stage of the Conservatoire Maubel in Montmartre; presented as a "surrealist drama," it inspired several members of the audience, including Louis Aragon,* André Breton,* and Philippe Soupault, to seize on this mysterious term to name the movement they created in the 1920s. The first manifesto of surrealism was published in 1924. J-L C

Marcel Adéma and Michel Décaudin. *Album Apollinaire*. Paris: Gallimard, 1971.
Guillaume Apollinaire. *Alcools: Poèmes 1898–1913*. Paris: Mercure de France, 1913.
————. *The Cubist Painters*. Translated and with commentary by Peter Read. Berkeley: University of California Press, [1913] 2004.
————. *Calligrammes*. Paris: Mercure de France, 1918.
————. *Calligrammes*. Translated by Anne Hyde Greet. Berkeley: University of California Press, [1980] 2004.
————. *Selected Poems*. Translated with an introduction and notes by Martin Sorrell. Oxford World's Classics. Oxford: Oxford University Press, 2015.
Laurence Campa. *Guillaume Apollinaire*. Paris: Gallimard, 2013.

1. *The Cubist Painters*, trans. Peter Read (Berkeley: University of California Press, [1913] 2004), 82.

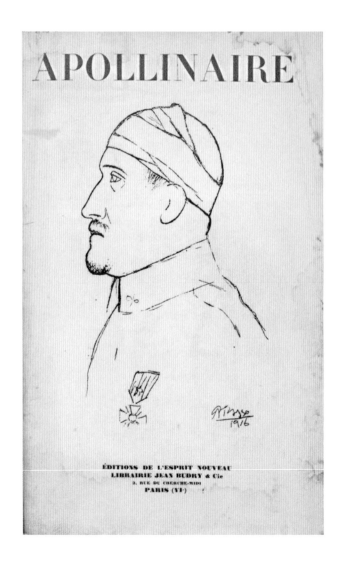

S
A
LUT
M
O N
D E
DONT
JE SUIS
LA LAN
GUE É
LOQUEN
TE QUESA
B O U C H E
O PARIS
TIRE ET TIRERA
T O U JOURS
AUX A L
LEM ANDS

Louis Aragon

1897, Paris
1982, Paris

With a foot in both the literary and political worlds, Aragon played a central role in Paris, where he immediately gained recognition for his first novel *Anicet ou le Panorama* (*Anicet or the Panorama*) of 1921. Along with André Breton* and Philippe Soupault, whom he met at the Val-de-Grâce hospital and on the battlefront respectively, he was one of the founding members and foremost exponents of surrealism. He revealed the secrets of the capital's streets and parks in *Le Paysan de Paris* (*Paris Peasant*) of 1926, and later recorded the tensions between the classes of Parisian society in *Les Beaux Quartiers* (The Fashionable Districts), published in 1936.

In 1928, he met the Russian-born writer Elsa Triolet. This proved to be a decisive moment in his life, and their marriage established them as a legendary literary couple.

Aragon joined the French Communist Party in 1927, and he broke with the surrealists in 1931 after publishing his poem "Front Rouge" ("Red Front"). He was an outspoken supporter of the Soviet Union and was unrestrained in his praise, celebrating its politics in his works, including his poetry collection *Hourra l'Oural!* (Hooray the Urals!) published in 1934. Twenty-five years later, he distanced himself from his early writings and ended up condemning Stalin's crimes.

As a journalist, Aragon reported for *L'Humanité*, and from 1933 he wrote for *Commune*, a monthly publication by the Association des Écrivains et Artistes Révolutionnaires. In 1935, he founded the Maison de la Culture with André Malraux, which organized lively debates on art and literature. He was an active supporter of the Republicans in the Spanish Civil War and was committed to the Resistance, dedicating some of his most memorable poems to the cause, including "La Rose et le réséda" ("The Rose and the Mignonette") from 1943. During the Occupation, he wrote *Aurélien*, a novel that describes the impossibility of happy love and presents a panoramic retrospective of Paris between the wars. J-L C

Louis Aragon. *Anicet ou le Panorama*. Paris: Gallimard, 1921.
———. *Anicet or the Panorama*. Translated and with an introduction by Anthony Melville. London: Atlas Press, 2016.
———. *Le Paysan de Paris*. Paris: Gallimard, 1926.
———. *Paris Peasant*. Translated and with an introduction by Simon Watson Taylor. Cambridge, MA: Exact Change, 2011.
———. *Les Beaux Quartiers*. Paris: Denoël, 1936.
———. *La Diane française*. Paris: Pierre Seghers, 1944.
———. *Aurélien*. Paris: Gallimard, 1944.

Photo-booth portrait of Louis Aragon, c. 1928.

Jean Arp

1886, Strasbourg
1966, Basel

Hans Arp—an Alsatian born in what was then Germany—was naturalized as a French citizen in 1926, after which he changed his first name. For almost twenty years, his work was inextricably linked to that of his wife, Sophie Taeuber-Arp.* They both moved in Dadaist circles and participated in the groups Cercle et Carré and Abstraction-Création, while maintaining their ties with the surrealists. Arp was close to André Breton,* Louis Aragon,* René Crevel, and Man Ray,* who took a series of portraits of him. He also had links with Florence Henri* and El Lissitzky, with whom he published *The Isms of Art* in 1925.

Having received a traditional art education, Arp first became known as a poet, and he continued to pursue his activities as a writer while maintaining a prominent career as a sculptor throughout his life. In the 1920s and 1930s, the majority of his work consisted of drawings and collages of torn paper, as well as his wood *Reliefs* forming simple abstract figures—both painted and unpainted—that often displayed an antic sense of humor. In 1928, he collaborated with Sophie Taeuber-Arp on the decorative scheme for L'Aubette, a brasserie-dance hall in Strasbourg. Devastated by his wife's accidental death in 1943, he returned to the home and studio that she had designed for them in Clamart, on the outskirts of Paris, and for several years he continued to pursue the work they had shared, before turning his attention to organic sculpture in stone and bronze. G MJ

Jean Arp. *Jours effeuillés: Poèmes, essais, souvenirs, 1920–1965*. Paris: Gallimard, 1966.
Isabelle Ewig and Emmanuel Guigon. *Art is Arp: Dessins, collages, reliefs, sculptures, poésie*. Strasbourg: Musées de la Ville de Strasbourg, 2008. Exhibition catalog.

↓ El Lissitzky, double-exposure portrait of Jean Arp, 1924.

→ *Woman*, 1927. Oil on plywood, wood, bronze.

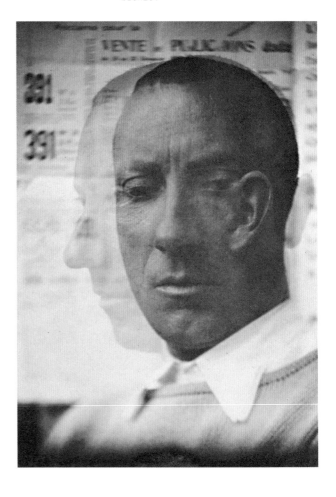

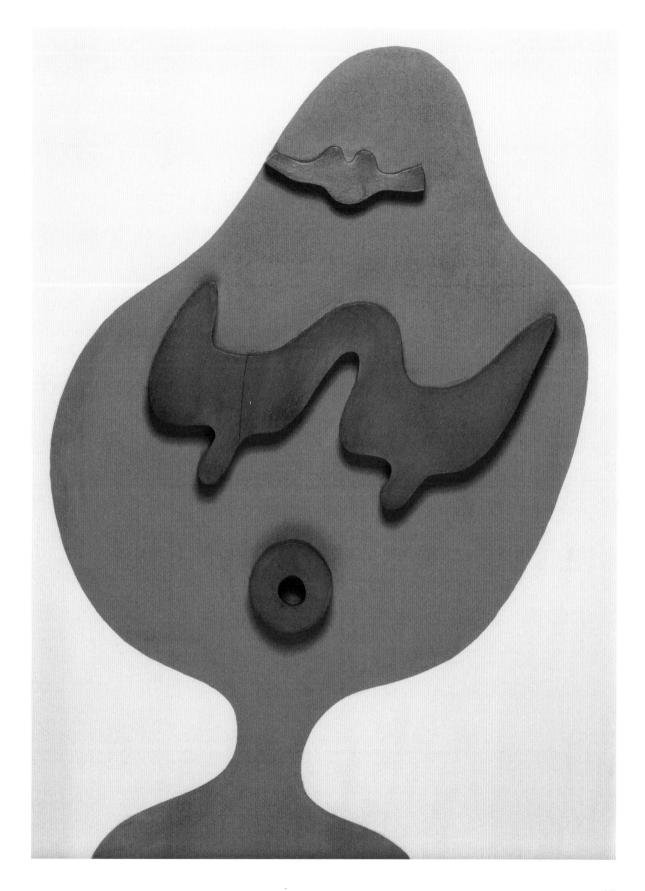

Eugène Atget

1857, Libourne (France)
1927, Paris

Between 1897 and 1927, Eugène Atget tirelessly walked the streets of Paris and its outskirts, methodically recording block after block of dilapidated buildings, squalid alleys, decrepit dwellings, and the humble stalls of street peddlers. So much of "old Paris" had seemed to disappear in the blink of an eye with the completion of Baron Haussmann's massive urban renewal projects and the city's astonishing growth. Atget immortalized five thousand sites on twenty thousand glass plates using a large view camera that he lugged around with him constantly, usually starting out at dawn.

Atget, who was self-taught, defined himself as a documentary photographer rather than an artist. He marketed a body of work that was intended for artists, who used his pictures in their studios as a kind of repertory of forms, titling his collections *Paris pittoresque*, *Intérieurs parisiens*, and *Métiers, boutiques et étalages de Paris* (Picturesque Paris, Parisian Interiors, and Trades, Shops and Shop Windows of Paris).

In the early 1920s, Atget met Man Ray* and his assistant, the American photographer Berenice Abbott, who were his neighbors in Montparnasse. This association brought Atget out of obscurity, and in 1926 they advocated for his photos to be published in André Breton's* journal, *La Révolution surréaliste*. In 1928, the Salon de l'Escalier (Salon of the Stairs) exhibited Atget's photographs side by side with those of the new arrivals in Paris: Germaine Krull,* André Kertész,* Man Ray, and Paul Outerbridge. Atget passed the torch to them, confiding at the end of his life, "I can say that I possess all of Old Paris." P M

Berenice Abbott. *Atget, photographe de Paris*. Preface by Pierre Mac Orlan. Paris: Éditions Jonquières, 1930.
Anne de Mondenard and Agnès Sire, eds. *Atget, Voir Paris*. Paris: Atelier EXB, 2020.
Molly Nesbit. *Atget's Seven Albums*. New Haven, CT: Yale University Press, 1994.

↓ Boulevard de Bonne-Nouvelle, c. 1928.

→ View of Rue de Seine, 1924.

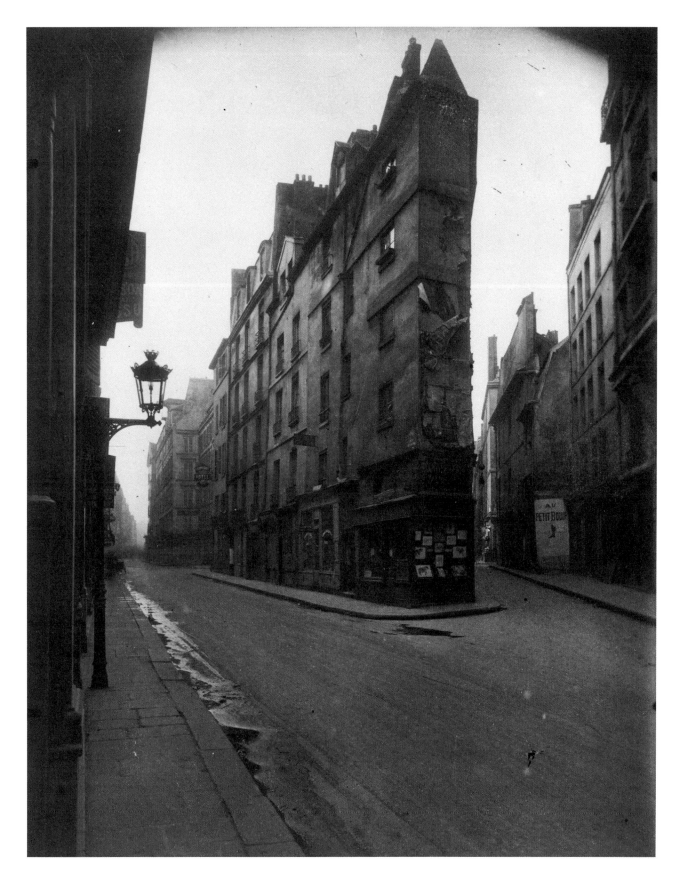

Claude Autant-Lara

1901, Luzarches (France)
2000, Antibes

Trained at the École des Arts Décoratifs in Paris, Autant-Lara became a stage designer, working with his parents who managed the Art et Action laboratory. He met Marcel L'Herbier,* with whom he collaborated on a play and several films, including *L'Inhumaine* (*The Inhuman Woman*), and he also worked with René Clair,* Jaque-Catelain, and Jean Renoir* on *Nana*, and Nikolaï Malikoff on *Paname n'est pas Paris* (*Apaches of Paris*). His first film, *Fait divers* (*News in Brief*), from 1923, was a low-key tale of intrigue set in Paris, whose streets, squares, and monuments play a significant role in its storyline. In *Ciboulette* (*Bill*), he returned to directing (the film's art direction was by Lazare Meerson* assisted by Alexandre Trauner*). In a remarkable tracking shot at the beginning of the film, he linked the extended Paris landscape of 1867, the square of Les Halles, and the Fontaine des Innocents. *Fric-Frac* (1939), in which a naïve employee is hoodwinked by grifters, conveys us from Rue de Turbigo to the Stade Buffalo and the Longchamp racecourse. F A

Claude Autant-Lara. *La Rage dans le cœur: Chronique cinématographique du 20ᵉ siècle.* Paris: H. Veyrier, 1984.

Stills from the film *Fait divers* (*News in Brief*), 1923.

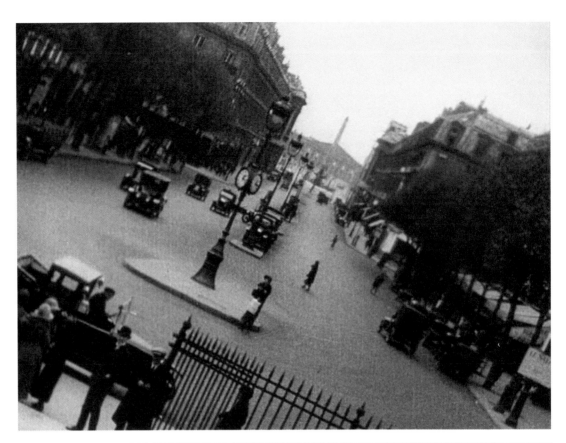

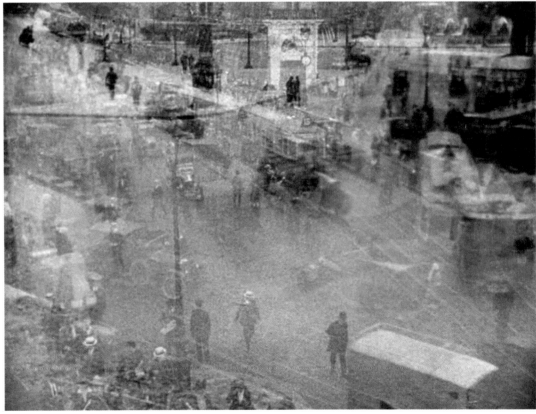

Jean Badovici

1893, Bucharest
1956, Monaco

This Romanian-born architect was best known as the creator of Villa E1027 in Roquebrune-Cap-Martin. Today, it is generally agreed that he shares the credit for this iconic work with his partner of the time, the interior designer Eileen Gray.*

Badovici earned a degree from the École Spéciale d'Architecture (like Robert Mallet-Stevens,* Adrienne Gorska,* and Gabriel Guevrekian*) in 1919, and from 1923 he dedicated himself to publishing on architectural topics. On behalf of the firm Albert Morancé, which also fostered the early work of Christian Zervos*, he founded and managed the quarterly magazine *L'Architecture vivante* (Living Architecture). This periodical was published in the form of exquisite portfolios combining photogravure plates and carefully composed texts, complemented by meticulously redrawn graphic documents. He recognized contemporary creative movements in France and abroad, including the Dutch De Stijl of Theo van Doesburg,* the Russian constructivists, and the German Bauhaus, as well as the work of Tony Garnier, Erich Mendelsohn, and Le Corbusier.* Badovici dedicated eight volumes to the works of Le Corbusier, published between 1927 and 1938; he had been very close to him since the early 1920s, and hired him to create a fresco for the interior of his house in Vézelay, not far from the work he had earlier commissioned from Fernand Léger.*

Badovici was also a sea lover and sailing enthusiast, and he registered several patents for rescue boats. He resumed his studies on urban planning during World War II and, after 1945, collaborated with André Lurçat* to reconstruct the town of Maubeuge. G MJ

Jean Badovici and Eileen Gray. *Maison en bord de mer.* Special issue, *L'Architecture vivante*, no. 26 (Winter 1929).
Jean-François Archieri. "Jean Badovici: Une histoire confisquée." In *Eileen Gray.* Edited by Cloé Pitiot. Paris: Centre Pompidou, 2013, 88–94.

↓ Front cover of *L'Architecture vivante*'s portfolio on Villa E1027 by Eileen Gray and Jean Badovici, 1929.

→ Front cover of *L'Architecture vivante*'s portfolio entitled *Grandes Constructions: Béton armé, acier et verre* (Large Constructions: Reinforced Concrete, Steel, and Glass), 1927.

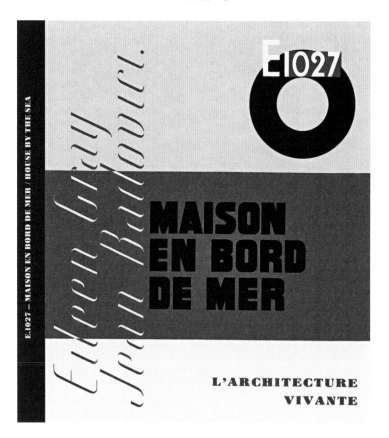

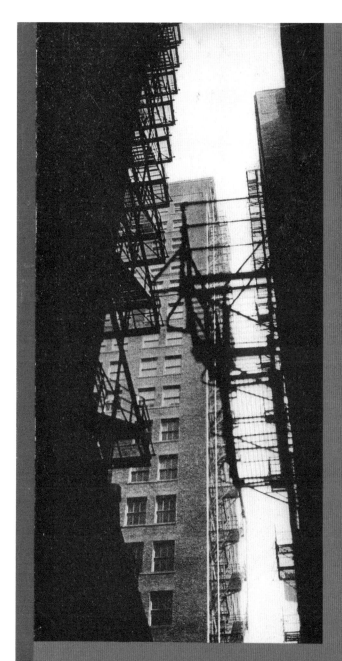

ÉDITIONS
ALBERT
MORANCÉ

GRANDES CONSTRUCTIONS

BÉTON ARMÉ ACIER ET VERRE

Josephine Baker

1905, St. Louis, Missouri
1975, Paris

The African American dancer Freda Josephine McDonald (who became known under the name of her second husband, Willie Baker) was the star of *La Revue nègre*, a music-hall show that introduced her to the Parisian public in 1925. With close ties to writers of the Harlem Renaissance, who were met with a cordial welcome in Paris, she was the darling of artists such as Fernand Léger* and a favorite of the audiences of musical reviews at the Folies-Bergère and Casino de Paris. Her theme song "J'ai Deux Amours" ("I Have Two Loves"), composed by Vincent Scotto (1931), was a spectacular success, and she subsequently featured in a number of films that he scored.

Baker was celebrated by poster artists such as Paul Colin* and Jean Chassaing, and was courted by numerous photographers. She crossed paths with architectural legends on two occasions. In 1927, Adolf Loos* designed a private residence for her; with its bicolored, striped façade, it would have caused as big a sensation as her performances did, but the plans remained on paper. This was equally the case for the home that Le Corbusier* imagined for her when he made her acquaintance in 1929, aboard the ocean liner *Giulio Cesare* en route between Buenos Aires and Rio de Janeiro.

In 1935, she attempted a comeback on the American stage, but its disappointing reception gave an additional impetus to her life and work in France.

During World War II, she carried out missions for the secret services of Free France. She later welcomed "the rainbow tribe" of adopted children in her Château des Milandes in Périgord. Her generosity and patriotic dedication earned her a place in the Paris Panthéon in 2021. J-L C

Lynn Haney. *Naked at the Feast: A Biography of Josephine Baker*. New York: Dodd, Mead & Co., 1981.
Mae G. Henderson and Charlene B. Regester, eds. *The Josephine Baker Critical Reader: Selected Writings on the Entertainer and Activist*. Jefferson, NC: McFarland & Company, Inc., 2017.
Phyllis Rose. *Jazz Cleopatra: Josephine Baker in Her Time*. New York: Doubleday, 1989.
Jacques Pessis. *Joséphine Baker*. Paris: Gallimard, 2007.
Marcel Sauvage. *Les Mémoires de Joséphine Baker*. Paris: Dilecta, 2006.

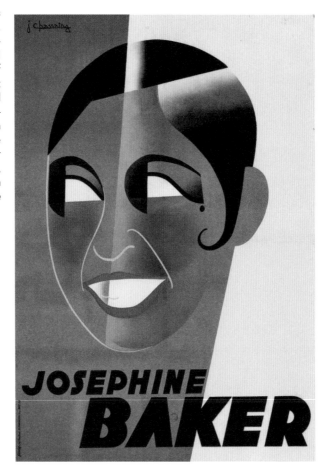

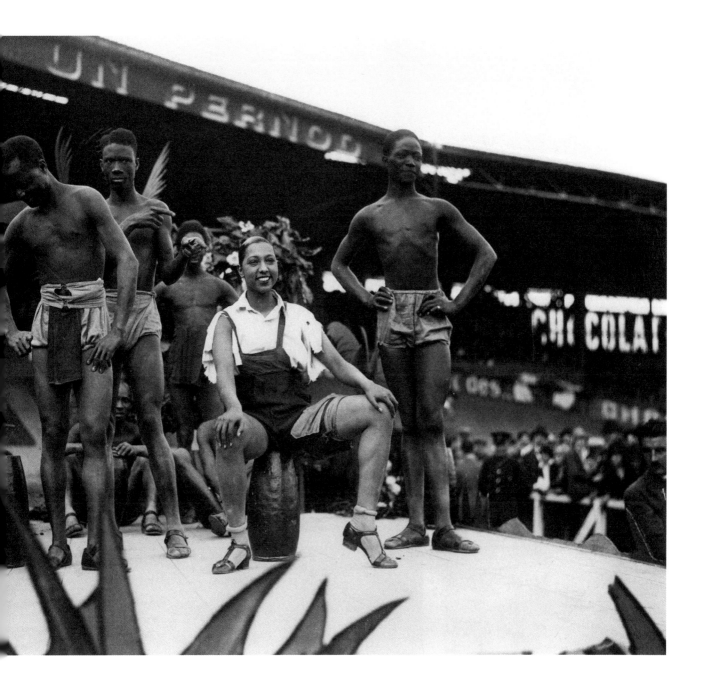

← Jean Chassaing, poster featuring
a portrait of Josephine Baker, 1931.

↑ The Bal Nègre cast and Josephine
Baker at the Buffalo velodrome,
Paris, 1926.

Eugène Beaudouin

1898, Paris
1983, Paris

Marcel Lods

1891, Paris
1978, Paris

In the 1930s, the Beaudouin-Lods partnership was the indisputable leader in research on multifamily housing and the application of industrial techniques to construction. The firm's success was based on the complementary talents of its two founders— one adept in broad conceptual planning (Eugène Beaudouin), the other a master of innovative technique (Marcel Lods).

Beaudouin trained at the École des Beaux-Arts in Paris and received the Premier Grand Prix de Rome in 1928. In 1933, he completed his eclectically classical training with a research trip to the United States. Working in the urban design field, he collaborated with Henri Prost on the first regional plan for Paris, for which he drafted a series of remarkable perspective overviews (1930–34).

Lods studied at the École Nationale Supérieure des Arts Décoratifs and at the École des Beaux-Arts, graduating in 1923.

He served as a pilot in the French army during both world wars, satisfying a long-held fascination with aeronautics and aerial photography. He brought his energy and passion for modern industrial advances to the firm that the two architects managed from 1928 until 1940.

Two of their housing projects, located in the Paris suburbs, were the Cité du Champ des Oiseaux in Bagneux (1930) and the Cité de la Muette in Drancy (1934); the latter was unique for its apartment towers, which were the tallest in the Paris region. Beaudouin was responsible for the structural aspects of the housing, while Lods provided the designs for the details of the homes, and notably developed the concept of dry-mounting prefabricated concrete elements on a metal skeleton, following processes established by the engineer Eugène Mopin.

Lods focused the team on designs for increasingly lightweight buildings, a principle that he put into practice for the École de Plein Air (Open-Air School) in Suresnes (1932–34) and the Roland-Garros air club in Buc (1935), both to the west of Paris. Beaudouin's grand ambitions were complemented by his partner's technical expertise in their plans for a vast Palais des Expositions structured from steel and glass at La Défense (1935), which never came to fruition. Its metal roof would have been accessible to automobiles via ramps spanning its glass façades.

The firm's most striking project was the Maison du Peuple (1936–39) in the Paris suburb of Clichy, built with the engineer

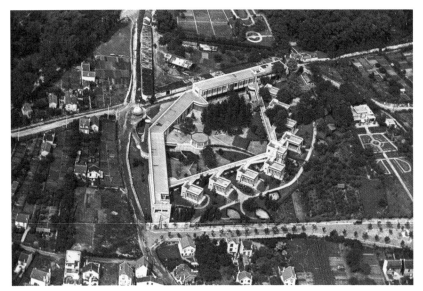

← École de Plein Air (Open-Air School), Suresnes, 1932-34. Retouched aerial view.

↗ Competition project for a Palais des Expositions (exhibition hall) at La Défense, 1934. View of the maquette.

→ Cité de la Muette, Drancy, 1934. Aerial view.

Vladimir Bodiansky and the young *constructeur* Jean Prouvé,* which combined a market and a performance hall. The building was remarkable for its metallic façades and mechanical devices that allowed the roof and floors to retract and the wall partitions to adjust to provide maximum adaptability.

After the firm folded in 1940, Beaudouin established the École d'Architecture de l'Université de Genève and supervised the students of the Paris Beaux-Arts who had been relocated to Marseille, where he also worked on the city's urban development plan. Lods participated in the consultations of Ascoral—Association de Constructeurs pour une Révolution Architecturale (Association of Builders for an Architectural Revolution)—with Le Corbusier.* Beaudouin, like Lods, was fully committed to policies for large-scale building projects following World War II. J-L C

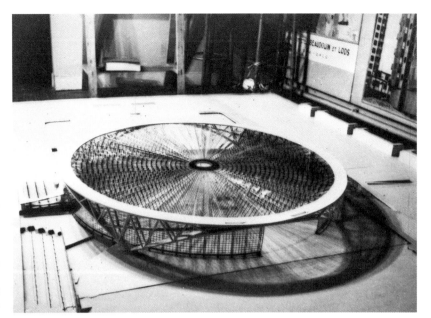

Marcel Lods, with Hervé Le Boterf. *Le Métier d'architecte.* Paris: France-Empire, 1976.
Georges Nelson. "Eugène Beaudouin, France." *Pencil Points,* March 1936: 129–36.
Pieter Uyttenhove. *Marcel Lods: Action, architecture, histoire.* Lagrasse: Verdier, 2009.

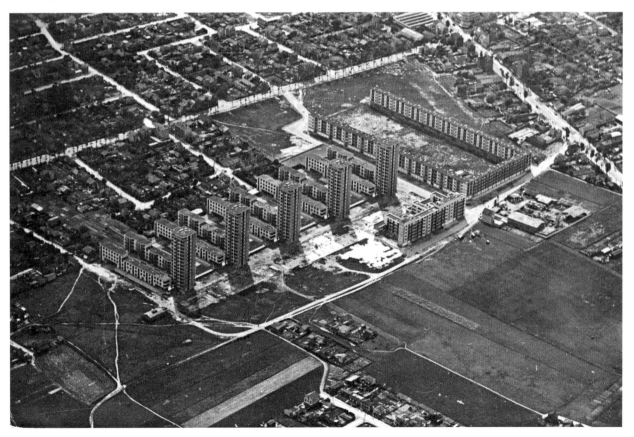

Walter Benjamin

1892, Berlin
1940, Portbou (Spain)

Walter Benjamin grew up in Berlin, as commemorated in *Berliner Kindheit um 1900* (*Berlin Childhood around 1900*), the title of his posthumous reminiscences. He spent his later years in his chosen city—Paris—which he deemed the "modern" capital par excellence. From the 1970s onwards, his work occupied a central place on the international intellectual scene, yet it was little known during his lifetime, due to his ambiguous position on the fringes of many fields, including philosophy, literature, history, art criticism, and the social sciences, and his failure to gain a university position, as well as his nomadic European existence and the conflict he felt between his Jewish roots and his commitment to Marxism.

After obtaining a PhD in Switzerland, Benjamin became an expert French-to-German translator of the writings of Baudelaire—notably *Tableaux parisiens* (*Parisian Scenes*)—Paul Valéry, and Marcel Proust. He visited Paris on and off in the 1920s, gravitating toward Dadaist and surrealist circles. Fleeing Nazism, he moved to the French capital in 1933 and continued working on a monumental volume that he had begun in 1926: the *Passagenwerk* (*The Arcades Project*). It was composed of fragments of texts compiled in the Bibliothèque Nationale, then located on Rue de Richelieu. He was particularly interested in Parisian architecture, especially the city's covered passages as photographed by his friend Germaine Krull.* He also admired the new metallic constructions, which were celebrated in 1928 in *Bauen in Frankreich, Bauen in Beton, Bauen in Eisenbeton* (*Building in France, Building in Iron, Building in Ferro-Concrete*), by the historian Sigfried Giedion, a friend of Le Corbusier.* Benjamin's life and work were cut short by his suicide, as he attempted to flee the Nazis and escape to Spain. G MJ

Libero Andreotti, ed. *Spielraum: W. Benjamin et l'architecture*. Paris: Éditions de la Villette, 2001.
Walter Benjamin. *The Arcades Project*. Translated by Rolf Tiedemann. Cambridge, MA: Belknap Press, 1999.
Heinz Wismann, ed. *Walter Benjamin et Paris*. Paris: Cerf, 1986.

Walter Benjamin in the catalog room of the Bibliothèque Nationale, 1937. Photograph by Gisèle Freund.

Paulette Bernège

1896, Tonneins (France)
1973, Miramont-de-Guyenne (France)

The journalist Paulette Bernège was the foremost French exponent of household organization during the interwar period, and was a highly visible figure in Paris. She espoused the principles of the American home economist Christine Frederick, and applied to the domestic realm the concepts of scientific management codified by Frederick Winslow Taylor.

Editor in chief of the monthly magazine *Mon chez moi* (My Home), which she published from 1923 until 1930, Bernège founded the Ligue de l'Organisation Ménagère (League for Household Efficiency) in 1924. From that point on, she was a constant presence in the public sphere, writing more than five hundred articles by the 1950s.

Bernège's aim was to transform the homemaker into an engineer who managed her household like a business, exerting the utmost economy in materials and practices, by constantly measuring all the household's parameters and transcribing the details in tables and records, and by maintaining constant and total control over her physical movements. Bernège's book *De la méthode ménagère* (The Household System), published in 1928 and republished on several occasions, detailed these procedures, which she strove to introduce into primary education.

In her booklet *Si les femmes faisaient les maisons* (If Women Built Houses), written for the general public, Bernège engaged in a combat against wasteful "vampire distances" and "materials that wear one out," viewing the house as an "essential element of civilization." Le Corbusier,* whom she often quoted, was a patron of the league and urged Sigfried Giedion to invite her to the Congrès International d'Architecture Moderne in Frankfurt in 1929. J-L C

Paulette Bernège. *De la méthode ménagère.* Paris: Dunod, 1928.
———. *Si les femmes faisaient les maisons.* Paris: Mon Chez Moi, 1928.
Jackie Clarke. "L'organisation ménagère comme pédagogie. Paulette Bernège et la formation d'une nouvelle classe moyenne dans les années 1930 et 1940." *Travail, genre et sociétés* 13, no. 1 (2005): 139–57.

↓ "Les distances vampires" (Vampire distances), illustration in *Si les femmes faisaient les maisons* (If Women Built Houses), 1928.

→ Paulette Bernège in her kitchen, 1930.

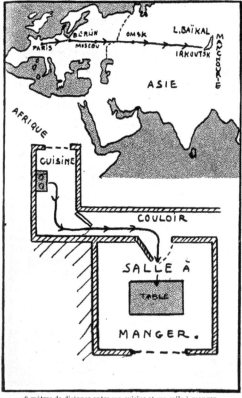

LES DISTANCES VAMPIRES

8 mètres de distance entre ma cuisine et ma salle à manger, m'obligent, en 40 ans, à parcourir la distance de Paris au lac Baïkal.

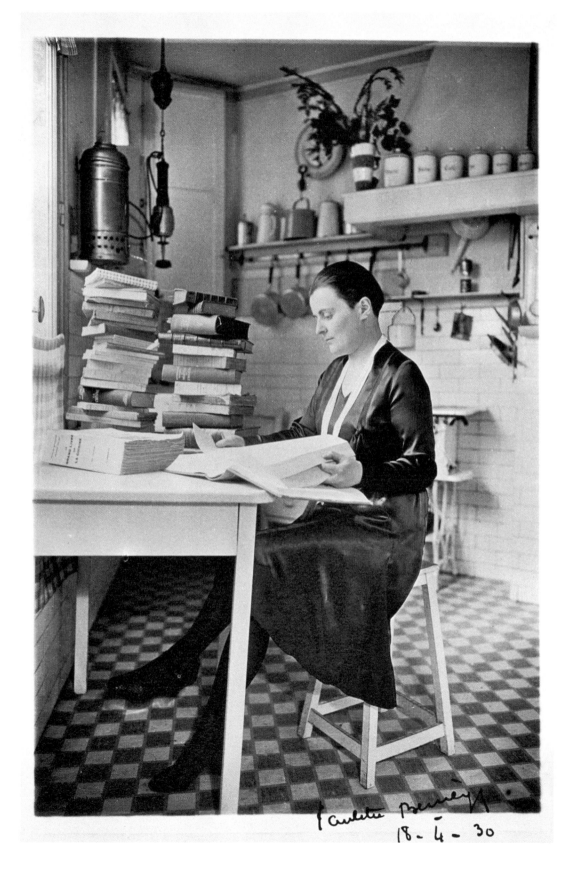

Paulette Bernège
18-4-30

Boris Bilinsky

1900, Bendery (Russian Empire)
1949, Catania (Italy)

Born in the region of Moldavia, which was still under Russian control at the time, Bilinsky moved to Berlin in 1921. There, he learned the basics of theater set design from Max Reinhardt and met Léon Bakst, artistic director of the Ballets Russes, Yury Annenkov, and Simon Lissim. When he arrived in Paris in 1923, he was immediately embraced by the Russian film community in neighboring Montreuil. The Russian-born set designers Alexandre Lochakoff and Édouard Gosch trained him in the profession, and it was not long before he was creating the sets for *Âme d'artiste* (*Heart of an Actress*) by Germaine Dulac and Alexandre Volkoff, and *Le Lion des Mogols* (*The Lion of the Mogols*) in 1923, followed by *L'Affiche* (*The Poster*) by Jean Epstein* in 1924. The latter was inspired by a familiar image from contemporary urban life: a gigantic poster featuring a laughing baby—Bébé Cadum—for the soap brand of the same name. The poster in the film is associated with a human tragedy: the baby depicted dies prematurely, and the incessant appearance of her laughing face on streets and building façades drives the child's mother to madness—and yet the advertiser refuses to take the posters down. This was an instance when Paris formed not merely a backdrop, but a dramatic milieu.

Bilinsky was keenly interested in modernism in both his posters and his costumes, but he also designed entire architectural environments. Working with Ivan Mosjoukine, he developed plans for a futuristic film, *Paris 1975*, featuring a metallic structure three times taller than the Eiffel Tower, with the Opéra and the Arc de Triomphe literally preserved under glass. More prosaically, in *Paname n'est pas Paris* (*Apaches of Paris*) by Nikolaï Malikoff in 1927, he toyed with the exoticism of the setting through his costumes, contrasting the chic and seedy sides of Paris, and shaping the cliché of a working-class, cosmopolitan city, which was popularized in the homonymous song by renowned entertainer Mistinguett. F A

Boris Bilinsky: Decors and Costumes. New York: Leonard Hutton Galleries, 1975. Exhibition catalog.

Still from *Paname n'est pas Paris* (*Apaches of Paris*) by Nikolaï Malikoff, 1927.

Thérèse Bonney

1894, Syracuse, New York
1978, Paris

Arriving in Paris in 1918, Bonney was among the first American women to earn a doctorate from the Sorbonne University, in 1921. She founded an international press agency in 1923, and went on to cover World War II. The French capital would remain her lifelong home.

Immediately embraced by the worlds of art and architecture, she photographed the multiple facets of modern creative activity in the interwar period: exhibitions, boutiques, apartments, manufactured products, fashion, and applied arts. While commercializing photographs taken by other artists, she also documented the work of numerous furniture and interior designers, including René Herbst,* Émile-Jacques Ruhlmann,* Pierre Chareau,* and Eileen Gray,* and couturiers, such as Paul Poiret.* She gained a thorough understanding of Paris's artistic and high-society circles, and in 1929, in collaboration with her sister Louise, she drew on this knowledge to publish a series of practical guides written in English, revealing the secrets of Parisian *art de vivre* to an American readership. She took a strong interest in modern architecture, especially the work of Robert Mallet-Stevens,* and her photographs of his buildings did full justice to his elegant style.

In 1939, Thérèse Bonney became a war reporter, and her work immortalized numerous episodes of World War II. G MJ

Thérèse and Louise Bonney. *Buying Antique and Modern Furniture in Paris*; *A Guide to the Restaurants of Paris*; *French Cooking for American Kitchens*; *A Shopping Guide to Paris*. New York: Robert M. McBride and Co., 1929 (for all four volumes).
Lisa Schlanasker Kolosek. *The Invention of Chic: Thérèse Bonney and Paris Moderne*. London: Thames & Hudson, 2002.

↓ Thérèse and Louise Bonney, *A Shopping Guide to Paris*, 1929. Front cover featuring a map of Paris.

→ The photographer's apartment by Gabriel Guevrekian, Rue des Petits-Champs, 1927. View of a corner with a carpet from the Galerie Myrbor.

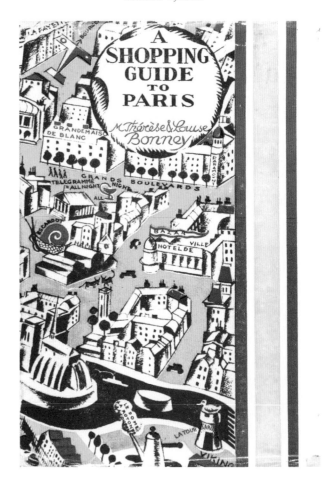

Brassaï

1899, Brassó (Austro-Hungarian Empire)
1984, Beaulieu-sur-Mer

Gyula Halász, who would assume the pseudonym "Brassaï," arrived in Paris as a young man, after studying at the School of Fine Arts in Budapest, and subsequently in Berlin. In Paris, he began a career in journalism and became a correspondent for two periodicals: the Hungarian *Periszkóp* (Periscope), established in 1924 and modeled on *L'Esprit nouveau* (The New Spirit), and the German *Kölnische Illustrierte Zeitung* (Cologne Illustrated Newspaper), founded in 1926, which became one of Germany's most important illustrated magazines between the wars.

Acutely aware of the artistic effervescence in Paris, Brassaï made the acquaintance of fashionable society while cultivating friendships with members of the Hungarian exile community, including the photographer André Kertész,* who urged him to switch from pen to silver print photography. Working late, when the moon and the gas lamps illuminated the wet paving stones in the north of the capital, Brassaï immortalized the city's reflections, nocturnal ramblers, and ladies of the night. These shots caught the eye of Lucien Vogel, publisher of the magazine *VU*, but it was Charles Peignot,* director of the lavish magazine *Arts et métiers graphiques* (Graphic Arts and Crafts), who published his book *Paris la nuit* (*Paris by Night*) in 1932. In his preface, Paul Morand wrote, "Night is not the negative of day; black surfaces and white are not merely transposed, as on a photographic plate, but another picture altogether emerges at nightfall."

Brassaï's following work, which was to be entitled *Le Livre de l'amour* (The Book of Love) and feature the wild side of Parisian nightlife, the brothels wreathed in opium smoke, and the homosexual balls, was published only in a censored version under the title *Volupté de Paris* (Pleasure of Paris). Disillusioned, the photographer turned to the fashion press, working for publications such as *Votre beauté*, *Harper's Bazaar*, and *Coiffure de Paris*, which gave him the opportunity to shoot portraits of Pablo Picasso,* Henri Matisse, Jean Genet, and Henri Michaux. P M

Sylvie Aubenas and Quentin Bajac. *Brassaï, le flâneur nocturne*. Paris: Gallimard, 2012.
Brassaï. *Brassaï: Paris by Night*. Paris: Flammarion, 2011.
———. *Paris la nuit*. Paris: Arts et Métiers Graphiques, 1932; Paris: Flammarion, 2001.
———. *Le Paris secret des années 1930*. Paris: Gallimard, 1976.
Agnès de Gouvion Saint-Cyr. *Brassaï in America*. Paris: Flammarion, 2011.
———. *Brassaï: For the Love of Paris*. Paris: Flammarion, 2014.

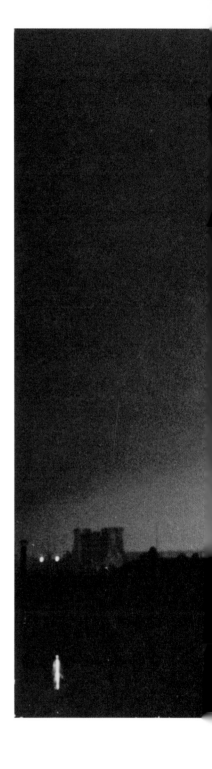

Les Toits de Paris (Rooftops of Paris), 1932.

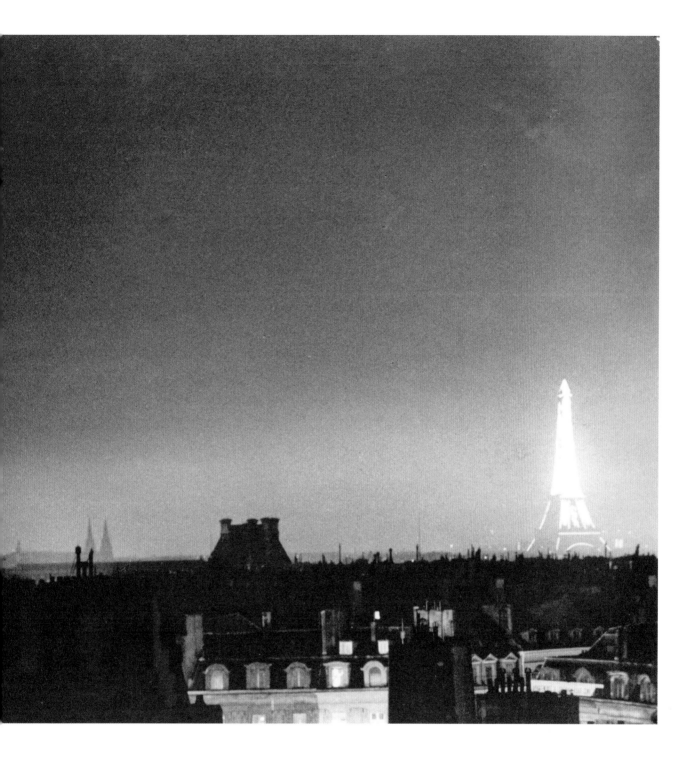

Arno Breker

1900, Wuppertal
1991, Düsseldorf

As official state sculptor for the Nazi regime, Breker escorted Hitler, accompanied by the architect Albert Speer, on a tour of Paris monuments that was organized on the day immediately following the Armistice of June 22, 1940. For Breker, it was a return to his roots, in a way. As a young man, he had been a student of Aristide Maillol and had frequented the Paris studios of sculptors Alexander Calder and Constantin Brancusi, as well as meeting writers such as Jean Cocteau. When he returned to a Nazi-governed Germany, the success of the statues he created for the Olympic stadium in Berlin earned him significant government commissions, ranging from portraits of the regime's dignitaries to the embellishment of Speer's monumental structures in Berlin.

Breker shared Hitler's monumental ambition, illustrated by the Führer's urgent wish to explore Paris in 1940. According to Breker, Hitler had always had "the burning desire to travel there," adding that he would draw "important lessons" from this "model."

In 1942, the Institut Allemand organized an exhibition of Breker's work in the Orangerie in the Tuileries. It was the culminating moment of Germany's cultural sway in Paris. The honorary committee included the architects Jacques Gréber and Auguste Perret.* It was lauded by Cocteau, while the sculptor Charles Despiau, recently returned from Germany, dedicated a hagiographical tome to this "young, energetic, and determined man, who exudes sanity and optimism." On this occasion, Breker lunched with Le Corbusier,* but their conversation was limited to a cordial exchange of platitudes. J-L C

Arno Breker. *Paris, Hitler et moi*. Paris: Presses de la Cité, 1970.
Charles Despiau. *Arno Breker*. Paris: Flammarion, 1942.

Opening of the Breker exhibition at the Musée de l'Orangerie in the Tuileries Garden, May 22, 1942. Jacques Benoist-Méchin makes his introductory speech; to his left is Louis Hautecœur.

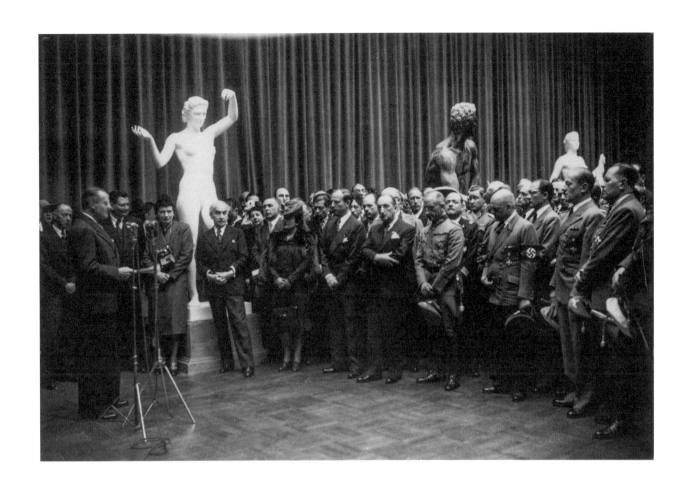

André Breton

1896, Tinchebray (France)
1966, Paris

André Breton—who would later be dubbed "the Pope" of surrealism—was mobilized in 1915 and assigned to a psychiatric center where he encountered Freudian theory. Apollinaire's* "surrealist drama" *Les Mamelles de Tirésias* (*The Breasts of Tiresias*), which he saw in 1917 with Louis Aragon* and Philippe Soupault, inspired the movement's name. In 1919, the trio founded the journal *Littérature* with the collaboration of Paul Valéry and André Gide.* The "Surrealist Manifesto" established the movement's reputation in 1924, but its origins date back to 1922 when they split from Tristan Tzara* and the Dada movement.

An exponent of automatic writing, Breton worked with Soupault on *Les Champs magnétiques* (*The Magnetic Fields*), published in 1921. Breton defined surrealism as "psychic automatism by which one offers oneself the opportunity to express, whether in words or writing, or any other means, the actual functioning of thought, in the absence of any control exercised by reason, leaving aside any aesthetic or moral concerns." The movement's influence extended beyond France, and the 1938 Exposition Internationale du Surréalisme attracted submissions from fourteen countries, ranging from Japan to Brazil.

Like Louis Aragon and Paul Éluard,* Breton joined the French Communist Party in 1927, but the relationship between surrealists and Marxists was stormy. An anti-colonialist, Breton signed the "Ne visitez pas l'Exposition coloniale" ("Don't Visit the Colonial Exhibition") tract in 1931, advocating against the spectacular public event orchestrated by Marshal Lyautey* in Vincennes.

In 1941, he met Aimé Césaire in Martinique, and, in 1947, wrote the preface to his *Cahier d'un retour au pays natal* (*Return to My Native Land*). When visiting New York, he challenged Antoine de Saint-Exupéry over his complacency toward the Vichy regime, while "Saint-Ex" accused Breton of ideological sectarianism. M-P U

André Breton. *Nadja*. Paris: Gallimard, 1928.
———. *Nadja*. Translated by Richard Howard. London: Penguin Modern Classics, 1999.
———. *Qu'est-ce que le surréalisme?* Brussels: Henriquez, 1934.
———. *What is Surrealism?* Edited and with an introduction by Franklin Rosemont. London: Pluto Press, 1978.
———. *L'Amour fou*. Paris: Gallimard, 1937.
———. *Mad Love*. Translated by Mary Ann Caws. New York: Bison Books, 1988.

Breton posing in front of pieces from his collection of "primitive" art, 1938. Photograph by Boris Lipnitzki.

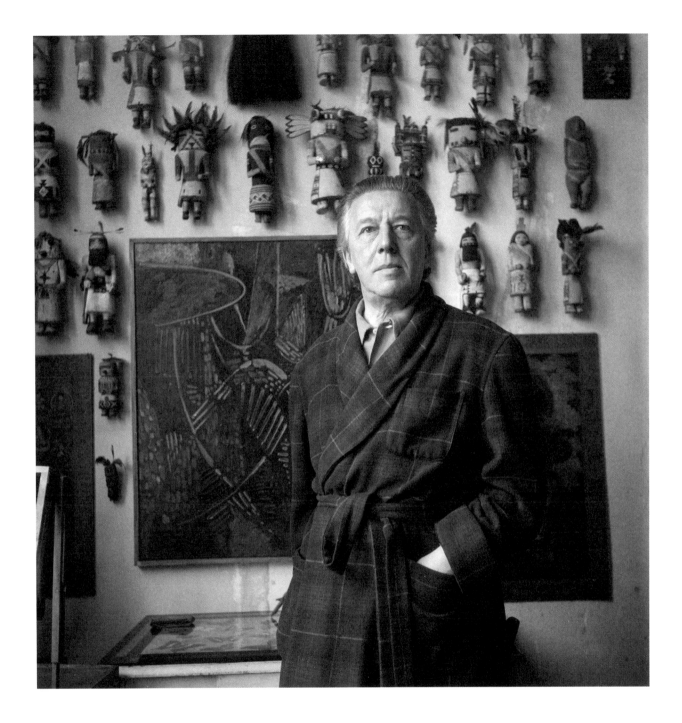

Jean Carlu

1900, Bonnières-sur-Seine
1997, Nogent-sur-Marne

The son and brother of architects, Jean Carlu also studied architecture before deciding on a different career path. Following an accident at the age of eighteen, his right arm was amputated, so he learned to draw with his left hand. He worked at the poster printer Sirven until 1921, and rapidly gained a reputation among advertising clients; he was soon considered one of the most accomplished advertisement designers of his era. However, his striking 1925 poster for Monsavon is an interesting case, as it illustrates the potential gap between visual appeal and commercial success: the widespread display of the image did not result in the expected increase in sales.

Carlu was a highly demanding artist, who was very closely affiliated with the Union des Artistes Modernes, and he was a pioneer in several fields. He embarked on the design of monumental three-dimensional advertising panels in collaboration with the Martel* brothers, designed light panels, and developed the technique of photomontage. His 1932 poster "Pour le désarmement des nations" (For the disarmament of nations), created in collaboration with the photographer André Vigneau, is one of the most famous examples of his work, and is also proof of his ideological commitment.

Carlu was a founding member of the Office de la Propagande Graphique pour la Paix (Bureau of Graphic Propaganda for Peace) and a supporter of the Popular Front. As commissioner of the advertising pavilion at the 1937 Exposition Internationale, he presented a spectacular demonstration of graphic creativity, featuring the work of French and international designers. He left for New York in 1939, as a delegate of the French government's propaganda agency, and he spent the duration of the war there. After his return to France, he continued his career for another three decades. C d S

Jean Carlu. "Réflexions sur l'esthétique de l'affiche." *Arts et métiers graphiques*, no. 7 (1928): 436–38.
Alain Weill. *Jean Carlu*. Paris: Musée de l'Affiche, 1980. Exhibition catalog.

"Pour le désarmement des nations" (For the disarmament of nations) poster, with André Vigneau, on the corner of Avenue des Champs-Élysées and Rue de Marignan, 1932.

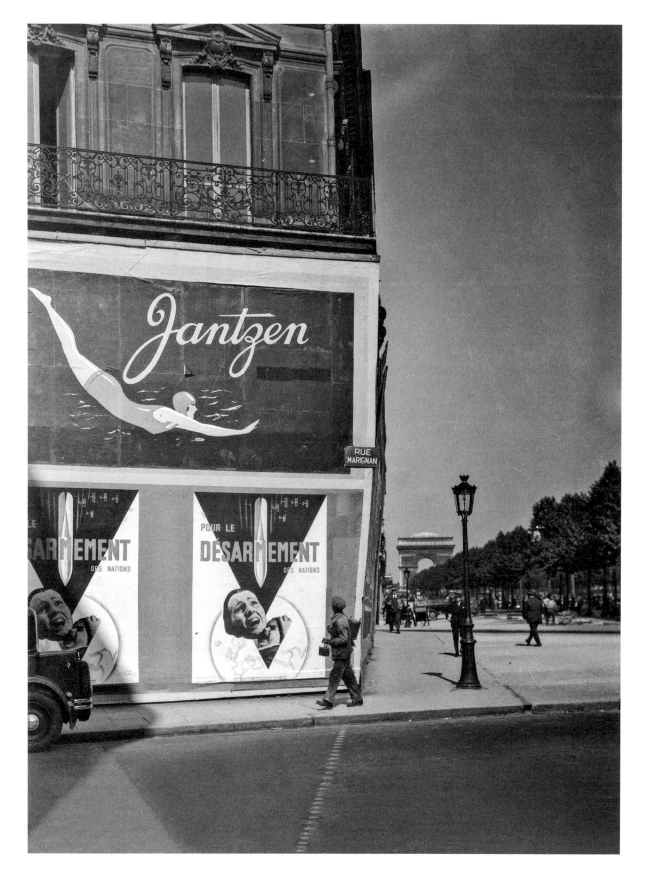

Marcel Carné

1906, Paris
1996, Clamart

Marcel Carné studied photography at the École des Arts et Métiers, and served as an intern assisting on the shoot of Jacques Feyder's* *Les Nouveaux Messieurs* (*The New Gentlemen*). He then became a film critic for several magazines, while continuing to work as an assistant to René Clair* and Feyder, to whom he claimed "to owe everything." He became known for his appeal "When will the cinema go down onto the street?" which was published in 1933. However, although he filmed *Nogent Eldorado du dimanche* (Nogent, The Sunday Eldorado) on the banks of the Marne river in 1929, his later films—including *Jenny* (1936), which was set in Paris—were increasingly shot in the studio, with only occasional outdoor takes. His films *Hôtel du Nord* of 1938—based on the novel by the populist writer Eugène Dabit—and *Le Jour se lève* (*Daybreak*) of 1939 offered a contrived but iconic vision of working-class Paris that owed much to its production designer Alexandre Trauner.* This was a city where fog, slick wet cobbled streets, and shadows created a sinister atmosphere that far right critics found demeaning and "Judeo-Bolshevik." F A

Marcel Carné. "Quand le cinéma descendra-t-il dans la rue?" *Cinémagazine*, no. 11 (November 1933): 12–14.

Stills from the film *Portes de la nuit* (*Gates of the Night*), 1946. Views from and in the elevated metro.

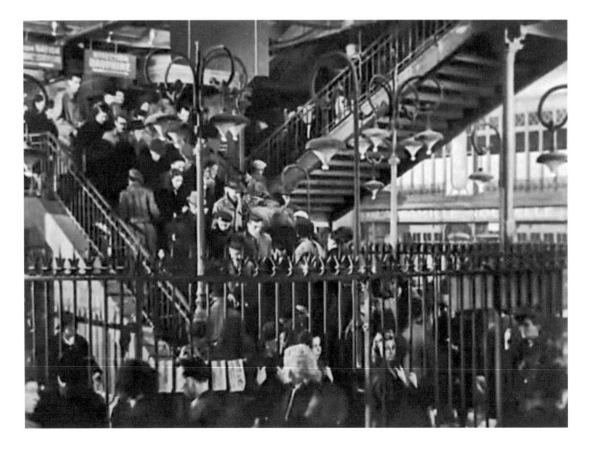

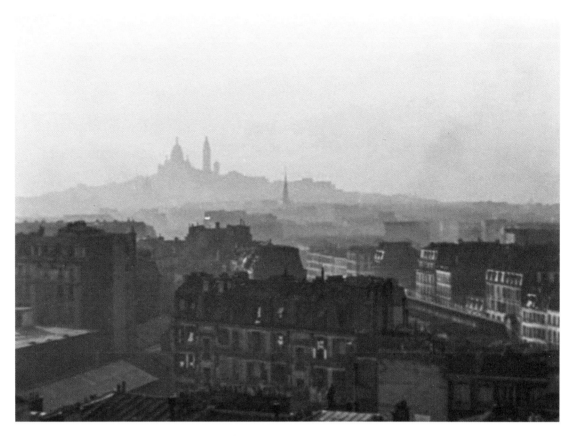

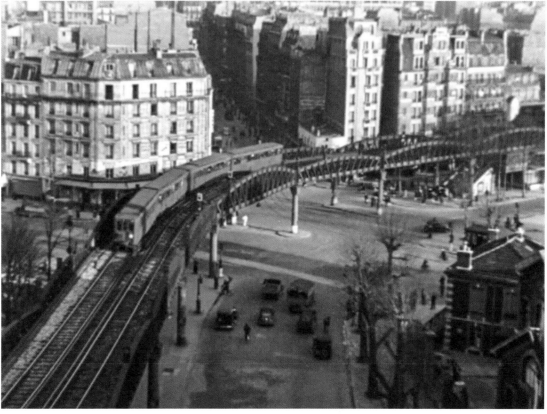

Cassandre

1901, Kharkov (Russian Empire)
1968, Paris

As a young man, Adolphe Jean Marie Mouron studied art at the Académie Julian in Paris, where he precociously adopted the pseudonym that he would use throughout his working life. His career was launched with his poster for the Parisian furniture dealer Au Bûcheron, which earned him a prize at the Exposition Internationale des Arts Décoratifs et Industriels Modernes in 1925, and he worked in close collaboration with contemporary painters as well as maintaining a constant proximity with avant-garde circles. He commissioned the Perret* brothers to build his house in Versailles, after a failed attempt to hire Le Corbusier* for the task. Cassandre's definition of a poster as an "advertising machine" paid implicit homage to the architect.

Cassandre was a close friend of writer Blaise Cendrars, who, in the preface to a promotional brochure published by the printer Draeger in 1935, described him as the "foremost street artist." Cassandre created numerous posters that remain iconic today: for Nicolas wine merchants (anticipating op art); the aperitif Dubonnet (with a playful interplay of three successive images and a progression of colors, captioned "Dubo, Dubon, Dubonnet"); the national railroad Compagnie des Wagons-Lits (Nord Express and L'Étoile du Nord); and the transatlantic liner companies (*Normandie*). He enjoyed fame far beyond the borders of France, as demonstrated by the *Posters by Cassandre* exhibition organized by MoMA in New York in 1936.

He was responsible for designing the typographical fonts Bifur, Acier, and Peignot, produced by the Deberny et Peignot* foundry, as well as the logo of the Yves Saint Laurent couture house, which he conceived in 1963 and is still in use today. From the 1940s, Cassandre created numerous theater sets and devoted considerable time to painting. C d S

Posters by Cassandre. New York: Museum of Modern Art, 1936. Exhibition catalog.
Anne-Marie Sauvage, ed. *A.M. Cassandre: Œuvres graphiques modernes, 1923–1939*. Paris: Bibliothèque Nationale de France, 2005. Exhibition catalog.
Maximilien Vox. *A.M. Cassandre, peintre d'affiches*. Paris: Éditions Parallèles, 1948.

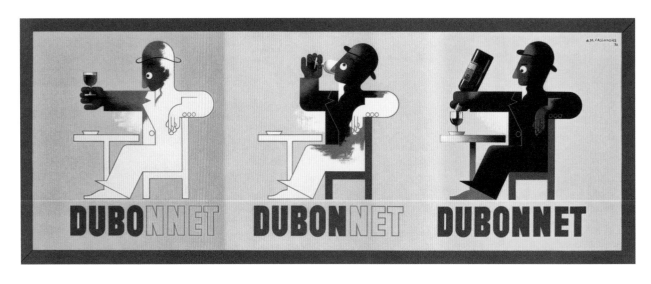

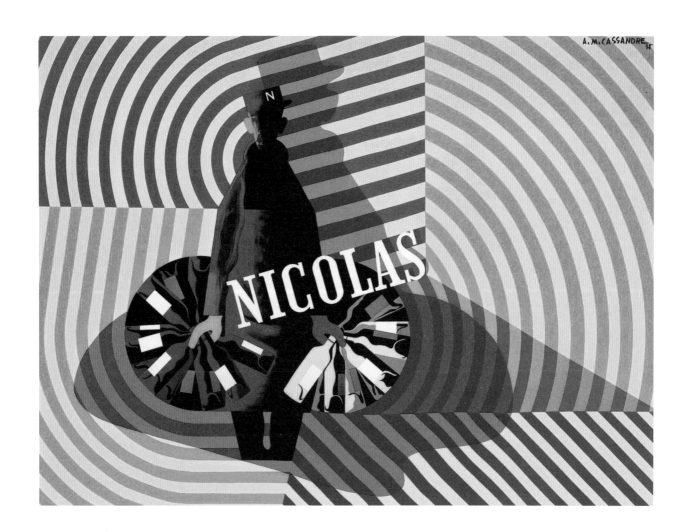

← Poster for the aperitif Dubonnet,
1932.

↑ Poster for the wine merchant
Nicolas, 1935.

Gabrielle Chanel

1883, Saumur
1971, Paris

Gabrielle Chanel—who adopted the nickname "Coco" during early attempts to establish herself as a singer—came from a modest background. She set herself up as a milliner in Paris, where her strikingly simple hat designs forged her reputation. In 1912, she opened a boutique in Deauville, Normandy, and began promoting her clothing creations, which, in 1916, included versatile and comfortable jersey knit suits. Henceforth, she was known almost exclusively for her fashion designs, described by Paul Poiret* as "luxurious poverty."

Chanel catered to a new clientele in the 1920s, who considered the styles of the past obsolete and were highly receptive to her new designs. Her clothes were stylishly spare and comfortable, and her selection of day outfits was completed by a range of shimmering evening gowns that gave a woman's body freedom of movement. She introduced her first perfume, Chanel No. 5, in 1921, and launched a line of cosmetics three years later.

A prominent figure in Parisian high-society circles, Chanel was her own muse, flaunting her liberated creativity. She surrounded herself with artistic innovators, including creatives of the Ballets Russes, and collaborated with them enthusiastically. A tireless designer, she always preferred to eliminate rather than to add; this principle of austerity contrasted with her love of a profusion of flamboyant costume jewelry.

In 1926, American *Vogue* published a photograph of a little black dress: the "Ford signed by Chanel." It was the antithesis of the exuberance typical of the 1920s, heralding the profound transformation that was to follow the Great Crash of 1929. Chanel expressed her brilliance as a couturier through extreme sophistication and simplified lines. She closed her design studio in 1939, but her career continued until her death in 1971. C Ö

Isabelle Fiemeyer. *Intimate Chanel*. Paris: Flammarion, 2011.
———. *Chanel: The Enigma*. Paris: Flammarion, 2016.
Gabrielle Chanel: Manifeste de mode. Paris: Paris-Musées, 2020. Exhibition catalog.
Justine Picardie. *Coco Chanel*. London: Harper Collins, 2010.

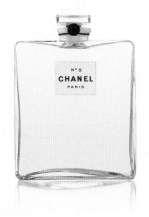

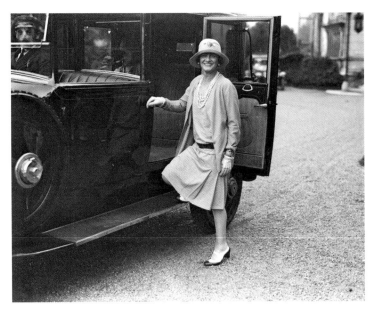

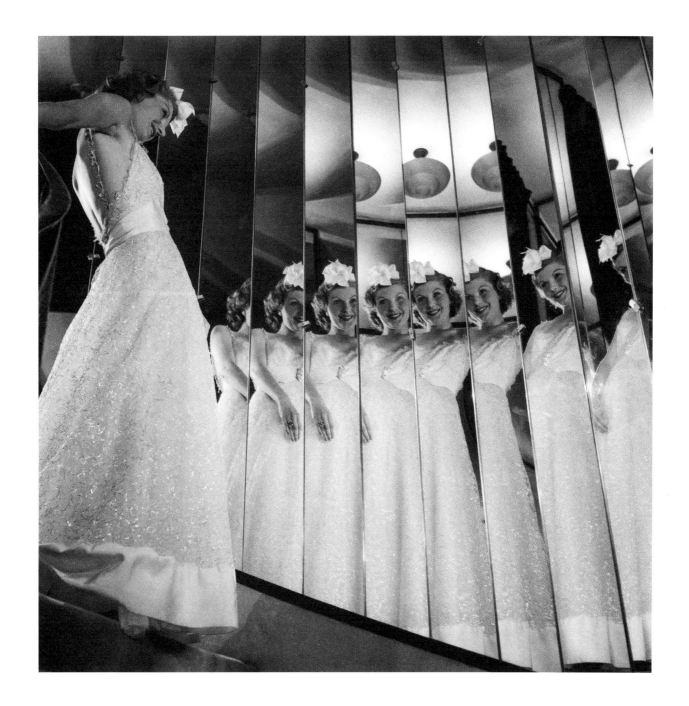

↖ Bottle of Chanel No. 5 perfume,
1921.

← Chanel in Chanel getting into
an automobile, 1928.

↑ Model on the staircase of Chanel's
haute couture salon, 31 Rue Cambon,
1937. Photograph by François Kollar.

Pierre Chareau

1883, Bordeaux
1950, East Hampton, New York

The name Chareau is inextricably linked to the Maison de Verre (House of Glass) that he built for Dr. Jean Dalsace in 1931 with the Dutch architect Bernard Bijvoet. Chareau also occupied a prominent place in the realm of Parisian interior design and furniture between the wars. His combination of artisanal skill and knowledge of luxury in the decorative arts offered a modern sensibility that was well suited to the spare lines and new materials created by modern industry.

Having failed the entrance examination for the École des Beaux-Arts in 1900, he learned his profession on the job in an English interior design firm, and, at the end of World War I, he established his own business. His order book filled rapidly, and five years later he opened a shop with the unassuming name of La Boutique, on Rue du Cherche-Midi in Paris. There, he sold his own designs as well as creations by other contemporary designers of furniture and household items. His work included various types of furnishings, ranging from office lamps to shelving to armchairs.

In 1924, Chareau contributed to the set designs for L'Inhumaine (The Inhuman Woman), a film by Marcel L'Herbier,* alongside Fernand Léger* and Robert Mallet-Stevens.* Mallet-Stevens invited him to collaborate on the interior design for the Villa Noailles* in Hyères, together with Jean Prouvé,* Eileen Gray,* Charlotte Perriand,* Francis Jourdain,* and Sonia Delaunay.* While carrying out these private commissions, he presented his work in numerous Paris venues: the Salon des Artistes Décorateurs, the Salon d'Automne, and a variety of exhibitions, including those sponsored by the Union des Artistes Modernes. He was one of the founding members of this organization, in association with the designers who had participated in the Villa de Noailles project. At the 1925 Exposition Internationale des Arts Décoratifs et Industriels Modernes, he attracted attention with his luxurious office-library in the French Embassy section of the Société des Artistes Décorateurs pavilion.

In 1928, Dr. Jean Dalsace, a prominent gynecologist who had already worked with Chareau, and his wife, Annie Bernheim, approached the designer to build a three-level residence on Rue Saint-Guillaume in Paris. The building was to house his medical office on the ground floor with the family quarters above it. The entire ensemble would replace the bottom three floors of an existing building located at the back of a courtyard in Saint-Germain des Prés, leaving the original top floor intact (the top-floor tenants refused to move). The new building was entirely metallic, like most of the interior equipment in Dalsace's residence and medical office, and the main façade was made of glass blocks that lent an extraordinary luminosity to the spacious double-height living room within. The entire house contained furniture and fittings designed by Chareau himself. In 1933, in L'Architecture d'aujourd'hui, Paul Nelson* described this building as "a machine that enhances the sensation of living" and "a departure point for genuine architecture."

Chareau was an avid collector. His apartment on Rue Nollet was the setting for many sophisticated artistic soirées, and contemporary music played a very important role at these gatherings. The space was filled with works by those artists he admired the most, including Jacques Lipchitz,* Georges Braque, Max Ernst, and Pablo Picasso.* G MJ

Olivier Cinqualbre, ed. Pierre Chareau, 1883–1959: Un art intérieur. Paris: Éditions du Centre Pompidou, 1994.
Denis Doria. Pierre Chareau: Un architecte moderne de Paris à New York. Paris: Michel de La Maule, 2016.
Esther da Costa Meyer, ed. Pierre Chareau: Modern Architecture and Design. New Haven, CT: Yale University Press, 2016.
Pierre Vago, Paul Nelson, and Julien Lepage [Julius Posener]. "Un hôtel particulier à Paris." L'Architecture d'aujourd'hui, no. 9 (1931): 4–15.

↗ Furniture designed between 1920 and 1930. Sketches, c. 1930.

→ Study-library for a French Embassy. Exposition Internationale des Arts Décoratifs et Industriels Modernes, 1925.

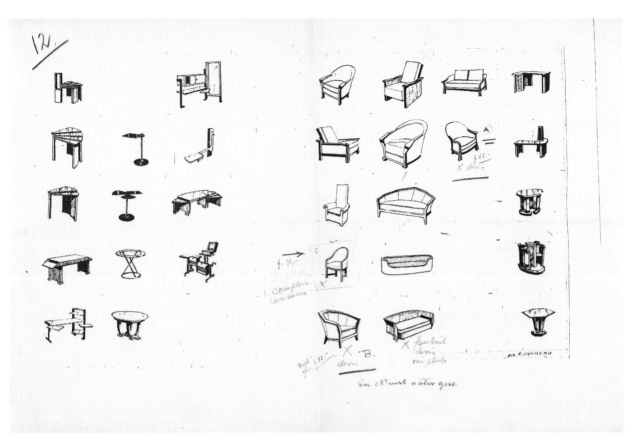

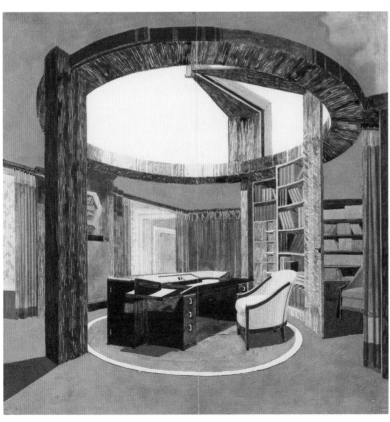

Cinema

PARIS ON THE BIG SCREEN: 1914–45

The invention of cinematography is credited to the Lumière brothers, who were from Lyon, and the first films were made in their home city or at their country retreat in La Ciotat, on the Riviera. However, the origin of cinema as such dates to two screenings in Paris. The first took place on March 22, 1895, at the Société d'Encouragement à l'Industrie Nationale (Society for the Encouragement of National Industry), Place Saint-Germain-des-Prés, before an audience of professionals. The second, open to the public, was held on December 28 of the same year, in the basement of a café on Boulevard des Capucines, the thoroughfare that Claude Monet had painted on two occasions twenty years earlier. It was in Paris and its environs that this new medium experienced exponential growth and a throng of eager participants: Georges Méliès, Léon Gaumont, Charles Pathé, and later Charles Jourjon and Ambroise François Parnaland (of L'Éclair films). Technical installations, production sites for movies, and equipment and film were developed in this region, but were primarily concentrated in suburban districts and in eastern Paris (apart from Gaumont, who moved to the Buttes-Chaumont district in the north of Paris, and Pathé-Natan to Montmartre in 1929). Others were established in Vincennes, Montreuil, Fontenay-sous-Bois, Joinville-le-Pont, Neuilly, Boulogne, Épinay-sur-Seine, Nogent-sur-Marne, Saint-Maurice, and Bry-sur-Marne.

From the outset, it is necessary to make a distinction between "cinema in Paris" and "Paris in the cinema." Certainly, there were interactions between the two phenomena. The urban views and short productions that were made in the early years often used Paris as a backdrop, as well as the various neighborhoods that housed the studios, and sometimes even the production facilities themselves. Much film work was done outside due to lighting requirements. Those frenzied scenes of dogs making off with sausages while shopkeepers, passersby, and, finally, gendarmes give chase, or other madcap scenarios, actually occurred in the streets of Belleville in Paris, and they often continued into areas outside the city limits: waste grounds, suburban farms, bridges spanning rivers, or railroad tracks. Later, however, films—both documentaries and fictional features—were liberated from the confines of nearby locales, or, when they were set in such places, they made

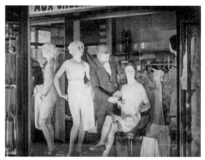
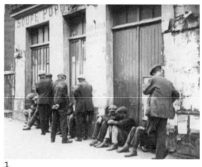

1

1 Stills from *Rien que les heures* (*Nothing but Time*), by Alberto Cavalcanti, 1926.

2 Stills from *Ménilmontant*, by Dimitri Kirsanoff, 1926.

3 Still from *La Fin du monde* (*End of the World*), by Abel Gance, 1931.

4 Stills from *La Tour* (*The Tower*), by René Clair, 1926.

a point of emphasizing the special features of the neighborhood. Belleville and Ménilmontant inspired avant-garde films in the mid-1920s, such as *Rien que les heures* (*Nothing but Time*) by Alberto Cavalcanti (1926), and *Ménilmontant* by Dimitri Kirsanoff (1926). One could compile a whole filmography of titles that include the name of a Parisian street or quarter (*Montparnasse*, *rue de l'Estrapade*, and so on), all the way down to the sketches of *Paris vu par...* (*Six in Paris*) in 1965, in which each vignette bears the name of a neighborhood, square, or railway station.

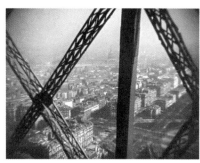

The Tower and the Labyrinth

Film studios and production sites were generally located in eastern Paris, whereas western Paris was most often depicted in films: the Champs-Élysées, Arc de Triomphe, and Place de la Concorde were omnipresent in the 1920s, both in commercial fiction productions and in films by avant-garde directors: *Fait Divers* (*News in Brief*) by Claude Autant-Lara,* *Voici Paris* by Jacques-Henry Levesque, and *Le Lion des Mogols* (*The Lion of the Mogols*) by Jean Epstein,* to name but a few. This continued up to the 1960s, with *À bout de souffle* (*Breathless*) by Jean-Luc Godard. And, of course, the Bourse, the Opéra, and the church of La Madeleine were also prominently featured.

The Eiffel Tower was given special treatment, since it was recognized by filmmakers as being not only the emblematic symbol of the city but also an icon of modernity that inspired poetry (Guillaume Apollinaire,* Blaise Cendrars), theater (Jean Cocteau), photography (Brassaï*), and painting (Robert Delaunay*). Marcel L'Herbier* used it in the logo of his production company, playing on the initials F.L. (Films L'Herbier). The tower, which was excoriated in 1943 by the aged urban planner played by Marcel Levesque in *Lumière d'été* (*Summer Light*) by Jean Grémillon and Jacques Prévert, was not just another monumental landmark. It was at once a mobile viewpoint that offered novel perspectives on the city from its elevator, a radio antenna, and an assembled metal structure that shared with cinema this notion of assembly. Directors filmed it from every possible angle. They filmed from its elevator (as did the Lumière brothers) and they shot from its platforms, as in René Clair's* *Paris qui dort* (*Paris Asleep* or *The Crazy Ray*) of 1923–25.

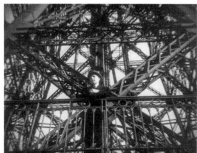

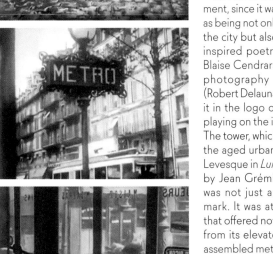

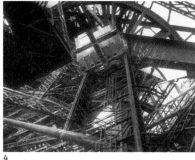

They explored it and they scaled it, as in René Clair's *La Tour* (*The Tower*) of 1926. It was endowed with an ominous quality, as in Julien Duvivier's *Le Mystère de la Tour Eiffel* (*The Mystery of the Eiffel Tower*) of 1928. After being threatened with destruction in Luitz-Morat's *La Cité foudroyée* (*The City Destroyed*) of 1924, it became the site of a confrontation and a disjointed view of the landscape with the vertiginous plunge of its elevator in Abel Gance's *La Fin du monde* (*End of the World*) of 1931. In the same year that Apollinaire, "tired of this elderly world," addressed the tower in his poem "Zone," a 1912 Pathé newsreel showed a "birdman" attempting to fly from the tower's first level and crashing to the ground.

This dramatization of the tower, from detective series to tragedy to apocalyptic saga, eloquently expresses cinema's ambivalent modernity. Film is modern because it involves machinery—lenses, fragile celluloid film, mechanical devices—but also because it captures the world as it is and heightens the effect. Never before had people seen a train, a dreadnought battleship, a pylon, or an automobile in the way that they appeared in films. As Louis Delluc repeatedly observed, industrial and technical objects, as well as new materials were highly photogenic. What's more, film captured those qualities that haunt and disturb us, whether in landscapes or objects. Pierre Mac Orlan later spoke of

the "social fantasy of our time . . . that film allows us to observe." The prolific director Louis Feuillade, who had previously made several comedy series (*Bébé*, *Bout-de-zan*) or series with artistic pretensions (*Le Film esthétique* [Aesthetic Film]), began the film series *Fantômas*, based on the books by Marcel Allain and Pierre Souvestre, in 1913. This series was later followed by *Les Vampires*—with his muse, the actress Musidora—(ten episodes from 1915 to 1916) and *Judex* (twelve episodes in 1916 and another twelve in 1918). These serial films featured scenes shot outdoors in Paris and the nearby suburbs, conveying an impression of the city that was stripped of all cultural reverence. Earlier, in Victorin-Hippolyte Jasset's *Zigomar* series (1910–13), and then, even more markedly, in *Fantômas*, the city was no longer content to be the mere setting for crime stories or detective adventures, as demonstrated by the Gaumont poster on which an immense, masked Fantômas, in tailcoat and opera hat, looms over Paris, emerging from the dawn breaking over the Seine, its bridges, and the Eiffel Tower. The villain dominates the city he terrorizes, and, henceforth, the shots taken in its streets and from its rooftops would develop a poetic idiom, in this metropolis rendered mysterious and troubling: a strange quotidian. This image of the city as a labyrinth, an unsettling space of latent dangers and "magical" encounters—which inspired surrealist writings—electrified the contem-

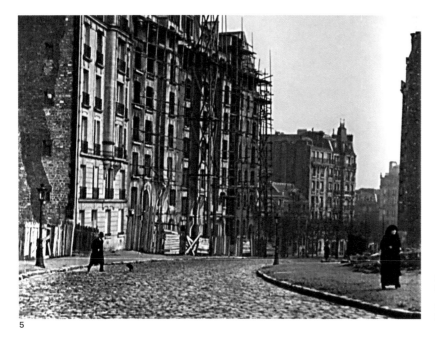

5

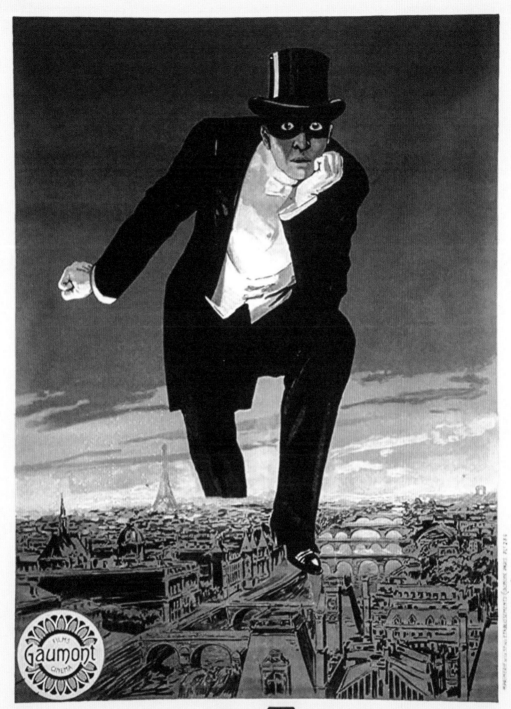

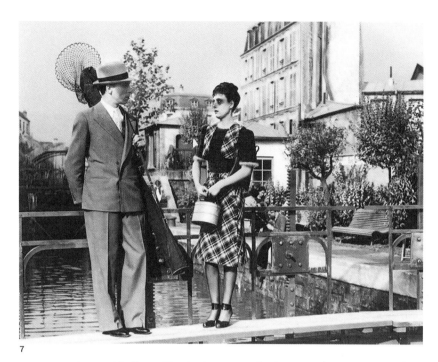

7

porary poetic trend in filmmaking in the 1920s and 1930s, in works by the likes of Alberto Cavalcanti, Dimitri Kirsanoff, or Jean Vigo. This aesthetic was embodied by Marcel Carné* and Jacques Prévert in *Le Quai des brumes* (*Port of Shadows*), which was filmed on the eve of World War II.

A Real or Imaginary City?

When studying the representation of Paris in film, it is important to make certain distinctions. One such distinction concerns the difference between documentaries (with no actors) and fictional films (with performers). Each one has its own style, production techniques, and audience, and they both use the urban setting for different purposes. In the case of documentaries, the city itself is the subject of the film; in fictional accounts, the city provides a frame or backdrop. Around eighty documentaries were made about Paris in the 1920s, and countless fictional films were set in the city. However, this distinction is not absolute, due to the "stylistic permeability" between these two categories, which occurs in both directions. The films by Feuillade have just been discussed, but in contrast the role of staging in most documentaries should also be emphasized, beginning with the views depicted by the Lumière brothers. All fictional films have a documentary aspect that increases with the passage of time. When films are shot outdoors, this occurs

naturally: they record contemporary views of the city and its daily activities, which lead us to ask questions about the filmmaker's choice of locales. But this is also the case for films shot on sets constructed in the studio. A "primitive" film like *Les Cris de Paris* (*Street Cries of Paris*)—a *phonoscène* by Gaumont made in 1910, which incorporated sound and was a forerunner of sound films—represents urban spaces through the use of painted canvases. These sets are equally representative of different aspects of reality, both societal (the street trades depicted) and urbanistic (the spatial layout, suggested by the settings, types of thoroughfares and squares). In any case, the *phonoscène* records the cries, as well as the movements and gestures of genuine street tradesmen and traveling artisans who were summoned before the camera, in relation to this clichéd recreation of a space.

The same is true when an unspecified working-class neighborhood is represented—a version of an actual district modified through a distorting lens—as in René Clair's *Sous les toits de Paris* (*Under the Roofs of Paris*) of 1930, which included buildings, waste ground behind fencing, and proximity to the tracks of the city's belt railway. Other examples can be seen in the depiction of the Canal Saint-Martin in Marcel Carné's *Hôtel du Nord* of 1938; Barbès and Montrouge in Autant-Lara's *Fric-Frac* of 1939; the Latin Quarter in the

7 Photograph of the filming of *Hôtel du Nord*, by Marcel Carné, 1938.

8 Still from *Boudu sauvé des eaux* (*Boudu Saved from Drowning*), by Jean Renoir, 1932.

9 Stills from *Paris en 5 jours* (*Paris in 5 Days*), by Nicolas Rimsky and Pierre Colombier, 1926.

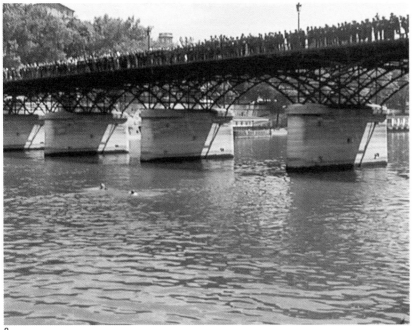

8

the difficulties of operating outdoors, from a vehicle or a window, often restricted the perspectives of the city. Renoir used sets in *La Chienne* (*The Bitch*) and *Le Crime de M. Lange* (*The Crime of Monsieur Lange*), although they were clearly "situated" in a Parisian setting. The pragmatic necessities of filming clashed with the material realities of street life (crowds, traffic, business activities, curious onlookers), which often forced film crews to work very early in the morning, to partially frame the exterior décor, or to interrupt the street's activities artificially. Some directors managed to turn this artifice to their advantage in their films. In *Paris qui dort*, Clair filmed deserted streets which only reinforced his portrayal of a petrified city.

Depictions of Paris

The films explicitly concerning the city of Paris, its activities, and its architectural, urbanistic, and human qualities—in short, those films that make the city its main subject—fall into three categories. 1) Descriptive documentary films, featuring the monuments, neighborhoods, and emblematic sites of the city. They pursue and intensify the original approach of the Lumière brothers and, like them, owe a great debt to tourist guidebooks such as the Baedeker (which filmmakers often consulted to select the sites to film) and travel memoirs. Evidence of this practice is seen in *Paris en 5 jours* (*Paris in 5 Days*) by Nicolas Rimsky and Pierre Colombier (1926), in which American tourists visit the city at top speed in an open-top vehicle; the sites include the Exposition Internationale des Arts Décoratifs, the Musée du Louvre, Place de la Concorde, the Arc de Triomphe, and the Champs-Élysées. 2) Films considered avant-garde, that do not so much offer a portrait of the city as explore and celebrate its defining aspects in the eyes of the filmmakers, whether this be the harmony of its diversity and the complementarity of its various aspects—the city as organism—or rather its strange, mysterious, ominous qualities, or alternatively its modernity, speed, and functionalism—the city as machine. 3) Fictional films whose action is set in very specific Paris locations. These settings may be depicted in a quasi-documentary fashion and even, in many cases, may take on the avant-garde approach described above, but they often offer "selected

film of the same name by Pierre Colombier from 1939; La Villette in Carné's *Les Portes de la nuit* (*Gates of the Night*) of 1946; the Rue Poliveau and nearby Jardin des Plantes, all the way to the Marais and Montmartre in Autant-Lara's *La Traversée de Paris* (*The Trip across Paris*) of 1956; and Les Halles in Jean Grémillon's *L'Étrange Madame X* (*The Strange Madame X*) from 1951, or in Julien Duvivier's *Le Temps des assassins* (*Deadlier than the Male*) of 1956. These are synoptic and codified depictions, in which architecture and urban landscapes are the creations of set designers (most notably Lazare Meerson,* Alexandre Trauner,* and Max Douy), who condensed the space and restructured the layout of streets and squares (altering their length, density, etc.). They allowed the director to convey an image of urban activity, a variety of stores and workshops, and the comings and goings of pedestrians and workers in the streets (porters, delivery men, produce sellers). These depictions are, of course, to be seen in relation to shots of real streetscapes, heeding Carné's admonition in 1933: "When will the cinema go down onto the street?" The scene on the Pont des Arts and its surroundings in Jean Renoir's* *Boudu sauvé des eaux* (*Boudu Saved from Drowning*) of 1932 may have provided him with inspiration. But these shots cannot automatically be given preference in the name of "authenticity" without a more stringent analysis, because

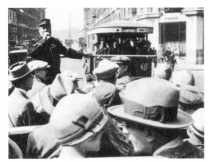

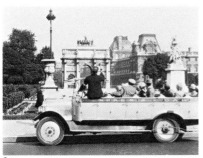

9

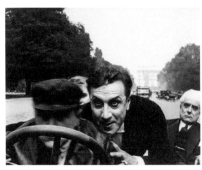

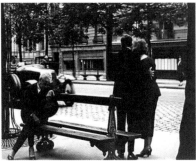

10

excerpts" or interludes that are unrelated to the narration and are primarily devoted to showing the city, its monuments, its squares, etc. Throughout the 1920s, in France as well as in Germany and the Soviet Union, fictional movies included intervals that were purely descriptive, depicting urban agitation and traffic, and sometimes lingering on iconic sites.

The "city" films in the second category mentioned above, which Alberto Cavalcanti introduced to France with *Rien que les heures* (*Nothing but Time*) from 1926, whose example was followed by Lucie Derain, Marcel Silver, André Sauvage,* Eugène Deslaw, Jean Lods, Éli Lotar, and Henri Storck, among others, examine the city over the course of a day. They show the different types of activities that are typical of the capital, from morning through evening, traversing the central districts, as in *Les Halles centrales*, all the way to the outlying areas, as in *La Zone* (The Wasteland). The history of cinema confers a somewhat special status on these films because critics such as Béla Balázs and Siegfried Kracauer paid them particular attention and attributed to them an almost archetypal role, drawing on the canonical examples of *Berlin: die Sinfonie der Großstadt* (*Berlin, Symphony of a Metropolis*) by Walter Ruttmann (1927) and *Chelovek s kinoapparatom* (*Man with a Movie Camera*) by Dziga Vertov (1928). The portrayal of cities from morning to

evening was to have a long trajectory: this approach became an almost obligatory exercise in short documentaries of the 1940s and 1950s, when the Swedish director Arne Sucksdorff triumphed with his remake of Joris Ivens's *Regen* (*Rain*) of 1929, for the umpteenth time.

However, it would be too restrictive to limit the analysis to this group of films. On one hand, movies like *Paris qui dort* and later *Entr'acte* (Intermission) by René Clair (1923–24) preceded the emergence of the "genre" in question, as well as *Le Ballet mécanique* (*Mechanical Ballet*) by Fernand Léger* (1925) and *Ménilmontant* by Kirsanoff (1926) in a more fragmentary fashion. On the other hand, fictional films sometimes brought into play in a significant manner this city life that was rooted in the posterity of unanimism as per Émile Verhaeren or Jules Romains, and that continued in modernist literature (which could be called "art deco," particularly in the case of Paul Morand, with his cursive and fragmentary writings and his elliptical style).

Les Halles as a Setting

Les Halles is the most iconic Parisian neighborhood of the nineteenth and twentieth centuries (right up to the 1970s). Its representation in film focused on a number of themes. The "Belly of Paris," in Émile Zola's words, was so fascinating because several worlds were juxtaposed there. There were denizens of the night; laborers on the job at the break of dawn, with all the hierarchical disparities that separated the foremen from the workers; food store buyers and individual grocery shoppers; and, finally, the vagrants who came to gather scraps to eat. The provision of food products, their shipment, and their storage necessitated a regulated organization and a degree of technology that implied excess and overabundance (piles of cabbages, shelves laden with calf heads, heaps of grain sacks, etc.), while, at the same time, the frenzied agitation of busy workers was evidenced by a continual clamor in the background. Photographers such as Éli Lotar, Germaine Krull,* and André Kertész* produced numerous reportages on the site. A year before he codirected *À Propos de Nice* (About Nice) with Jean Vigo—a "city-film" that conformed with the principles of "Film-Eye" practiced by his brothers who remained in the Soviet Union—Boris Kaufman undertook the

10 Stills from *Le Lion des Mogols* (*The Lion of the Mogols*), by Jean Epstein, 1924.

11 Still from *Études sur Paris* (*Studies of Paris*), by André Sauvage, 1928.

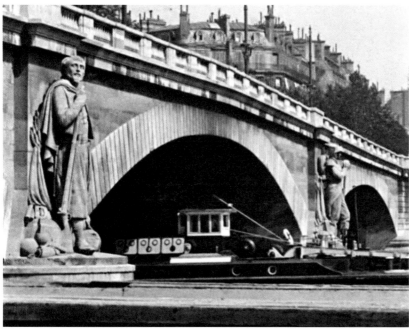

11

film *Les Halles centrales* (a title that was given to the film in retrospect) with André Galitzine, in 1929. In just twenty minutes, it touched upon all these aspects and presented a portrait of the location in a lapse of time that stretched from daybreak till mid-morning. Kaufman had previously made *Aujourd'hui*, or *24 Heures en 20 minutes* (*Today*), with Jean Lods. And fictional accounts were just as prolific; in 1924, the Société des Cinéromans commissioned René Leprince to make *L'Enfant des Halles* (The Child of Les Halles), adapted from a successful novel. Other films, including *Crainquebille* (*Bill*) by Jacques Feyder* (1923), set their story in this very specific and identifiable area of the French capital. In *Ce Cochon de Morin* (That Pig of Morin) of 1924, adapted from a tale by Guy de Maupassant, Victor Tourjansky depicted partygoers emerging at daybreak from the cabarets of Montmartre to move on to Les Halles, where they encounter and intermingle with the laborers in the market. *Paris en 5 jours* took American tourists to the legendary site, as well.

A Symphony-City or a Machine-City?

A pursuit of contrast inspired all of these films—whether it was the contrast between two different social milieus or two different temporal settings (morning and evening). Of course, no contrast was as striking as the comparison of leisure with labor. Idleness and debauchery form the dark side of the modern, functional city, which is driven by speed and funded by cash transactions. In *Le Lion des Mogols* (1924), Epstein depicts an Indian prince, exiled from a remote medieval kingdom, immersing him in a Parisian world of cabarets and automobiles. Sometimes these films were content to show the festive and nocturnal aspects of the Paris of luxury. *Paris la nuit* (Paris by Night) by Maurice Keppens (1924) reuses a trope that had already been employed by the Russian filmmaker Yevgeni Bauer in *Korol Parizha* (The King of Paris) of 1917, to depict the ruin of a gambler. Other films contrasted the elite of Paris with the poor, such as *Le Chiffonnier de Paris* (*The Ragpicker of Paris*) by Serge Nadejdine (1924), and others still the modern city with working-class Paris. In 1928, Feyder's *Gribiche* (*Mother of Mine*) featured a bourgeois progressive protagonist, who returns from the United States an enthusiastic convert to modern hygiene and functionalism. She adopts a fatherless girl to ease the burden on the girl's widowed mother. However, the child flees the world of comfort and luxury, on a Bastille Day evening, to return to her place of birth. In *Les Nouveaux Messieurs* (*The New Gentlemen*) from 1929, a dancer at the Paris Opéra, who is kept by a conservative politician, lives on Rue Mallet-Stevens in a modern duplex. She becomes romantically involved with a union worker who embarks

on a political career, thus betraying his working-class heritage.

In the script for *Paris* (René Hervil, 1924), the machine-obsessed writer Pierre Hamp contrasts the working-class characters (laborer, seamstress, engineer) with a banker, who is an idle speculator: "True happiness is not to be found in the Paris of luxury where joys are but ephemeral, but rather among those who love, work, and live sanely, those whose children you are," concludes one of the film's characters. Within this melodrama, whose scenes take place in sites ranging from the Butte Montmartre to the factories near Billancourt and Les Halles market, there are several standalone sequences offering views of Paris, which, according to one critic, stand out from the rest of the film; he declared them "a beautiful visual symphony that mingles in a close counterpoint evocative and moving images of our monuments, streets, gardens."[1] The expression "visual symphony"—which Ruttmann later echoed—is well chosen. As in André Sauvage's* *Études sur Paris* (Studies of Paris) from 1928, a quest for harmony prevails. This is the concept of the city as an autonomous, self-regulating organism. The city's effective functioning, its traffic, and its activities are highlighted, and the film pauses here and there on aspects that constitute noteworthy details or monuments. It is significant that Lucie Derain titled his 1928 film *Harmonies de Paris* (Harmonies of Paris), following *Voici Paris* by Jacques-Henry Levesque (1925), and *Paris Express* by Pierre Prévert and Marcel Duhamel (1928). Sauvage, whose film offers a kind of collage of the city within Paris—ports, the Nord-Sud metro line, Paris's islands, the Petite Ceinture railway, from the Tour Saint-Jacques to the Montagne Sainte-Geneviève—features views taken from a moving vehicle: automobile, tram, subway, or boat. This gives an impression of great fluidity, as the viewer travels primarily on avenues, boulevards, quays, and bridges that are teeming with activity. In contrast, the web of alleys in "Old Paris," the narrow staircases of the Butte Montmartre, and the outlying areas where the destitute were left to improvise their dwellings, are much less conducive to this "smoothing over" or "whitewashing" of urban reality; Georges Lacombe was the only one to film this world apart in *La Zone*. Medieval Paris was the exception, where harmony could be found in the views taken from the rooftops. Traveling

along the grand boulevards where bicycles, trams, automobiles, and horse-drawn carts intermingle, the viewer participates in a vast orchestration of the urban scene. There are no breakdowns or malfunctions, no traffic jams or accidents. This impression is created by the combination of the filming method and the actual movement of traffic. Cuts are made in the film to eliminate anything that does not move in the desired direction, and views are spliced and connected so that the audience speedily traverses streets, canals, and bridges. Films by certain avant-garde directors present a machine-city that pushes this assimilation to its extreme. Eugène Deslaw filmed machines in motion (pistons, gear shafts, etc.), and his films on the city convey the same sensibility, as in *Montparnasse* of 1929. Sauvage stops from time to time, pausing on gestures and details, before resuming the city's perpetual motion. Deslaw and Henri Chomette in *Jeux des reflets et de la vitesse* (Interplays of Reflections and Speed) of 1923 no longer depicted the travelers—they filmed only an abstract urban mechanism (hence the use of acceleration, and mere luminous traces of motion).

There is another category of film that addresses the issue of the city as machine: one that concerns itself with its chaotic disorder and frenzied excitement. The contrast between the organism-city and the machine-city is eloquently brought to light in Clair's *Paris qui dort*. In addition to the city as landscape (filmed from the Eiffel Tower), and the gastronomic city (restaurants, cafés, interiors), there is also a machine-city, which coincides with the machine-cinema: a combination of movement, rectilinear outlines, and acceleration. The plot includes a mad scientist who uses his power to stop all motion using a paralyzing wave. In 1979, Annette Michelson demonstrated the astonishing "epistemological" depth of this approach; it plays with the actual constituent parts of the film (a snapshot, a fixed image that a machine, external to the film strip itself, can put into motion to create the illusion of life). This technique establishes a link between *Paris qui dort* and Vertov's *Chelovek s kino-apparatom*. Note the sense of disruption that Clair insinuates in the "proper functioning" of the city by arresting an image. Several urban scenes of heavy traffic with crisscrossing vehicles are abruptly halted and then made to resume motion like film

12

12 Stills from *La Glace à trois faces* (*The Three-Sided Mirror*), by Jean Epstein, 1927.

strips in a viewer. Cinema thus becomes an agent of disorganization, sowing chaos. In *Entr'acte*, which owes its inspiration to Francis Picabia, Clair follows a hearse in a funeral procession. In so doing, he pushes to its extreme the proximity between the urban setting and cinema. Human motion is accelerated by mechanical means, and the film actually makes equivalent and comparable an entire series of transport methods that succeed one another in a kind of relay race or high-speed chase (walking, running, cycling; by automobile, boat, plane, roller coaster, etc.). A montage of disparate material connects the plot line through shared dynamic qualities. The stairway that the washerwoman endlessly climbs in Léger's *Ballet mécanique*, as she climbs up from the banks of the Seine with her load, evokes the same sense of disruption by deploying a practice used in phenakistoscopes. Léger explained that by repeating the woman's gesture eighteen times in this sequence, he was testing the audience's limits of acceptability of such an effect. There are therefore two interpretations of the machine-city: the modernist functionalism associated with efficiency and the performance of urban activities (transport, interchanges, traffic, production, circulation of goods), which contrasts with the machine run amok: the surrealist notion of a "bachelor machine," the progenitor of absurdity.

Epstein represents one side of this continuum. In addition to the films already mentioned, one could cite others such as *La Glace à trois faces* (*The Three-Sided Mirror*) from 1927 (adapted from Morand), in which a seducer's speedy escape by automobile allows him to conduct several romantic relationships simultaneously. Paris is traversed at top speed until the final accident on a country road, when a lark crashes into the driver's roadster, sending it careening into a tree. At the time, Epstein was exploring the idea of a screenplay recounting "the end of the world by speed" or "the machine created by man that crushes its creator, who is incapable of keeping pace with its speed."[2] At the other extreme was the Dadaist assertion of *L'Esprit nouveau*, based on the model of the efficient machine that was espoused by Le Corbusier,* and was endorsed by Man Ray,* Léger, Picabia,* Clair, and Charles Dekeukeleire. The potentially tragic conclusion, which may be the inevitable destiny of the functionalist vision (the auto-

mobile accident), nevertheless preserves the integrity of the mechanical functioning of the film. This outcome is contrasted with the crisis of the cinema as machine.

Film offers the historian documentation of architecture, urban design, and city practices, through a kind of replication of the camera and its object. In addition, while calling into question its own principles, cinema prompts a critical reflection on the city. F A

Annabel Audureau. *Fantômas: Un mythe moderne au croisement des arts.* Rennes: Presses Universitaires de Rennes, 2010.
Béla Balázs. *Der Geist des Films.* Halle (Saale): Wilhelm Knapp, 1930; in English, *Visible Man and the Spirit of Film.* Translated by Rodney Livingstone. Edited by Erica Carter. New York/Oxford: Berghahn Books, 2010.
Marcel Carné. "Quand le cinéma descendra-t-il dans la rue?" *Cinémagazine*, no.11 (November 1933): 12–14.
Myriam Juan. "Le cinéma documentaire dans la rue parisienne." *Sociétés & Représentations*, no. 17 (2004): 291–314.
Siegfried Kracauer. "Der Mann mit dem Kinoapparat. Ein neuer russischer Film," *Frankfurter Zeitung*, May 19, 1929.
Pierre Mac Orlan. "Le fantastique et le cinema." *Jabiru*, no. 3 (April 1926): 3–13.
Isabelle Marinone. *André Sauvage, un cinéaste oublié.* Paris: L'Harmattan, 2008.
Annette Michelson. "Dr. Crase and Mr. Clair." *October*, no. 11 (1979): 31–53.
Elizabeth Muelsch. "*Les Halles* (1929), une œuvre charnière dans le développement du jeune opérateur et cinéaste Boris Kaufman?" *1895, revue d'histoire du cinéma*, no. 85 (2018): 52–71.
Paris Cinéma. InterMedia/Ministère des Affaires Étrangères/Vidéothèque de Paris, 1989.
Jean-Louis Robert, Myriam Tsikounas, et al., eds. *Les Halles: Images d'un quartier.* Paris: Éditions de la Sorbonne, 2004.
Patrice Rollet, Christian Lebrat, and Prosper Hillairet. *Paris vu par le cinéma d'avant-garde.* Paris: Paris-Expérimental, 1985.

1. Émile Vuillermoz, "Chronique cinématographique," *Le Temps*, December 4, 1924.
2. "Imagine an automobile driver whose machine would go faster than the nerve impulses that, in man, command his muscles from his brain. I imagine a curve is coming up. The auto arrives at the curve before the driver's nervous impulse can transmit the command to his hands to turn the steering wheel. I thus imagine a man who has discovered the means to accelerate the mechanical speed to the point where it exceeds that of thought: that would be the ultimate catastrophe caused by speed." Jean Epstein, interview by Jean Mitry, *Théâtre et Comœdia illustré* (June 15–September 15, 1924): n.p.

André Citroën

1878, Paris
1935, Paris

The name Citroën loomed over western Paris during the 1925 Exposition Internationale des Arts Décoratifs et Industriels Modernes, glowing in neon lights on the sides of the Eiffel Tower. The brand was just as significant in the history of advertising as it was in the history of the automobile.

This advertising triumph crowned the success of a business created in 1919 by the engineer André Citroën, who graduated from the prestigious École Polytechnique. His first technological triumph had been the invention of a double V gear system, which inspired the brand's logo. During World War I, he built a vast factory for manufacturing shells on the Quai de Javel. In 1919, he established the assembly line there for the successful Citroën Type A, designed by Jules Salomon.

A pioneer in introducing Taylorism and Fordism to France, Citroën launched the production of the B10 in 1924. It was the first European automobile built entirely from steel, and was succeeded by the C4 and the C6. At their peak in 1929, the assembly lines at Javel, Saint-Ouen, and Levallois made Citroën the second largest car manufacturer in the world. By the mid-1930s, however, the company was mired in debt. Although the remarkable Traction Avant designed by engineer André Lefebvre, with its revolutionary steel stressed-skin body and front-wheel drive technology, was introduced by Citroën in 1934, the design came on the scene too late to save the company, and it was acquired by the tire manufacturer Michelin.

In 1939, Pierre-Jules Boulanger created the company's "TPV" (*très petite voiture* or very small car), which was universally known as the 2CV and assured Citroën's successful future after 1945. J-L C

Joël Broustail. *Citroën et le citroënisme: Essai historique sur la passion automobile et l'innovation.* Paris: Au Pont 9, 2020.
John Reynolds. *Andre Citroën: Engineer, Explorer, Entrepreneur.* Haynes: Haynes Motor Museum, 2006.

Assembly line for the Citroën
Traction Avant in the Javel factory,
c. 1934.

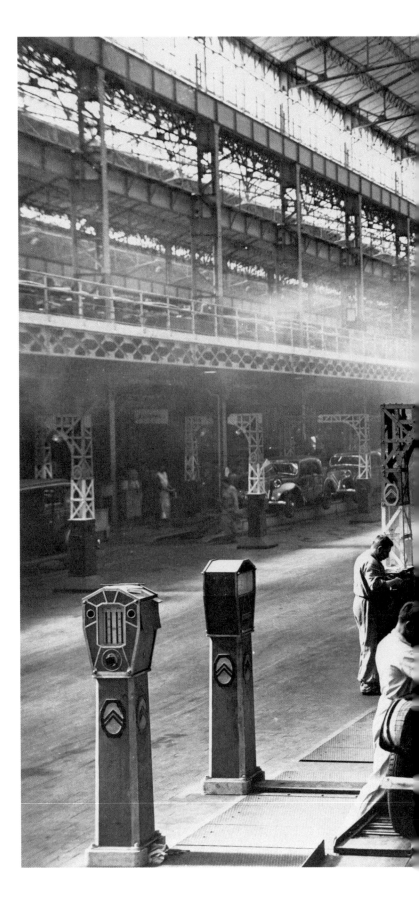

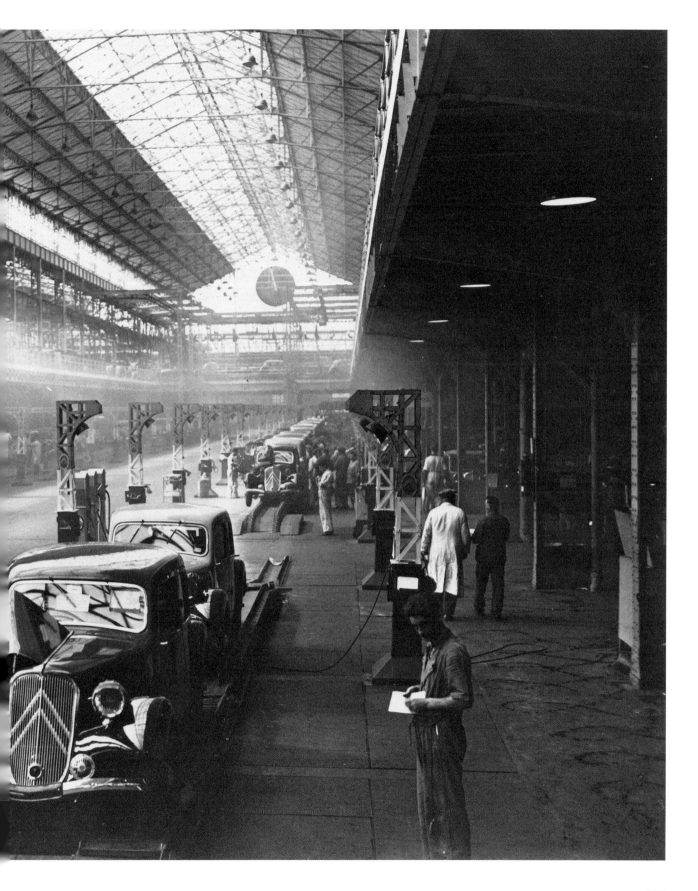

René Clair

1898, Paris
1981, Neuilly-sur-Seine

Born René Chomette, René Clair began his career as a journalist for the newspaper *l'Intransigeant*. He subsequently edited the *Théâtre et Comœdia Illustré* and acted in several films. After serving as Jacques de Baroncelli's assistant, he began working as a filmmaker, and his early work was closely tied to the city of Paris, where he filmed *Paris qui dort* (*Paris Asleep* or *The Crazy Ray*) in 1923, followed by *Entr'acte* (Intermission) in 1924, *Le Fantôme du Moulin Rouge* (*The Phantom of the Moulin Rouge*) in 1925, *Le Voyage imaginaire* (*The Imaginary Voyage*) in 1926, and *La Tour* (*The Tower*) in 1928, all filmed in natural settings. He reverted to conventional 1900-style sets in his brilliant adaptation of *Un Chapeau de paille d'Italie* (*The Italian Straw Hat*) of 1928. He then turned to sets that became prototypes for various neighborhoods on the fringes between the city center and the suburbs: *Sous les toits de Paris* (*Under the Roofs of Paris*) in 1930, *Le Million* and *À nous la liberté* (*Freedom for Us*) in 1931, *Quatorze juillet* (*14 July* or *Bastille Day*) in 1933, and a film that was planned but abandoned with the arrival of sound, *Prix de beauté* (*Miss Europe*), ultimately made by Augusto Genina in 1929. Clair's distinctive take on the image of working-class Paris owed a great deal to Lazare Meerson.* The "poetic realism" genre, based on Pierre Mac Orlan's "fantastic realism" and inspired by the *Kammerspiel* of German cinema, found its most iconic expression in Clair's work, which was pursued by Marcel Carné* with the collaboration of the production designer Alexandre Trauner.* The social world evoked by Clair reflected a photographic trend that partly originated among workers who were encouraged by the Communist movement to use cameras, and among other photographers who were active in the movement (Germaine Krull,* Éli Lotar, André Kertész,* Henri Cartier-Bresson). This world progressed from the homeless to the taxi driver and the proletariat, continually threatened by the police and contrasted with the wealthy or the bourgeoisie. F A

Barthélemy Amengual. *René Clair*. Paris: Seghers, 1963.
Noël Herpe, ed. "René Clair." Special issue, *1895, revue d'histoire du cinéma*, no. 25 (September 1998).

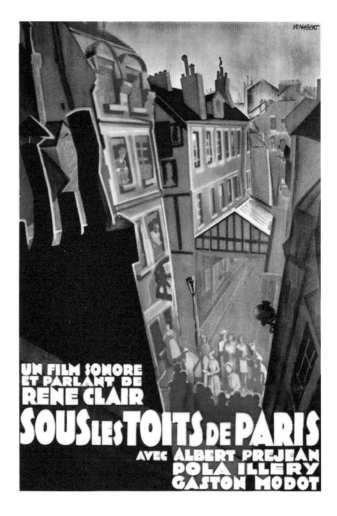

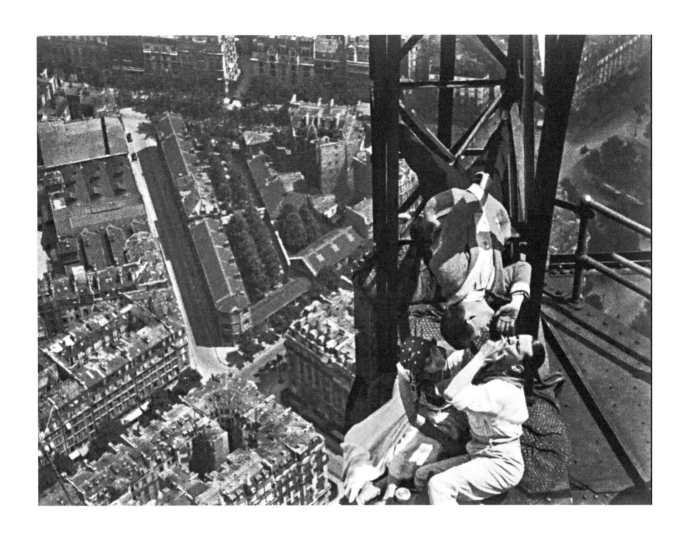

← Venabert, poster for *Sous les toits de Paris* (*Under the Roofs of Paris*), 1930.

↑ Still from *Paris qui dort* (*Paris Asleep* or *The Crazy Ray*), 1923.

Paul Colin

1892, Nancy
1985, Paris

Paul Colin moved to Paris after World War I and became one of its most sought-after graphic designers over the following twenty years. He was asked to create posters for the Théâtre des Champs-Élysées in 1923, and was commissioned to design sets for its shows shortly thereafter. The production of *La Revue nègre* in 1925 gave him the opportunity to attend rehearsals, where he met Josephine Baker.* They began a relationship, and he created a poster that typified the early years of her success. Colin was captivated by the New York-based troupe of the *Revue*, and he continued to demonstrate his enthusiasm for Black performers and jazz. He published his famous *Tumulte Noir* (Black Uproar) in 1927; the book included forty-five lithographs that captured the suppleness and energy of the dancers and musicians.

Colin founded a school in his name in 1929. He joined the Union des Artistes Modernes and designed a poster for the group's first exhibition. He engaged in a variety of collaborations in both graphic and stage design for the leading lights of Parisian music-hall theater—Casino de Paris, Concert Mayol, and Folies Wagram—as well as the Comédie-Française and Théâtre Saint-Georges. While remaining dedicated to the stage, Colin also made posters for a wide range of business and cultural clients throughout a career that flourished until the 1960s. He willingly shared his expertise in the service of common causes, including his 1939 poster protesting the Spanish Civil War, "Paris ne doit pas être le Madrid de demain" (Paris must not be the Madrid of tomorrow). C d S

Louis Chéronnet. "Paul Colin." *Art & Décoration* 62, no. 5 (May 1933): 129–38.
Alain Weill, Jack Rennert, et al. *Paul Colin affichiste.* Paris: Denoël, 1989.

↓ "Paris ne doit pas être le Madrid de demain" (Paris must not be the Madrid of tomorrow), poster supporting the Spanish Republic, 1937.

→ Poster for the Musée d'Ethnographie du Trocadéro (Ethnographic Museum of the Trocadéro), 1930.

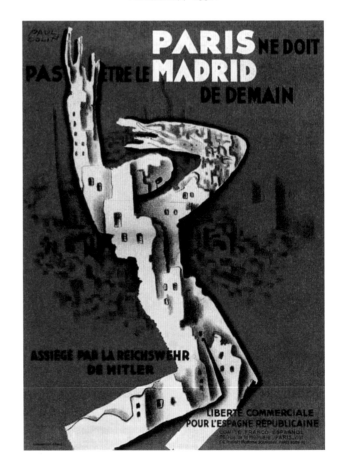

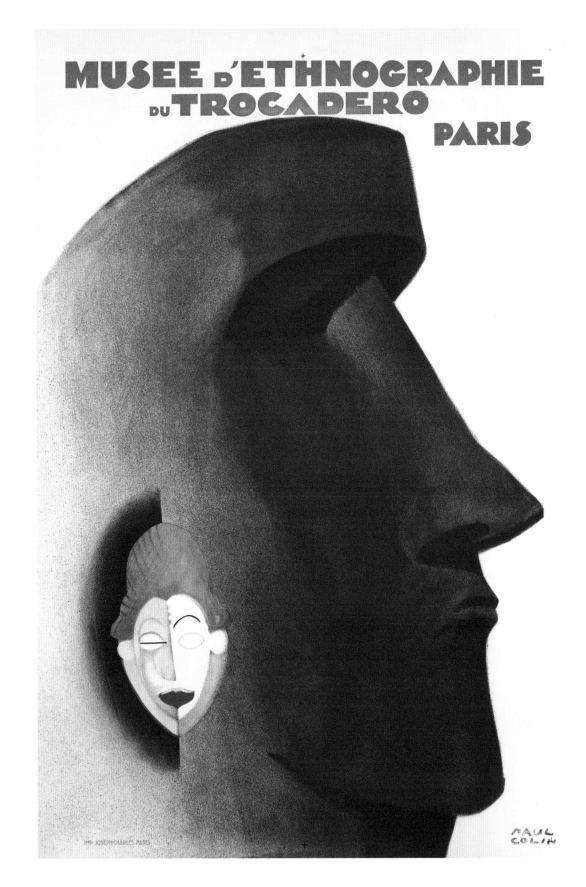

Couture

PARIS: THE FASHION CAPITAL

On the eve of World War I, fashion was a key sector of the French economy. It provided much employment and was the source of significant export revenues. The bustling Paris of the Belle Époque was incontestably the international capital of luxury, and this dominant position was further enhanced between the wars.

Haute couture—a uniquely French phenomenon—first appeared in Paris in 1857. It was based on principles established by the English-born fashion designer Charles Frederick Worth, and introduced seasonal collections of exclusive designs, made to measure for a sophisticated clientele, both mondaine and demimondaine. Meanwhile, burgeoning department stores devoted their efforts to copying the fashionable trends featured in the press. They made garments that were targeted at a rapidly expanding class of petite and *moyenne* bourgeoisie. Paris was soon supplying fashion to the provinces, colonies, and overseas territories, thanks to its mystique, allure, and creativity, and, more practically, the development of its distribution systems by railroad and mail order sales.

An Emancipating War and an Iconoclastic Peace

In 1906, the couturier Paul Poiret* freed fashion from the corset. His fluid dresses clung to the body, evoking the fashions of the First Empire (early nineteenth century). Few women dared to wear these outfits, but they heralded the tremendous upheavals in dress that were to ensue following the onset of the war. Skirt lengths immediately rose above the ankle to facilitate walking. Clothing was simplified. Faced with new responsibilities, bourgeois women no longer changed their outfits several times a day, and their apparel became more practical. They adopted functional tailored suits, inspired by military garb, featuring pockets and buttons, and simply trimmed. This look became the norm, and with mourning so

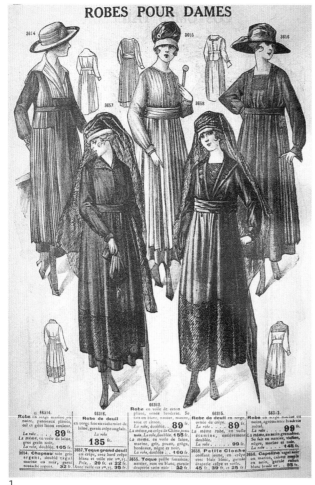

1 Page from the sales catalog of the Printemps department store, 1918.

2 Yola Letellier in a Chanel suit at the Auteuil racecourse, 1927. Photograph by the Séeberger Brothers.

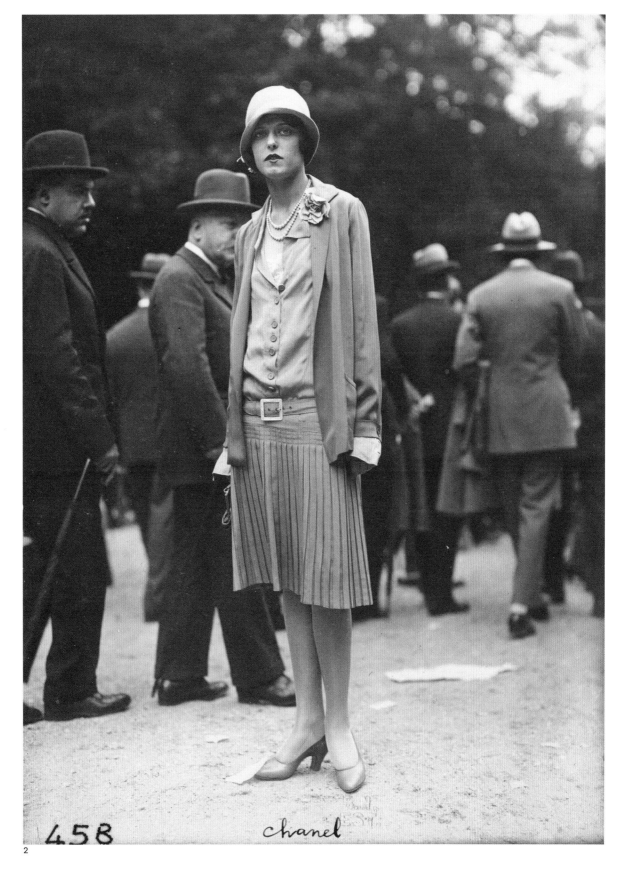

458 chanel

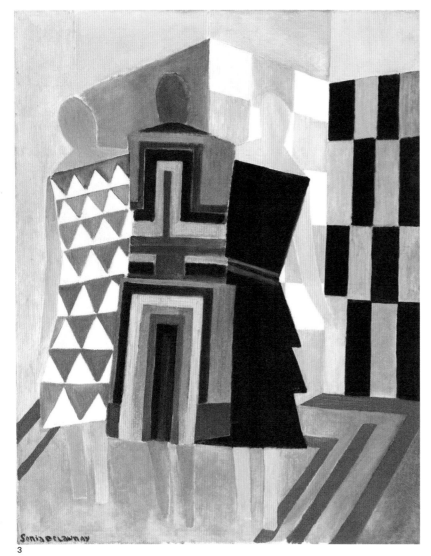

3

and the British-born designer Edward Molyneux understood this clientele very well. Their collections were modern and easy to wear. Life was lived at a fast pace: women wanted to be able to slip on a dress, coat, or sweater for daywear, and quickly change into a glittering gown trimmed with beads, sequins, and spangles to go dancing in the evening. For daytime, with the exception of Poiret's designs, hems continued to rise and were just below the knee by 1925—a first in the history of women's fashion. Styles were resolutely short, straight, and loose, hanging from the shoulders. Waists were no longer emphasized, or else were set very low with a belt at hip level. These dresses did not highlight any of the traditional feminine attributes. Corsets were banished, replaced by bandeau brassieres that flattened the breasts and girdles that compressed the hips, creating a rectangular silhouette. This "garçonne"[2] or tom-boy look, athletic and tanned,[3] became the ideal. Tanning itself was a revolutionary concept that put an end to centuries of the cult of pale white skin. The captivating image of Josephine Baker,* the main icon of the Roaring Twenties, doubtless contributed to this phenomenon. Another revolution ensued: women bobbed their hair and donned cloche hats with brims that dipped over their eyes. Makeup was now acceptable—encouraged, in fact—even in the day (yet another revolution!), while cosmetics began to be produced on an industrial scale.[4] Films were very popular, and, thanks to women's magazines—also a flourishing sector—the looks they popularized were simple and easy to copy. If a woman lacked the means to dress in haute couture or pay for a neighborhood seamstress, or could not purchase her clothing from department stores, she could make her own outfits. As simplified models proliferated, they gradually eliminated regional particularities, such as had persisted in Brittany, for example, and could still be found in Paris, especially among domestic servants.

While fashion radically altered women's style, it also changed status in the 1920s, thanks to the favorable context. Couturiers were no longer mere suppliers; as Chanel aptly demonstrated, they were now counted among the sophisticated elite that dictated style to fashionable Paris. Social exchanges became more open, cosmopolitan, generous, and creative. The traditional aristocracy made common cause

widespread, black increasingly prevailed over brighter hues. Hats, whose proportions were reduced in scale, were pulled down over the head. Fabric was used more sparingly, but evening gowns were still worn to lift the spirits of soldiers on leave: it was all part of the war effort. When peace was restored, however, women had no desire to abandon their new-found freedoms, and they emerged transformed and rejuvenated from the conflict.

Following the end of World War I, Paris was a "moveable feast."[1] International visitors flocked to the city for entertainment, and couturiers rejoiced in this influx of new clients. Women from both North and South America hastened to the couture houses, unencumbered by earlier prejudices and unaware of past conventions. Gabrielle Chanel* (nicknamed Coco), Jean Patou,*

3 Sonia Delaunay, *Robes simultanées (Simultaneous Dresses)*, 1925. Oil on canvas. Museo Nacional Thyssen-Bornemisza, Madrid.

4 Mannequin by the staircase of the Pavillon de l'Élégance at the Exposition Internationale des Arts Décoratifs et Industriels Modernes, 1925. Photograph by Man Ray.

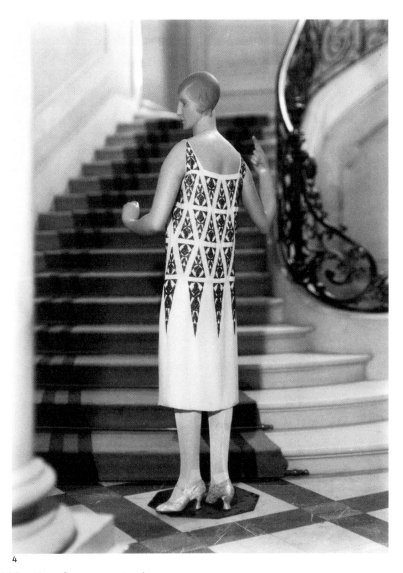

4

with millionaires and artists from all walks of life. Balls were hugely popular, and a sense of effervescent festivity facilitated creative encounters, leading to collaborations with the worlds of stage design and interior decoration. Madeleine Vionnet* commissioned contributions from René Lalique, Georges de Feure, and Boris Lacroix. Jeanne Lanvin* called on the services of Armand-Albert Rateau. J. Suzanne Talbot worked closely with Eileen Gray.* The hierarchy between the arts faded, and fashion made the most of this opportunity to elevate itself to the status of an art form. Originating from military terminology and already used in the vocabulary of the fine arts, the concept of the avant-garde came to be applied to fashion.[5] Working together, artists and couturiers contributed to this movement as they sought to completely revolutionize looks

and lifestyles. Ornamentation became geometric and silhouettes were more regular, based on simple forms—cylinders, cones, spheres, and cubes. Throughout the 1920s, a "Picasso* spirit" blew through the arts and shook them to their core, as Paul Fierens observed.[6]

The 1925 Exposition Internationale des Arts Décoratifs et Industriels Modernes marked a watershed for fashion. With Lanvin presiding, fashion and jewelry had the lion's share of the show, taking prominence in the Grand Palais, on the Pont Alexandre III, and in the Pavillon de l'Élégance. Man Ray,* who had just arrived in Paris and had already made a name for himself as a fashionable portraitist, did a reportage on the show featuring mannequins in disturbing poses, dressed in creations by the most renowned couturiers: Lanvin, Callot Sœurs, and Jenny,

among others. Jacques Heim set up his "boutique simultanée" for designs created with Sonia Delaunay.* And Poiret spared no expense in lavishly fitting out three barges—*Amours*, *Délices*, and *Orgues* (Loves, Delights, and Organs)—where he displayed his fashion and decorative creations. Department stores also staked their claim, each sponsoring a magnificent pavilion that, in addition to fashions, presented decorative art products made under the aegis of the most celebrated designers: Primavera for Printemps, La Maîtrise for Galeries Lafayette, Pomone for Le Bon Marché, and Le Studium for the Grands Magasins du Louvre. The year 1925 marked the triumph of art deco and a fashion that would never again be so visible.

The Chronicle of a Changing Silhouette

In 1926, American *Vogue* published a sketch of a Chanel design that was captioned "Ford signed by Chanel." The plain black dress was the very antithesis of the contemporary colorful fashion, and a paradigm of simplicity. It was essentially a new kind of uniform whose look could be refreshed with a scarf, a flower (a camellia, for example), or a piece of jewelry. By the next season, most designers had created their own version. Then stylish hems started to lengthen again: Vionnet, famed for her skillfully cut geometric designs, attracted notice with her new longer lengths in 1927. In no time, all the couturiers were following in her footsteps. But with lengthening hemlines, cuts had to change as well, becoming more complex and refined in order to accentuate the shape of the body. Bias cuts were required to give dresses a fluid line. Evening gowns were floor length again, particularly for special events, which required more fabric and better craftsmanship. They were designed for a well-off clientele that was gradually reverting to type and becoming increasingly self-involved. The gulf between the elite and the masses began to reopen in the late 1920s.

At the very start of the 1930s, a radical change in silhouettes took place, which soon put every article of a woman's wardrobe hopelessly out of fashion. Exit the flat-chested tomboy: the eternal woman in all her feminine glory now emerged in three dimensions, assuming a sculptural presence thanks to corsetry that slimmed and perfected the body's shape. Fashion

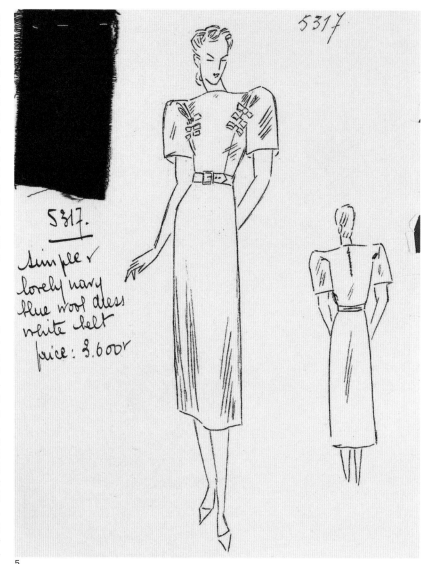

5

drew on classical antiquity for inspiration and styles were pared down, with ornamentation disappearing to give prominence to the silhouette. Vionnet, Lelong, Patou, Lanvin, Heim, and Augustabernard made living statues out of the women they dressed for evening galas.[7] Even Chanel, who had established an athletic look, with detailing that was heavily based on menswear, succumbed to the delicacy of lace, which she used with brio. Matchlessly elegant evening gowns were accessorized with fur stoles, capes, and evening wraps. Daytime fashion was equally sophisticated: there was an outfit for every occasion, and a different hem length for each season. New strategies were devised in

5 Madeleine Vionnet, sketches of an evening gown and fabric sample, 1938.

6 Pierre Imans, wax hairstyling busts, c. 1925.

7 Parisian women applying makeup in a public garden, c. 1930. Photograph by Albert Harlingue.

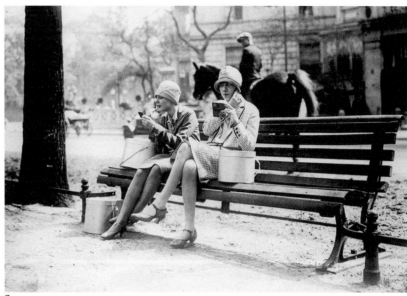

7

response to the economic crisis. Instead of selling finished garments, which were sometimes taxed at a rate of 90 percent, couturiers exported their designs and savoir-faire in the form of toiles and paper patterns. Couture houses further diversified their activities, branching out into home décor, perfumes, cosmetics, and secondary lines, following the example of Lucien Lelong, who opened an "Édition" department in 1934. Each couture house emphasized its own specialties, from custom-made lingerie (Cadolle, La Dubarry, Charmis, and Rouff) to furs, and from sportswear (Hermès, Henry à la Pensée, Anny Blatt) to suits (Creed, Raphaël). There was something for every taste, although not for every budget.

Photographers such as George Hoyningen-Huene, Horst P. Horst, and Cecil Beaton glorified women with sophisticated lighting that transformed them into black-and-white sculptures. Fashion and commercial photography filled magazines, contributing to the expansion of their audience. Idealized, inaccessible, but increasingly present in the media, beauty was now part of fashion. Columns on the subject became widespread, and a magazine dedicated exclusively to the topic, *Votre beauté* (Your Beauty), was first published in 1932. It revealed the early indications of the arrival of cosmetic surgery and, in particular, explained how makeup should be adjusted and accentuated throughout the day. There was even advice on applying cosmetics for bedtime. Rigid injunctions proliferated, also communicated

through cinematographic channels. Hair, makeup, clothing, and accessories had to be adapted to suit the circumstances. The hairstyles of the 1930s were asymmetrical, cropped, and waved, and blond hair was de rigueur. Hats were the indispensable final touch of elegance, worn perched at an angle and adjusted to the wearer's facial features. In brief, beauty was (once again) a full-time occupation. Entire days could be devoted to fitness sessions, tanning salons, hairdresser and beautician appointments, fittings, and outfit changes.

Jewelry was once again seen as a safe investment, and even Chanel, who had advocated costume jewelry for any time of the day, designed a collection of diamond jewelry with Paul Iribe in 1932. This was fashion for the upper classes, intended to impress others from the same milieu: complicated, refined, and exorbitantly priced, it was designed for the wealthiest clients to flaunt at racetracks, holiday resorts, and automobile concours d'elegance.

Department stores, which targeted a more modest middle-class clientele, did not do so well. To boost demand, they introduced new variety stores—Uniprix in 1930, Prisunic in 1931, and Monoprix in 1932—where products of all kinds were sold at reasonable prices. Mass-manufactured clothing was of mediocre quality, but it strove to keep up with fashion trends. Toutmain, specializing in mail order sales and a leader in this field, opened an enormous store on the Champs-Élysées, which included a café.

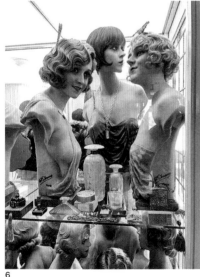

6

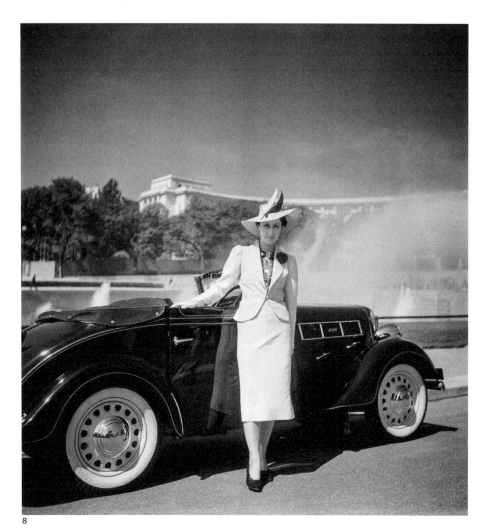

8

Frivolity in the Face of Danger

In 1935, Vionnet had a feeling that classicism was on the way out, and she turned to more fanciful designs. Embellishments soon regained pride of place with most couturiers. Evening gowns became more voluminous, drawing inspiration from past centuries. There was romance in the air, which translated into more frills and trimmings. Most notably, Elsa Schiaparelli,* working with her artist friends, Jean Cocteau, Marcel Vertès, Christian Bérard, Salvador Dalí, and his muse, Gala, introduced surrealism into couture, together with an innovative approach to each collection: every season she designated a theme, which facilitated communication with the press. A shoe-hat, a telephone-purse, a dress adorned with a lobster—humor and quirkiness won her spectacular success with her international clients, who included the Duchess of Windsor, Daisy Fellowes, Marlene Dietrich,

Greta Garbo, Millicent Rogers, Gloria Guinness, and Nancy Cunard (all of whom she enticed away from her competitors). The 1930s drew to a close in an aura of incredible insouciance, although Vionnet shut down in August 1939, and Mainbocher and Chanel closed their salons when war was declared. Chanel kept her boutique open, however, and from her perch in the Ritz hotel, she could monitor sales of her legendary fragrance Chanel No. 5, which was introduced in 1921.

In 1936, the Popular Front transformed the conditions for thousands of couture workers, or at least those who worked in the ateliers. The many others who labored at home were scarcely affected by the newly mandated forty-hour week, with two weeks of paid vacation. But among those who obtained these rights, new sartorial trends appeared: shorts and light dresses were now preferred to dressing up in "Sunday-best" outfits, and women ventured to wear

8 Concours d'elegance in front of the new Palais de Chaillot, 1938.

9 Jeanne Lanvin, design for a black taffeta coat covered with Bakelite squares, 1935.

10 Gabrielle Chanel in her suite at the Ritz, 1937. Photograph by François Kollar.

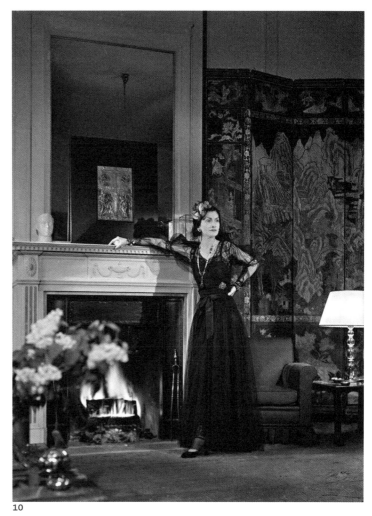

10

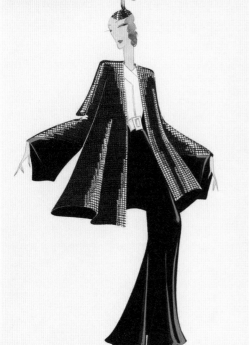

9

swimsuits. Working-class pride was also apparent in the rejection of traditional bourgeois codes; this was particularly evident in films, which offered some of the earliest manifestations of street fashion.

From Occupied Paris...

At first, the phony war seemed to have little impact on the couture houses. Molyneux, Schiaparelli, Patou, Piguet, and Lanvin presented their collections, but rumors were rampant. The Nazis wanted to transfer this lucrative and prestigious business to Berlin and profit from its activities. Lucien Lelong, president of the Chambre Syndicale de la Couture (Trade Association of Couture), was responsible for these negotiations. In the end, haute couture remained in Paris, with its thousands of outsourced jobs: embroiderers, feather workers, florists, trimming makers, dyers, pleaters, jewelers,

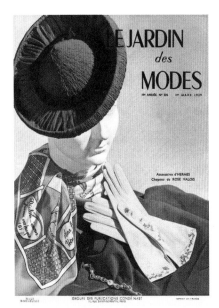

11

and lacemakers. However, the entire sector was subjected to very strict controls, with quotas imposed on essential raw materials; silk, wool, and leather were primarily reserved for Germany. Cut off from the rest of the world, the couture houses dressed the wives of German dignitaries, actresses, and performers, as well as a clientele that profited from black market activities. Furriers and dressmaking companies, which were often owned and managed by Jewish families, were either seized by the Nazis, forced to decamp to the Free Zone, or eradicated. [8]

Most newspapers were subject to censorship, but they continued to publish. Articles encouraged women to use their creativity to recycle, transform, refashion, and make use of everything at their disposal to retain their elegance. "System D"—as in "se débrouiller" ("to make do")—was deployed. The fashionable silhouette altered: the shoulders broadened while waists narrowed, accentuated by darts or a belt. Skirts climbed to knee length to economize on fabric. Nothing matched, so patchwork was king. Ersatz fabrics appeared,[9] but they were not very satisfactory. Stockings were unavailable, so women dyed their legs. Some wore clogs with wooden soles, sometimes articulated, while others used old tires, rope, or cork for soles. This thick-soled footwear at least had the advantage of elongating the figure, as did the turbans that became fashionable headwear. No one went to the hairstylist anymore, and being seen bare-headed was frowned upon. The "cache-misère," a cunningly wrapped piece of fabric, became very popular. And makeup was a huge asset: it was within every woman's reach to enhance her facial features in defiance of the occupier.

. . . to Liberated Paris!

In 1944, haute couture houses were determined to revive the press's interest and reengage its international clientele. To do so, they organized a promotional campaign to tour the world: the *Petit théâtre de la mode* (Little Theater of Fashion). This traveling exhibition featured mannequins measuring just 27½ inches (70 cm) in height, dressed in couture creations and displayed in settings designed by artists. It was a wasted effort. Shortages and ration tickets still prevailed, the streets were empty, and the fashion industry was in tatters. The situation did not improve until 1947, when

Christian Dior burst upon the scene. His "New Look" reignited an appetite for luxury and a longing for indulgence. Once again, the spotlight was on Paris. C Ö

Didier Grumbach. *Histoires de la mode*. Paris: Seuil, 1993.
Catherine Örmen. *L'Art de la mode*. Paris: Citadelles & Mazenod, 2015.

1. See Ernest Hemingway's autobiographical account, *A Moveable Feast: Sketches of the Author's Life in Paris in the 1920s* (New York: Charles Scribner's Sons, 1964). Published posthumously, this volume evokes the world of the young author in 1920s Paris.
2. The term refers to the scandalous and highly successful novel by Victor Margueritte, *La Garçonne* (Paris: Flammarion, 1922).
3. See Pascal Ory, *L'Invention du bronzage* (Paris: Complexe, 2008).
4. George Vigarello, *Histoire de la beauté: Le corps et l'art d'embellir, de la Renaissance à nos jours* (Paris: Seuil, 2004), 184.
5. See *Europe, 1910–1939: Quand l'art habillait le vêtement* (Paris: Musée de la Mode et du Costume/Paris-Musées, 1997), exhibition catalog.
6. Paul Fierens, "Influence de Picasso sur la décoration moderne," *Art & Décoration* 61 (1932): 275.
7. Despite the economic crisis, new couture houses appeared—Bruyère, Maggy Rouff, Lucile Paray, Mainbocher, Nina Ricci, Véra Boréa, Robert Piguet, and Alix—which also contributed to this classical trend. See Guillaume Garnier, "Le milieu de la mode," in *Paris-couture, années 1930* (Paris: Paris-Musées/Société de l'Histoire du Costume, 1987), 99.
8. The sector, which produced twenty million items in 1938, made no more than 5.8 million in 1943; eighty thousand people were employed in 1938, and no more than twenty-five thousand in 1943. Source: Monographie de la confection féminine, Centre d'information interprofessionnelle, 1944. Quoted in Didier Grumbach, *Histoires de la mode* (Paris: Seuil, 1993), 128.
9. See Dominique Veillon, "Fibranne, rayonne et ersatz," in *La Mode sous l'Occupation* (Paris: Payot, 1990), 133–59.

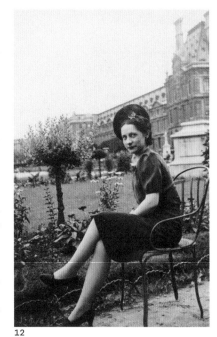

11 *Le Jardin des modes*, front cover of the March 1, 1939 issue.

12 Parisian woman posing in the Jardin des Tuileries during the Occupation.

13 Model posing at Place Vendôme, c. 1940. Photograph by Jean Moral.

12

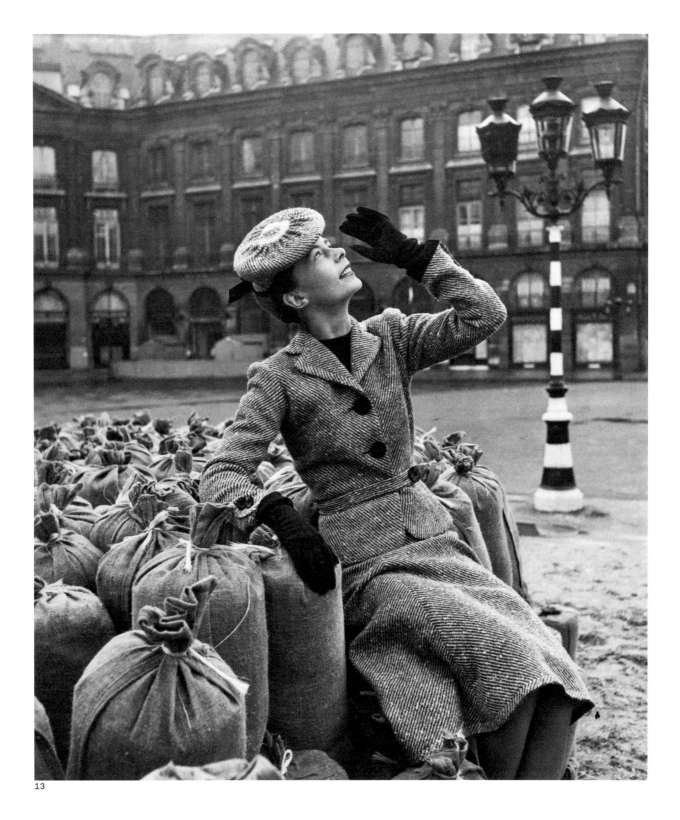

13

Marie Cuttoli

1879, Tulle
1973, Antibes

Revered as a founder, patron, and producer of modernist tapestry, Marie Cuttoli established Myrbor, a very distinctive fashion boutique, in 1922, not far from the church of La Madeleine. There she sold embroidery and carpets featuring simple lines and subdued colors, fashioned in her Algerian workshop by local women. Displayed and admired at the 1925 Exposition Internationale des Arts Décoratifs et Industriels Modernes, they soon appeared in the most modern interiors, in Helena Rubinstein's* home, for instance, as well as in some of the apartments designed by Robert Mallet-Stevens.* An astute collector and businesswoman, Marie Cuttoli hired André Lurçat* to establish another boutique and extended its range by commissioning carpets and tapestries from contemporary artists who were her friends, including Fernand Léger,* Joan Miró, Jean Lurçat, Pablo Picasso,* and even Le Corbusier.*

Noting Cuttoli's determination to break down the distinctions between the fine and applied arts, the photographer Thérèse Bonney* commented in her 1929 *Shopping Guide to Paris*, "If you'd like to see a Léger or a Lurçat or a Picasso on your walls, you will like to wear Myrbor clothes." In the early 1930s, Cuttoli revived the art of Aubusson tapestries, distributing them through her boutique, to clients as far away as the United States. With her partner Henri Laugier, she began constituting the famous Cuttoli-Laugier modern art collection just before World War II. G MJ

Cindy Kang, ed. *Marie Cuttoli: The Modern Thread from Miró to Man Ray*. Philadelphia: Barnes Foundation/New Haven, CT: Yale University Press, 2020.
Dominique Paulvé. *Marie Cuttoli: Myrbor et l'invention de la tapisserie moderne*. Paris: Norma Éditions, 2010.

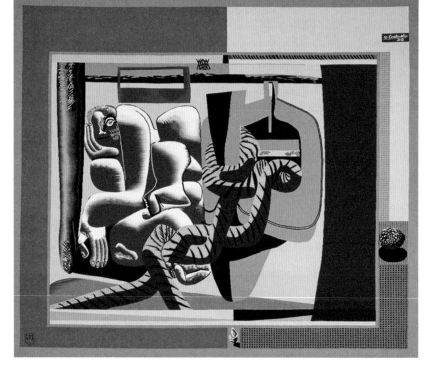

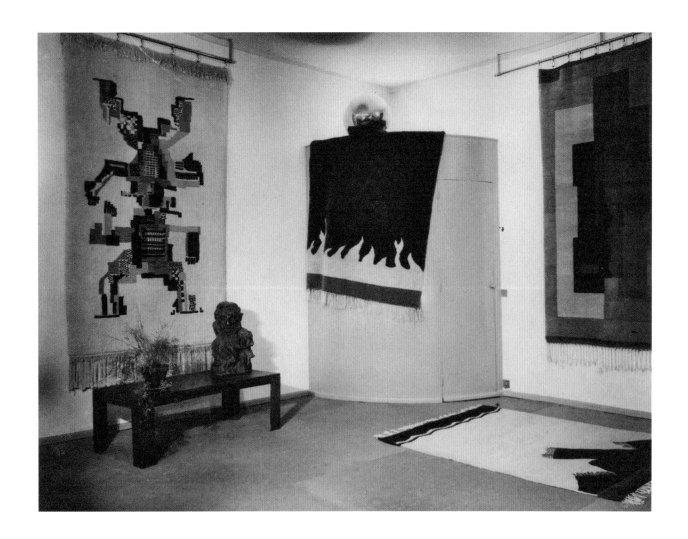

← Le Corbusier, *Marie Cuttoli*, 1936.
Tapestry.

↑ Boutique Myrbor, designed by André
Lurçat, Rue Vignon, 1926. View of
the interior with the tapestries
sold by Marie Cuttoli. Photograph
by Thérèse Bonney.

DEFG

Raoul Dautry

1880, Montluçon
1951, Lourmarin

Particularly active in the urban development of Paris and its region, Raoul Dautry made a significant contribution to the modernization of the French state. An engineer trained at the prestigious École Polytechnique, he was named director of the Compagnie des Chemins de Fer du Nord in 1914. Following World War I, he pioneered the creation of several garden cities intended for railway employees. For a competition organized by the Conseil Général de la Seine in 1924, he worked with the architect Jean-Marcel Auburtin on plans to develop a large satellite city in La Courneuve, to the north of Paris. Its urban morphology was based on British precedents, and its districts would have been served by a local railway line with connections to the major national rail routes.

Appointed general director of the state railway system in 1928, Dautry introduced innovative rolling stock that was partially imported from the United States, and encouraged the creation of modernist railway stations, such as André Ventre's designs for Versailles-Chantiers, or Henri Pacon's for Le Havre.

Dautry participated in the plans for the development of the Paris region, a project led by Henri Prost.* In 1938, he became one of the first directors of the Société Nationale des Chemins de Fer Français, when the private rail networks were nationalized. He was named minister of armaments at the beginning of World War II, and commissioned several factories from modern architects, including Auguste Perret* and Le Corbusier.* He advised the Resistance from his retreat in Lourmarin, after which General de Gaulle appointed him to the Ministry of Reconstruction and Urbanism—a role he filled from 1944 until 1946. He later became director of the Atomic Energy Commission. J-L C

Rémi Baudouï. *Raoul Dautry, 1880–1951: Le technocrate de la République*. Paris: Balland, 1992.
Raoul Dautry. *Métier d'homme*. Paris: Plon, 1937.

↓ Paul Martial, publisher, poster for the SNCF, 1938.

→ Jean-Marcel Auburtin, with the Chemins de Fer de l'État (State Railroad). Project for a garden city in La Courneuve, 1924. General plan.

PLAN D'ENSEMBLE

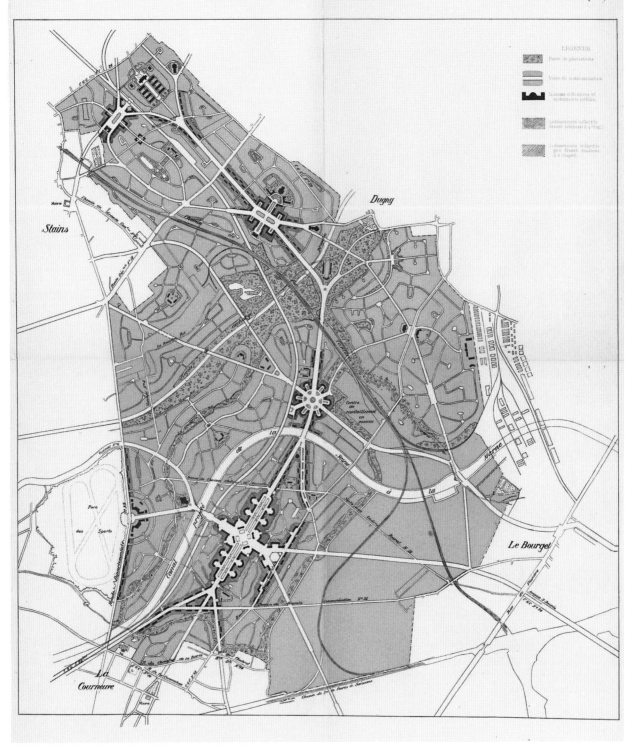

Robert Delaunay

1885, Paris
1941, Montpellier

Robert Delaunay placed Paris—and partic-
ularly the Eiffel Tower, which was the subject
of nearly fifty of his paintings—at the heart
of his work. He received no formal artistic
education, and his painting owed much to
his wife, Sonia Delaunay,* who at the time
of their meeting was known as Sonia Terk.
Rarely has an artistic couple collaborated so
closely. Initially influenced by fauvism, they
founded the movement that their close
friend Guillaume Apollinaire* referred to
as "Orphism." The poet believed it was
the other leading trend in modern paint-
ing, along with Pablo Picasso's* cubism.
The couple also developed simultanism,
which was inspired by the work of Wassily
Kandinsky; like the Italian futurists, they
were attracted by the dynamic power of
contrasting colors and formal rhythms—
often circular—that they believed reflected
the movement of modern life and cities.
 While he was working on his series of
Rythmes paintings in the 1930s, Delaunay
frequented surrealist circles, and in partic-
ular Tristan Tzara* and André Breton.* His
prolific work was displayed in numerous
galleries, and major international exhi-
bitions in Paris provided him with many
monumental commissions. In 1925, in the
entrance hall of the French Embassy pavil-
ion designed by Robert Mallet-Stevens*
for the Exposition Internationale des Arts
Décoratifs et Industriels Modernes, one
of Delaunay's panels depicting the Eiffel
Tower was juxtaposed with an equally color-
ful work by Fernand Léger.* In 1937, collab-
orating with Sonia, and the decorator Félix
Aublet, he participated in designs for the
vertiginous *"hall tronconique"* (tapered
hall) of the Palais de l'Air. G MJ

Vicky Carl. *Robert Delaunay.* New York: Parkstone Press
International, 2020.
"Robert Delaunay, Rythmes sans fin." Educational
document. Paris: Centre Pompidou, 2014. http://
mediation.centrepompidou.fr/education/ressources/
ENS-Delaunay/
Pascal Rousseau, ed. *Robert Delaunay: De l'impres-
sionnisme à l'abstraction.* Paris: Éditions du Centre
Pompidou, 1999.

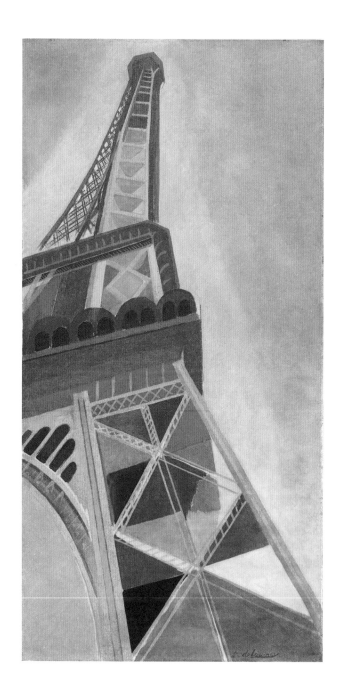

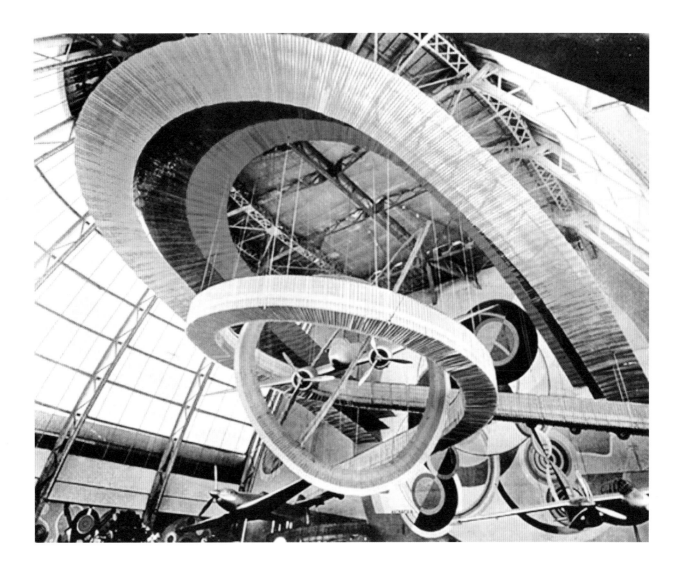

← *La Tour Eiffel*, 1926. Oil on canvas.

↑ Colorful composition inside the Palais de l'Air at the Exposition Internationale des Arts et des Techniques Appliqués à la Vie Moderne, 1937. With Sonia Delaunay and Félix Aublet.

Sonia
Delaunay

1885, Gradizhsk (Russian Empire)
1979, Paris

Née Sarah Stern, the artist, who had assumed the name Sonia Terk, moved to Paris at the age of twenty. There, she met the painter Robert Delaunay,* whom she married in 1910. Her life was dedicated to her art, which was for a long time eclipsed by her husband's oeuvre. Throughout her lifetime, she was committed to breaking down the distinctions between the fine and applied arts. She worked persistently in both domains and in a variety of media: wall paintings, textiles, clothing, bookbinding, carpets, decorative objects, and even cars. Collaborating with Blaise Cendrars in 1913, she designed the first "*livre simultané*" ("simultaneous book"), *La Prose du Transsibérien et de la petite Jehanne de France* (Prose of the Trans-Siberian and of Little Jehanne of France). It was a folded leaflet measuring almost seven feet (2 m) in length that presented text in parallel with a frieze of brightly colored circles. She posed at the 1925 Exposition Internationale, wearing one of her fashion designs and seated at the wheel of a Citroën B12 parked beneath the Martel brothers'* concrete trees. She opened a "*boutique simultané*e" on Pont Alexandre III, which met with great critical, commercial, and high society acclaim.

While working on designs for textiles, notably for the Lyonnais silk industry, she continued to paint and exhibit her other works. She was committed to the principles of abstraction, and, when she returned to Paris after World War II, she took part in the exhibition *Art concret* in 1945, and in the first Salon des Réalités Nouvelles (Salon of New Realities) the following year. G MJ

Stanley Baron. *Sonia Delaunay: The Life of an Artist.* Paris: Jacques Damase, 1995.
Lærke Rydal Jørgensen, ed. *Sonia Delaunay.* Humlebæk: Louisiana Museum of Modern Art, 2022.
Anne Montfort, ed. *Sonia Delaunay: Les couleurs de l'abstraction.* Paris: Paris-Musées, 2014. Exhibition catalog.
Sonia Delaunay: Ses peintures, ses objets, ses tissus simultanés, ses modes, with contributions from André Lhote, Blaise Cendrars, Joseph Delteil, Tristan Tzara, and Philippe Soupault. Paris: Librairie des Arts Décoratifs, 1925.

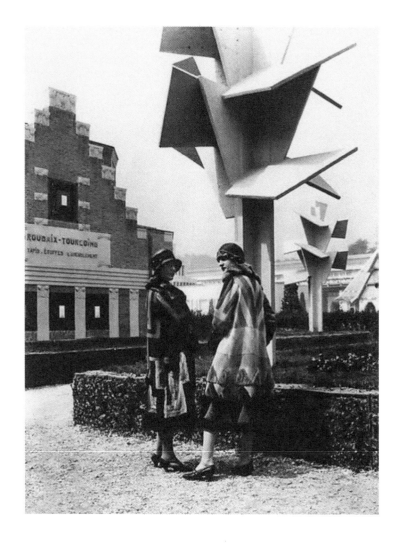

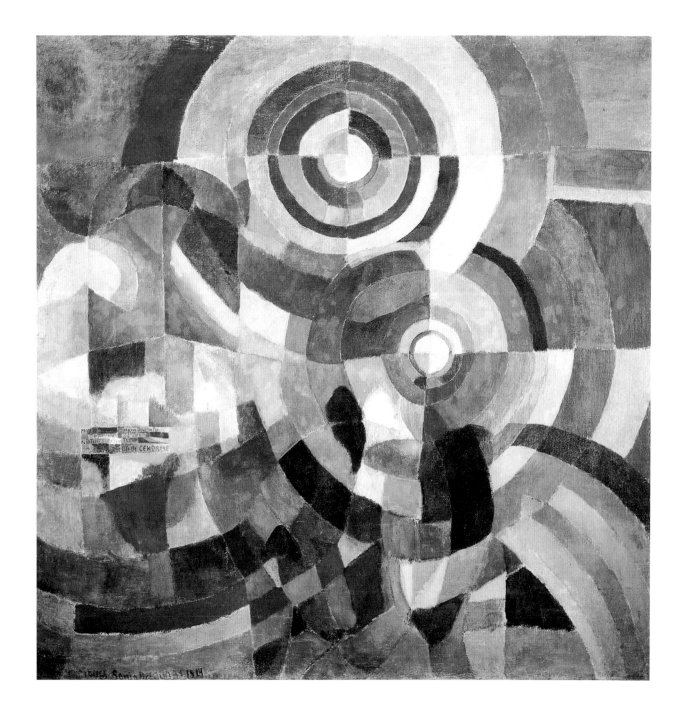

←"Simultanés" coats worn by models
in front of the Martel brothers'
concrete trees, Exposition
Internationale des Arts Décoratifs
et Industriels Modernes, 1925.
Photograph by Thérèse Bonney.

↑ *Prismes électriques* (*Electric
Prisms*), 1914. Oil on canvas.

Marie Dormoy

1886, place unknown
1974, place unknown

A significant figure on the Parisian literary and artistic scene, Marie Dormoy was a free-thinking woman who successfully managed simultaneous careers as art critic, translator (notably the letters of Michelangelo in 1927), and librarian. However, she was best known for her relationships with several illustrious figures including Paul Léautaud, whose *Journal littéraire* she collated and edited.

In 1921, she met the architect Auguste Perret* in the studio of sculptor Antoine Bourdelle and became both his devoted disciple and his mistress. A prolific architecture critic, she published almost seventy articles in various periodicals, including *L'Art vivant*, *L'Architecture d'aujourd'hui*, and *L'Œil*. She wrote on François Hennebique, Robert Mallet-Stevens,* and Le Corbusier,* and commented extensively on the work of Perret. Her comprehensive volume *L'Architecture française* (French Architecture) was published in 1938, and it was reissued in 1951 with a foreword by Louis Hautecœur.* The couturier Jacques Doucet* hired her in 1924 to manage his manuscript collection, and in 1932 she became the curator for the literary library named after him. Her close relationship with Perret made her an apostle of a style that was both classical and rational, removed from all "nudist formalism"—her term for the exceedingly abstract buildings by the more radical designers. She frowned upon what she considered the deceptive use of "faux" concrete in buildings designed by certain modern architects, such as André Lurçat* and Le Corbusier. She criticized them harshly, on the grounds that they masked the "honest" structure of their buildings. G M J

Ana Bela de Araujo, ed. *Auguste Perret et Marie Dormoy: Correspondance, 1922–1953*. Paris: Éditions du Linteau, 2009.
Marie Dormoy. "Le Faux Béton." *L'Amour de l'art*, April 1929: 127–32.
———."Contre le nouveau formalisme." *L'Architecture d'aujourd'hui*, December 1931: 4–6.
———. *L'Architecture française*. Boulogne: Éditions de l'Architecture d'Aujourd'hui, 1938.

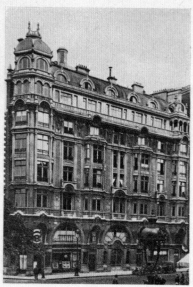

Le Faux Béton

LE béton, selon la définition universellement donnée, est une maçonnerie formée de sable, de fragments de pierre ou de cailloux, agglomérés au moyen d'un liant, chaux ou ciment. Pour lui donner la forme voulue, on le coule dans des moules généralement en bois. On dit que le béton est armé quand il est coulé sur une carcasse métallique qui augmente sa résistance.

Le béton armé fut inventé en 1849 par Joseph Monnier, jardinier à Boulogne. Faisant de la rocaille pour des bancs et des ponts de jardin, il eut l'idée, un jour, afin de rendre son travail à la fois plus économique et plus durable, de couler du ciment sur une armature de tiges de fer.

On ne se rendit pas compte tout de suite de l'importance de cette trouvaille, et les quelques ingénieurs qui y prêtèrent attention l'employèrent seulement à de menus ouvrages. En Allemagne on l'utilisa davantage sous le nom de *Monnierbéton*. Quand l'usage s'en généralisa, on en réserva l'emploi aux seuls travaux d'art. Pour des raisons économiques autant qu'utilitaires, des recherches furent faites, des résultats obtenus et, dans la composition des ciments, les chimistes obtinrent rapidement de grandes améliorations. Par sa solidité, par la modicité de son prix de revient, la souplesse de construction qu'il permet, on pouvait considérer ce matériau comme celui qui nous doterait d'une architecture nouvelle, car il est indéniable, si on étudie les monuments élevés depuis les anciennes civilisations jusqu'à nos jours, que ce n'est pas la forme qui asservit la matière, mais bien de la matière que jaillit la forme.

L'architecture de béton armé est une architecture monolithe. C'est-à-dire qu'à l'inverse de l'architecture de pierre ou de brique formées de petits éléments appareillés, l'architecture de béton forme un tout d'une seule pièce.

Les premières constructions en béton furent faites avec ce seul matériau. On s'aperçut alors que ces édifices présentaient de sérieux inconvénients. Ils étaient trop sonores, mal défendus contre la chaleur et le froid ; de plus il était difficile d'enfoncer dans les murs soit des clous, soit des pattes pour tenir les meubles ou les glaces. Ceci est seulement pour l'intérieur des monuments. Quant à l'extérieur, c'est une autre histoire, et c'est là qu'il faut réagir vigou-

HENNEBIQUE. - MAISON 1, RUE DANTON.
Cette maison Louis XIII est-elle en pierre? Non, mais en béton, qui, employé comme stuc, donne lieu à des ornementations d'un goût affreux.

Pages from the article "Le Faux Béton" ("Faux Concrete") in *L'Amour de l'art*, April 1929. Views of the building by François Hennebique and Édouard Arnaud, Rue Danton, 1902, and of the Bomsel residence in Versailles, by André Lurçat, 1926.

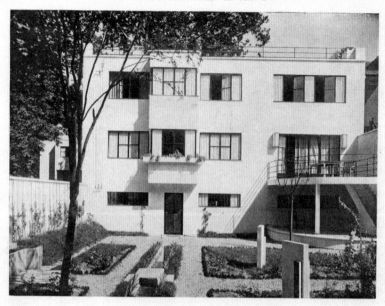

ANDRÉ LURÇAT. - HOTEL PARTICULIER A VERSAILLES.

En quoi est cette maison? En carton? En plâtre? Elle est, paraît-il, en béton. Pourquoi ne serait-elle pas en pans de fer, qui permet les mêmes portées?

reusement contre un mouvement qui s'amplifie chaque jour un peu plus.

Jusqu'à maintenant, les architectures avaient été franches. On appelle ainsi celles qui laissent apparaître, de l'extérieur, la structure même de l'édifice, et aussi le matérial employé.

Les anciens avaient une architecture franche, et les médiévaux encore plus. En Egypte, en Grèce, les édifices étaient faits de pierre ou de marbre, sans aucune dissimulation. A Rome, on construisait en briques. Comme cette matière était pauvre et d'aspect peu agréable, on recouvrait la plupart des monuments avec des revêtements de marbre ou de matières précieuses, mais l'ensemble était tel, que l'on sentait, sous ce revêtement, la brique qui en était le support.

Ce n'était qu'un épiderme sur un squelette que l'on ne cherchait pas à dissimuler.

Cette franchise, on la retrouve aux époques romanes et gothiques, pendant la renaissance, aux pires moments du baroque, et aussi pendant le court règne de l'architecture de fer. Il a fallu que ce soit notre époque, pourtant si féconde et si sincère, qui invente le mensonge architectural. C'est cette erreur primordiale qu'il faut combattre résolument, partant de ce principe que l'ossature d'un bâtiment doit se voir au moins autant que se voit le squelette d'un animal.

Le béton étant coulé dans des moules en bois, c'est le bois qui déterminera la forme. Le bois étant une matière rigide, imposera tout naturellement l'emploi presque constant

Jacques Doucet

1858, Paris
1929, Neuilly-sur-Seine

Jacques Doucet was the scion of a long line of lingerie makers established in Paris since 1816. He began his career in 1875, creating a dressmaking division within the family business. Although he was not a member of the Chambre Syndicale de la Couture, he was renowned for his highly elegant designs at the turn of the twentieth century, which were lavishly adorned with lace and embroidery. International high-society socialites and actresses alike admired his airy tea gowns, negligees, and diaphanous mousseline dresses. He continued his activity until 1924.

The fortune that Doucet made in the couture business enabled him to become a distinguished collector and patron. Initially, he sought out eighteenth-century furniture and artworks. In 1912, advised by André Breton,* he sold his entire collection to devote himself to the art of his own era. At the same time, between 1913 and 1925, he amassed an impressive library of art and archeology that he bequeathed to the University of Paris (today the library of the Institut National d'Histoire de l'Art), as well as the literary library that bears his name.

Doucet was one of the instigators of the art deco style. His apartment was decorated by Paul Iribe, Pierre Legrain, Rose Adler, and Eileen Gray.* He also commissioned his former assistant Paul Poiret* and his Atelier Martine to design the salon where Pablo Picasso's* *Les Demoiselles d'Avignon* was to be displayed. (Doucet was the painting's first owner, in 1924.) In 1928, he moved to 33 Rue Saint-James, in Neuilly-sur-Seine, to a private residence redesigned by Paul Ruaud, assisted by Pierre Legrain for its interior decoration. C Ö

François Chapon. *Mystères et splendeurs de Jacques Doucet, 1853–1929.* Paris: J.-C. Lattès, 1984.

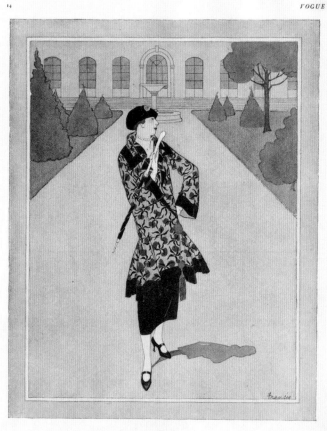

La
ROBE A SUCCÈS
chez
DOUCET

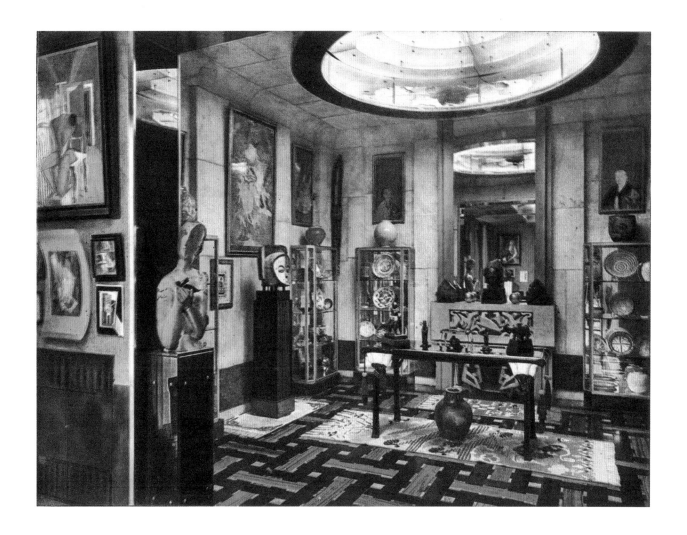

← Design for a "robe à succès"
(success dress). Page from *Vogue*,
May 1924.

↑ The Asian Treasury in the
couturier's townhouse in Neuilly,
with the Lotus Table by Eileen
Gray. Photograph published in
L'Illustration, May 3, 1930.

Marcel Duchamp

1887, Blainville-Crevon
1968, Neuilly-sur-Seine

Although he made frequent stays in the United States from 1915 onwards, Marcel Duchamp took part in numerous avant-garde art shows in Paris, playing a role that was as discomfiting as it was decisive.

His *Nude Descending a Staircase* had created a scandal at the 1913 Armory Show in New York, and his "readymades," including the porcelain urinal that he entitled *Fountain*, were also exhibited in New York, in 1916. But it was earlier in Paris, while working as a librarian at the Bibliothèque Sainte-Geneviève from 1913 to 1915, that he created the initial components of what would become the enigmatic *Large Glass* (*The Bride Stripped Bare by Her Bachelors, Even*). He pursued the development of this multifaceted project—which was never actually completed—until 1923.

While in Paris in 1919, he met the founders of Dadaism and surrealism, with whom he maintained episodic relationships, but he spent most of his time playing in chess tournaments. René Clair* filmed him on the roof of the Théâtre des Champs-Élysées in 1924, confronting his good friend Man Ray* across a chessboard in *Entr'acte* (Intermission). Duchamp switched to the other side of the camera to film *Anémic cinéma* in 1926. His circular plates with their geometric figures—particularly spirals—became *Rotoreliefs* in 1935, thanks to the patronage of the couturier Jacques Doucet.*

Duchamp was the *"générateur-arbitre"* ("generator-referee") of the Exposition Internationale du Surréalisme organized by André Breton* and Paul Éluard at the Galerie des Beaux-Arts in 1938. He created a dark grotto, which spectators entered, equipped with flashlights, to discover twelve hundred sacks of coal suspended above a brazier.

In 1942, Duchamp managed to travel to the United States, where he spent the remainder of the war years. J-L C

Matthew Affron. *The Essential Duchamp*. New Haven, CT: Yale University Press, 2019.
Robert Lebel. *Marcel Duchamp*. New York: Paragraphic Books, 1967.
Jean-François Lyotard. *Duchamp's Trans/Formers*. Venice, CA: Lapis Press, 1990.
Bernard Marcadé. *Marcel Duchamp: La vie à crédit*. Paris: Flammarion, 2007.
Michel Sanouillet and Paul Matisse. *Marcel Duchamp: Duchamp du signe suivi de Notes*. Paris: Flammarion, 2008.

Ciel de roussettes (1 200 sacs de charbon suspendus au plafond au-dessus d'un poêle) (Sky of Bats [Twelve Hundred Bags of Coal Suspended from the Ceiling over a Stove]), Exposition Internationale du Surréalisme, Galerie des Beaux-Arts, 1938. Photograph by Roger Schall.

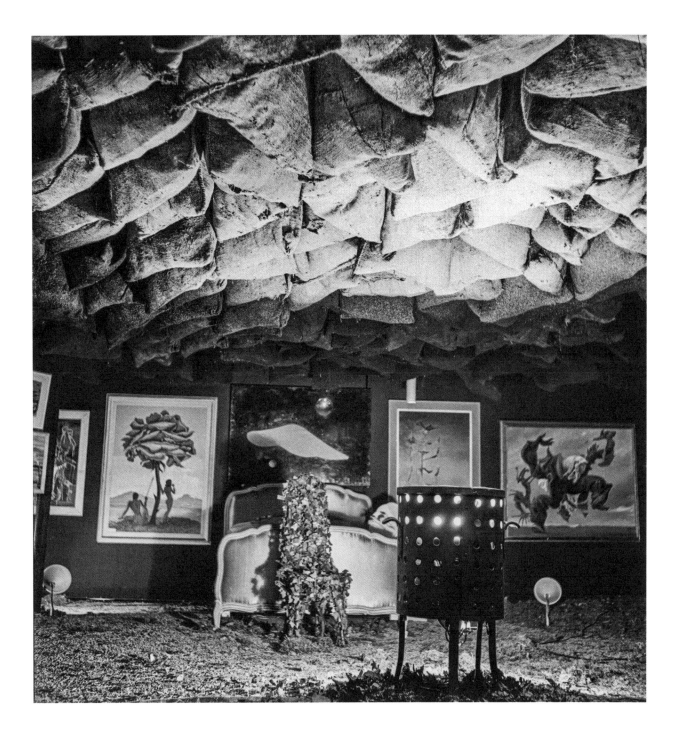

Jean Epstein

1897, Warsaw
1953, Paris

Jean Epstein was the son of a French father and Polish mother. Following his father's death, he emigrated to Switzerland with his mother and sister. He later began medical studies in Lyon, while embarking on a career as a poet and essayist. Secretary and reader of scientific publications for Auguste Lumière, he rhapsodized over the seventh art in his book of essays *Bonjour cinéma* (1921), weighing the medium's novelty against its technical qualities. He gave film a place of honor in the renaissance of poetry and took inspiration from Blaise Cendrars, who introduced him to his Parisian circle of friends, including Fernand Léger* and Abel Gance. His first film on Louis Pasteur, codirected with Jean Benoit-Lévy (1922), won him professional recognition that led to his being hired by Pathé-Consortium Cinéma for three feature films and one short, all released in 1923.

As a prominent figure of the avant-garde, he took part in the *Exposition de l'art dans le cinéma français* (Exhibition of Art in French Cinema) at the Musée Galliera with Robert Mallet-Stevens,* Léon Moussinac, Marcel L'Herbier,* Lionel Landry, and Germaine Dulac. He made four films for Albatros between 1924 and 1926: *Le Lion des Mogols* (*The Lion of the Mogols*), *Le Double Amour* (*Double Love*), *L'Affiche* (*The Poster*), and *Les Aventures de Robert Macaire* (*The Adventures of Robert Macaire*), transitioning from exoticism to melodrama to costume drama series. The plot of *L'Affiche* was based on the giant advertising poster featuring a child used to promote Cadum soap—Bébé Cadum—"that enormous object" of the streets, in the words of Léger. In *Six et demi onze* (*Six and One Half Times Eleven*) and *La Glace à trois faces* (*The Three-Sided Mirror*), which he produced himself, his art deco style was evident; his work had a dandyish aesthetic—featuring high society, the Riviera, music-halls, androgynous characters, and gleaming automobiles—echoing the modernist writer Paul Morand. These features combined with a penetrating analysis of the technical nature of film images, the medium's immaterial qualities,

and its evanescence. Following *La Chute de la maison Usher* (*The Fall of the House of Usher*), whose settings and lighting reflected German and Scandinavian influences, Epstein abruptly abandoned this world of fantasy, the artificiality of studio sets, makeup, and high society, to make films without actors, set in natural landscapes: *Finis Terræ* in Brittany was followed by *Mor vran*. For talkies, he made commissioned works including *Les Bâtisseurs* (*The Builders*) of 1937, filmed at the time of the Exposition Internationale for the CGT (General Confederation of Labor) trade union, in which Auguste Perret* and Le Corbusier* were interviewed and which focused on redevelopment plans for Paris. F A

Jean Epstein. *Bonjour cinéma*. Paris: Éditions de la Sirène, 1921.
———. *Œuvres complètes*. Montreuil: Éditions de l'Œil, 2019–20.
Sarah Keller, ed. *Jean Epstein: Critical Essays and New Translations*. Amsterdam: Amsterdam University Press, 2012.

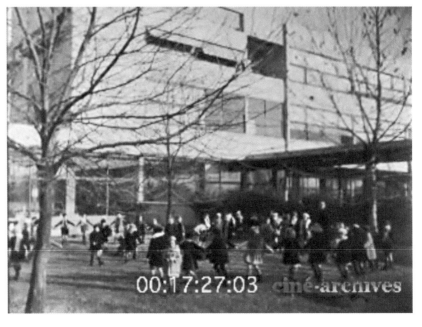

00:46:07:19 ciné-archives

00:40:40:23 ciné-archives

Stills from the film *Les Bâtisseurs*
(*The Builders*), 1937:

Le Corbusier drawing the schema for
the "Ville Radieuse" (Radiant City).

Karl Marx School complex, Villejuif,
designed by André Lurçat. The
courtyard during a recess period.

Auguste Perret on the construction
site of the Musée des Travaux
Publics (Museum of Public Works).

Reinforced concrete being used on
a building site.

Exposition Internationale des Arts Décoratifs et Industriels Modernes, 1925

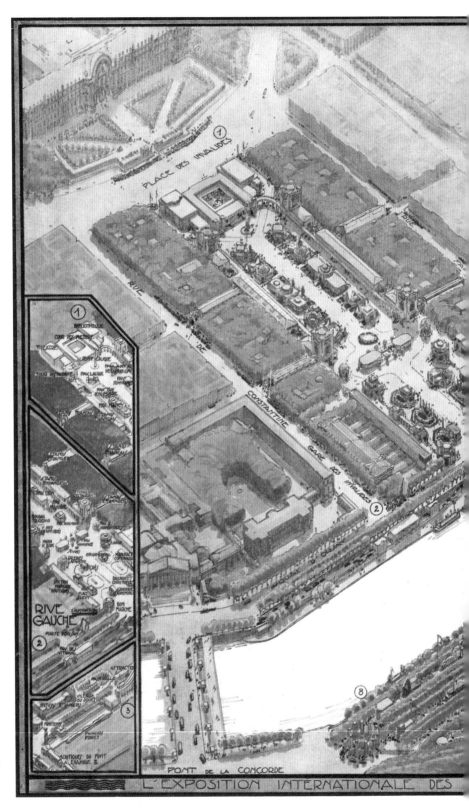

Exposition Internationale des Arts Décoratifs et Industriels Modernes, 1925. Axonometric overview and seven detailed views. Double page in *L'Illustration*, special issue, April 1925.

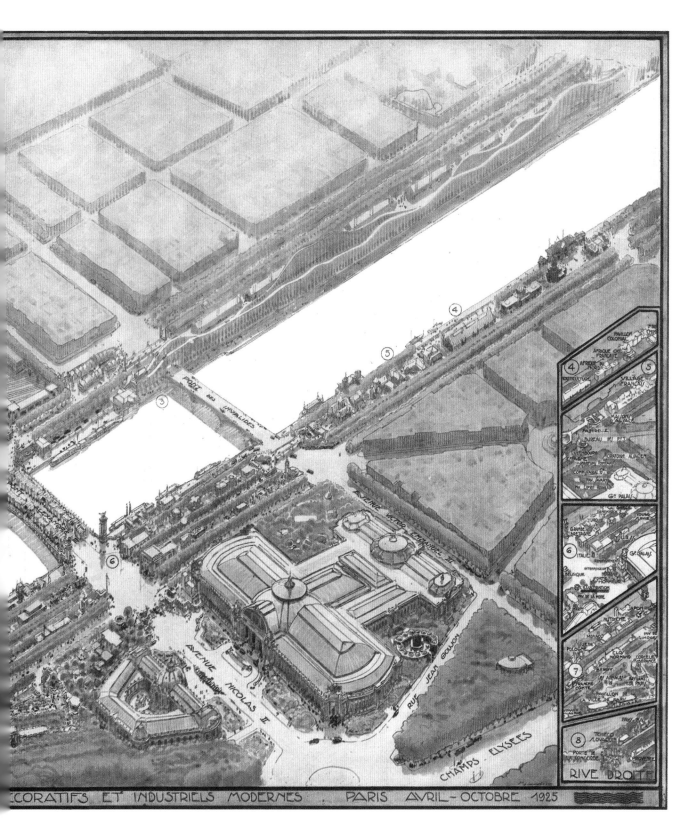

PONT DES INVALIDES

AVENUE ALEXANDRE III

AVENUE VICTOR EMMANUEL III

AVENUE NICOLAS II

RUE JEAN GOUJON

CHAMPS ELYSEES

③ ④ ⑤ ⑥ ⑦ ⑧

④ AFRIQUE DU NORD
PAVILLON COLONIAL
AFRIQUE OCC. FRANÇAISE
RECONSTRUCTION

⑤ VILLAGE FRANÇAIS
MAISON RURALE
PASTORALE
BUREAU DE PTT
L'ALLUMOIR
ESPAGNE
ORATOIRE ALSACIEN
PARFUM FONTANE
CONSTRUCTION Gre
PAV. AVARY
PAV. ESPRIT ROMA
Gd PALAIS

⑥ ITALIE
GRANDE BRETAGNE
TURQUIE
SUEDE
FINLANDE
JEUNE SYRIE
BELGIQUE
INTERNATIONALE
L'ILLUSTRATION
PAV. DE LA MODE
Gd PALAIS

⑦ POLOGNE
AUTRICHE
MONACO
JAPON
CLUB NORMAND
CORCELLET GODANCE
RUE DES ANNALES
CERAMIQUE FRANCO
BERRY
PYRAMIDE CONTE
PAVILLON DE LA PRESSE
PAV. DE LIMOGES
NATIONS PARI

⑧ TCHECO SLOVAQUIE
PORTE DE LA CONCORDE
PROVENCE

RIVE DROITE

CORATIFS ET INDUSTRIELS MODERNES PARIS AVRIL - OCTOBRE 1925

149

Exposition Coloniale Internationale, 1931

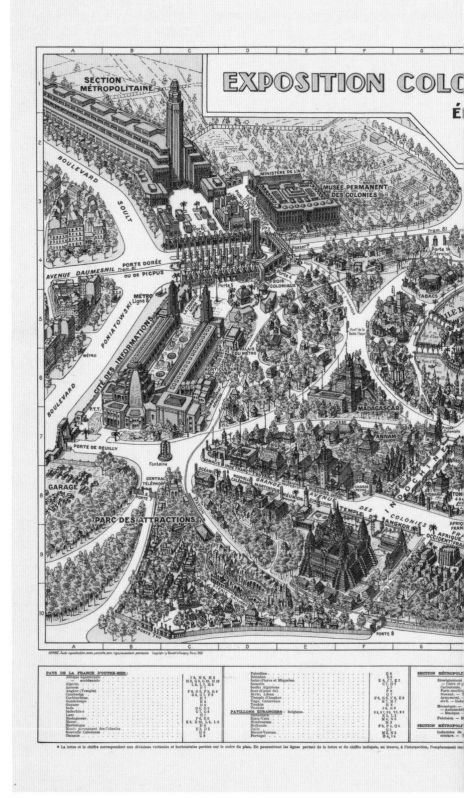

Exposition Coloniale Internationale, 1931. Aerial perspective, with identification of the pavilions. Published by Blondel La Rougery.

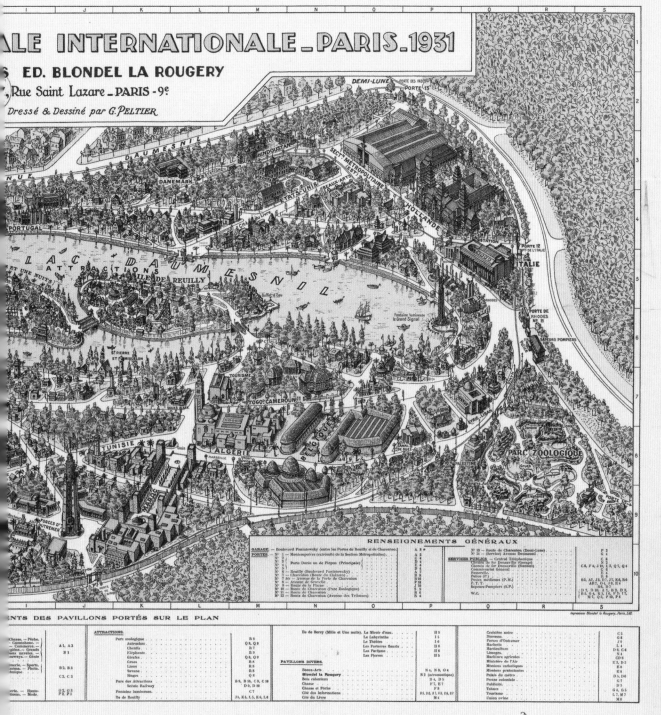

Exposition Internationale des Arts et des Techniques Appliqués à la Vie Moderne, 1937

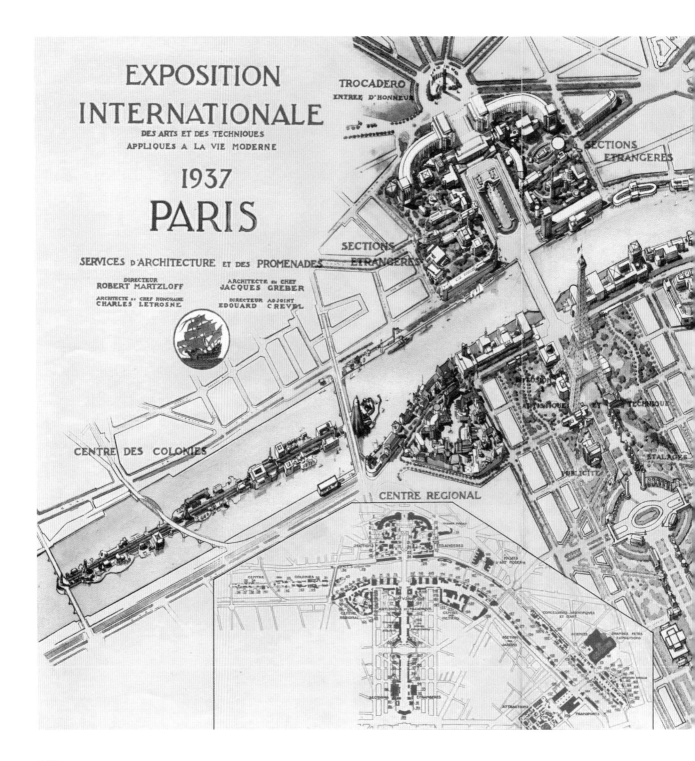

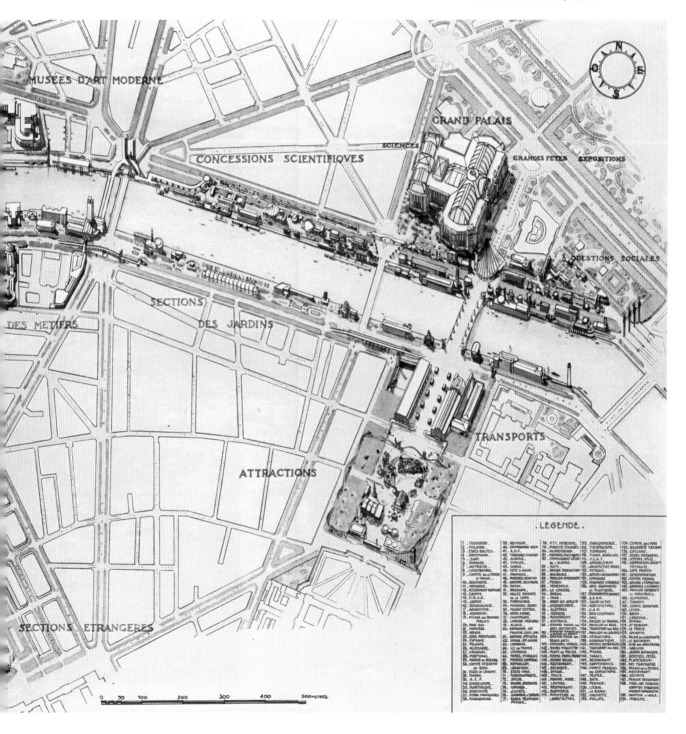

Exposition Internationale des Arts et des Techniques Appliqués à la Vie Moderne, 1937. Aerial overview and map. Gatefold from *L'Illustration*, special issue, May 1937.

Jacques Feyder

1885, Ixelles (Belgium)
1948, Prangins (Switzerland)

Jacques Frédérix came from a family of military officers and industrialists. After briefly serving in the army and the state canon foundries in Liège, he moved to Paris. He began as a theater actor and then moved on to film in 1912, working under the name Jacques Feyder. He performed in several films by Victorin Jasset (*Protéa*) and Louis Feuillade (*Les Vampires*), and turned to directing in 1915, making several comedies for Gaumont.

After World War I, he adapted Pierre Benoit's novel *L'Atlantide* (*Atlantida*), which was filmed in the Saharan Hoggar Mountains, incorporating an exotic element into his work. He went on to make films of very different genres, including *Crainquebille* (*Bill*) in 1922, which took place against the backdrop of Les Halles in Paris; *Visages d'enfants* (*Faces of Children*), filmed in the mountains of the Valais in 1923; and *L'Image* (*The Portrait*), shot in Vienna in 1925. After making *Gribiche* (*Mother of Mine*) in 1925, *Carmen* in 1926, *Thérèse Raquin* in 1927, and *Les Nouveaux Messieurs* (*The New Gentlemen*) in 1928, he was recruited to Hollywood, where, in 1929, he made *The Kiss* starring Greta Garbo. In *Les Nouveaux Messieurs*, his art director, Lazare Meerson,* succeeded in establishing a dramaturgy of location that had been initiated earlier in *Gribiche*. Feyder trained Marcel Carné* and influenced other filmmakers who admired his work, such as Jean Grémillon. F A

Jacques Feyder and Françoise Rosay. *Le Cinéma, notre métier*. Geneva: Éditions Pierre Cailler, 1946.
Jean A. Gili and Michel Marie, eds. "Jacques Feyder." Special issue, *1895, revue d'histoire du cinema*, no. 26 (October 1998).

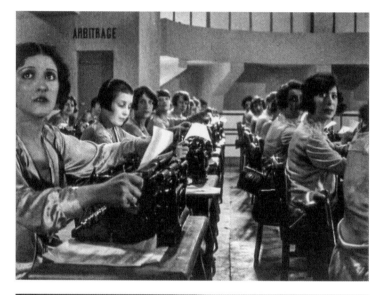

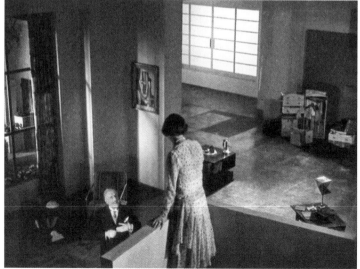

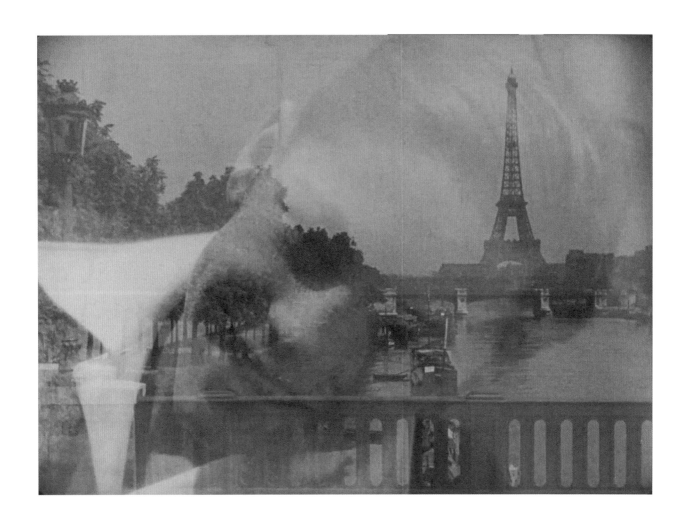

← Two stills from *Les Nouveaux Messieurs* (*The New Gentlemen*), 1928. Sets by Lazare Meerson.

↑ Still from *Gribiche* (*Mother of Mine*), 1925.

Eugène Freyssinet

1879, Objat (France)
1962, Saint-Martin-Vésubie (France)

In 1923, Le Corbusier* sent his manifesto *Vers une architecture* (*Toward an Architecture*) to the engineer Eugène Freyssinet. In it, he praised the "magnificent effort of engineers," as illustrated, in his view, by Freyssinet's airship hangars in Orly (1921–23). These structures were remarkable for their parabolic sweep, standing 148 feet (45 m) high and fashioned from thin shells whose undulating shapes were perforated to allow natural light inside.

A graduate of the École Polytechnique and the École des Ponts et Chaussées, Freyssinet built the elegant railroad bridge in Ferrières-sur-Sichon (1906) and the Boutiron road bridge in Vichy (1912), which featured three particularly widely spaced arches. Working in early 1916 for the public works contractor Limousin, he designed the freight-processing hall of the Gare d'Austerlitz (1927–29) and the vast two-level viaduct connecting Plougastel to Brest above the Elorn river (1922–30).

He also collaborated with Jean-Charles Séailles on research projects that led to the invention in 1928 of prestressed concrete, whose formula he perfected over the following years. In 1938, working with the company Wayss & Freytag, he built a bridge for the state Autobahn at Oelde in Westphalia, the first prestressed concrete structure built in Germany.

During the Occupation, the contractor Edme Campenon founded the Société Technique pour l'Utilisation de la Précontrainte (Technical Society for the Use of Prestressed Concrete) to introduce these techniques to other companies. Freyssinet worked with him on the construction of the Luzancy bridge spanning the Marne river, which was completed in 1946. J-L C

Jupp Grote and Bernard Marrey. *Freyssinet, la précontrainte et l'Europe, 1930–1945*. Paris: Éditions du Linteau, 2000.
José Antonio Fernández-Ordoñez. *Eugène Freyssinet*. Paris: Éditions du Linteau, 2013.

Airship hangars, Orly, 1921-23.
Aerial view and interior view.

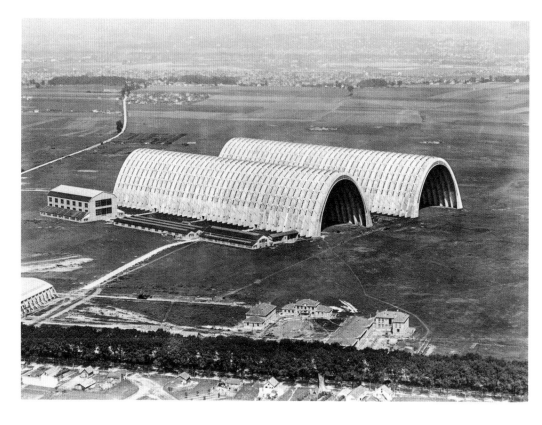

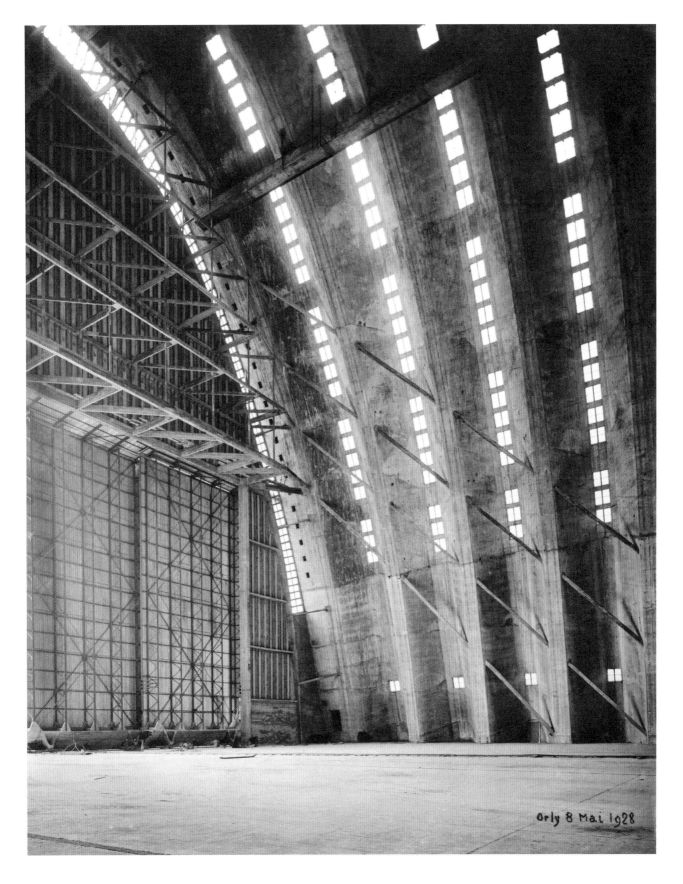

Orly 8 Mai 1928

André Gide

1869, Paris
1951, Paris

André Gide was a leading light among the European intelligentsia of his time. The author of innovative literature, he was modern and committed, and was seen as an intellectual authority by the younger generation. He referred to his first stories, including *L'Immoraliste* (*The Immoralist*) of 1902 and *La Porte étroite* (*Strait Is the Gate*) of 1909, as "farces," and he pursued his experimentation in narrative structure and literary forms with *Les Caves du Vatican* (*The Vatican Cellars*) of 1914 and *Les Faux-monnayeurs* (*The Counterfeiters*) of 1925, his only "novel."

Following the launch of the *Nouvelle Revue française* with Gallimard in 1909, he became the spokesman for an entire generation, but the apogee of his fame came after World War I. Keenly interested in the work of Shakespeare, Goethe, and Montaigne, he influenced both surrealism and existentialism, along with the Nouveau Roman and the anti-colonialist movement. He was a politically engaged intellectual and a committed Dreyfus supporter; he denounced colonialism in *Voyage au Congo* (*Travels in the Congo*) of 1927 and *Retour du Tchad* (*Return from Chad*) of 1928. Although he had close ties to the French Communist Party, he broke with the Soviet Union in his travel account *Retour de l'URSS* (*Return from the USSR*), published in 1936.

Gide debated and sometimes battled with many of his contemporaries. His correspondence with Paul Claudel demonstrates their discord over religion, while letters to and from his friend Paul Valéry are filled with literary and political exchanges.

He published autobiographical texts that touched on his homosexuality, including *Si le grain ne meurt* (*If It Die...*), published in 1926, and maintained a journal from 1889 until 1939. He left his position as director of the *NRF* in 1940 and received the Nobel Prize for Literature in 1947. M-P U

André Gide. *La Symphonie pastorale*. Paris: Gallimard, 1919.
———. *La Symphonie Pastorale / Isabelle*. Translated by Dorothy Bussy. Harmondsworth: Penguin Classics, 1974.
———. *Les Nourritures terrestres*. Paris: Mercure de France, 1897.
———. *Fruits of the Earth*. Translated by Dorothy Bussy. Harmondsworth: Penguin Classics, 1976.
———. *Les Faux-monnayeurs*. Paris: Gallimard, 1925.
———. *The Counterfeiters*. Translated by Dorothy Bussy. Harmondsworth: Penguin Classics, 1966.

Gide speaking at the first International Congress of Writers for the Defence of Culture, Paris, June 1935. Front cover of *Regards*, June 27, 1935. From left, Mikhaïl Koltzov and Heinrich Mann; André Malraux can just be seen behind them on the right.

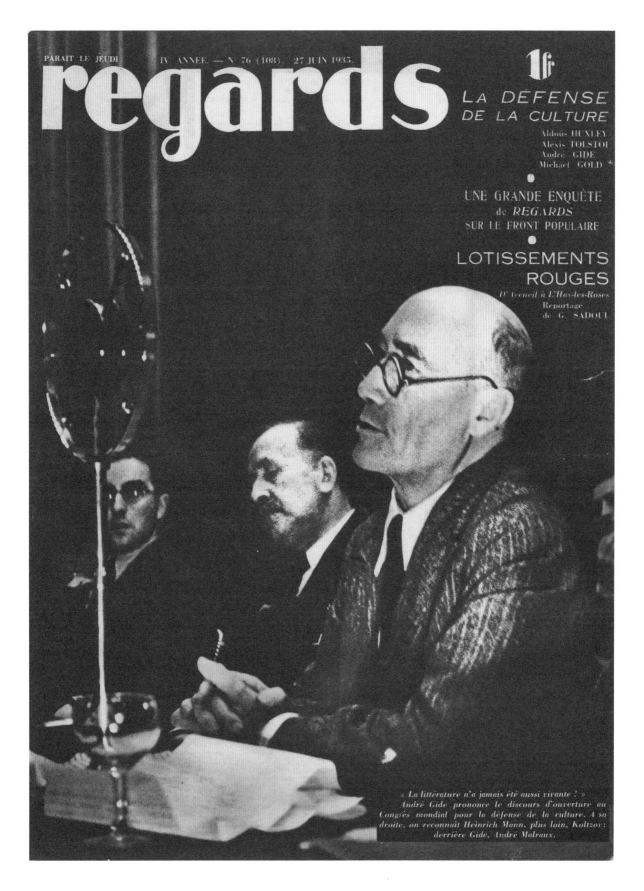

PARAIT LE JEUDI — IV ANNEE. — N 76 (108). 27 JUIN 1935.

regards

1f

LA DÉFENSE DE LA CULTURE

Aldous HUXLEY
Alexis TOLSTOI
André GIDE
Michael GOLD

⦁

UNE GRANDE ENQUÊTE
de *REGARDS*
SUR LE FRONT POPULAIRE

⦁

LOTISSEMENTS ROUGES

D' Arcueil à L'Hay-les-Roses
Reportage
de G. SADOUL

« La littérature n'a jamais été aussi vivante ! »
André Gide prononce le discours d'ouverture au
Congrès mondial pour la défense de la culture. A sa
droite, on reconnaît Heinrich Mann, plus loin, Koltzov;
derrière Gide, André Malraux.

Jean Ginsberg

1905, Częstochowa (Russian Empire)
1983, Paris

Jean Ginsberg arrived in Paris in 1924 and completed the architectural studies he had begun in Warsaw at the École Spéciale, where he was taught by Robert Mallet-Stevens.* He graduated in 1929, and, after an internship with Le Corbusier,* followed by another with André Lurçat,* he established his own architectural firm.

He soon built several luxury apartment buildings in Passy, in affluent western Paris, two of which were located on Avenue de Versailles. The first, designed with the Russian architect Berthold Lubetkin, who then moved to London, was completed in 1931. The second, completed in 1934, was designed with François Heep, who collaborated with him until the war years. The maquette for the first structure, shoehorned into a very narrow lot, was shown at the 1930 Salon d'Automne, when its designer was just twenty-six years old. It was displayed alongside works by Adolf Loos* and Georges-Henri Pingusson. The second building had façades clad with stone panels with visually pronounced joints. The windows were set horizontally, and, at its corner, the structure featured a cylindrical form that transposed a post-Haussmannian idiom in a modern artistic language. A year later, his building on Avenue Vion-Whitcomb presented a calmer façade, combining horizontal windows with projecting balconies—a composition that seemed to give a nod to Le Corbusier's Villa Stein.

Even after World War II, almost all of Ginsberg's work was concentrated on private apartment buildings in Paris and its environs. Recognized as a successful commercial architect whose work featured a readily acceptable interpretation of modernity, Ginsberg was also committed to the movement for the "synthesis of the major arts," bringing together the plastic arts and architecture, which was to be the subject of an exhibition in 1950. G MJ

Philippe Dehan. *Jean Ginsberg: La naissance du logement moderne*. Paris: Éditions du Patrimoine, 2019.

↓ Apartment building, Avenue de Versailles and Rue des Pâtures, with François Heep, 1934.

→ Design for an apartment building, 1938.

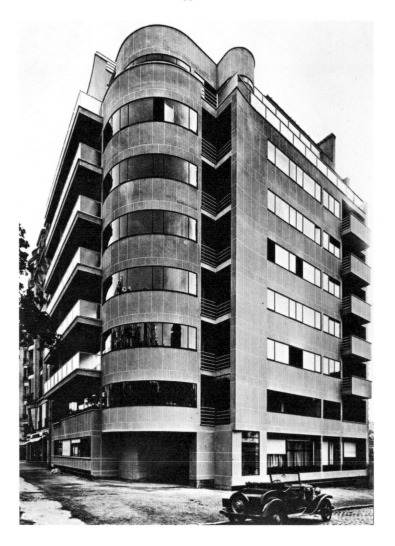

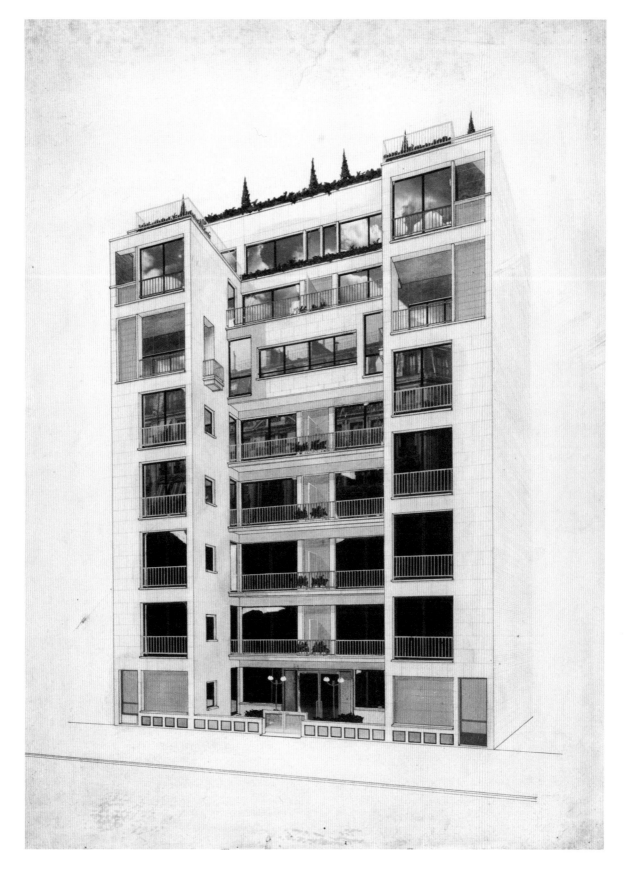

Adrienne Gorska

1899, Moscow
1969, Beaulieu-sur-Mer

Fleeing the Russian Revolution, Adrienne Gorska arrived in Paris in 1919. In 1924, she became one of the first women to earn a degree from the École Spéciale d'Architecture. Little is recorded about the early years of her career, but she was known to have been an architectural draftsman for Eileen Gray* and to have contributed to the design of the apartment-studio of her sister, the painter Tamara de Lempicka,* in a building designed by Robert Mallet-Stevens* on Rue Méchain.

In the early 1930s, she met and married the architect Pierre de Montaut. Working together, they designed many movie theaters in Paris and the provinces, including various branches of the Cinéac theaters, known for their newsreels that were shown day and night. All of these theaters, from the most modest to the largest—such as the Normandie located on Avenue des Champs-Élysées—featured ingenious and spectacular neon lighting effects. In 1931, Gorska and Montaut built an apartment building on Rue Casimir-Pinel in Neuilly-sur-Seine, which demonstrated the influence of their mentor, Mallet-Stevens. It featured windows set in the building's corners, irregular cantilevered volumes, and a cylindrical staircase.

In 1932, Gorska joined the Union des Artistes Modernes; she was one of the few women members of the organization, along with Charlotte Perriand,* Sonia Delaunay,* Eileen Gray,* Charlotte Alix, and Hélène Henry. G MJ

Germaine Kellerson. *Vingt salles de cinéma: De Montaut et Gorska, architectes dplg - desa.* Strasbourg: Société Française d'Éditions d'Art, 1937.

↓ Tamara de Lempicka's apartment-studio, in a building designed by Robert Mallet-Stevens, Rue Méchain, 1929. Photograph by Thérèse Bonney.

→ Cinintran movie theater (part of the Cinéac theater network), Boulevard de la Madeleine and Rue de Sèze, 1935.

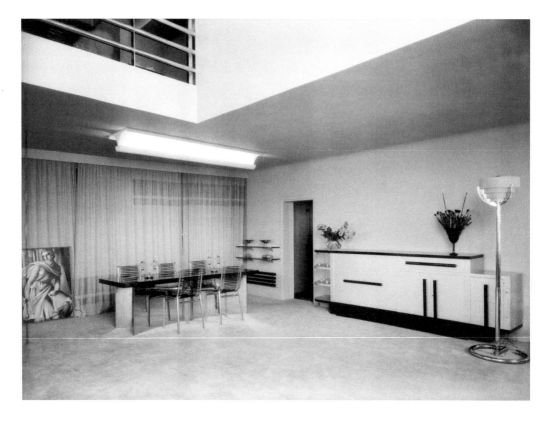

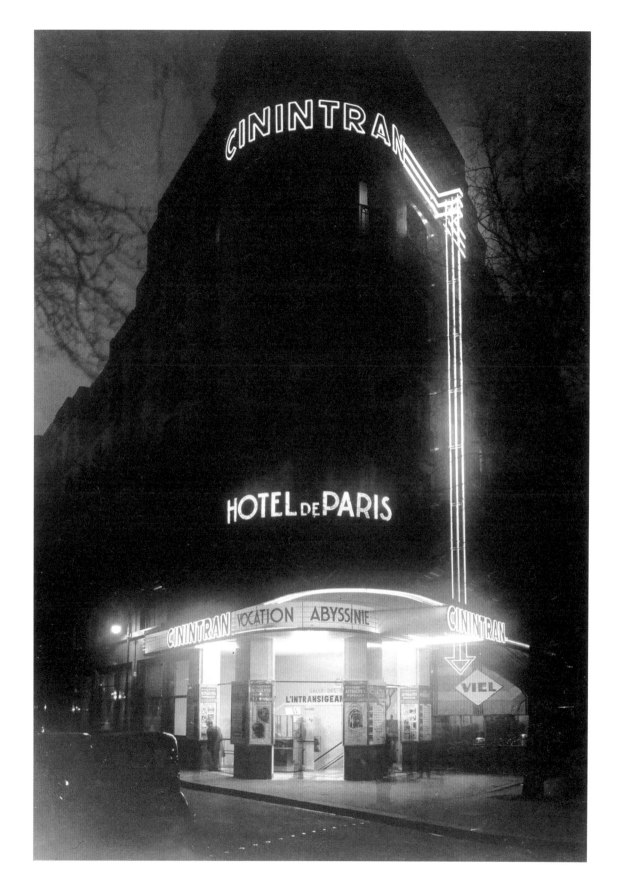

Graphic Design

FROM BÉBÉ CADUM TO BIFUR: THE GRAPHIC LANDSCAPE OF INTERWAR PARIS

The effects of advertising and its meteoric rise on Paris during this period were significant. Although Fernand Léger* referred to the "tone on tone, soft grisaille before the war" to emphasize the contrast with the advent of the colorful 1920s,[1] those muted hues had nevertheless long been interspersed with the twinkle of billboards or punctuated by splashes of color featured in signs, lithograph posters, and painted walls. Even before the turn of the century, in 1899, the first illuminated advertising sign—a gigantic "K" for Kodak, with a zinc framework lit up by incandescent bulbs—had been installed on a balcony overlooking the Place de l'Opéra;[2] the company's founder, George Eastman, had at first hoped to see it shining from the roof of the Palais Garnier. The Italian artist Leonetto Cappiello had launched his career in Paris as a poster artist, following in the wake of Henri de Toulouse-Lautrec, Alphonse Mucha, and Jules Chéret. From the beginning of the 1900s, he animated the streets with his prancing green devil for the Maurin Quina aperitif, and his fire-breathing Pierrot for the Thermogène brand, demonstrating a new approach to capturing the attention of hurried passersby. Advertisements were not only omnipresent on rooftops and façades, in shop windows and vitrines, on pediments and balconies, or on fences and Morris columns—they also descended underground. On the platforms of the two metro lines of the Société du Nord-Sud, opened in 1910

and 1911, the architect Lucien Bechmann normalized the presence of advertising, demarcating specific spaces with decorative ceramic borders to accommodate advertising posters. Even neon, which in the following two decades was to alter profoundly urban landscapes throughout the world, had made its appearance in the French capital; the first example—a sign for a hairdressing salon on Boulevard Montmartre—dates to 1912. This invention by physicist Georges Claude, whose factory was located in a suburb of Paris, offered advertisers the possibility to write and draw using luminous tubes in a multitude of colors, and it rapidly made numerous converts.

But the war dimmed the city, condemning it to "a life of silence, a nocturnal, groping life," as Léger recalled, explaining how "[t]he man of 1921, having returned to normal life . . . is changed. Economic struggles have replaced the battles at the front. Manufacturers and merchants face each other brandishing color as a weapon of advertising."[3] Color and, it should be added, light. There were, however, lingering traces of earlier times, such as the legendary—and classic—Bébé Cadum painted by Arsène-Marie Le Feuvre in 1912; the image of a laughing child for the Cadum soap brand was reproduced on a monumental scale on the city's gabled walls. Its longevity was due to the early mastery of marketing principles by the brand's American founder. "Only Bébé Cadum, this

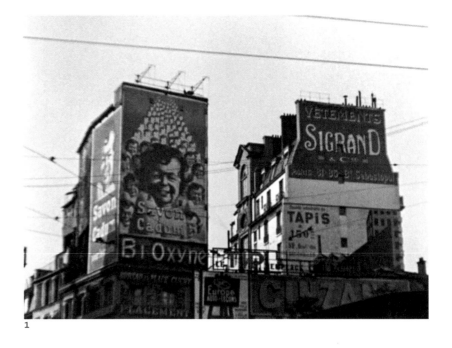

1

enormous object, endures,"[4] wrote Léger, just as Philippe Soupault had remarked a few years earlier: "Makers of illuminated signs increasingly use motion. Only Bébé Cadum remains immutable.... New inventions are tried out all around him. Film makes a bid for him, ... but Bébé Cadum, who has seen all this before, doesn't give it a glance."[5] In an article from 1927, Siegfried Kracauer described the illuminated advertisements in the Pigalle district as those "mechanical firebrands, atremble with venal sensuality." He mischievously concluded the passage with a reference to the famous giant baby—a model of cleanliness—looming over the cacophony of the street life below, with its drunks and carnal appetites: "A smiling child looks down from above, just fresh from his bath. With a highly recommended soap."[6]

Nighttime Enchantment

The Moulin-Rouge and other Montmartre cabarets were not alone in benefiting from the expansion of advertising signs. In 1928, the fourth issue of the magazine *Arts et métiers graphiques* printed an article arguing that advertising's use of light was the only real change to the face of Paris, despite all the destruction, construction, and other profound urban upheavals it had undergone over the course of the preceding years.[7] "Luminous architecture is the *ordre du jour*," claimed Philips in the trade press, vaunting the merits of its design office. Numerous techniques and media were available. Neon became increasingly widespread, but other systems were also used, and were written about in specialist periodicals. One such example was the Atrax Cube—a standardized opalescent form that allowed for multiple combinations—which was developed in Germany and commercialized in France by Mazda.[8] *Parade—Revue du décor de la rue* also commented on the commercial impact of these new systems, such as the success of the illuminated signs on the garages of Rue Marbeuf (built by Albert Laprade and Robert Mallet-Stevens*). Mounted along the entire height of their façades, forming huge arrows pointed downward, they were credited with increasing customer traffic for local businesses.[9]

Architects and designers were the first to be concerned by the new advertising platforms offered by shopfronts and store windows, which were featured in *Parade*

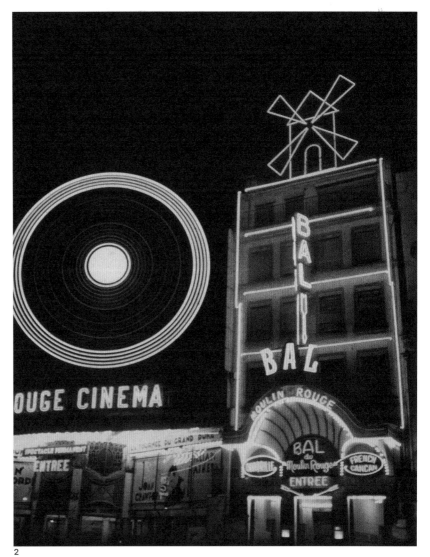

2

1 Advertisement for the Cadum soap brand. Wall painting based on the poster by Arsène-Marie Le Feuvre, 1912. Still from the film *Études sur Paris* (Studies of Paris) by André Sauvage, 1928.

2 Illuminated signs and decorations on the Moulin-Rouge, Boulevard de Clichy, c. 1930. Autochrome plate. Photograph by Léon Gimpel.

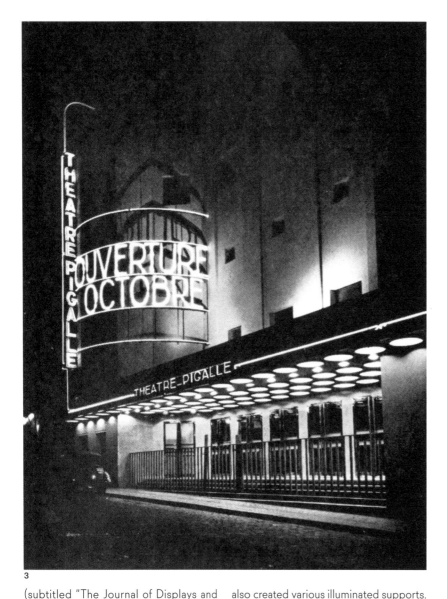

3

(subtitled "The Journal of Displays and Related Industries"). They were joined by commercial artists, who were soon referred to as "graphic artists," as Pierre Mac Orlan advocated in his 1929 article entitled "Graphismes." He declared that "decorative art, signage art, graphic art . . . these are arts that henceforth will find their masterpieces displayed exclusively in spaces dedicated to advertising."[10] Among those artists working in Paris between the wars, whose advertisements contributed to the city's street décor—which was constantly renewed in accordance with the demands of marketing—Jean Carlu* was particularly interested in this electrical dimension. He collaborated with Charles Siclis to design the signage for the Théâtre Pigalle, which opened in 1929,[11] and he

also created various illuminated supports. In 1935, at the request of the Compagnie Parisienne de Distribution d'Électricité, he adapted his poster "Cuisine électrique: économique, exquise, propre, pratique" (Electric cooking: economical, exquisite, clean, practical), which featured a female figure standing over a pot on the stove, triumphantly brandishing her purse. The poster's oblique composition was proof of the recent adoption of the principles of the Nouvelle Typographie by French designers,[12] and the illuminated version combined neon tubes with the reflective system used for nighttime road signs. The construction of the advertising panels was complex, requiring the contribution of several different trades (for the carpentry, electricity, glass and mirrors, and luminous

3 Charles Siclis, Théâtre Pigalle, Rue Pigalle, 1929 [destroyed]. Signs by Jean Carlu.

4 Neon signs, Boulevard des Italiens, c. 1930. Autochrome plate. Photograph by Léon Gimpel.

166

tubes), and these panels sometimes stood as high as twenty-five feet (7.5 m).[13] In his report on the third Salon de la Lumière, the critic Louis Chéronnet, an enthusiastic commentator on advertising, described the fruits of the collaboration between Carlu and the engineer Armand Zuckermann as a "luminous tableau whose grid is made of countless little yellow, green, and red lights, which, by illuminating one set after the other, allow any design one wishes to be drawn with astonishing flexibility and freedom."[14]

The luminous newspaper already existed: it was installed in 1926 on the corner of a street on the Right Bank. "As soon as night falls, the mesmerized crowds stop to raise their eyes toward the building's roof where, in flashing lights, on a screen that rounds the building's corner, a flow of advertisements speeds by, interspersed with the latest news."[15] New technology appeared regularly; the 1937 Exposition Internationale inaugurated the "lumino-graph," which allowed colored texts and drawings to be combined as desired, using thousands of lightbulbs.[16] Department stores offered their own spectacular illuminations, particularly during the holiday season; as Chéronnet noted, "Santa Claus advertises!"[17] The Galeries Lafayette, Samaritaine, Bazar de l'Hôtel de Ville, Bon Marché, and Grands Magasins du Louvre all strove to outdo each other, and the extravagant multicolored light displays orchestrated by Fernand Jacopozzi* were captured on autochromes by Léon Gimpel.

Advertising Masterpieces

In this context, posters became just one of many elements within a vast array of media that new advertising agencies were doing their utmost to exploit. Some advertisers relegated posters to the ranks of "pre-publicity," preparatory to "well-reasoned advertising."[18] In light of "the attractive displays that constitute modern stores," Léger found that posters were "no longer up to the task."[19] However, "paper," as outdoor advertising companies called it, still held its own on the walls of Paris. Advertisements were posted in quantity, playing on the effects of repetition: the same image was juxtaposed and superimposed as many times as the space would allow. There was a concerted effort to adapt to every format possible, while also occupying ever larger

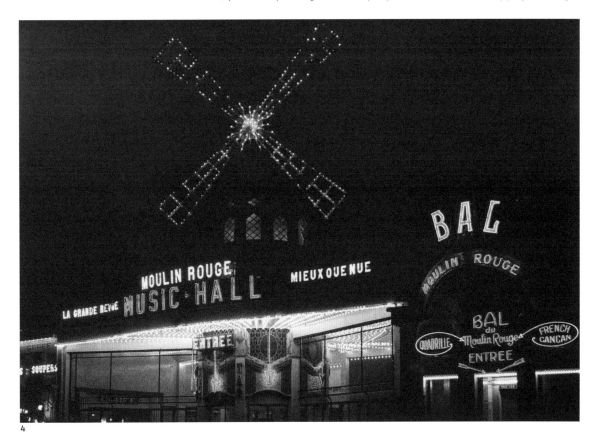

4

spaces. The famous 1923 poster created by Cassandre* for the furniture store Au Bûcheron became the focal point of an unprecedented campaign the following year: "The Au Bûcheron posters were plastered all over Paris, mounted every which way on any available surface. Some were small, others large, certain were wide, while others were long, and some were not even rectangular, yielding to the whim of gables, windows, and doors."[20] Noted in the press, this campaign further enhanced the artist's reputation, which the geometric simplicity and originality of his poster had already established. Moreover, paper was sometimes abandoned in order to create an even more powerful impression, and immense painted canvases based on Cassandre's models occupied the walls. This practice was repeated in other campaigns, such as the one for the launch of the magazine *VU* by Lucien Vogel in 1928.

However, the city fathers were growing concerned about this relentless, ever-increasing onslaught of commercial advertising. The Law of April 20, 1920, which regulated billposting on buildings, historic monuments, and protected sites, was followed by various decrees that aimed to safeguard the capital's historic heritage by limiting the presence of advertisements.[21] A resistance movement was organized in response, with strong support from the world of the arts and literature. In *L'Art vivant*, Chéronnet denounced the "philistines," who were blind to the merits of "this splendid and spontaneous art in which Paris could, once again, take pride."[22] Léon Paul Fargue depicted the situation as a nightmare: "I dreamt that advertising had disappeared, and I thought I'd gone blind. People were running through the streets that were no longer Rue du Bac, or Rue de la Paix, or Rue des Abbesses. They were running, stifled. . . . The metro rushed like a shot through stations that were stripped down and bare."[23] Blaise Cendrars proposed the famous equation "Advertising = Poetry."[24] The written word gained in significance: it was exhibited more than ever on signs and posters, both day and night, in a multitude of sizes and scales, introducing a novel approach to its interpretation. "The elements of familiar language are assembled into compositions that are no longer decipherable," commented Kracauer. As the visual challenge became all the more acute, Mac Orlan noted with regret that "luminous lettering lacks style."[25]

New typographical fonts were developed in response to the era's needs: one such example was Bifur, introduced by the Deberny et Peignot* foundry in 1929. Its design was simplified, stripped of archaic calligraphic flourishes and of all elements that were not essential to the identification of each letter, in a bid to give back to the written word its power as an image, as Cassandre, the font's creator, explained. He cited a statement made by Cendrars in response to a survey on advertising: "May you discover, you who today call on men of letters, that impulsive poetic genius who will find the simple, gigantic word to match the gargantuan poster of the Cadum baby over Paris."[26] Cassandre concluded, "It was to print this word that Bifur was created."[27] Several years later, another of his font designs—Peignot—met with an even greater success in the public spaces of Paris, notably on the occasion of the 1937 Exposition Internationale, when it was widely used in both interior and exterior spaces. Paul Valéry's verses inscribed on the frieze of the Palais de Chaillot were composed in the Peignot font, in bronze letters in relief, and can still be seen there today. They are a testament and reminder of the mighty efforts made to assert the capital's graphic identity, rebelling against the phenomenon of standardization in cities that Kracauer, an attentive observer of urban typography, had so rightly identified.[28] C d S

5

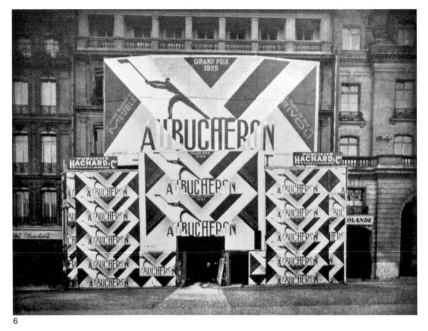

6

168

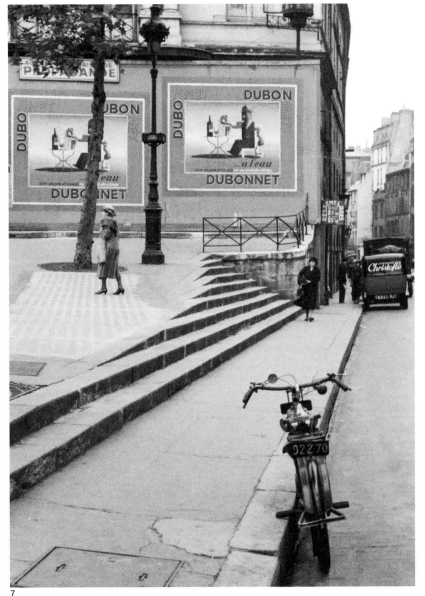

7

6. Siegfried Kracauer, "Publicité lumineuse," in *Le Voyage et la danse: Figures de ville et vues de films*, ed. Philippe Despoix (Saint-Denis: Presses Universitaires de Vincennes, 1996), 68–69.

7. P. P. "La publicité lumineuse," *Arts et métiers graphiques*, no. 4 (January 1928): 250–53.

8. Anonymous, "Un nouvel élément lumineux," *Art & Décoration*, June 1931: VI–VII.

9. "La publicité lumineuse," *Parade*, no. 2 (1927): 6. On the journal, see Jérémie Cerman, "De la rue au décor des boutiques: Les enseignes, objets publicitaires," in *L'Enseigne: Une histoire visuelle et matérielle*, ed. Anne-Sophie Aguilar and Éléonore Challine (Paris: Citadelles et Mazenod, 2020), 108–27.

10. Pierre Mac Orlan, "Graphismes," *Arts et métiers graphiques*, no.11 (1929): 645–52.

11. Michel Wlassikoff, *Histoire du graphisme en France* (Paris: Les Arts Décoratifs/Dominique Carré, 2005), 86–87.

12. "Qu'est-ce que la Nouvelle Typographie et que veut-elle?" *Art et métiers graphiques*, no. 19 (1930). Article attributed to Jan Tschichold, who heralded this new trend.

13. Anonymous, "La publicité lumineuse," *Arts et métiers graphiques*, no. 48 (1935): 65.

14. Louis Chéronnet, "3e Salon de la lumière," *Art & Décoration*, January 1935: 361.

15. *Vendre* (1926), quoted in Bernard Ulmer and Thomas Plaichinger, *Les Écritures de la nuit*, 34.

16. Jacques Darjel, "Le luminographe," in "Publicité 1937," special issue, *Arts et métiers graphiques* (1937): 35–36.

17. Louis Chéronnet, "Le père Noël fait de la publicité," in *La Publicité: Art du XXe siècle*, ed. Éric Dussert (Paris: La Bibliothèque, 2015), 79–86.

18. Jean Neuilly, *Vendre* (February 1928), quoted in Réjane Bargiel, "L'affiche et la publicité durant l'entre-deux-guerres," in *A.M. Cassandre: Œuvres graphiques modernes, 1923–1939*, ed. Anne-Marie Sauvage (Paris: Bibliothèque Nationale de France, 2005), 21.

19. Fernand Léger, "La rue. Objets, spectacles," 68.

20. *Vendre* (December 1925), quoted in Réjane Bargiel, *A.M. Cassandre*, 37.

21. On this topic, see Sonia de Puineuf, "La publicité et le développement de la métropole à Paris et Berlin dans les années 1920," in *L'Horizon de la grande ville: Constructions et représentations entre Allemagne et France, 1850–1950*, ed. Jean-Louis Cohen and Hartmut Frank (Berlin: Deutsche Kunstverlag, 2013), 265–82.

22. Louis Chéronnet, "Paris la nuit," *L'Art vivant*, January 1927: 27.

23. Léon Paul Fargue, "Salut à la publicité," *Arts et métiers graphiques*, no. 45 (1935): 5–8.

24. "Publicité = Poésie" is the title of a chapter in Blaise Cendrars, *Aujourd'hui* (Paris: Grasset, 1931).

25. Pierre Mac Orlan, "Graphismes," 651.

26. Cassandre, "Bifur," *Arts et métiers graphiques*, no. 9 (January 15, 1929): 578, quoted in Pascal Béjean and Frank Adebiaye, *Cassandre: Spécimens* (Paris: Art Book Magazine Éditions, 2015).

27. Ibid.

28. Siegfried Kracauer, "Analyse d'un plan de ville," in *Rues de Berlin et d'ailleurs* (Paris: Le Promeneur, 1995), 23.

5 Cassandre, presentation brochure for the Bifur typeface. Publication by the Deberny et Peignot foundry, 1929.

6 Cassandre, posters for the furniture store Au Bûcheron, c. 1925. Illustration in *Commercial Art*, January 4, 1928.

7 Street corner with posters designed by Cassandre for Dubonnet, 1934. Photograph by André Kertész.

1. Fernand Léger, "Couleur dans le monde," in *Fonctions de la peinture* (Paris: Denoël/Gonthier, 1965), 86.

2. On this subject, see Bernard Ulmer and Thomas Plaichinger, *Les Écritures de la nuit: Un siècle d'illuminations et de publicité lumineuse* (Paris: Syros Alternatives, 1987), as well as Philippe Artières, *Les Enseignes lumineuses: Des écritures urbaines au XXe siècle* (Paris: Bayard, 2010).

3. Fernand Léger, "Color in the World," in *Functions of Painting*, trans. Alexandra Anderson, ed. Edward F. Fry, pref. George L.K. Morris (New York: Viking, 1973), 120.

4. Fernand Léger, "La rue. Objets, spectacles," in *Fonctions de la peinture*, 68.

5. Philippe Soupault, "La Rue," *Paris-Journal* (February 28, 1934), quoted in Myriam Boucharenc, "La vérité sur bébé Cadum," in *Frontières de la non-fiction: Littérature, cinéma, arts,* ed. Alison James and Christophe Reig (Rennes: Presses Universitaires de Rennes, 2019), 189–99. On this topic, see also Michel Wlassikoff and Jean-Pierre Bodeux, *La Fabuleuse et exemplaire histoire de bébé Cadum* (Paris: Syros Alternatives, 1990).

Eileen Gray

1878, Enniscorthy (Ireland)
1976, Paris

The young Irishwoman Eileen Gray was trained in London and moved to Paris in 1902. She would stay there for the rest of her life—except for a few trips abroad and regular visits to the Côte d'Azur, in the residence she designed with Jean Badovici,* then in her own home. She studied art and specialized in interior decoration, particularly the art of lacquerwork. Her mastery of this Asian technique and her talent for furniture design gave her an immediate entrée to Parisian high society. She received commissions from couturiers Jacques Doucet* and Juliette Lévy, for whom she designed an apartment on Rue de Lota between 1919 and 1924. In 1933, she created the interiors for another apartment on Boulevard Suchet.

The early years of the 1920s marked a turning point in her work, which evolved from a certain decorative preciosity into a thoroughly modern rigorousness. She was profoundly influenced by her discovery of the De Stijl group at the exhibition organized by Léonce Rosenberg in the Galerie L'Effort Moderne in 1923. She explored this aesthetic vocabulary, employing refined and luxurious materials, such as lacquer, leather, precious woods, and custom-woven fabrics, combined with metal tubes, often in asymmetrical forms—combinations that were sometimes pushed to the point of imbalance. Her creations were displayed and sold in her shop, Jean Désert, which she opened on Rue du Faubourg-Saint-Honoré in 1922. As the contemporary press observed, "A visit to Jean Désert is an adventure, an encounter with the unfamiliar, a voyage to parts unknown." Eileen Gray created a skillful balance between luxury and austerity, fantasy and reason, femininity and masculinity. This mastery explains why, after several decades of disregard, Gray is today hailed as one of the most original voices of modernity. G MJ

Caroline Constant. *Eileen Gray*. Paris: Phaidon, 2003.
Cloé Pitiot, ed. *Eileen Gray*. Paris: Centre Pompidou, 2013. Exhibition catalog.
Cloé Pitiot and Nina Stritzler-Levine, eds. *Eileen Gray*. New York: Bard Graduate Center, 2020. Exhibition catalog.

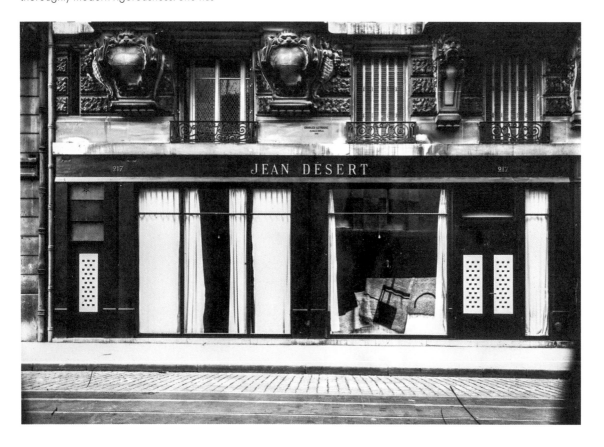

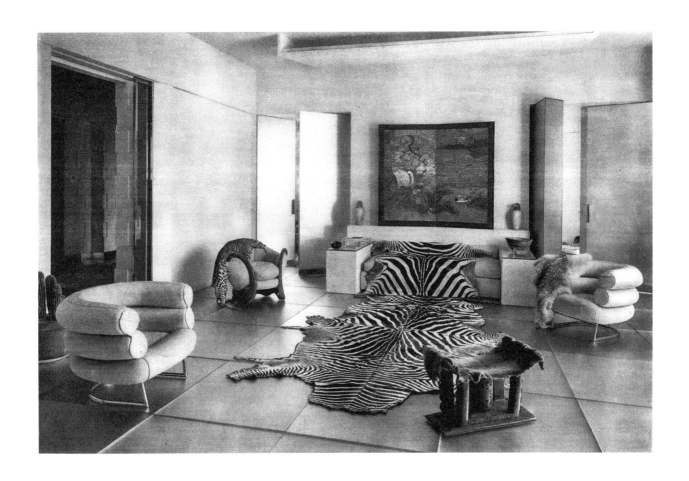

← Jean Désert boutique, Rue du
Faubourg-Saint-Honoré, after 1922.

↑ Juliette Lévy's apartment, Rue
de Lota. View of the living room,
in *L'Illustration*, May 27, 1933.

171

Gabriel Guevrekian

1900, Constantinople
1970, Antibes

A nomadic figure, Gabriel Guevrekian studied architecture in Vienna and practiced in France, Iran, the United Kingdom, and the United States. Active in Paris between 1922 and 1933, he initially collaborated with Robert Mallet-Stevens,* for whom he supervised a project on Rue Mallet-Stevens. Establishing his own business in 1926, he designed furniture and interiors, took part in several Paris exhibitions and salons, and contributed to numerous publications, such as the series of portfolios *L'Art international d'aujourd'hui* (International Art of Today). In 1928, he assisted Le Corbusier* in organizing the French entry for the first Congrès International d'Architecture Moderne.

His masterwork is the private residence that he designed in Neuilly-sur-Seine (1927–28) for the couturier Jacques Heim, whom he no doubt met through Sonia Delaunay.* The street façade, smooth and unadorned, contrasts with the garden side, which features several superimposed terraces. Guevrekian did not refer to Le Corbusier's "five points of a new architecture" in his design, and the villa's layout is closer to that of the *Raumplan* by Adolf Loos,* whom he knew in Vienna. As the critic Marcel Zahar wrote in 1931, "The body [of the building] is not formed of floors or sections of the same proportions. Here, each unit has, depending on its function, a determined space and an individual conformation. The units are associated not in a regular arrangement but in nodules, a mass of interdependent organs."

Guevrekian spent the late 1930s in Iran, where he introduced modern architecture. He took part in the reorganization of the Saarbrücken School of Art during the postwar French Occupation, and later moved to the United States to teach. G MJ

Hamed Khosravi. *Gabriel Guevrekian: The Elusive Modernist*. Berlin: Hatje Cantz, 2020.
Elisabeth Vitou, et al. *Gabriel Guevrekian: Une autre architecture moderne*. Paris: Connivences, 1987.
Marcel Zahar. "La maison de Monsieur et Madame Heim. Morphologie et structure d'une maison." *La Renaissance de l'art français*, no. 14 (1931): 47–58.

Water garden and lighting at the Exposition Internationale des Arts Décoratifs et Industriels Modernes, 1925. Perspectival illustration. Watercolor on paper.

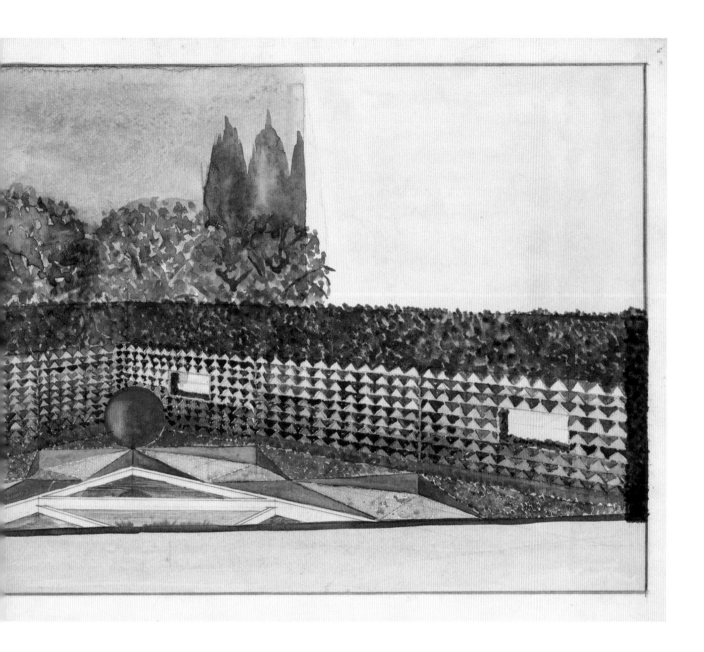

H I J K L

Habitation

LIVING IN PARIS IN THE 1920s AND 1930s

The housing shortage in Paris was exacerbated after World War I by a wave of immigration from the provinces and abroad. Added to the problem of overcrowding caused by large families was the threat of tuberculosis. Politicians had mobilized just before the war, and the Bonnevay Law of December 23, 1912 had allowed municipal intervention in housing construction via the creation of the Offices Publics d'Habitations à Bon Marché (HBM [Public Authorities for Low-Cost Housing]), whose function was to create new inexpensive apartment blocks while also managing those already built by the city. The crisis proved lasting: with World War II looming, economic slowdown was reflected in housing production: eighty-six thousand units were built in 1936, as opposed to only fifty-seven thousand in 1939, on the eve of the conflict.

A trial run to increase working-class housing and reduce the number of shanties in the "Zone" surrounding Paris coincided with the construction of two of the winning projects in the 1913 City of Paris competition, and, although building work was interrupted by World War I, it resumed shortly afterward. The project by architects Georges Albenque and Eugène Gonnot on Rue Henri-Becque, in the Glacière district, was completed in 1922. Intended for the poorest population groups, it became a veritable model for a category of low-budget, basic housing—it was so widely reproduced that it came to be known as "the Henri-Becque type." The building on Avenue Émile-Zola in the Grenelle neighborhood, designed by the architect Maurice Payret-Dortail and completed at the same time, offered the upper fringe of the working class the comfort of "standard facilities" that included running water, gas, and toilets. In this project, the communal bath and laundry amenities were located on the ground floor of the building, while on Rue Henri-Becque they were in the basement. Each housing plan corresponded to a social stratum, and the types of apartments were ranked according to the income and composition of the tenant families, with priority being given to large families at the time of allocation. The influence of architects who worked with philanthropic foundations, such as Henry Provensal or Auguste Labussière, was evident in the inclusion of elements that touched on hygiene and welfare—ventilation, orientation, systematic inclusion of a courtyard—as well as in the choice of materials: a concrete structure; brick infill; glazed, often blue stoneware cabochons; and similar materials for the façade.

HBMs on the Outskirts

Demolition of the city's ramparts cleared the way for development of the area

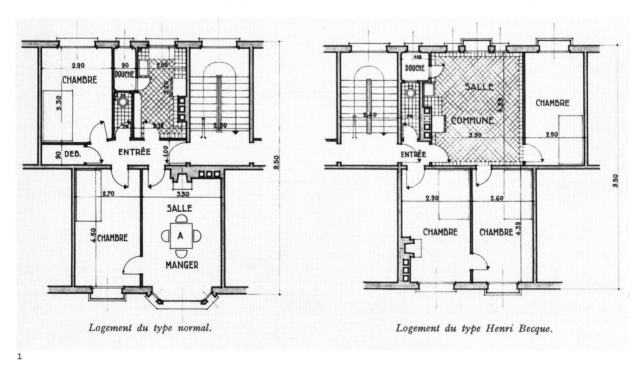

Logement du type normal.

Logement du type Henri Becque.

1

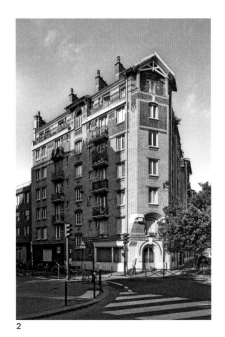

2

between the ring road formed by the Boulevards des Maréchaux and the outer boundary of the surrounding military easement. What is now commonly referred to as the "red belt" was built between 1921 and 1939 by the Offices Publics and semi-public companies linked to the city, notably the RIVP and the SAGI.[1]

Despite its apparent homogeneity, with its predominant use of brick, which was similarly colored, and its inclusion of an open or closed courtyard, this red belt presented numerous disparities. Each of these major projects was founded on specific architectural and aesthetic choices, and drew on constructional preferences— doctrines, even—that evolved over time. Funded by the state and the municipalities, the buildings reserved for the working classes, which provided standard yet limited surface areas—although a hierarchy of size and comfort did exist— actually housed a diversity of populations up to and including the well-to-do middle class. These HBMs had another point in common: the initial analysis of their use, often dictated by a bureaucratic vision of the lifestyles of the populations to be housed. There was also a hierarchy of location: proximity to the metro or the city gates was reserved for buildings for the middle classes, while the HBMs destined for the more impoverished groups were the furthest away. Moreover, the creation

of these districts required advance thinking about facilities and businesses that could also benefit the neighboring towns.

Construction along the ring road by the Office de la Ville de Paris began with the Cité Montmartre: a group of buildings occupying a large part of Boulevard Ney, at the corner of Avenue de la Porte-de-Saint-Ouen. Built between 1920 and 1926, this housing estate consisted of 2,734 units designed by the architects of the Office Public: Léon Besnard and Raoul Brandon, Alexandre Maistrasse and Henry Provensal. Initially intended to reduce the number of shanties in the outer zone, this large-scale operation was opened up to the middle classes:[2] some of the buildings even offered their inhabitants service stairs and a door leading directly into the kitchen, allowing the comings and goings of employers and domestic servants to remain separate— an unexpected requirement for supposedly modest accommodation. Moreover, certain projects, such as the group of buildings at Porte Champerret, included a double-height artist's studio on the upper floors. Site plans differed according to the group, ranging from a large square arranged around four courtyards to Greek-style sinuous forms outlining open courtyards or exploiting triangular layouts. Courtyards were omnipresent: in these times of epidemics and the implementation of hygiene regulations, ventilation was

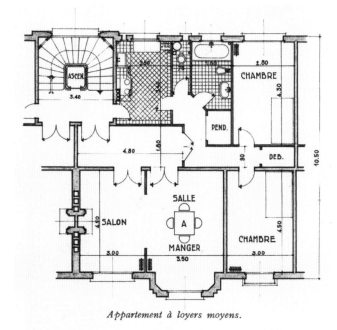

Appartement à loyers moyens.

3

1 Plans for low-cost apartments: "normal" type and "Henri Becque" type. Illustration in *L'Office public d'habitation de la Ville de Paris*, 1937.

2 Georges Albenque and Eugène Gonnot, low-cost apartments, Rue Henri-Becque, 1921–22. Photograph by Antonio Martinelli.

3 Medium-cost apartment building, standard type. Illustration in *L'Office public d'habitation de la Ville de Paris*, 1937.

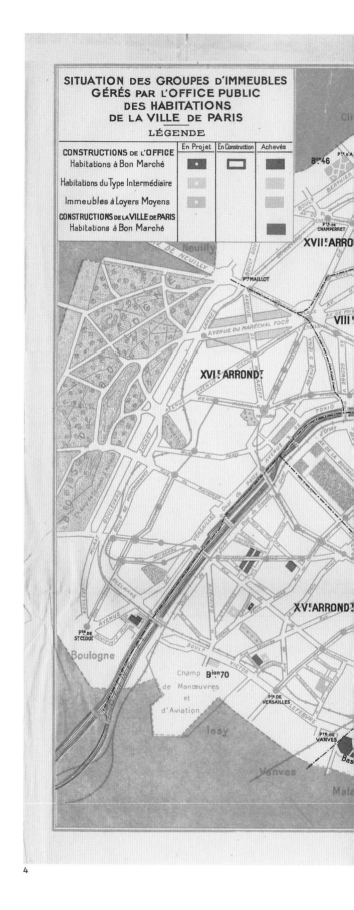

4 Illustration in *L'Office public d'habitation de la Ville de Paris*, 1937, showing groups of apartment buildings managed by the organization.

4

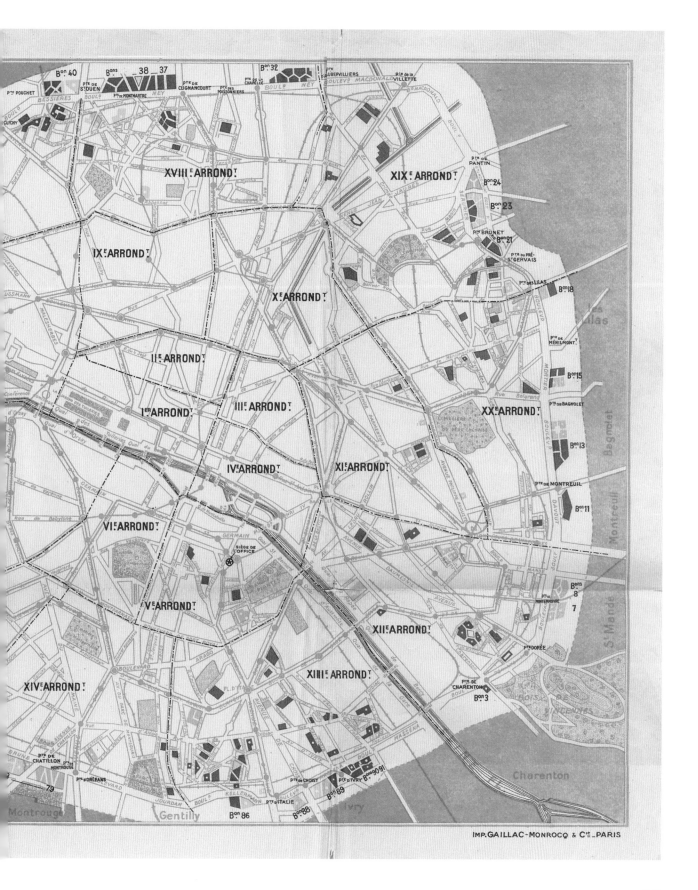

IMP.GAILLAC-MONROCQ & Cⁱᵉ _ PARIS

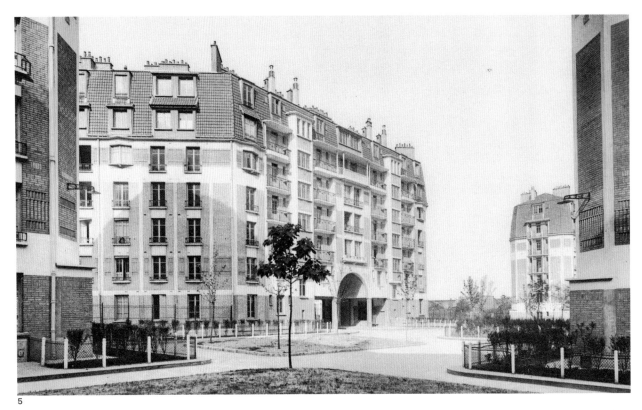

5

a primary consideration. Without question, the first City of Paris housing projects stole the show, although they drew heavy fire for their density (roughly one thousand inhabitants per hectare, or four hundred inhabitants per acre) and their compactness, despite their open courtyards. Some sixty thousand of these units were built in eighteen years.

From Low-Cost and Mid-Range to Intermediate Housing

Intermediate or "improved low-cost" housing had 129 square feet (12 m^2) more floor space than HBMs, plus a shower room. The minimum surface area of a habitable room was fixed at 97 square feet (9 m^2).[3] Between 1922 and 1928 a succession of laws was passed stipulating minimum surface areas required for comfort.[4] In the case of ILMs ("*immeubles à loyers moyens*," or medium-rent buildings) intended for the middle classes, running water, gas, and electricity were obligatory, and corridors were not to exceed 15 percent of the apartment's overall surface area. If the building was equipped with central heating, a fireplace was still mandatory; otherwise, there had to be a flue in each room. A bathroom or toilet/shower room was also required, but

not a bathtub. A freight elevator had to be installed in buildings of more than six floors.[5]

The interwar years were particularly interesting, bringing, on the one hand, an increase in the often minimal thinking about social housing, and, on the other, a reversal of the trend in domestic architecture that had all the makings of a revolution. Indeed, for the first time in the twentieth century, equipment developed for the working classes before World War I, such as the fully equipped kitchen (already introduced in 1905 by the Groupe des Maisons Ouvrières) was integrated into luxury housing. Public housing often provided a higher level of comfort than that of privately rented accommodation, which was less compliant with standards.

Small Apartments for the Middle Class

Construction of revenue houses (multifamily residences) for the middle classes boomed during this period and became a subject of debate, as these buildings were linked to an economic crisis that had seen a drop in middle-class incomes. The use of brick, with the astute tricks it permitted, was rare, as stone—or what resembled stone—still remained a social indicator. However,

5 Low-cost apartment buildings, Avenue de la Porte-de-Clignancourt, 1920-26. General view. Illustration in *L'Office public d'habitation de la Ville de Paris*, 1937.

6 Medium-cost apartment buildings, Boulevard Brune. Aerial view, block plan, and interior views. Illustrations in *L'Office public d'habitation de la Ville de Paris* 1937.

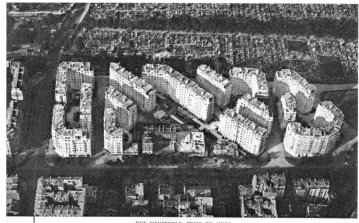

VUE D'ENSEMBLE, PRISE EN AVION
Cette vue générale a été prise avant la construction des immeubles
en bordure de la rue Achille Luchaire et du boulevard Brune.

IMMEUBLES A LOYERS MOYENS, BOULEVARD BRUNE
PORTES DE MONTROUGE ET DE CHATILLON

PLAN D'ENSEMBLE
576 appartements ; 128 chambres isolées.

brick did inspire certain architects, such as Léon Joseph Madeline, who would intersperse Paris with buildings displaying a sober elegance. In 1939, Madeline constructed a dual-aspect building with a concrete and brick frame, on Boulevard du Montparnasse and Rue Notre-Dame des Champs. On the rear side, the service stairs were illuminated via glass bricks, which along with the brick formed a highly distinctive style in this period. The interplay of openings, loggias, overhangs, and indents (termed in this case "open courtyard") was remarkable, and the placement of double corner windows brought light into the bedrooms at the back and the living and dining rooms on the boulevard side. L'Architecture française stressed the virtues of the "open courtyard" allowing for "developments in the façade for the lighting of the rooms of apartments."[6]

Opting for a long, developed façade, an open courtyard, or setbacks allowed for the creation of more main rooms giving onto desirable views, or even onto the Seine and its banks. The inclusion of a very large courtyard-garden was also a solution that could be combined with others. Joseph Bassompierre, Paul de Rutté, and Paul Sirvin's apartment block on the Mirabeau traffic circle (1930–33) was appreciated by

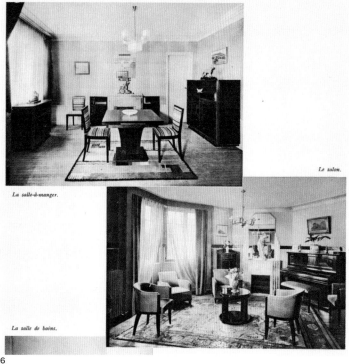

La salle-à-manger.

Le salon.

La salle de bains.

6

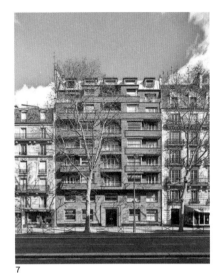

7

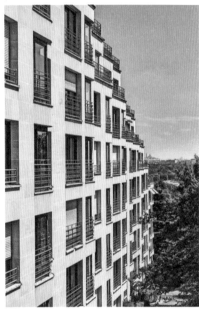

8

Parisians for its entrance courtyard facing the bridge, its undulating façade and two rounded corners, its Raymond Subes ironwork, and its courtyard-garden complete with lawn, porches, and pergolas.

Large-Scale Housing Projects and Facilities for the Middle Classes

In and around Paris, what came to be known as the "large-scale housing projects" appeared before the end of the 1920s. The category was invented for the bourgeoisie and upwardly mobile middle classes, well before the term itself was coined by the urban planner Maurice Rotival; the latter described this type of accommodation in 1935 in connection with the groups of collective housing schemes built by the Offices Publics, including Drancy-La Muette, considered at the time as a garden city: "We dream, in a word, of an urban-planning program, of low-cost housing in conjunction with the development of large cities."[7] Rotival's dream defined an ideal model for the expansion of the Paris region, which certain architects and urban planners would later lay claim to. Built before and after World War II, this example was intended for a very large number of residents, and was composed of parallel rows of low-rise buildings with repetitive, prefabricated elements. Rotival defined these large-scale projects as a morphological type, not as housing reserved exclusively for the working classes.

Indeed, they were sometimes to be found in prestigious settings, such as Louis Faure-Dujarric's construction in Neuilly (1929–31). Bordering on the Seine and the Bagatelle gardens, its thirty-three buildings and 450 apartments can be seen as the earliest of the large-scale housing projects. However, it did not occur to anybody to describe them as such at the time, and it was rather the term "residence" that sprang to mind. Yet they, too, were just as repetitive, sometimes made up of groups of long low-rise buildings, and the limited series of window types as well as the interior streets accentuated the analogy with what would become the stereotype of the large-scale housing development. It was one of the most important constructions of the time: the thirty-three eight-story low-rises or "blocks" were arranged around open or closed courtyard-gardens, set in a green space with geometric porticoes, or aligned along Rue Deloison, or arranged in an L-shape on Boulevard Richard-Wallace and Rue Julien-Potin. While some components of the façades were mass produced, such as the windows in each repeated module, the huge blond stones of the openings were carved on site and the frames of the windows with balconies overlooking the courtyard-gardens were in yellow brick. These large windows were the only real highlights in the sobriety of the façade. There were several types of openings: windows and French windows for the main rooms, with multiple panes (four or six) or outward-opening mechanisms, and sash windows for the bedrooms and bathrooms. Recesses and terraces made their appearance on the upper floors.

Following the same principle, engineer Louis-Clovis Heckly and architect Paul Béguin built two series of four middle-class rental buildings on Boulevard Suchet for the SAGI, lined up along the edge of the Auteuil racetrack. Less luxurious, these buildings—blocks or low-rises separated by large courtyard-gardens—were composed of small two- to five-room apartments, with entrances opening onto passageways and courtyards. On the roofs were actual houses with gardens.

In this housing for the middle classes, neither architects nor commissioning bodies relinquished opulent décor and the luxury of space, however. The communal areas of these well-located buildings were where skillful ironwork, double heights, and adroit lighting effects were best put to use, accentuating the impression that life there was an art, as these spaces offered the very first indication of the building's status.

The craze for terraces was characteristic of this period when the hygienists' slogan, "Air and Light," began to be internalized by many French people. But those same terraces also gave residents a view over the city and a new mode of sociability.

Garden Cities

According to French historian Danièle Voldman, "With Henri Sellier,* the expression 'garden city' quickly became synonymous with social housing financed by the public sector and a tool for the planning and development of the Parisian metropolitan area."[8] Originally inspired by British garden cities and the ideas of Ebenezer Howard, the fifteen garden cities[9] that made the extension of Paris a reality were initially proposed by Sellier, the socialist

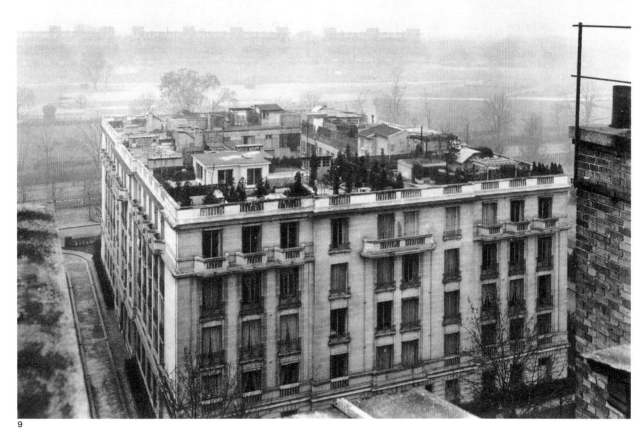

9

mayor of Suresnes and president of the Office Public d'Habitations à Bon Marché for the Seine département. They were the result of creative thinking about types of housing, but also about the quality of neighborly relations and proximity relationships, and about the facilities required for urban life and for moving around, particularly for children.[10] In this respect, they were similar to Clarence Perry's notion of the "neighborhood unit," used throughout the twentieth century.[11]

Sellier appears to have been initially influenced by the village model with its houses, bungalows, and local amenities. For him, these cities linked to each other by the railroad would enable the transition from dense city to a city that opened up to its surrounding agricultural countryside. One of the most interesting examples is Butte-Rouge in Châtenay-Malabry, south of Paris, which developed from 1929 until the 1960s, as it showcases the notion of typological diversity and it enjoys an exceptional stepped site. By the late 1930s, it had grown to over fifteen hundred dwellings. Its charm, in keeping with

functionalist thinking,[12] lies in the way the architects and landscape designer André Riousse took advantage of the site's differences in level and laid out roads, squares, and schools along a pedestrian route punctuated by wide stairs that reinforce the impression of living in a garden. The details on the entrances to the earliest buildings (1929–32), together with the awnings and trellises, gave an identity to each of these modest, unevenly staggered buildings. They comprised small apartments for the middle class (especially those on lower incomes), structured differentially according to the position of the "block," with the wet areas—kitchen, laundry that also served as a shower, and toilet—grouped together. The dining room, which doubled as a reception area, gave onto a bedroom. Hygiene and cleanliness were the watchwords here, and the presence of cleaning appliances—still recent in working-class housing at that time—which until then had either been inexistent or located on the ground floor, should be noted.

In later phases, however—even if the bathroom became an autonomous, well-lit

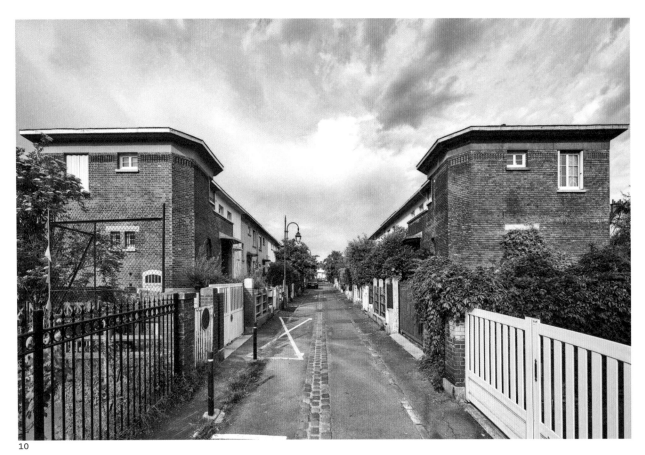

10

room and all the bedrooms were now independent—a decline in the quality of the materials and repetitiveness in the interior features became dominant factors.[13] Sellier insisted on the need to build towers in key points of the city in order to ensure the general equilibrium once established in villages by the church bell tower and the castle keep.[14] Interrupted by the Crash of 1929, construction was resumed after World War II and continued in a style closer to that of typical large-scale public housing developments. Only Paul Sirvin's semicircular building can compare with the first part of the initial city.[15]

This proliferation of models was characteristic of a period in which individual houses and skyscrapers coexisted, especially in some garden cities, and when financing methods intersected with architectural models to house populations whose needs were being analyzed more and more closely. There was a clash between the advocates of Le Corbusier's theories—who built slabs that were set amid greenery or were more mineral in aspect, such as the towers at Drancy—and those who dreamed of responding to the desires of the majority of French people: recent urbanites who were attached to the single-family home and who identified with garden cities, even if some of them mixed houses with apartment buildings and tower blocks.

Although apartment buildings were on the point of prevailing immediately after World War II, the state and local elected officials continued to question the relevance of collective accommodation as opposed to individual homes. In 1945, Le Merlan "cité d'expérience" in suburban Noisy-le-Sec was built: it was an experiment to create full-scale sections of a town composed of prefabricated houses designed by architects from around the world, and to gauge their reception by the inhabitants.[16] This experimental site would pave the way for the construction of display villages featuring often innovative houses, until the state pulled out, leaving developers and other constructors to cover the Paris region with housing developments, with no consideration for local amenities or the vegetation—precisely the aspects that had ensured garden cities could offer a high-quality environment in which to live. M E

10 Alexandre Maistrasse, garden city, Suresnes, 1921-26. View of a street of row houses. Photograph by Antonio Martinelli.

11 Joseph Bassompierre, Paul de Rutté, and Paul Sirvin, Butte-Rouge garden city, Châtenay-Malabry, 1931-34. General view with the tower block. Photograph by Antonio Martinelli.

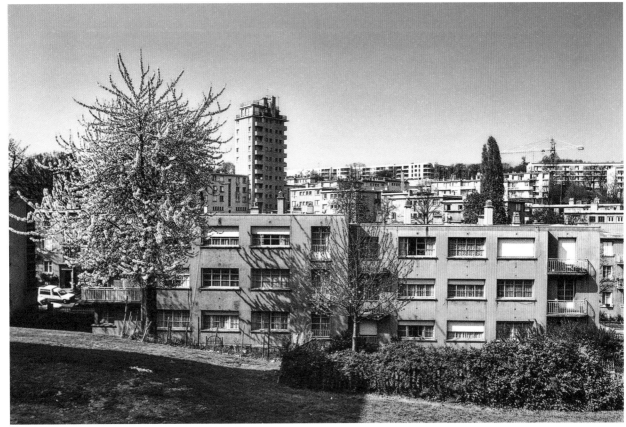

11

1. In addition to the RIVP (Régie Immobilière de la Ville de Paris [Real Estate Agency for the City of Paris]) and the SAGI (Société Anonyme de Gestion Immobilière [Real Estate Management Company]), there were the SGIM (Société de Gérance d'Immeubles Municipaux [Municipal Property Management Company]) and the CGP (Compagnie Parisienne de Gestion [Parisian Management Company]). See *Les Habitations à bon marché de la ceinture de Paris: Étude historique* (Paris: Atelier Parisien d'Urbanisme, 2017).

2. The so-called Loucheur Law of July 13, 1928 permitted the construction of medium-rent buildings. The Bonnevay Law of 1912 had already allowed for the creation of "intermediate housing," between "low-cost housing" and "medium-cost apartments." Also known as "improved low-cost housing," this intermediate category was intended for "that portion of the middle class that cannot benefit from HBMs, but whose incomes are not high enough to pay the monthly instalments of a medium-rent apartment." See *L'Office public d'habitation de la Ville de Paris* (Paris: OPHVP, 1937).

3. For the emergence of this norm, see Monique Eleb, with Anne Debarre, *L'Invention de l'habitation moderne. Paris, 1880–1914* (Paris/Brussels: Hazan/Archives de l'Architecture Moderne, 2000).

4. The Law of December 5, 1922 on the HBM, the Law of July 13, 1928 on the improved HBM, and finally the Laws of July 13 and October 28, 1928 for the intermediate ILM.

5. *L'Office public d'habitation de la Ville de Paris*, 1937.

6. H.B. (Bodecher), "Immeuble Boulevard du Montparnasse. Léon Joseph Madeline architecte DPLG," *L'Architecture française*, no. 10 (1941): 8.

7. Maurice Rotival, "Les grands ensembles," *L'Architecture d'aujourd'hui*, no. 6 (June 1935): 57–72.

8. Danièle Voldman, "Les modèles urbains d'Henri Sellier et leur mise en œuvre à l'Office départemental d'HBM de la Seine," *Histoire urbaine* 2, no. 37 (2013): 95–106.

9. See the indispensable publications on this subject: Thierry Roze, *Les Cités-jardins de la région Île-de-France*, Cahiers de l'IAURIF, no. 51 (June 1978); and Julie Corteville, ed., *Les Cités-jardins d'Île-de-France: Une certaine idée du bonheur* (Lyon: Lieux-Dits, 2018).

10. For a short history on the vagaries of the type, see "La disparition progressive d'un concept," in Benoît Pouvreau, et al., *Les Cités-jardins de la banlieue du nord-est parisien* (Paris: Le Moniteur, 2007); and Ginette Baty-Tornikian, ed., *Cités-jardins: Genèse et actualité d'une utopie* (Paris: Éditions Recherches, 2001), 151.

11. *The Neighborhood Unit: From the Regional Survey of New York and Its Environs*, vol. 7, *Neighborhood and Community Planning* (New York: Regional Plan of New York, 1929).

12. Thierry Roze, *Les Cités-jardins de la région Île-de-France*.

13. See François Laisney, "Quand les HLM étaient roses," *Architecture Mouvement Continuité*, no. 35 (December 1974): 79–105.

14. Henri Sellier, preface to *Réalisations de l'Office public d'habitation du département de la Seine* (Strasbourg: EDARI, 1933), 8.

15. Élise Guillerm, *Une cité-jardin moderne: La Butte-Rouge à Châtenay-Malabry* (Marseille: Parenthèses, 2021).

16. See the chapter on Villagexpo in Monique Eleb and Lionel Engrand, *La Maison des Français: Discours, imaginaires, modèles (1918–1970)* (Brussels: Mardaga, 2020).

Louis
Hautecœur

1884, Paris
1973, Paris

Art historian Louis Hautecœur played a
decisive role in state policy during the
Occupation. A brilliant archeologist and
skilled diplomat, Hautecœur had been
director of the French Institute in Saint
Petersburg (1911–13) and director of the
School of Fine Arts in Egypt (1927–31).
After World War I, which was spent mostly
in government ministries, he taught in many
institutions, including the University of
Caen, the École du Louvre, and the École
des Beaux-Arts in Paris, while also direct-
ing the journal *L'Architecture* (1922–39).
In addition to carrying out his own research,
brought together in the monumental
*Histoire de l'architecture classique en
France* (History of Classical Architecture
in France) that he published between 1943
and 1957, he was a curator at the Musée
du Louvre.

In 1940, he replaced the director gen-
eral of the École des Beaux-Arts, Georges
Huisman, who was Jewish and close to
the Popular Front, before becoming its
secretary-general from March 1941 to
March 1944. An energetic supervisor of
artistic education, he strove in particular
for a merger between the Beaux-Arts and
the École des Arts Décoratifs. In 1942, he
curated the Arno Breker* exhibition at the
Tuileries. His main legacy remains the law
of 1943 on the preservation of the sur-
roundings of historical monuments, and
the opening of the Musée National d'Art
Moderne, whose first exhibition was held
in August 1942, at the Palais de Tokyo in
Paris.

The Liberation brought him relatively few
difficulties and he went on to pursue a long
institutional career. J-L C

Antonio Brucculeri. *Du dessein historique à l'action
publique: Louis Hautecœur et l'architecture classique
en France*. Paris: Picard, 2007.
Louis Hautecœur. *Les Beaux-Arts en France: Passé et
avenir*. Paris: A. and J. Picard, 1948.

← *Histoire de l'architecture classique en France* (History of Classical Architecture in France), front cover of the first volume, 1943.

↑ Louis Hautecœur at the opening of an exhibition of Japanese prints, July 1941. Photograph by François Tuefferd.

Florence Henri

1893, New York
1982, Compiègne (France)

The origins, life, and work of Florence Henri, who settled in Paris in 1924, are as elusive and diffracted as her best-known photographs.

After losing her mother in 1895 and her father in 1907, Henri left the United States for Berlin in 1912, using her family inheritance to study painting. There she fell in love with her teacher, Carl Einstein—the art historian and theoretician of cubism—and the two of them mixed in circles with artists like Hans Richter, John Heartfield, and László Moholy-Nagy. She pursued her studies as a painter in Paris, but, during a stay at the Bauhaus in Dessau in the summer of 1927, she discovered the latest trends in photography, which struck her as a revelation. Committing herself to this medium, she founded her own Paris studio, which rivaled that of Man Ray.* She photographed her friends, notably Fernand Léger,* Sonia Delaunay,* Wassily Kandinsky, and Jean Arp,* as well as carrying out commissions such as the advertisement for Lanvin's* Arpège perfume. She also conducted personal artistic experiments on the subject of the female nude, and with compositions that incorporated a use of mirrors, allowing her to combine cubist diffraction with constructivist geometric constructions.

From 1932, she took part in numerous exhibitions, notably in London, New York, and Essen. She left Paris in 1937 and spent World War II in Brittany, where the scarcity of photographic equipment led her to take up painting again. P M

Florence Henri: Le Miroir des avant-gardes, 1928–1940. Paris: Éditions du Jeu de Paume, 2015. Exhibition catalog.

Advertising artwork for Lanvin's Arpège perfume, 1929.

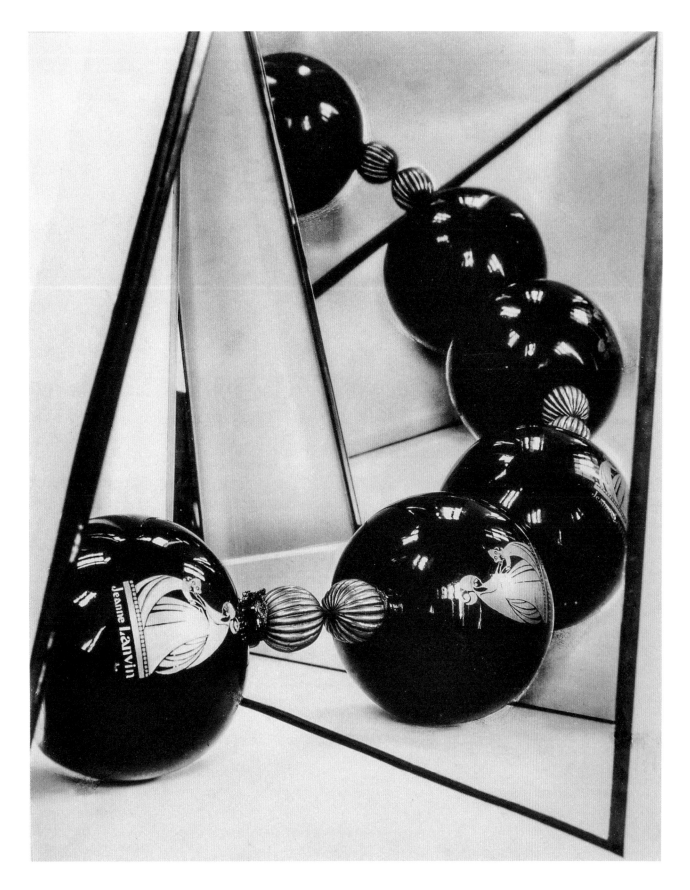

René Herbst

1891, Paris
1982, Paris

René Herbst's oeuvre as decorator and designer was Parisian through and through. It was in the French capital that he created his numerous store interiors and exhibition scenographies, as well as decorating luxury apartments and designing furniture and lighting.

The 1920s saw a radical change in his vocabulary: one need only compare his contribution to the 1921 Salon d'Automne—a precious, elaborately ornamented coin de repos ("resting corner")—with his offering at the 1928 Salon des Artistes Décorateurs: a smoking room equipped with metal furniture, which formed a group with Charlotte Perriand's* dining room and Djo-Bourgeois's living room. The shift was confirmed two years later, in 1930, with his music room presented at the first exhibition of the Union des Artistes Modernes, which had been founded the previous year by Herbst and, among others, Robert Mallet-Stevens,* Francis Jourdain,* Charlotte Perriand,* and Hélène Henry. This was the first appearance of his piano with metal legs, designed for Pleyel, and of the nickel-plated chairs and elastic rubber cords that would become his trademark. That same year, Herbst began working closely with the Office Technique pour l'Utilisation de l'Acier (Technical Office for the Use of Steel) or OTUA: an organization representing the metal industry. For more than thirty years, he designed all OTUA's exhibition stands in steel, starting with its pavilion at the 1937 Exposition Internationale in Paris, as well as numerous furniture prototypes whose mass-production earned him the nickname "Iron Man." G MJ

Guillemette Delaporte. René Herbst: Pioneer of Modernism. Paris: Flammarion, 2004.
Solange Goguel. René Herbst. Paris: Éditions du Regard, 1990.

School desk displayed at the Salon d'Automne, 1936.

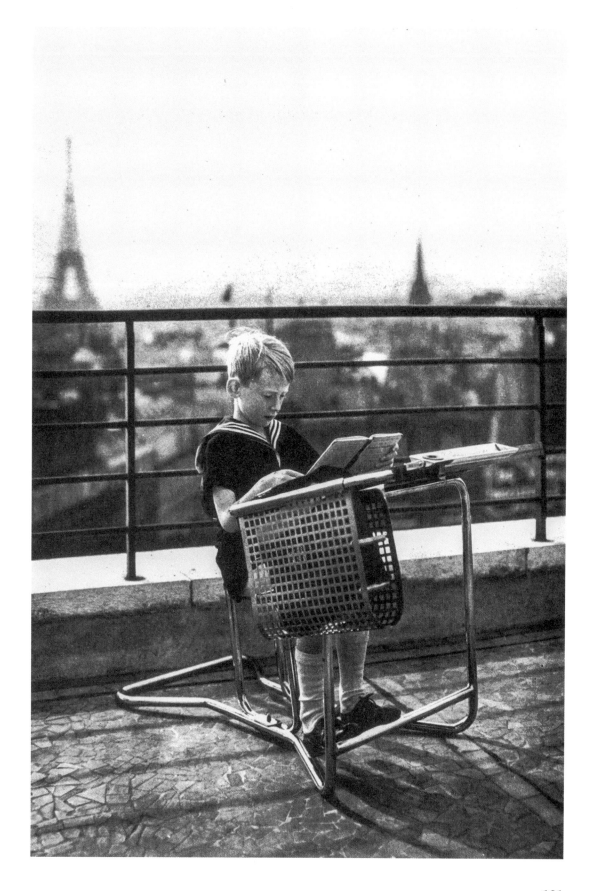

Fernand Jacopozzi

†1877, Florence
†1932, Paris

The nocturnal spectacle presented by the City of Light in the period following World War I was largely the work of Fernand Jacopozzi—a prolific creator of light installations.

Jacopozzi worked initially as a sign painter, before becoming artistic director at the Paz & Silva lighting and illuminated advertising company, where he developed the first store decorations using neon. Toward the end of the war, when German Zeppelin raids were escalating, he designed an extravagant "faux Paris" for the French general staff: it was a vast light installation reproducing the layout of the capital as a decoy for enemy aircraft bombing the city at night. However, the project was cut short by the Armistice of 1918.

In the postwar era, Jacopozzi became the celebrated orchestrator of after-dark magic, fueling competition among the large Paris department stores during the festive season; their storefronts were enlivened with his dynamic, vibrantly colorful evocations of, for example, Venice, the circus, or characters from the works of Rabelais.

At the request of Gabriel Thomas, administrator of the Eiffel Tower, Jacopozzi and the painter Italo Stalla devised a light display for the monument and succeeded in convincing André Citroën* to rent it to spell out his family name in sixty-six-foot- (20-m-) tall letters. This was only one of the motifs drawn by its 250,000 bulbs: other astonishing shows followed, the most daring of which simulated the tower being struck by lightning, then burning to the ground. J-L C

Xavier Boissel. *Paris est un leurre: La véritable histoire du faux Paris*. Paris: Inculte, 2012.
Fabien Sabatès. *Jacopozzi: Le magicien de la lumière*. La Celle-Saint-Cloud: Éditions Douin, 2017.

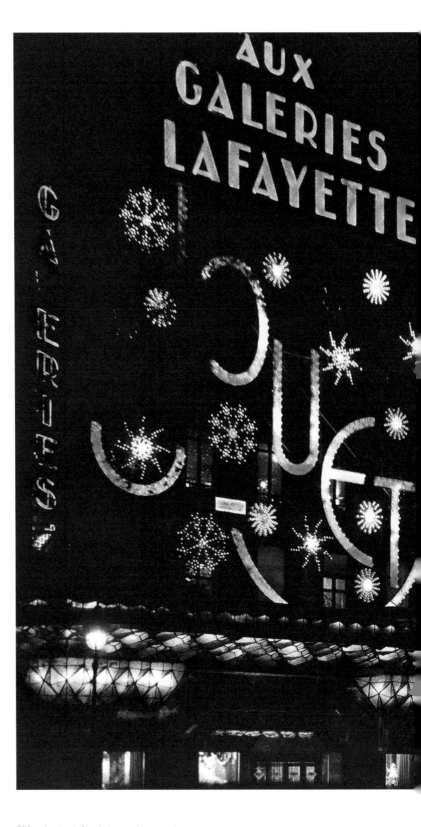

Illuminated Christmas decorations for the Galeries Lafayette, 1933. Autochrome plate. Photograph by Léon Gimpel.

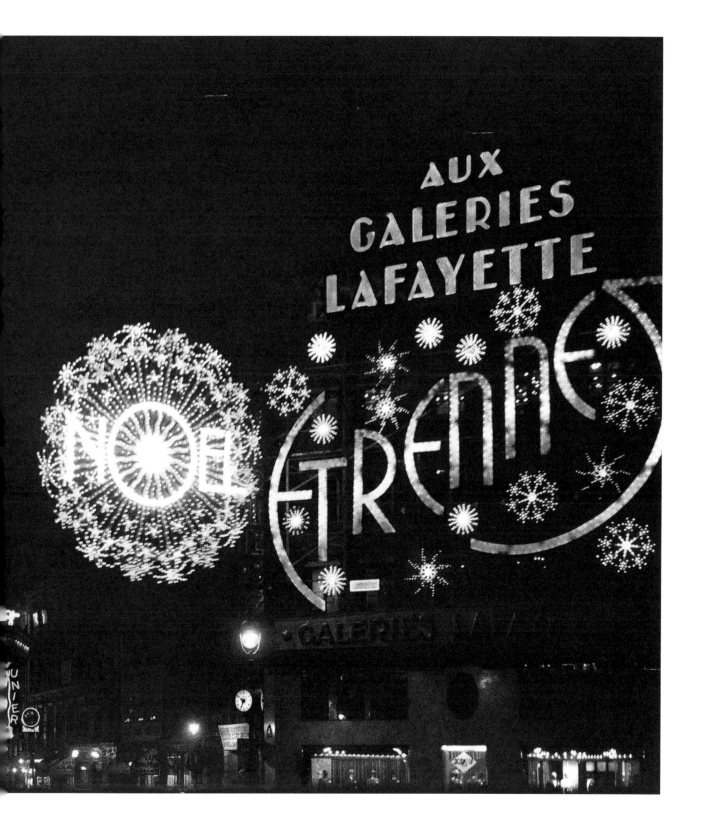

Francis Jourdain

1876, Paris
1958, Paris

Initially a painter, Francis Jourdain began to focus on interior design from 1913 onwards, and by the 1920s he had made a name for himself well beyond his native Paris for his ensembles, furniture, and ceramics. He was familiar with the post-impressionists and the Nabis, he was also a close friend of Henri de Toulouse-Lautrec. Jourdain managed to break free of the influence of his father, Frantz, an architect and publicist, while still working with him at the Samaritaine stores, where he painted murals and, around 1920, designed the director's office.

A committed anarchist, he collaborated with art critic Georges Besson on *Cahiers d'aujourd'hui*, in which he inspired the publication of two significant essays by Adolf Loos.* This prompted a clean break with the formal themes of art nouveau, as shown in the interior of his apartment in Henri Sauvage's* building on Rue Vavin and, above all, in the "interchangeable furniture" he produced at the Ateliers Modernes, which he had founded in 1912. The writer Octave Mirbeau saw his work as "quite simply objects illustrative of our life and dutifully taking part in it."

In 1919, while working for the Innovation luggage company, he opened his Chez Francis Jourdain store on Rue de Sèze, selling affordable furniture, lighting, and ceramics. Another store followed in the Urban Art section of the Salon d'Automne in 1923. At the 1925 Exposition Internationale des Arts Décoratifs et Industriels Modernes he presented two smoking rooms: one for a railroad car and the other for the French Embassy, collectively designed by the Société des Artistes Décorateurs. In 1929, together with the most radical of the society's members, he helped to found the Union des Artistes Modernes (UAM). However, his project for a "bazaar" of readily accessible objects in the UAM pavilion at the 1937 Exposition Internationale in Paris came to nothing: he only just managed to design the interior of one room in the building conceived by his son Frantz-Philippe and Georges-Henri Pingusson.

After visiting the Soviet Union in 1927, he developed close ties with the Communist Party and was instrumental in having the design for the new school in Villejuif entrusted to André Lurçat* by the town's mayor Paul Vaillant-Couturier in 1930. With Lurçat, he was a member of the Association des Écrivains et Artistes Révolutionnaires. In 1938, he designed the office of the medievalist Edmond Faral, administrator of the Collège de France, which was one of the first pared-down modern interiors to be featured in a French public building. He lived an underground existence during the Occupation, and after World War II he devoted his sharp sense of irony to writing, publishing his memories of the artists he had once known. J-L C

Francis Jourdain, 1876–1958: Peintures, dessins, gravures, architecture d'intérieur. Saint-Denis: Musée Municipal d'Art et d'Histoire, 1976. Exhibition catalog.
Arlette Barré-Despond. *Jourdain.* New York: Rizzoli, 1991.
Léon Moussinac. *Francis Jourdain.* Geneva: Pierre Cailler, 1955.

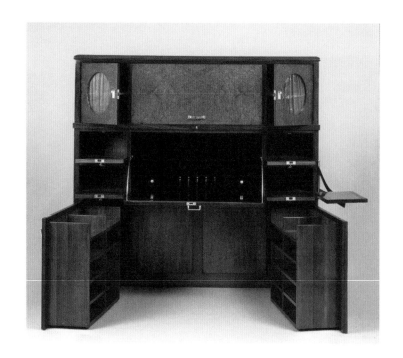

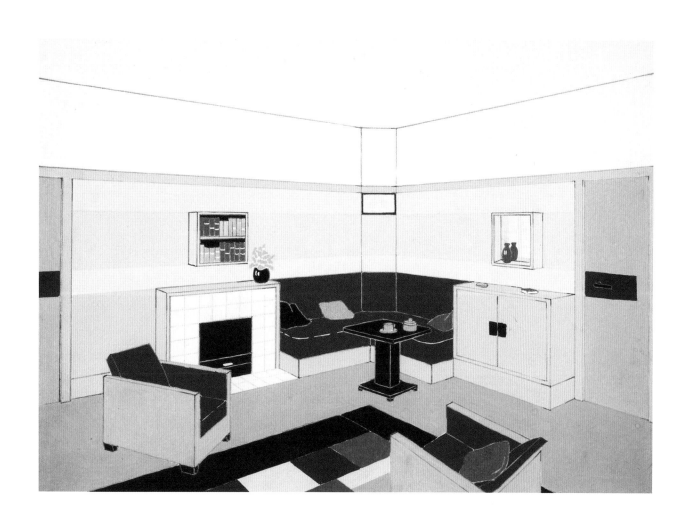

← Secretaire-filing cabinet,
c. 1920.

↑ Living room displayed at the
Salon d'Automne, 1924. Watercolor
on paper.

André Kertész

1894, Budapest
1985, New York

The eye that the young Andor Kertész cast on the French capital upon his arrival in 1925 was already one of an experienced photographer. Through the local Hungarian community in Paris, he met influential members of the intellectual scene, including the Lurçat brothers,* Piet Mondrian, Fernand Léger,* and Colette, and he took their portraits and photographed their studios.

His images capture the urban landscape and its participants: an Eiffel Tower struck by lightning or veiled by a thick fog of pollution, the bustle of passersby and cars on Boulevard Malesherbes, street corners, wounded veterans, empty chairs in the Luxembourg Gardens, a train crossing a viaduct in Meudon. These photographs appeared in publications all over Europe, but also in the surrealist magazine *Bifur*. In 1934, Kertész published *Paris vu par André Kertész* (Paris Seen by André Kertész): a collection of views of the French capital. Within its pages, he revealed what Pierre Mac Orlan somewhat enigmatically called "the social fantastic" in his foreword: the mysterious, disturbing dimension of life overtaken by modernity, as rendered in Kertész's photographs of Paris, which followed the legacy of Eugène Atget.* His views of the tangle of zinc roofs undulating into the distance recall shots from the films of René Clair* and Marcel Carné* from the same period. P M

Christian Bouqueret. *Des Années folles aux années noires: La nouvelle vision photographique en France, 1920–1940*. Paris: Marval, 1997.
Michel Frizot and Anne-Laure Wanaverbecq, eds. *Kertész*. Paris: Hazan/Éditions du Jeu de Paume, 2010.
Danièle Sallenave, ed. *André Kertész*. London: Thames & Hudson, 2007.

Crippled man selling lily of the valley on Avenue des Champs-Élysées, May 1, 1928.

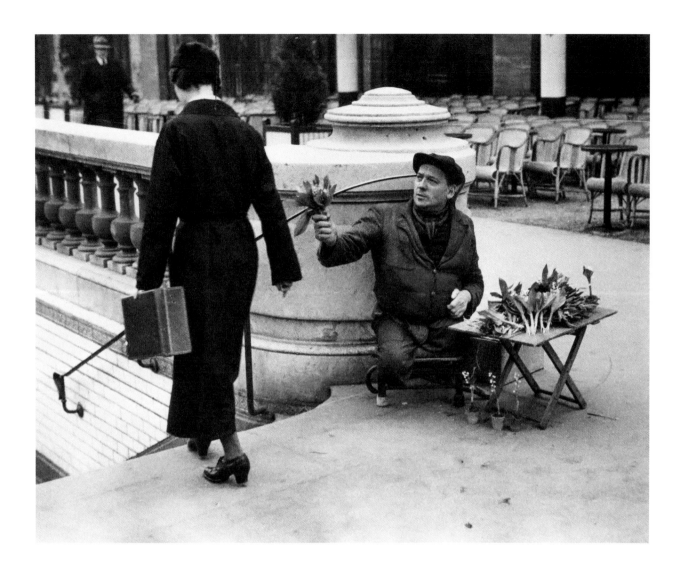

François Kollar

1904, Senec (Austro-Hungarian Empire)
1979, Créteil

František Kollar was twenty years old when he left what is now Slovakia in 1924 to come to Paris. He began as a factory worker at Renault before later becoming the photojournalist of French industry and its workers.

From 1927 to 1930, he worked at various jobs in the fields of printing and photography, acquiring in the process a sound knowledge of the techniques of photomontage, solarization, and overlaying.

In 1930, Kollar opened his own studio, where he took artistic photographs and advertising shots that were published in the weekly magazines *L'Illustration* and *VU*. He participated in the historic *Film und Foto* exhibition in Stuttgart in 1929, along with other Parisian photographers including Germaine Krull,* Florence Henri,* and André Kertész.* His photographs were widely published, notably *The Eiffel Tower* (1930), which seems to oscillate through the overlaying and duplication of the three top floors.

In 1931, he received the most significant French photographic commission of the decade: a report on the country's industrial and agricultural métiers. For this project, he took more than ten thousand photographs, a selection of which was published between 1932 and 1934 in the fifteen thematic volumes of the book series *La France travaille* (France at Work).

He obtained several public commissions during the Popular Front period. Charlotte Perriand* used his photographs in her large-scale photomontages for the Ministry of Agriculture in 1936, and his images featured in numerous pavilions at the 1937 Exposition Internationale. He also continued his advertising work, playing with double exposure, backlighting, and reflections in his coverage of the collections of such celebrated couturiers as Jeanne Lanvin,* Gabrielle Chanel,* and Elsa Schiaparelli.* P M

François Kollar: Un ouvrier du regard. Paris: Éditions de La Martinière, 2016. Exhibition catalog.
Anne-Claude Lelieur and Raymond Bachollet. *La France travaille: Regard sur le monde du travail à la veille du Front populaire*. Paris: Société Nouvelle des Éditions du Chêne, 1986.

Aux Sources de l'énergie (To the sources of energy), illuminated signs, 1931.

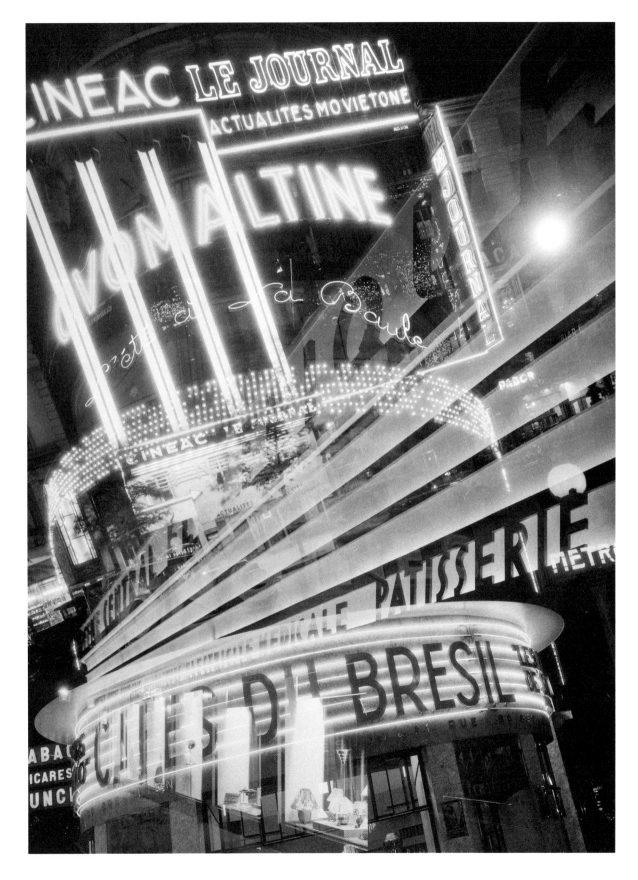

Germaine Krull

1897, Posen (German Empire)
1985, Wetzlar (Germany)

Germaine Krull may have lived in Paris for only a decade, between 1926 and 1937, but it was a crucial period in her especially rich career as a photographer. Her political commitment was constant: she was involved with the German Communist Party after World War I, joined the Allies during World War II, and spent her last years in a Buddhist retreat in India.

Having studied photography in Munich in the late 1910s, Krull moved to Paris at the end of 1926 and turned her art to various purposes, including commissions to make ends meet, advertising campaigns (for the new Peugeot in 1929, for example), and fashion assignments (with Paul Poiret* as well as Sonia Delaunay*). She also reinvented the genre of the female nude, and worked, above all, in artistic avant-garde circles, where her talent was quickly recognized and she was invited to take part in prestigious national and international exhibitions. She mostly earned her living as a photojournalist, working for the magazine *VU*, like her colleagues André Kertész* and Man Ray.* She also took memorable portraits of notable figures such as Colette, André Gide,* André Malraux, and her friend Walter Benjamin.*

Working in the spirit of László Moholy-Nagy and the New Vision movement, she published the photogravure portfolio *Métal* in 1928, in which she revealed an unprecedented, dynamic approach (tightly framed, low-angle, or Dutch-angle shots) to photographing the great industrial constructions that embodied modernity: transporter bridges, cranes and, later, the Eiffel Tower, to which she devoted a famous series. *Métal* was followed by *100 × Paris* in 1929 and, a year later, by *Études de nus* (Study of Nudes), with an introduction by Jean Cocteau.

Krull left Paris in 1939 for Monte Carlo, then Rio de Janeiro, before joining the Free French in Brazzaville in 1942. She covered the Provence landings in 1944 and the advance of the First French Army under General de Lattre de Tassigny up to the liberation of the Struthof concentration camp in Alsace, in November 1944. G MJ, P M

Michel Frizot. *Germaine Krull*. New Haven, CT: Yale University Press, 2015.
Germaine Krull. *La Vie mène la danse*. Paris: Textuel, 2015.
Pierre Mac Orlan. *Germaine Krull*. Paris: Gallimard, 1931.
Kim Sichel. *Germaine Krull: Photographer of Modernity*. Cambridge, MA: MIT Press, 1999.

Boulevard des Maréchaux, 1930.

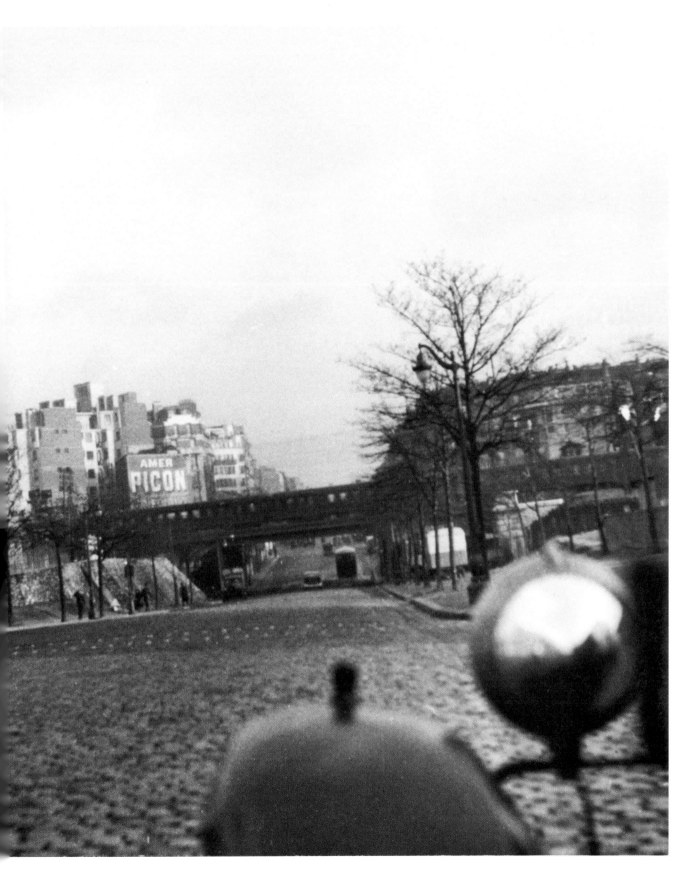

Jeanne Lanvin

1867, Paris
1946, Paris

Jeanne Lanvin established herself as a milliner in 1889. Nine years later she opened a department for children's clothes, which became a fashion house in 1909. Endowed with an innate sense of sophistication, she instinctively looked to history for inspiration, and her *robes de style*, with their long bodices, low waists, and full skirts, reminiscent of seventeenth- and eighteenth-century dresses, made her famous. She also drew on traditional folklore for her embroideries, which were in keeping with a repertoire of simple shapes. She made lapis lazuli her signature color.

She soon branched out into other sectors: Lanvin Sport opened in 1923 with suits for women, and in 1926 her fashion house became unique when it established a men's department, which produced made-to-measure suits and shirts; a boutique was added for articles designed by her nephew, Maurice Lanvin. The company flourished, employing up to twelve hundred people and opening branches in Cannes, Biarritz, Deauville, and Le Touquet, as well as in Madrid, Buenos Aires, São Paulo, New York, and London. Another key to the house's success was its range of perfumes, including the famous Arpège, created in 1927, whose bottle was exalted in advertising photographs by Florence Henri.*

In addition to her fashion house, Jeanne Lanvin created Lanvin Décoration in 1920, whose director, Armand Albert Rateau, designed the interiors for the couturière's townhouse on Rue Barbet-de-Jouy, the Faubourg Saint-Honoré boutiques, and the Théâtre Daunou. In the 1930s, she turned to Eugène Printz to design her offices. A discreet, commanding, respected figure, she was also an active member of her profession's institutions and associations. Her fashion house is the oldest still in operation in Paris. C Ö

Hélène Guéné. *Décoration et haute couture: Armand Albert Rateau pour Jeanne Lanvin, un autre Art* déco. Paris: Les Arts Décoratifs, 2006.
Jeanne Lanvin. Paris: Paris-Musées/Musées de la Ville de Paris, 2015. Exhibition catalog.
Dean L. Merceron. *Lanvin*. New York: Rizzoli, 2007.

↓ Sketch of the Lesbos dress, 1925.

→ Fitting session in the atelier, c. 1930. Photograph by Laure Albin-Guillot.

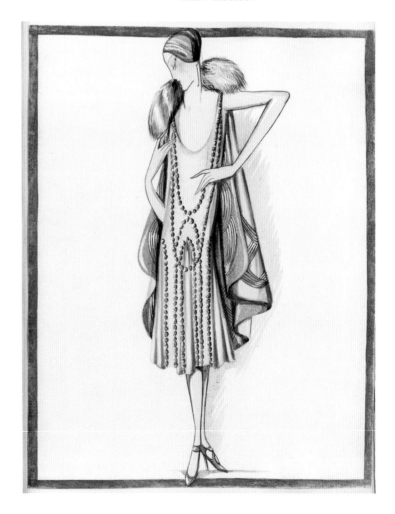

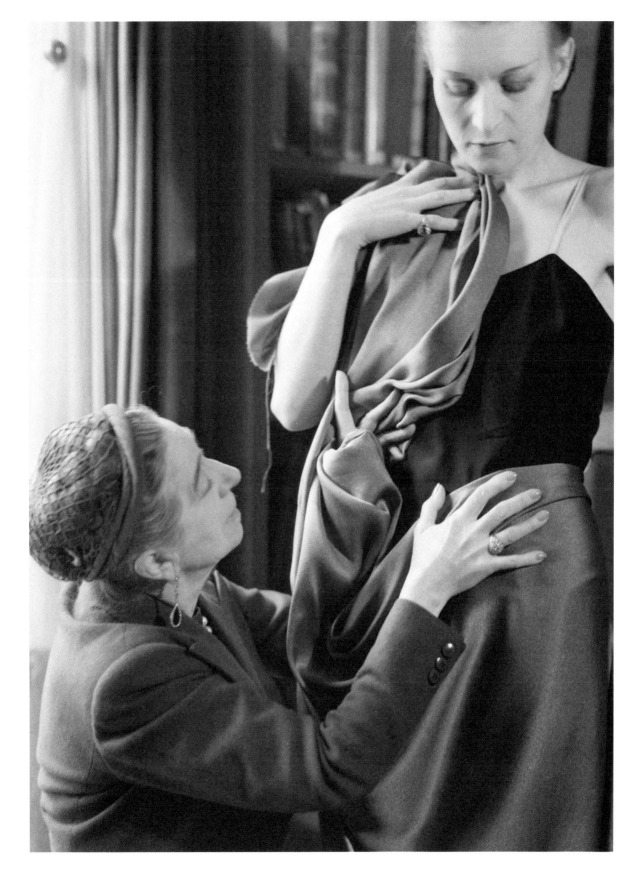

Le Corbusier

(b. Charles-Édouard Jeanneret)

1887, La Chaux-de-Fonds (Switzerland)
1965, Roquebrune-Cap-Martin (France)

The young Charles-Édouard Jeanneret (who would not adopt the pseudonym Le Corbusier until 1920) viewed Paris from his native Switzerland rather like a Rastignac, with the eyes of an ambitious arriviste. Just like the homonymous character in Balzac's *Père Goriot*, he could have issued the same famous challenge, "It's between you and me now!" when he moved to the French capital in 1917. Before World War I, he had spent a year or so studying there, working with the Perret brothers* and painting watercolors along the banks of the Seine, but it was this definitive move, at the age of thirty-one, that would lay the foundations for his career as an international modern architect. For how could he conquer the world, if not from Paris? He lived in the capital until his death nearly fifty years later, first in Saint-Germain-des-Prés, not far from his studio at 35 Rue de Sèvres, and then, in 1934, on the top floor of the building he designed on Rue Nungesser-et-Coli, on the edge of Boulogne. This did not prevent him from traveling extensively throughout his life, however, to lecture and seek commissions. During the interwar period, Le Corbusier visited almost every country in Europe and spent time in North Africa, North and South America (where he was charmed by the exuberance of Josephine Baker* in 1929), and the Soviet Union.

Upon his arrival in Paris, he met the painter Amédée Ozenfant—who introduced him to oil painting, and cofounded with him the purist pictorial movement and the magazine *L'Esprit nouveau*—and this meeting gained him entry into Paris's avant-garde circles of the 1920s, although he remained on its fringes. His long friendship with Fernand Léger* dates back to those early years.

Le Corbusier's first forays into Parisian architecture, always in collaboration with his cousin Pierre Jeanneret, maintained his links with his Swiss roots: the adjacent villas he built in 1923–25 in western Paris were commissioned by his older brother, the musician Albert Jeanneret, and by a

↓ Villa Stein-de Monzie, Garches, 1928. View of the front façade. Photograph by Charles Gérard.

→ The Esprit Nouveau pavilion at the Exposition Internationale des Arts Décoratifs et Industriels Modernes, 1925. Interior view with a sculpture by Jacques Lipchitz, Le Corbusier's "*casiers standards*" (industrial storage units) and Fernand Léger's *Le Balustre* (*The Baluster*).

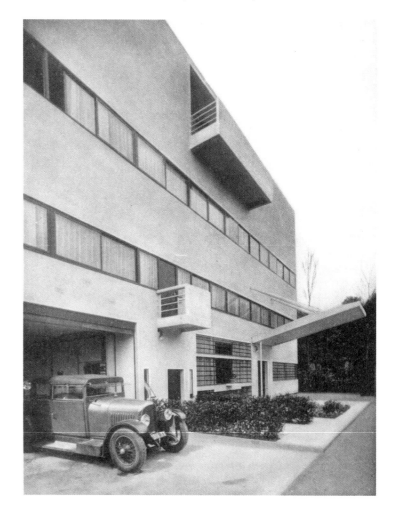

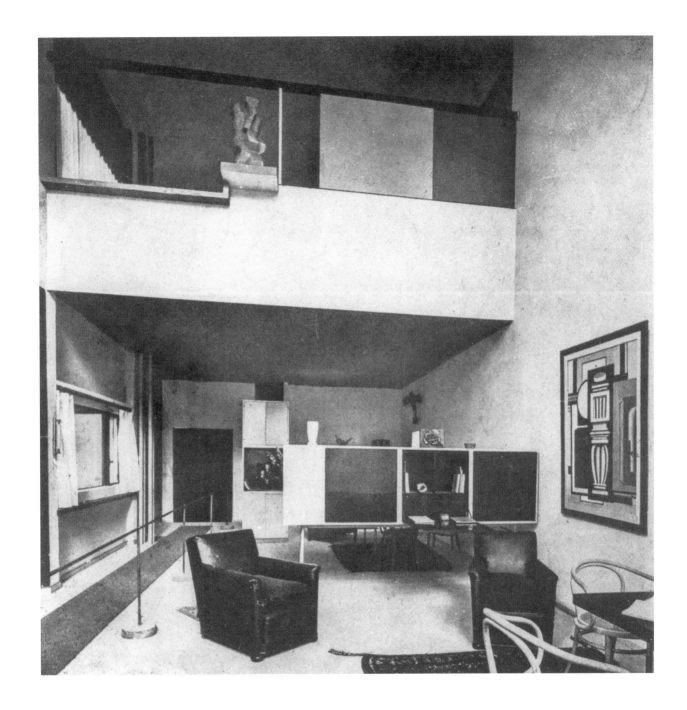

Basel banker, Raoul La Roche. The latter acquired the first purist paintings and followed Le Corbusier's recommendations for the purchase of other modern works, which he exhibited in the double-height gallery that was the showpiece of his home. This paved the way for the nine more or less luxurious villas he built in Paris and its western suburbs over the next ten years. The most striking examples are those Le Corbusier constructed in 1923–24 in Boulogne for his sculptor friend Jacques Lipchitz*; in 1926–27 in Boulogne (flanked by houses by Raymond Fischer and Robert Mallet-Stevens*) for the American journalist William Cook; in 1926–28 in Garches for Gertrude Stein's* brother Michael, his wife Sarah, and Gabrielle de Monzie (for its creator, this building "reveals the compression of the organs inside a rigid, absolutely pure envelope," thus inducing a "spiritual delight"); and in 1928–31 in Poissy-sur-Seine for the businessman Pierre Savoye (a white parallelepiped on pillars). This embodiment of the "Five Points of a New Architecture," formulated by Le Corbusier in 1927, also expressed the virtues of the "architectural promenade" and became an archetype of modern architecture. At the 1929 Salon d'Automne, the furniture designed with his cousin and Charlotte Perriand* (who had been working in the studio since 1927)—which is still produced and sold today, albeit frequently copied—was presented on the stand of "the interior equipment of a home." Pursuing this domestic register, Le Corbusier delivered a vibrant tribute in 1931 to what he called "the spirit of Paris," in the form of Charles de Besteigui's apartment on Avenue des Champs-Élysées: the terraces of this penthouse offered carefully framed views of various places in the capital, whose landscape was projected into the apartment by a periscope.

His contributions to the two major Expositions Internationales held in Paris during the interwar period were modest in size but significant in their impact. In 1925, the Esprit Nouveau pavilion revealed a life-size demonstration of one of his leading projects of the time: the "apartment block-villas" of 1922. In 1937, the tent of the Temps Nouveaux pavilion presented the ideas arising out of his theoretical "Ville Radieuse" (Radiant City) project. The 1925 pavilion also displayed drawings of the Plan Voisin, which proposed razing the Right Bank neighborhoods of central Paris

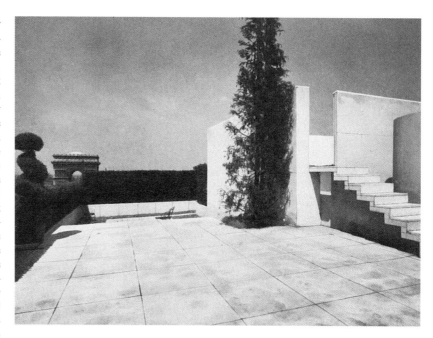

to make way for office skyscrapers, no less, preserving only a few monuments such as the Louvre and Notre-Dame. Although it remains uncertain just how serious a proposition this was, his provocative project earned him (and still does) a chorus of protestations from conservatives and friends of old Paris. His subsequent proposals for the capital (which were always made on his own initiative)—notably regarding "insalubrious block" no. 6, in the north-east of the city, on the occasion of the 1937 Exposition Internationale—confirmed this radical attitude to the existing fabric. He nevertheless made repeated declarations of love for the City of Light, to which he devoted numerous projects and two of his books.

Two buildings for collective use were erected in 1933 in the south of Paris: the Salvation Army's Cité de Refuge—a large glass-clad vessel in which Le Corbusier experimented with a primitive form of air-conditioning—and the Pavillon Suisse (also known as the Fondation Suisse) student residence at the Cité Internationale Universitaire. However, despite his commitment to economical collective housing, he did not obtain any commissions in Paris; his first such project was commissioned by Raoul Dautry* for the Unité d'Habitation in Marseille in 1945.

Le Corbusier, the major modernist figure, addressed almost every possible architectural and urban program in Paris and its region. However, the majority of the

↑ Charles de Beistegui's apartment on Avenue des Champs-Élysées, 1929–31. View from the terrace, with the Arc de Triomphe in the background.

↗ Le Corbusier's Plan Voisin for Paris, 1925. Model made for Pierre Chenal's film *Architecture d'aujourd'hui* (Today's Architecture), 1930.

→ Development project for "insalubrious block" no. 6, 1935. Aerial perspective. Ink on tracing paper.

many projects he conceived never came to fruition. Thus his proposition for a museum of the twentieth century at Nanterre-La Défense, examined shortly before his death at the request of André Malraux, can be seen as the foretold epilogue to a thwarted Parisian destiny. G MJ

Tim Benton. *The Villas of Le Corbusier and Pierre Jeanneret, 1920–1930*. Basel: Birkhäuser, 2007.
Le Corbusier and Pierre Jeanneret. *Œuvre complète*. 8 vols. Zurich: Les Éditions d'Architecture, 1929–69.
Le Corbusier. *Destin de Paris*. Clermont-Ferrand: Sorlot, 1941.
Le Corbusier. *Les Plans Le Corbusier de Paris, 1956–1922*. Paris: Les Éditions de Minuit, 1956.
Le Corbusier. *Precisions on the Present State of Architecture and City Planning*. Translated by Tim Benton. Boston: MIT Press, 2016 (1930).
Jacques Lucan, ed. *Le Corbusier: Une encyclopédie*. Paris: Éditions du Centre Pompidou, 1987.
Bruno Reichlin. *Écrits sur Le Corbusier*. Zurich: Scheidegger & Spiess, 2022.

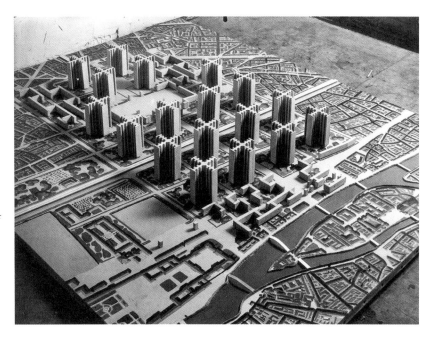

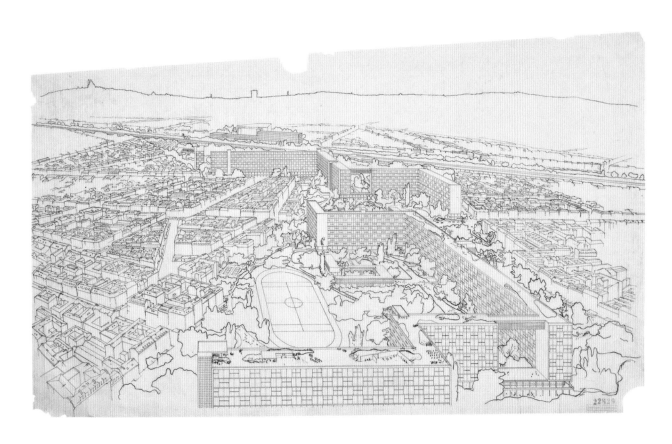

Fernand Léger

1881, Argentan (France)
1955, Gif-sur-Yvette (France)

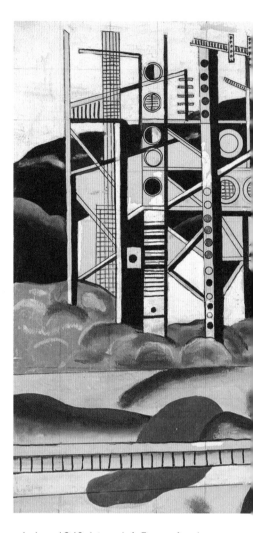

After an apprenticeship with an architect in Caen, Fernand Léger left Normandy in 1903 for Paris—where he would spend most of his life—to attend the École des Arts Décoratifs and, as an unregistered student, the École des Beaux-Arts. His career was already well underway, but would be interrupted by his years at the front during World War I. He was discharged in 1917, and his first solo exhibition was held in Léonce Rosenberg's Galerie L'Effort Moderne, a haven for contemporary art. A committed avant-gardist, Léger took part in the great Ballets Russes adventure, and contributed to Marcel L'Herbier's* film L'Inhumaine (The Inhuman Woman) in 1923, along with Robert Mallet-Stevens,* Pierre Chareau,* and Paul Poiret.* A year later, his own film Ballet mécanique (Mechanical Ballet), devoid of plot and relying solely on the contrast between image and rhythm, testified to his enduring interest in cinema. During the 1920s, the big city—that modern metropolis perpetually in motion, with its construction sites, its machines, and its crowds—was one of his favorite subjects.

Throughout his life, Léger was closely associated with architects and their milieu. He was close to Paul Nelson*—an American in Paris who would provide him with his only experience of architecture in color at the Saint-Lô hospital in the 1950s, following an earlier collaboration in the 1930s on his Maison Suspendue (Suspended House) project—and Jean Badovici,* for whose home in Vézelay he created a fresco in 1936. Léger also frequented Le Corbusier,* whom he met, according to legend, through Auguste Perret* at the Café de la Rotonde in 1920. They became very good friends. The architect invited the painter to speak at the Fourth International Congress of Modern Architecture, held in Athens in 1933, and they had the opportunity to cross swords during the controversial debates on painting organized by Louis Aragon* at the Maison de la Culture, published under the title La Querelle du réalisme (The Dispute about Realism). But it was only in the United States that he was able to implement his ideas on the relationship between wall and painting, thanks to the architect Wallace Harrison.

He took part in the 1937 Exposition Internationale with the young Charlotte Perriand,* his friend and neighbor from Rue Notre-Dame-des-Champs, and they worked together on immense collages for the event.

During the 1930s, Léger's work contributed to the general "return to order," while his canvases became increasingly large, even monumental. Among these are Composition aux deux perroquets (Composition with Two Parrots) from 1935–39 (13 ft. × 15 ft. 8 in./4 × 4.8 m), and, especially, his huge panel Le Transport des forces (16 ft. × 28 ft. 6 in./4.9 × 8.7 m), commissioned by the state for the 1937 Exposition Internationale.

In late 1940, Léger left France for the United States, where he had already stayed three times and where he enjoyed a very productive period, before returning to Paris in 1945. G MJ

Katia Baudin, ed. Fernand Léger: Painting in Space. Cologne/Munich: Museum Ludwig/Hirmer Verlag, 2016. Exhibition catalog.
Ariane Coulondre, ed. Fernand Léger—Le Beau est partout. Metz: Centre Pompidou Metz, 2018. Exhibition catalog.
Christian Derouet, ed. Fernand Léger. Paris: Centre Pompidou, 1997. Exhibition catalog.
Fernand Léger. Functions of Painting. Translated by Alexandra Anderson. London: Thames and Hudson, 1973.
François Mathey, ed. Fernand Léger. Paris: Musée des Arts Décoratifs, 1956. Exhibition catalog.

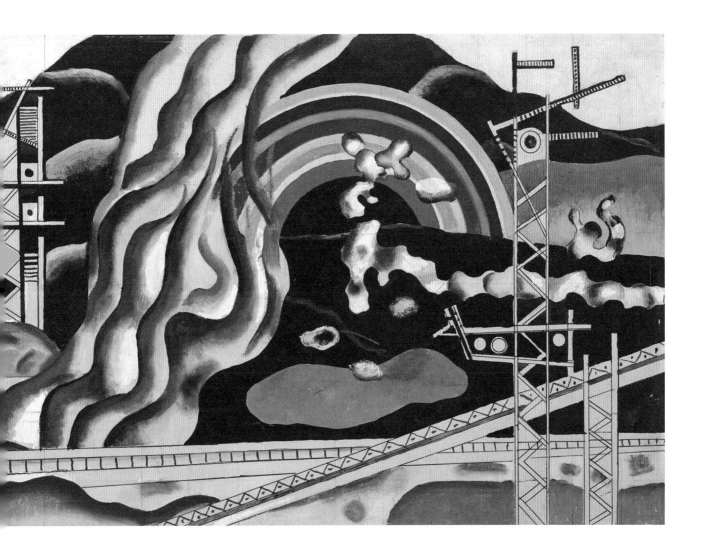

Le Transport des forces (*Transport of Forces*), displayed in the lobby of the Palais de la Découverte during the Exposition Internationale des Arts et des Techniques Appliqués à la Vie Moderne, 1937. Oil on canvas.

Tamara de Lempicka

1898, Warsaw
1980, Cuernavaca (Mexico)

Tamara de Lempicka fled the October Revolution to settle in Paris, where she completed her artistic training in various academies, before finding the style—at once figurative and modern—that brought her success. She was an active presence on the Parisian social scene, frequenting artists and the wealthy at Paul Poiret's* soirées and in cabarets and nightclubs, notably in the company of André Gide* and Suzy Solidor, who was one of her mistresses. This image of a liberated woman is evident in her famous 1929 self-portrait, *Tamara in the Green Bugatti*, which was used for the cover of a German fashion magazine.

To earn a living, she painted brightly colored portraits commissioned by the celebrities she met during her social whirl. In 1929, she set up her studio-apartment, designed and furnished in an uncompromisingly modern style by her architect sister Adrienne Gorska,* in a building in Montparnasse constructed by Robert Mallet-Stevens.*

In 1939, she emigrated to the United States, where she had already spent time ten years earlier, executing portrait commissions and, more originally, views of skyscrapers that testify to her fascination with the productions of modern life. G M J

Gioia Mori. *Tamara de Lempicka: The Queen of Modern*. Milan: Skira, 2013.

Portrait of the artist painting the portrait of her husband, Tadeusz Łempicki, 1928. Photograph by Thérèse Bonney (colorized).

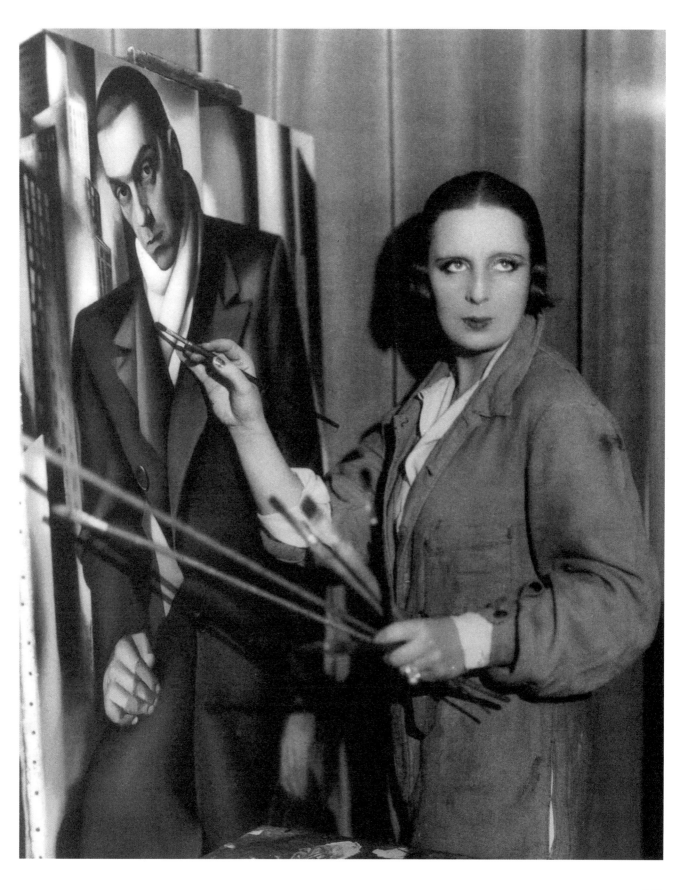

Marcel L'Herbier

1888, Paris
1979, Paris

After studying law and literature, Marcel L'Herbier channeled his literary and poetic ambitions into post-symbolist works inspired by Oscar Wilde, but which already revealed the influence of the "democratic art" advocated by Leo Tolstoy. Turning to screenplays in 1917, he was the filmmaker most in tune with the art deco trends of the time, and *L'Inhumaine* (*The Inhuman Woman*) of 1923 successfully blended his modernism with an urban setting, the automobile, still-virtual television, and . . . Paris. The pet project of singer Georgette Leblanc (who produced it with Cinégraphic,

L'Herbier's independent company), the film mobilized the talents of architects Robert Mallet-Stevens* (cubist house, plans, etc.) and Pierre Chareau;* of decorators Claude Autant-Lara* and Alberto Cavalcanti;* and of the painter Fernand Léger.* Costumes by Paul Poiret,* a concert by George Antheil, and a score by Darius Milhaud all contributed to this uneven but unique work, based on a pretext scenario derived from a roman à clef by Camille Mauclair and revised by Pierre Mac Orlan. With *Le Vertige* (Vertigo) of 1925, for the Cinéromans production company, the sets were once again by Mallet-Stevens and Chareau, while artworks by Robert and Sonia Delaunay,* Jean Lurçat, and Marie Laurencin were hung on the walls of the duplex where the film was shot.

L'Herbier lived on Rue Mallet-Stevens, where he had purchased one of Paris's most characteristic art deco apartments. Veering between films of different styles, he produced his best work of this first period with

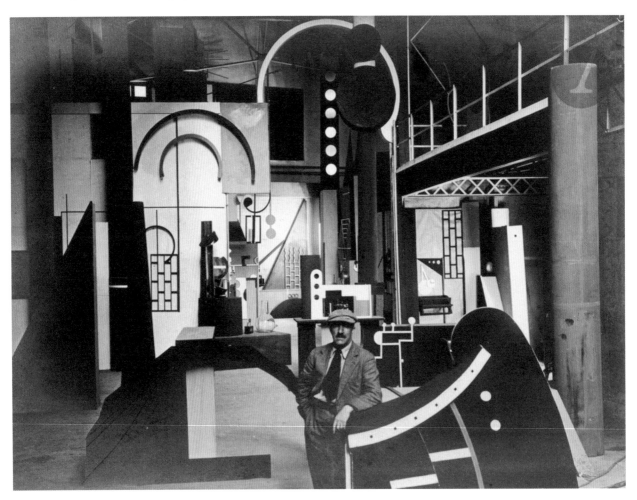

L'Argent (Money) of 1928, updating Émile Zola's novel of the same name to depict the Paris of high finance, speculation, and stock market swindles. The mobility of the camera, the rhythm of the cutting and editing which was tuned to the frenzied flow of money via telephone, the shouted orders on the stock exchange—this is the film of the generalized acceleration induced by financial capitalism. *Le Mystère de la Chambre Jaune, Le Parfum de la Dame en Noir* (The Mystery of the Yellow Room, the Perfume of the Woman in Black) of 1931, *La Comédie du Bonheur* (The Comedy of Happiness) of 1940, and *La Nuit Fantastique* (The Fantastical Night) of 1942 belong to a second period in which experimentation was no longer the order of the day. During World War II and the Occupation years, L'Herbier was the director of the Institut des Hautes Études Cinématographiques (Institute for Advanced Cinematographic Studies) and president of the Cinémathèque Française. In the early 1950s, he moved into television. F A

Noël Burch. *Marcel L'Herbier*. Paris: Seghers, 1978.
Laurent Véray, ed. *Marcel L'Herbier, l'art du cinéma*. Paris: Association Française de Recherche sur l'Histoire du Cinéma, 2008.

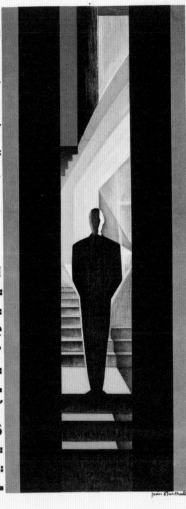

=qu'il soit d'a=
bord bien é=
tabli que le
modernisme
de"caligari"
et celui de —
"l'inhumaine"
-sont absolu=
ment différents.
pour marcel
l'herbier-
-le cubisme
n'est pas le
rêve d'un fou
c'est le résul=
tat d'une pen=
sée bien nette
— ce metteur
en scène a é=
tabli dans —
"l'inhumaine"
des images
qui vous en=
lèvent la res=
piration —

c'est une chanson
éclatante sur
la grandeur de
la technique mo=
derne.toute cet=
te réalisation
visuelle tend
vers la musique
et le cri de —
— tristan
devient vrai
"j'entends-
la lumière"
-les dernières
images de —
"l'inhumaine"
dépasse l'ima=
gination.en
sortant de la
voir on a l'im=
pression d'avoir
vécu l'heure
de la naissance
d'un nouvel art=
adolf loos —

← *L'Inhumaine* (The Inhuman Woman), 1924. Fernand Léger surrounded by the set for the film.

↑ Jean Burkhalter, poster for *L'Inhumaine*, 1924.

Jacques Lipchitz

(b. Chaim Jacob)

1891, Druskininkai (Russian Empire)
1973, Capri (Italy)

Sculptor Jacques Lipchitz came to Paris in 1909 and met several modern artists in the studios at La Ruche, including Amedeo Modigliani and Pablo Picasso.* Working in a markedly cubist idiom, he caught the eye of art dealer Léonce Rosenberg in 1916, who showed Lipchitz's work in his Galerie L'Effort Moderne in 1920. Lipchitz then returned briefly to classical figuration, creating celebrated portraits of figures such as Gertrude Stein,* Annie Bernheim-Dalsace—who commissioned Pierre Chareau's* Maison de Verre (House of Glass)—and Coco Chanel.*

Lipchitz's work intersected with modern architecture several times: in 1927, for the garden of the Villa Noailles* built by Robert Mallet-Stevens,* he created the mobile bronze sculpture La Joie de vivre, cast in Jean Prouvé's* workshops in Nancy. His most frequent collaborations were with Le Corbusier* who, in 1923, designed the artist's villa-studio in Boulogne-sur-Seine, paired with that of sculptor Oscar Miestchaninoff. In 1925,

during the Exposition Internationale des Arts Décoratifs et Industriels Modernes, Le Corbusier installed Lipchitz's *Baigneuse* (*Bather*) in front of the Esprit Nouveau pavilion, and inside was *Marin à la guitare* (*Sailor with Guitar*), a small work in stone dating from 1917. In 1931, the Le Corbusier villa built for Hélène de Mandrot in the Var region of France hosted *Nu couché avec guitare* (*Reclining Nude with Guitar*) on its terrace and, further out in the garden, perched on a high pedestal, *Le Chant des voyelles* (*Song of the Vowels*). Before Lipchitz left for the United States in 1941 to escape Nazism, the Popular Front commissioned the monumental *Prométhée étranglant le vautour* (*Prometheus Strangling the Vulture*) in plaster for the 1937 Exposition Internationale. The work was presented in the Palais de la Découverte. G MJ

Jacques Lipchitz. Paris: Éditions du Centre Pompidou, 2004. Exhibition catalog.
Jacques Lipchitz. *My Life in Sculpture*. New York: Viking Press, 1972.

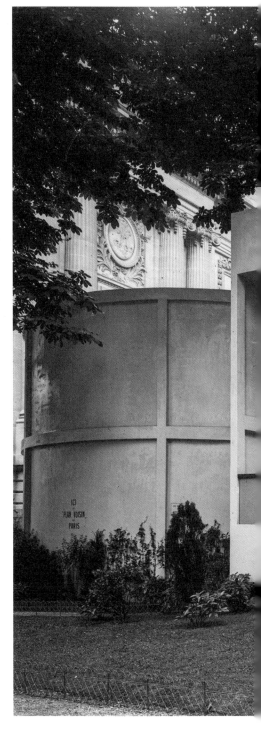

Baigneuse (*Bather*), c. 1923, in front of the Esprit Nouveau pavilion at the Exposition Internationale des Arts Décoratifs et Industriels Modernes, 1925.

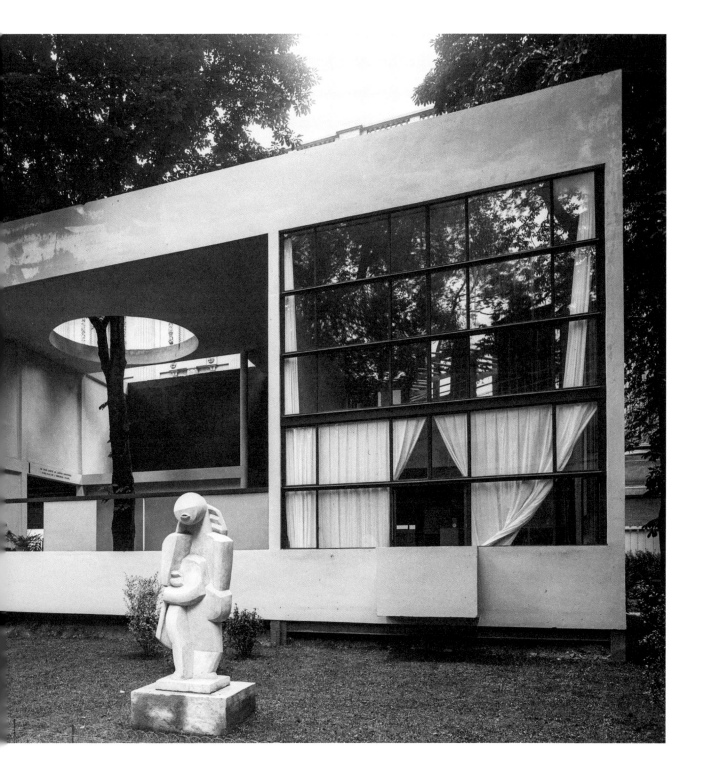

Adolf Loos

1870, Brno (Austro-Hungarian Empire)
1933, Kalksburg (Austria)

Renowned in Vienna as much for his writings as for his pared-down houses, architect Adolf Loos left his job at the helm of the housing office in the Austrian capital in 1922 and moved to Paris, where he remained until 1928. He was no stranger to the French public who, in 1912 and 1913, had been able to read the translation of his polemical essays "Ornament and Crime" and "Architecture" in the pages of Georges Besson's journal *Cahiers d'aujourd'hui*.

At the 1923 Salon d'Automne, he exhibited his project for the Grand Hôtel Babylone in Nice: a double ziggurat that would have dominated the Promenade des Anglais. In a similar vein, he soon embarked on plans for a building situated at the corner of the Avenue des Champs-Élysées and Rue La Boétie, returning to the

↓ House for Tristan Tzara, Avenue Junod, 1925-26. Plans, section, and elevations. Ink on tracing paper.

→ Retouched view of the façade on Avenue Junod, c. 1926.

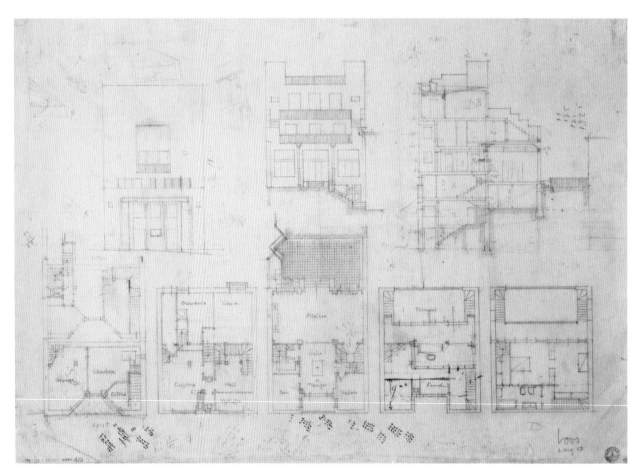

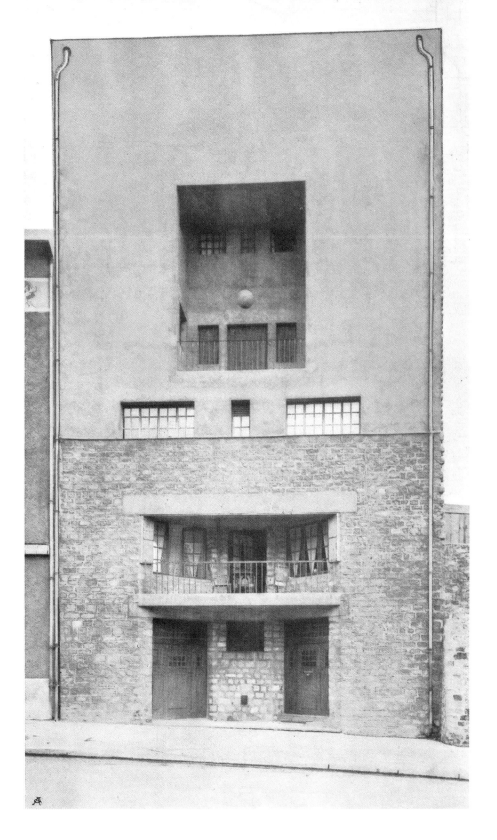

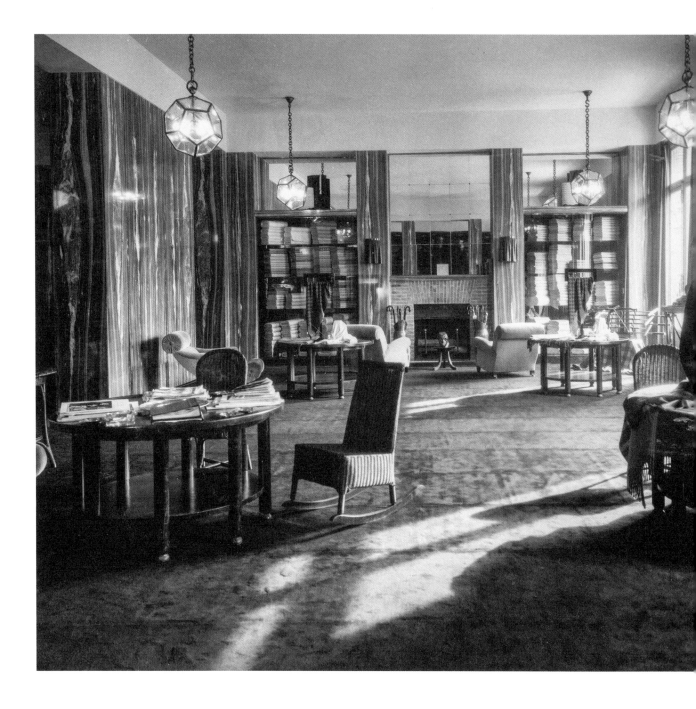

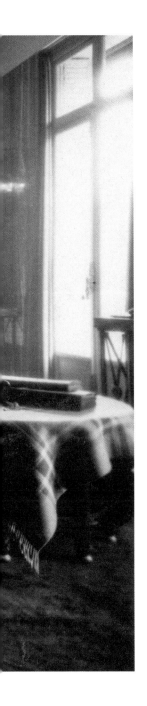

stepped form he had used for the hotel. His design shows the symmetrical façade on the avenue advancing in relation to the main volume in the background, while the two corners are treated as cylinders whose tops emerge above the plane of the roof, in an almost abstract interpretation of post-Haussmannian buildings.

On the same avenue, Loos created the Kniže store inside the Portiques des Champs-Élysées: a vast set of galleries designed by the architect Louis Grossard and the engineer Édouard Perrin for the brothers Adolphe and Léonard Rosenthal. Echoing the tailor's boutique he had built on the Graben in Vienna, he brought together the main elements of his Viennese lexicon: wall mirrors, a brick fireplace with hangings, and polyhedral lighting fixtures. He also installed reclining easy chairs of his own design to accompany the English-inspired furniture. *A Shopping Guide to Paris*, published in 1929 in New York by Louise Bonney* and illustrated with the photographs of her sister, Thérèse Bonney, pronounced this interior "every inch modern."

Loos had mixed success with his designs for residences, however. The extraordinary Paris mansion he designed in 1927 for the American music hall star Josephine Baker,* on the corner of Avenue Bugeaud and Rue du Général-Clergerie, never made it off the drawing board. A model shows the façade with its black-and-white stripes, which he had planned to execute in marble. This motif is extended to the cylinder that serves as a visual signal on the avenue. Designed as a theater rather than a home, the interior was intended to have a swimming pool in its center.

Loos had more luck with poet Tristan Tzara's* townhouse, which he built on Avenue Junot, on the slopes of Montmartre. The façade on the avenue is perfectly terse, with its millstone base and roughcast surface. The *Raumplan*— or spatial plan—that unfolds from room to room under the protection of the severe mask facing the avenue is revealed on the garden side only, which faces the interior of the block.

Along with Walter Gropius, Loos was one of the two foreign architects to whom Paris publisher Georges Crès devoted a (modest) monograph, after publishing the collection of his Viennese chronicles from the turn of the century. J-L C

Franz Glück. *Adolf Loos*. Paris: G. Crès & Co., 1931.
Adolf Loos. *Spoken into the Void*. Paris: G. Crès & Co., 1921.
Burkhardt Rukschcio and Roland Schachel. *Adolf Loos: Leben und Werk*. Salzburg: Residenz-Verlag, 1987.
Panayotis Tournikiotis. *Adolf Loos*. New York: Princeton Architectural Press, 1994.

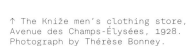

↑ The Kniže men's clothing store, Avenue des Champs-Élysées, 1928. Photograph by Thérèse Bonney.

→ Design for a townhouse for Josephine Baker, Avenue Bugeaud, 1927. View of the maquette.

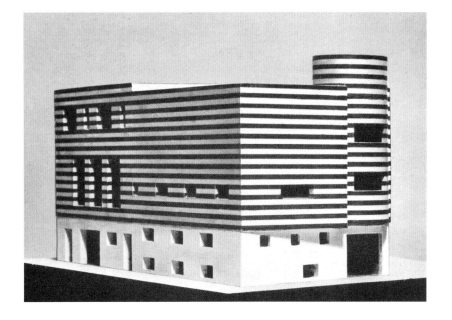

André Lurçat

1894, Bruyères
1970, Sceaux

André Lurçat studied in Nancy, in the studio of painter Victor Prouvé, then at the École des Beaux-Arts in Paris, where he was admitted to the Atelier Paulin in 1914. At the 1923 Salon d'Automne he made a name for himself with theoretical projects that perceptibly echoed the houses of Adolf Loos.* With the help of his brother Jean, a painter in vogue at the time, he built a group of artists' studios at the Villa Seurat between 1924 and 1926, presenting the very image of a modern ensemble with sharp edges and geometric openings, two years before Rue Mallet-Stevens was constructed.* In Versailles, he built the Bomsel house (1926) and in Paris the studio of the painter Walter Guggenbühl, facing the Parc Montsouris (1927), but he failed to make his mark in the domain of social housing.

Better known in Europe than other members of his generation, he organized in Nancy the architecture section of the Nancy-Paris Committee exhibition in 1926, where the buildings of the Bauhaus were presented in France for the first time. A member of the Congrès Internationaux d'Architecture Moderne (International Congresses of Modern Architecture) from their inception in June 1928, Lurçat sided with the Germans and Austrians within the organization's ranks in opposition to Le Corbusier.* He was then invited in 1932 by Josef Frank to build four houses in the Austrian Werkbund's model city in Vienna.

In 1929, Lurçat wrote *Architecture*, a manifesto inspired by Le Corbusier's *Vers une architecture* (*Toward an Architecture*). In the same period, he built the Nord-Sud Hotel in Calvi, Corsica: a pure white volume perched on the rocks. The following year, he was commissioned to build a school complex for the municipality of Villejuif, just outside Paris. Its long horizontal windows, its pilotis, its garden terrace, and the quality of its facilities made it a modern monument amid "red" suburbia. This flagship

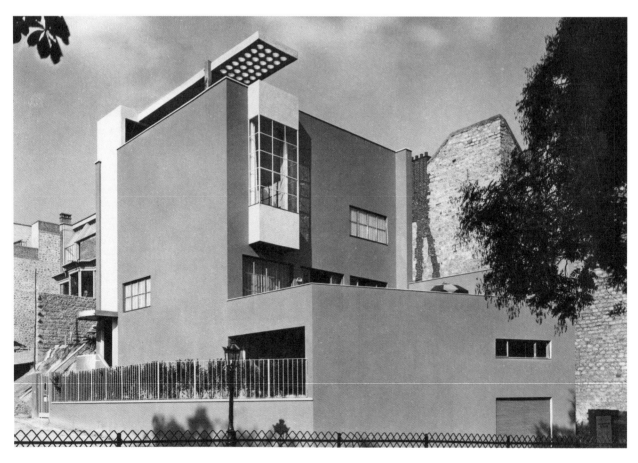

of the municipal policy of the Communist Party, with which Lurçat developed close ties, was unveiled in 1933 to great fanfare.

Lurçat continued to work on theoretical projects, such as a linear aerodrome superimposed on the Île des Cygnes, in the middle of the Seine (1931), but did not receive any more private commissions, with the exception of the Villa Hefferlin, in Sèvres, whose large horizontal volume is reminiscent of Frank Lloyd Wright's vocabulary. In 1933, after the Depression had forced him into idleness, he opened a teaching workshop in Paris, where the German philosopher Max Raphaël taught aesthetics. He was invited to Moscow in 1934 and worked on several projects for public buildings and a school. Resisting the pressure of socialist realism, he theorized a reasoned return to the historical principles of architecture, which led him to write his treatise *Formes, compositions et lois d'harmonie* (Forms, Compositions, and Laws of Harmony) during World War II. On his return to Paris, he conceived an unfinished project for the city hall in Blanc-Mesnil, which revealed traces of his Russian experience. During the Occupation, after drawing up several reconstruction plans, he became an active member of the Resistance: the fighting in August 1944 saw him take the headquarters of the Order of Architects, gun in hand. J-L C

André Lurçat, architecte: Projets et réalisations. Paris: Vincent, Fréal & Co., 1929.
Jean-Louis Cohen. *André Lurçat (1894–1970): Autocritique d'un moderne.* Liège: Mardaga, 1995.
André Lurçat. *Architecture.* Paris: Au Sans-Pareil, 1929.

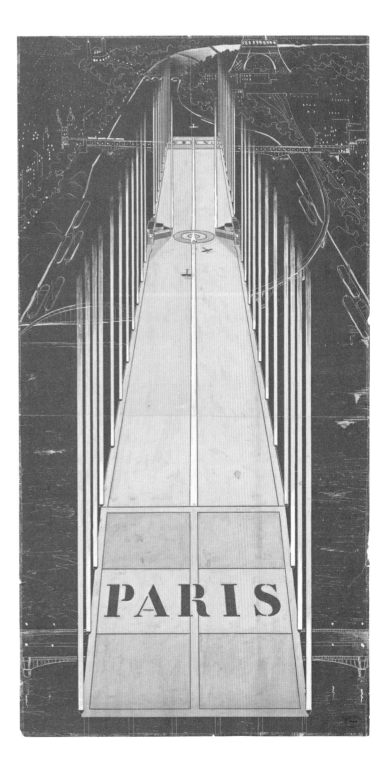

← House and studio for Walter Guggenbühl, Rue Nansouty, 1927. General view from Parc Montsouris.

↗ "Aéroparis" project for an aerodrome on the Île des Cygnes, 1931. Aerial perspective. Heliographic print on paper with added color.

Hubert Lyautey

1854, Nancy
1934, Thorey

Hubert Lyautey, the architect of the French conquest of Morocco, was a key figure in French urban planning. Advised by the reformers of the Musée Social (a philanthropic institution founded in 1894 as a research center for urban planning and social housing), he created a pioneering City Planning Department in Rabat in 1914, directed by Henri Prost,* which was a source of innovative projects for the extension of Moroccan cities.

It was thanks to this experience and the patronage of Lyautey—who was promoted to the rank of marshal at a very early age—that Prost was able to embark on the study of the regional plan of Paris. Made famous by his 1891 article "Du rôle social de l'officier" (On the Social Role of the Officer), Lyautey was surrounded by leading intellectuals and jurists, and was interested in the transformation of cities, particularly Paris. He publicly backed Le Corbusier's* ideas on modernizing its center, among other contemporary projects.

In metropolitan France, his major achievement was the organization of the Exposition Coloniale Internationale in Paris in 1931. He proposed holding the event in the eastern part of the city, in "underprivileged" neighborhoods, where, he said, "neither the beautiful people nor the tourists would go strolling." He added, "It is interesting, very interesting, extremely interesting, to go and plant our colonial shoots in the middle of this world of ordinary people, nine-tenths of whom are separated from us only by misunderstandings." He saw in "Lyauteyville"—the nickname attributed by the public to this event—"a great factor for social peace" and for the prevention of worker revolts.

The figure of this "great builder" was invoked countless times in support of the development policies of the Vichy regime, which claimed to be inspired by his Moroccan experiences. J-L C

André Le Révérend. *Lyautey*. Paris: Fayard, 1983.
Hubert Lyautey. *Paroles d'action*. Paris: Armand Colin, 1927.
André Maurois. *Lyautey*. New York: D. Appleton & Co., 1931.

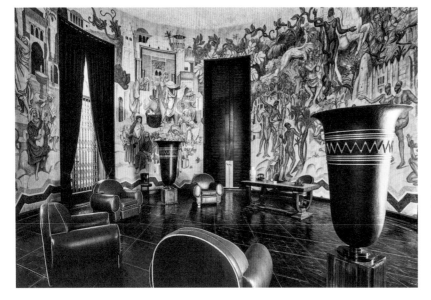

← Eugène Printz, The Lyautey Room decorated by Eugène Printz in the Musée Permanent des Colonies (Permanent Museum of the Colonies), 1931. Wall paintings by Ivanna and André Hubert Lemaître. Photograph by Antonio Martinelli.

→ Issue of *VU* magazine devoted to Marshal Lyautey, "builder of empires," August 1, 1934.

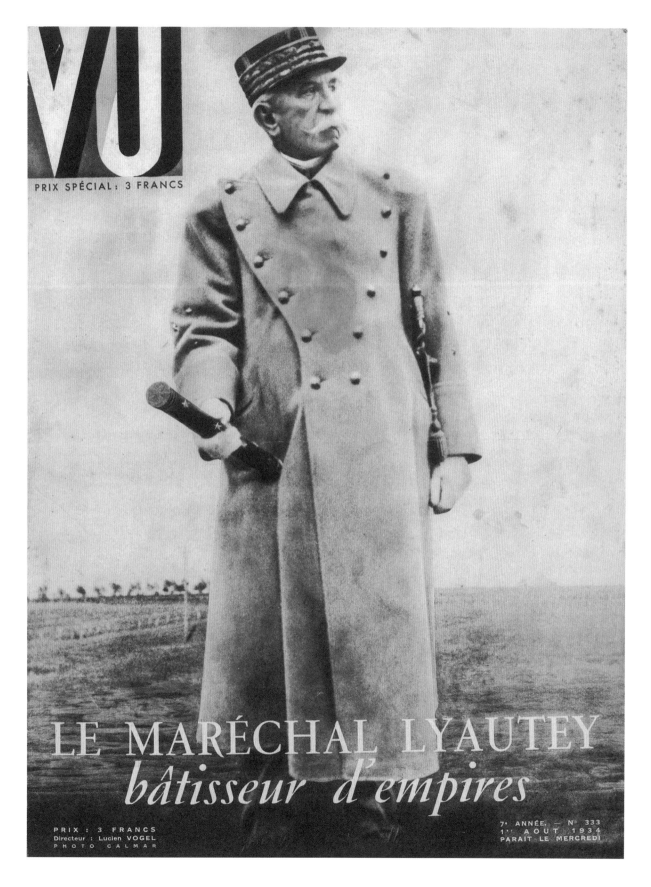

VU

PRIX SPÉCIAL : 3 FRANCS

LE MARÉCHAL LYAUTEY
bâtisseur d'empires

PRIX : 3 FRANCS
Directeur : Lucien VOGEL
PHOTO CALMAR

7ᵉ ANNÉE. — Nᵒ 333
1ᵉʳ AOUT 1934
PARAIT LE MERCREDI

M N O P

Dora Maar

1907, Paris
1997, Paris

For many years, historians of twentieth-century art regarded Henriette Theodora Markovitch, known as Dora Maar, as little more than Pablo Picasso's* mistress and muse from 1936 through 1943. Her work, however, is important in its own right. Born in Paris, she spent her childhood in Argentina, and returned to the French capital in 1926, where she trained as an artist.

Her photographic work explored three main paths: commissions for fashion magazines, politically committed documentary reportages, and surrealist creations. This independent woman opened her own studio, first at 29 Rue d'Astorg in Paris's eighth arrondissement—in 1936, this address would become the title of a strange montage of juxtaposed forms warped during the printing process—then near Montparnasse. There, she produced a host of fashion, beauty, and even erotic images, together with portraits of Parisian high society. In the 1930s, in London, Barcelona, and, to a lesser extent, Paris, she carried out photoreports on the urban poverty that came in the wake of the Crash of 1929. During the same period, her surrealist side blossomed in the form of collages and photomontages that she sometimes colorized. Paris often played a role in these, as in the untitled work from 1935 in which a bridge on the Seine is overlaid with a pair of female legs taken from a stockings advertisement that the artist is seemingly holding between her fingers in the foreground.

In 1937, she captured an important episode in the history of art when she photographed Picasso painting his *Guernica* in the studio on Rue des Grands-Augustins.

After World War II, at Picasso's urging, she devoted herself primarily to painting. GMJ

Mary Ann Caws. *Dora Maar, With and Without Picasso: A Biography.* London: Thames & Hudson, 2000.
Karolina Ziebinska-Lewandowska, et al., eds. *Dora Maar.* Los Angeles, CA: J. Paul Getty Museum, 2020. Exhibition catalog.

Untitled, 1935. Photomontage, with the outline of the Palais du Trocadéro on the horizon.

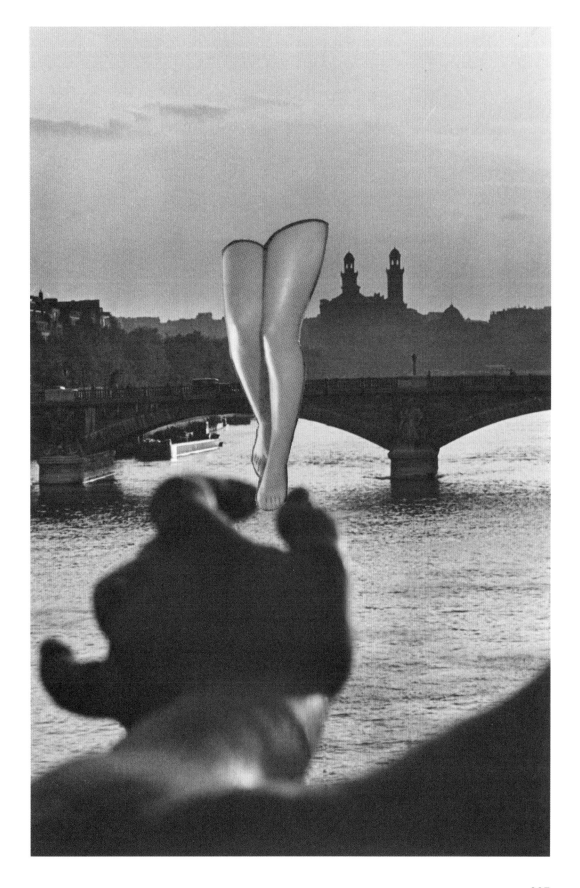

Robert Mallet-Stevens

1886, Paris
1945, Paris

If ever there was an architect who embod-ied Parisian chic, it was Robert Mallet-Stevens: an unfailingly well-groomed dandy with sophisticated creations and entrées into high society and the art world. He simultaneously led a career as an essayist-journalist, a film set designer, an interior and furniture designer, and an architect, having graduated from the École Spéciale d'Architecture in 1906. Writing, like inte-rior design, was an activity that he would pursue throughout his working life, but his involvement in the world of cinema was limited to the 1920s, his most significant contribution being to Marcel L'Herbier's* *L'Inhumaine* (*The Inhuman Woman*) in 1923, alongside Fernand Léger* (painted set), Paul Poiret* (costumes), and Pierre Chareau* (furniture).

Mallet-Stevens was a loyal collaborator, and he worked with many of the same partners on numerous projects, including Sonia and Robert Delaunay,* Jean and Joël Martel,* Jean Prouvé,* Gabriel Guevrekian,* and Francis Jourdain.* His commitment to the modernist cause led him to cofound in 1929 the Union des Artistes Modernes, which stood in opposition to the conser-vative Société des Artistes Décorateurs.

The legendary villa that he built in Hyères, on the Riviera, for Charles and Marie-Laure de Noailles* in 1923–28, and the "modern château" built for the Cavrois family in Croix in northern France (1929–32) are now con-sidered modern masterpieces, but he also designed other prestigious residences in and around Paris. Among the best known are the uncompleted villa for Paul Poiret* in Mézy-sur-Seine, west of Paris, and the ensemble that bears Mallet-Stevens's name in Paris's sixteenth arrondissement, a hundred yards from the equally famous La Roche-Jeanneret villas completed by Le Corbusier* just previously.

These townhouses and house-studios—in which Mallet-Stevens set up his firm, as did the Martel brothers their atelier—form

↓ Alfa Romeo garage, Rue Marbeuf, 1928. Partial view of the façade. Photograph by Thérèse Bonney.

→ House-studio of glassmaker Louis Barillet, Rue de Vaugirard, 1932. General view.

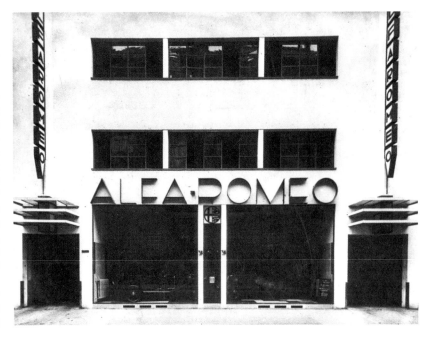

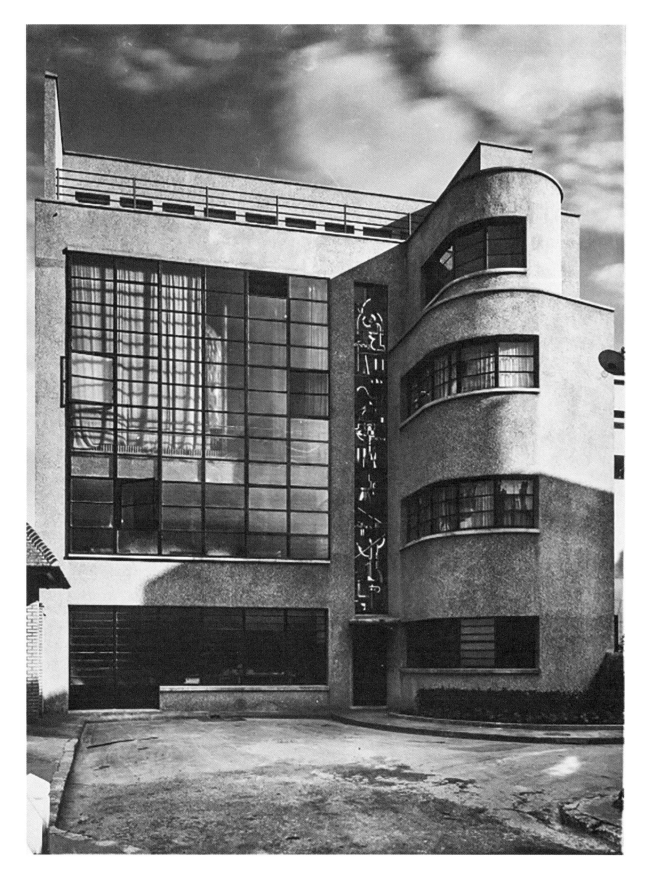

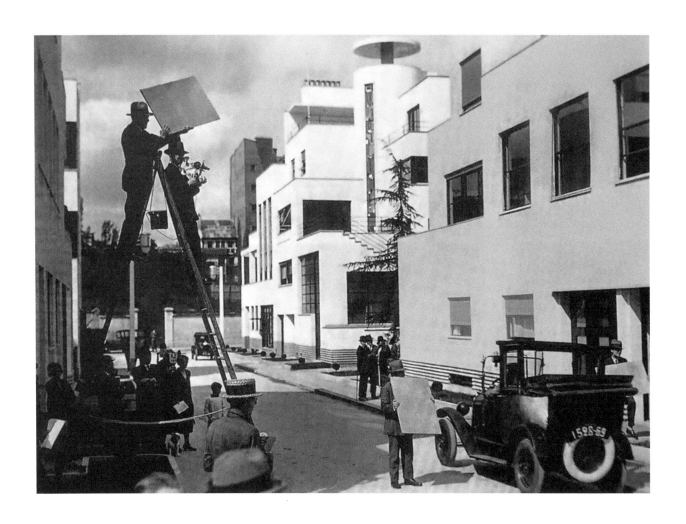

↑ Ensemble of townhouses, Rue
Mallet-Stevens, 1926-27. Photograph
of the shooting of the film *La
Sirène des tropiques* (*Siren of the
Tropics*), directed by Henri Etiévant
and Mario Nalpas, 1927.

→ Design for a study room, 1928.
Plate from *Répertoire du goût
moderne* (Directory of Modern Taste),
vol. 3 (1929).

an ensemble whose deliberately staggered, De Stijl-type volumes are in sharp contrast to the severity of similar but less luxurious buildings created in the same period by André Lurçat* and Auguste Perret,* near Montparnasse or in the inner suburbs.

In a curious reflection of his cinematic endeavors, Mallet-Stevens's own works have played roles in films: in 1927, "his" street featured in *La Sirène des tropiques* (*Siren of the Tropics*), and in 1929 the Noailles villa served as the location for Man Ray's* *Les Mystères du château du Dé* (The Mysteries of the Château of the Dice).

Mallet-Stevens's Parisian works also include many detached houses, which have since disappeared; they were built at the time of the two Expositions Internationales of the interwar period, in 1925 and 1937, for which the architect received both public and private commissions. G MJ

Olivier Cinqualbre, ed. *Robert Mallet-Stevens:L'œuvre complète*. Paris: Éditions du Centre Pompidou, 2005. Richard Klein. *Robert Mallet-Stevens: Agir pour l'architecture moderne*. Paris: Éditions du Patrimoine, 2014. Léon Moussinac. *Mallet-Stevens*. Paris: G. Crès & Cie., 1931.

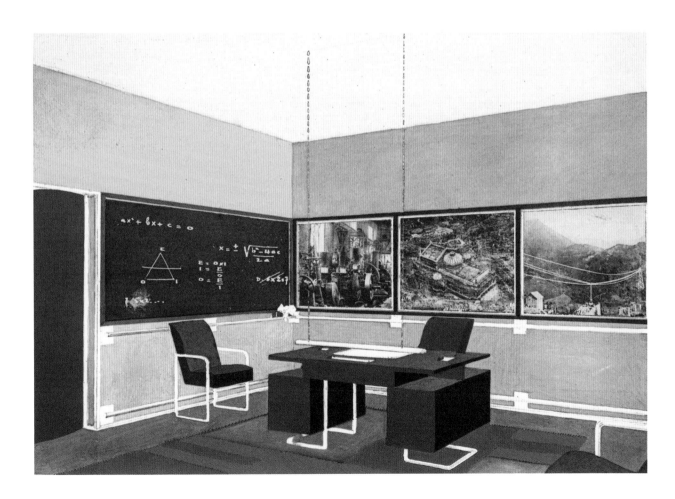

Jan and Joël Martel

1896, Nantes
1966, Lille and Paris

From automobile radiator caps to war memorials, and from busts to bas-reliefs, the works of twin sculptors Jan and Joël Martel are as diverse as the materials they worked with: reinforced cement, stone, wood, bronze, plaster, and metal, among others. When the brothers were ten years old, their family moved to Paris, and they trained and worked in the capital from 1927 onward, in the townhouse that Robert Mallet-Stevens* built for them on the street that bears his name. This construction, which housed their shared high-ceilinged studio—to accommodate their large works—and three independent apartments, testifies to their desire for collaboration between artists: it features stained-glass windows by Louis Barillet in the circular stairwell, railings by Jean Prouvé,* sliding cupboards by Francis Jourdain,* and fittings by Charlotte Perriand* and Gabriel Guevrekian.* As they wrote in 1933, "To confuse the minor with the major arts: such is, in our opinion, the first task of the new aesthetic."

They drew the public's attention at the Exposition Internationale des Arts Décoratifs et Modernes in 1925 with their so-called "cubist" trees in reinforced cement that stood nearly 16 1/2 feet (5 m) tall, and which served as a backdrop for photographs taken of dresses created by Sonia Delaunay.* Twelve years later, at the 1937 Exposition Internationale, they contributed to various pavilions, notably that of the Union des Artistes Modernes, of which they were founding members. G M J

Emmanuel Bréon, Bruno Foucart, et al. *Joël et Jan Martel, sculpteurs, 1896–1966*. Paris: Gallimard/Electa, 1996.

The Martel twins in their studio on Rue Mallet-Stevens, c. 1930. Photograph by Albert Harlingue.

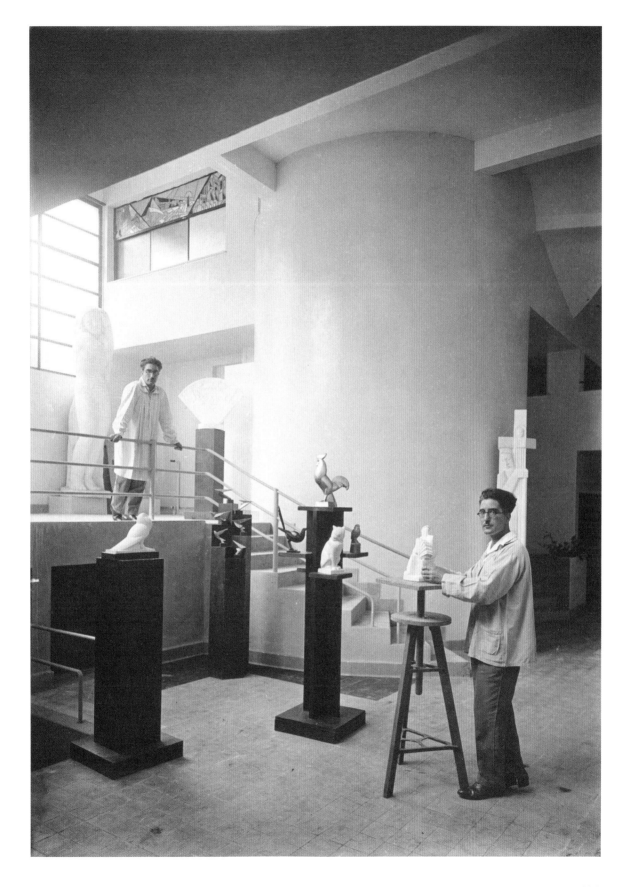

Lazare Meerson

1900, Warsaw
1938, London

In 1917, Meerson emigrated to Germany, and he attended the Akademische Hochschule für die Bildende Künste (Academic College of Fine Arts) in Berlin. He moved to Paris in 1923, and joined the Russian community in Montreuil, where, with Alexandre Kamenka, he studied under Alexandre Lochakoff and Boris Bilinsky,* who was only slightly more experienced than he was.

Between 1924 and his untimely death in 1938, he created some of the most remarkable film sets, combining or opposing modernism and populism. For René Clair,* he was "the true creator of modern set design." His compositions offered abstracts of working-class neighborhoods that were often more expressive than real settings would have been.

Meerson's style differed from that practiced in Germany, which his assistant Alexandre Trauner* would partly adopt; he played less with chiaroscuro and misty or smoky atmospheres than with a certain modern clarity of spirit. This approach was first expressed—particularly in the furnishings and interior design—in Jacques Feyder's* *Gribiche* (*Mother of Mine*), and it also forms one of the dramatic themes. For *Les Nouveaux Messieurs* (*The New Gentlemen*), he created a modernist set with white surfaces, rounded metal railings, and long windows for the headquarters of the workers' union, and imagined a workers' affordable housing project. With Clair, he returned to a typification of working-class Paris, through the use of sharp perspectives and foreshortening in *Sous les toits de Paris* (*Under the Roofs of Paris*), *Le Million* (The Million), and *Quatorze juillet* (*14 July* or *Bastille Day*), while for *À nous la liberté* (*Freedom for Us*) he created a "model" prison in the guise of a Taylorized factory. F A

Jean-Pierre Berthomé and André Rieupeyrout. *Lazare Meerson*. Grenoble: Fédération des Cinémathèques et Archives du Film de France, undated.
Catherine A. Surowiec. *Accent on Design: Four European Art Directors*. London: British Film Institute, 1992.

Stills from *Gribiche* (*Mother of Mine*), by Jacques Feyder, 1928.

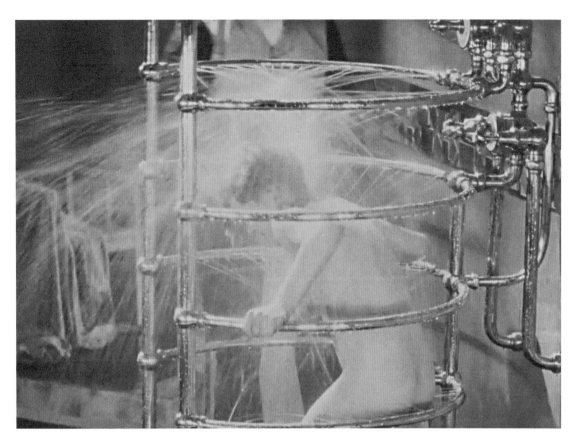

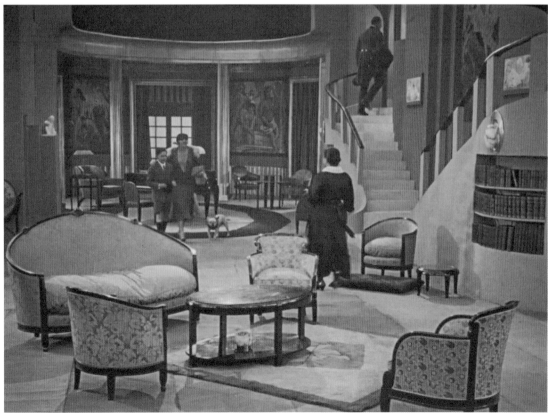

Paul Nelson

1895, Chicago
1979, Marseille

Paul Nelson—an American who volunteered to fight in France in 1917—settled in Paris in 1920. After studying in Auguste Perret's* studio at the Palais de Bois, he graduated from the École des Beaux-Arts in 1927. His only project to come to fruition was a small apartment building on Boulevard Arago in Paris, built in 1930 for his compatriot Alden Brooks. The exposed concrete frame, which stands out against the brick infill walls, is highly reminiscent of the vocabulary of his mentor.

The importance of Nelson's work lies elsewhere, in his hospital architecture projects, which were published in the 1930s in periodicals directed by Christian Zervos* and Jean Badovici.* Perhaps even more significant is the theoretical project on which he worked from 1935 to 1939, for which only two models and a few drawings are known: the "maison suspendue" (suspended house), with a metal structure, whose interior volumes are raised above the ground and connected by a system of ramps. This project represents the junction of several major artistic disciplines, since the architect invited his friends Fernand Léger,* Joan Miró, Jean Arp,* and Alexander Calder to contribute. According to Oscar Nitzchké* (with whom Nelson designed a Palais de la Découverte in Paris in 1938), Wassily Kandinsky hailed the work as an authentic example of artistic synthesis, while Pablo Picasso* compared it to a mouse trap. G MJ

La Maison suspendue: Recherche de Paul Nelson. Paris: Éditions Albert Morancé, 1937.
Olivier Cinqualbre, ed. Paul Nelson, architecte, inventeur. Paris: Éditions du Centre Pompidou, 2021. Exhibition catalog.
Paul Nelson. "Peinture spatiale et architecturale. À propos des dernières œuvres de Fernand Léger." Cahiers d'art, no. 1–3 (1937): 86–87.
Terence Riley and Joseph Abram, eds. The Filter of Reason: Work of Paul Nelson. New York: Rizzoli, 1990.

Project for a Palais de la Découverte, 1938, with Oscar Nitzchké and Frantz-Philippe Jourdain. Perspective view of the central hall.

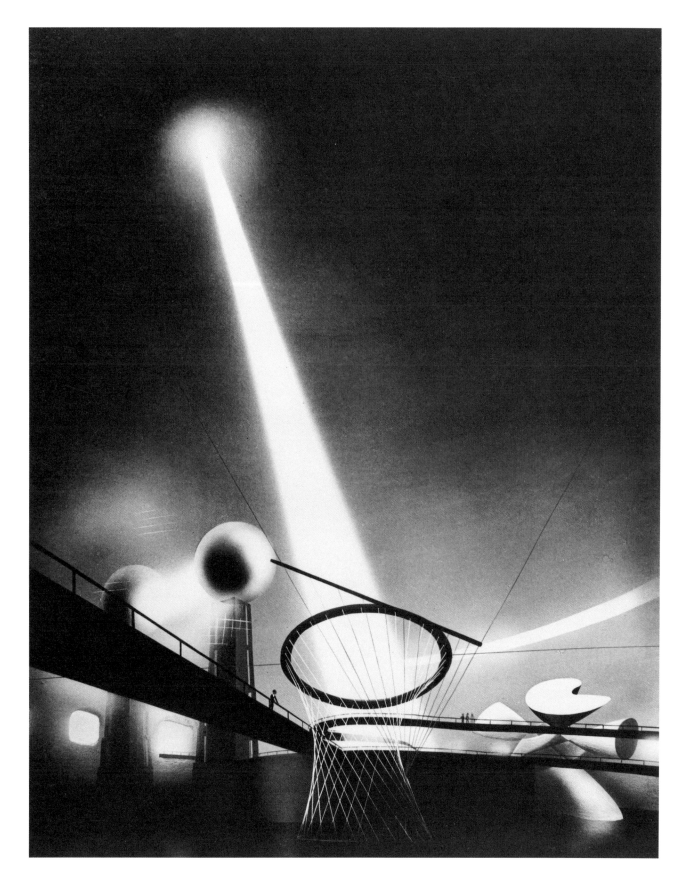

Oscar Nitzchké

1900, Hamburg
1991, Ivry-sur-Seine

An eccentric member of the radical wing of the modern movement in Paris, Nitzchké was a student at the Laloux-Lemaresquier atelier at the École des Beaux-Arts, before joining Auguste Perret's* studio at the Palais de Bois from 1923 to 1927. With his fellow students Adrien Brelet and André Le Donné, he designed a steel house for the Forges de Strasbourg, after contributing to the renovation of the brasserie-dance hall L'Aubette in Strasbourg with Theo van Doesburg,* Sophie Taeuber-Arp,* and Jean Arp.* With Paul Nelson* he designed a hospital for Ismailia, in Egypt in 1934, and he, Nelson, and Frantz-Philippe Jourdain designed an astonishing cable structure for a Palais de la Découverte in Paris in 1938.

His most remarkable project remains that of a Maison de la Publicité, envisaged on the Champs-Élysées for the publicist Paul Martial. An extraordinary nocturnal photomontage by Hugo Herdeg situates the project on the Boulevard Montmartre, where it seems to occupy the site of the Musée Grévin. With its steel frame façade, the building was conceived as a support on which advertising slogans, images, and projection screens could be changed day and night thanks to openwork floors set in the depth of the grid. Christian Zervos* noted that this three-dimensional luminous construction was "the screen on which could be fixed or moved powerful calls to attention ... as if by magic." The project fell through, and in 1938 Nitzchké emigrated to the United States, where he designed, among other things, the stamped aluminum curtain wall of the Alcoa headquarters in Pittsburgh, PA (1951–53), for the firm Harrison & Abramowitz. J-L C

Gus Dudley. Oscar Nitzchke, Architect. New York: The Cooper Union, 1985.
Christian Zervos. "Architecture et publicité." Cahiers d'art, nos. 6–7 (1936): 203–7.

Project for a Maison de la Publicité on Avenue des Champs-Élysées, 1936:

↓ Elevation. Indian ink and watercolor on paper.

→ Night view. White ink on a photograph of Boulevard Montmartre by Hugo Herdeg.

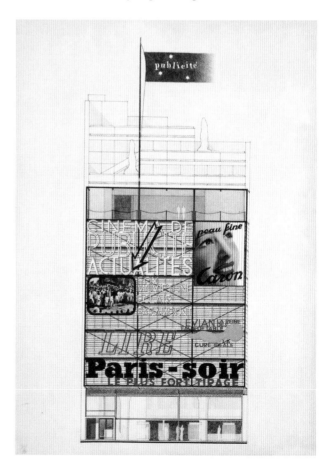

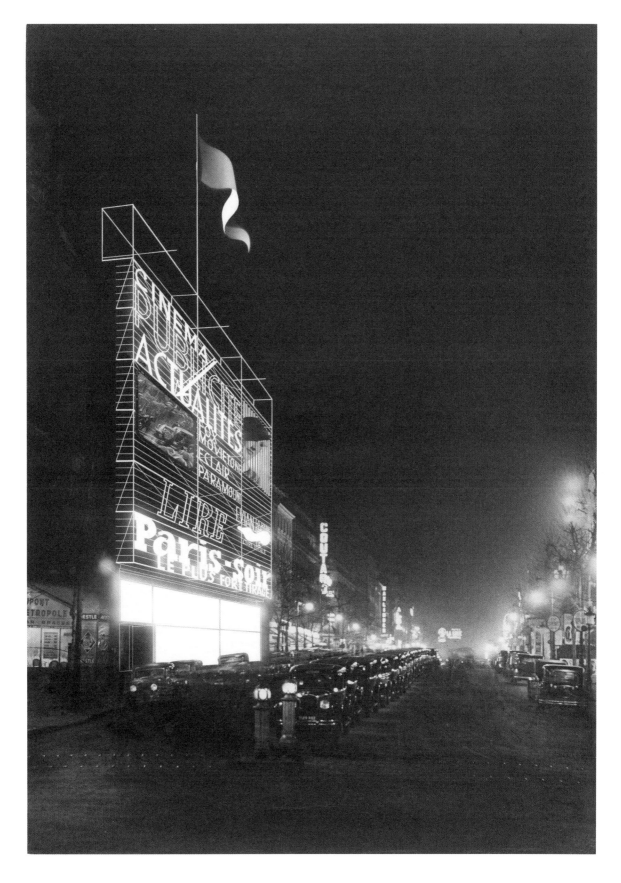

Marie-Laure
de Noailles

1902, Paris
1970, Paris

Marie-Laure Bischoffsheim, who was of aristocratic extraction on her mother's side and the wealthy heiress of a Jewish banking family on her father's, married Viscount Charles de Noailles at the age of twenty-one. As society figures and patrons, the couple were arbiters on the Paris scene between the wars; they were close to the surrealists and threw memorable parties in their townhouse in the sixteenth arrondissement—a meeting point for everyone who was anyone in the arts and high society.

During the first half of the 1920s, they commissioned Robert Mallet-Stevens* to build them a luxurious "cubist" villa in Hyères—a project on which Pierre Chareau,* Theo van Doesburg,* Gabriel Guevrekian* and a very young Charlotte Perriand* also participated. The de Noailles offered artists their patronage and financed the shooting of Man Ray's* experimental film *Les Mystères du château du Dé* (The Mysteries of the Château of the Dice) of 1928. Not content with financially supporting writers like Jean Cocteau and Georges Bataille, musicians including Igor Stravinsky and Francis Poulenc, and filmmakers such as Luis Buñuel—*L'Âge d'or* (The Golden Age) of 1930, for instance, which was immediately censored—the de Noailles were also important art collectors, acquiring old masterpieces as well as paintings by Henri Matisse, Pablo Picasso,* Piet Mondrian, Theo van Doesburg,* and Balthus.

Extremely wealthy, but sensitive to the struggles of the Left, Marie-Laure de Noailles was close to the Communists and the Popular Front, a supporter of the Spanish Republicans in 1936, and sympathetically attentive to the events of May 1968. She was the embodiment of a free-spirited, open-minded, enlightened patron, with an unfailing commitment to modern artists. G M J

Laurence Benaïm. *Marie-Laure de Noailles, la Vicomtesse du Bizarre*. Paris: Grasset, 2001.

Marie-Laure de Noailles in costume for the Count of Beaumont's ball, 1928. Photograph by Man Ray.

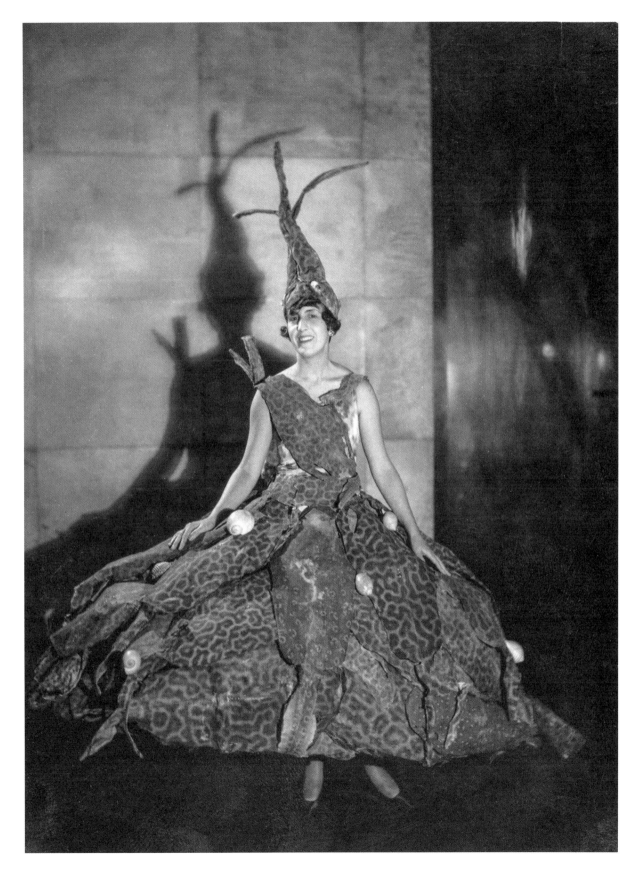

241

Chana Orloff

1888, Konstantinovka (Russian Empire)
1968, Tel Aviv

Born in what is today Ukraine, Chana Orloff arrived in Paris in 1910 to work for the couturière Jeanne Paquin; previously, she had lived in Palestine for five years. She studied at the École des Arts Décoratifs in Paris and settled into the artists' colony La Ruche, in the Vaugirard neighborhood. There, she rubbed shoulders with Jewish artists including Amedeo Modigliani, Chaïm Soutine, Jacques Lipchitz,* and Ossip Zadkine, as well as Fernand Léger,* Guillaume Apollinaire,* and Pablo Picasso.*

She began showing her cubism-inflected sculptures at the Salon d'Automne in 1913, and her figurative but resolutely modern works soon earned her a following among the Parisian elite. In 1927, she was honored with a personal monograph published by Georges Crès. Her work was presented in numerous salons, galleries, and boutiques, including the store of Eileen Gray,* who devoted an exhibition to her in 1924. Two years later, she had acquired a level of recognition and financial stability that allowed her to have a villa-studio built in the *cité d'artistes* Villa Seurat near Montparnasse. Its architect was Auguste Perret,* whose bust she had sculpted in 1923. In 1928, she made her first trip to the United States, where her works were exhibited on the East and West Coasts. She had her first exhibition in Tel Aviv in 1935, and during the 1937 Exposition Internationale an entire room was reserved for her works at the Petit Palais. After World War II, during which she narrowly escaped deportation, she lived between her studio in Paris and Israel. G MJ

Paula J. Birnbaum. *Sculpting a Life: Chana Orloff between Paris and Tel Aviv*. Chicago: Brandeis University Press, 2023.
Félix Marcilhac. *Chana Orloff: Catalogue de l'œuvre sculpté*. Paris: Éditions de l'Amateur, 2000.
Léon Werth. *Chana Orloff*. Paris: G. Crès & Cie, 1927.

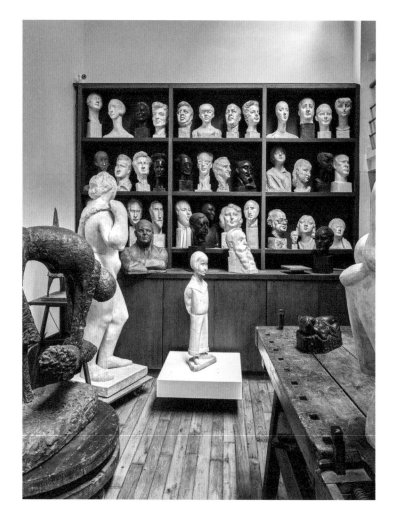

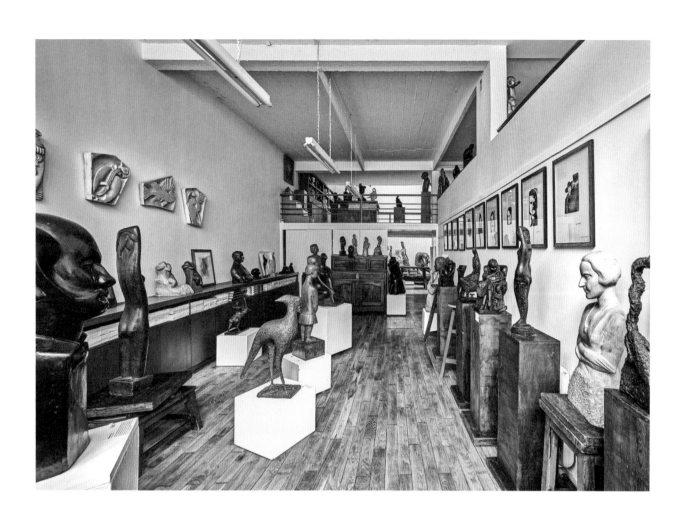

Chana Orloff's studio by Auguste
Perret, Villa Seurat, 1926-29.
Photographs by Antonio Martinelli.

Painting

REALISM AND AVANT-GARDE MOVEMENTS: SPLENDORS AND MISERIES OF A GREAT METROPOLIS

In 1914, artistic institutions inherited from the nineteenth century flourished in Paris; they continued after World War I in the form of the École des Beaux-Arts, private academies where young artists made life drawings of plaster casts and nude models, and exhibiting events such as the salons which punctuated artistic life throughout the year: the academic Salon des Artistes Français, the more recent Salon des Indépendants, and the Salon d'Automne, created in 1903. Private galleries had been established for the impressionist market, which prevailed; more experimental venues would henceforth cater to challenging new trends. Famous commissioned artists specialising in grand décors and society portraits contrasted with their avant-garde contemporaries, who, after 1914, nonetheless pursued traditional genres—landscapes, cityscapes, nudes, and portraits—but in an entirely new way. While success offered social prestige and financial stability, the paradigm of the artist as a bohemian, living in poverty prior to the recognition of his "genius," was played out time and again, with Pablo Picasso* as the most prominent example. The key to commercial success in this city of artists was having an identifiable "signature style," and, although Picasso himself constantly renewed his approach, the history of art in Paris has been recounted as a succession of stylistic developments by pioneers of various "-isms" and their followers, painting a picture far removed from the more complex truth.[1] The contrast between the achievements of the avant-garde cubist, futurist, Dada, and surrealist movements and the renewed debates on the subject of realism and the representation of the working classes reflects the tensions at the heart of this narrative.

Avant-Gardes and Internationalism

To get a clear picture, one must explore the origins of art in Paris during the interwar period through its earlier developments, like looking at a film in reverse. This is what the poet Blaise Cendrars did in 1919, in his book *La Fin du monde filmée par Ange N-D*[2] (*The End of the World Filmed by the Angel of Notre-Dame*), illustrated by the cubist artist Fernand Léger.* Cendrars was a friend of Sonia Delaunay,* who in 1914 had painted her *Prismes Électriques* (*Electric Prisms*), in which rainbow-like arches of bright abstract colors expressed the transformation of a turning and changing world into pure light and energy. The word "simultaneity" was on everyone's lips. Between 1900 and 1914, life had accelerated at an extraordinary rate.

Robert Delaunay,* Sonia's husband, had fused the vibrant colors of fauvism with the fractured spaces of cubism in his so-called "Orphic" works.[3] In 1912, his painting *L'Équipe de Cardiff* (*The Cardiff Team*) demonstrated this simultaneity. Paris's great Ferris wheel turns in front of the Eiffel Tower (which was already transmitting radio broadcasts), while a biplane flies through the sky. Louis Blériot had flown across the English Channel between France and Britain in 1909, and from 1914 onward biplanes would be used for both reconnaissance and strategic bombing missions during World War I.

Artistic life, with its salons and galleries, resumed after the war. The academies, both old and new, welcomed French and international students. Picasso surprisingly turned from cubism back to figuration. In the 1920s, a general move toward figuration across Europe was perceived as a "return to order," with realist painting and sculpture expressing these new times; Jean Cocteau's book *Le Rappel à l'ordre* (*A Call to Order*) was published in 1926.[4]

The Russian Revolution of 1917 had a huge impact on Parisian culture, although France only established diplomatic relations with the Soviet Union in 1924. The devaluation of the French franc and the stabilizing of the German mark, together with new American immigration quotas, led to a new wave of immigration in France. The tragic losses due to the war had created a labor shortage, and Paris now became a destination for political refugees from Russia and Eastern Europe. Alongside ordinary workers came poets, writers, and artists who constituted an "intellectual immigration," at the origin of the so-called "School of Paris" in painting and sculpture. White, often aristocratic Russians invested in the Parisian art market. Trained in Saint Petersburg, Tamara de Lempicka* set up her studio and residence, designed by her sister, Adrienne Gorska,* in an elegant, modern building designed by Robert Mallet-Stevens;* her clientele included rich industrialists and immigrant Russian princes.

The capitalist reconstruction of a France that was victorious but bled white was accompanied by another epoch-changing

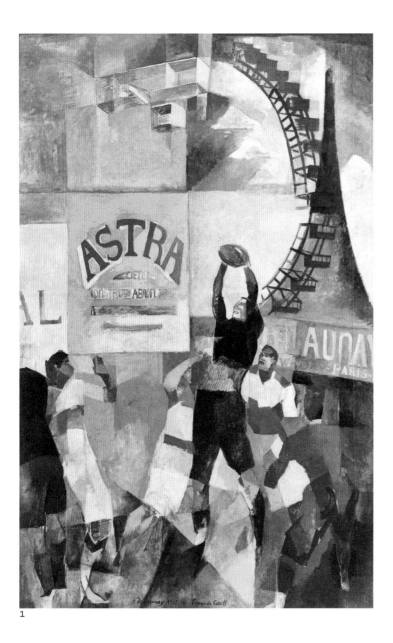

1

phenomenon: sexual politics. Women acquired a new independence—a direct outcome of their role in wartime productivity and losses due to the war—and adopted free, sexually-liberated behaviour; they were now driving cars and piloting planes, although French women still did not have the right to vote, unlike their counterparts in England and the United States. In addition, the politics of class infiltrated even avant-garde painting: Lempicka's art deco idiom clashed with the abstract, egalitarian modernism of Fernand Léger, whose work had evolved from cubism toward stylized, brightly colored designs with motifs from city life, ranging from traffic signals to film star Charlie Chaplin's bowler hat.

The Exposition International des Arts Décoratifs et Industriels Modernes in 1925 was the apex of Paris's interwar glory, transforming its center into a city within the city to serve as a showcase for all that was beautiful and luxurious. The show illustrated the relationship between the fine and decorative arts as well as the importance of commissions. Paris was reborn as an epicenter of world tourism, where painting and sculpture were marketed in the same way as fashion, furniture, or jewelry, and were exported abroad on the great new ocean liners to New York, Rio de Janeiro, and Shanghai.

The Parisian interior played a crucial role in all of this: the "modernist baroque" style of Raoul Dufy's paintings harmonized with eighteenth- and nineteenth-century architectural settings or the ornamented neoclassical pavilions of the 1920s, draped with stucco garlands. But the flattened, design-conscious late cubism of Fernand Léger, as in *Le Balustre* (*The Baluster*) of 1925, could only work within the cool, white, rectangular interiors of Le Corbusier's* Esprit Nouveau pavilion, which was one of the surprises of the exhibition. The others were the Soviet pavilion (a striking design by Konstantin Melnikov), Alexander Rodchenko's Workers' Club, and numerous examples of post-revolutionary Russian art. Once dismantled, the pavilion would be relocated in 1926 to the headquarters of the French Trades Union movement. Then, in 1929, just four years after the exhibition, the Wall Street Crash hit, with catastrophic repercussions around the world. The economic recession spread from the United States to Europe; the art market dwindled in the 1930s and the least famous artists lost their clients.

1 Robert Delaunay, *L'Équipe de Cardiff* (*The Cardiff Team*), 1913. Oil on canvas.

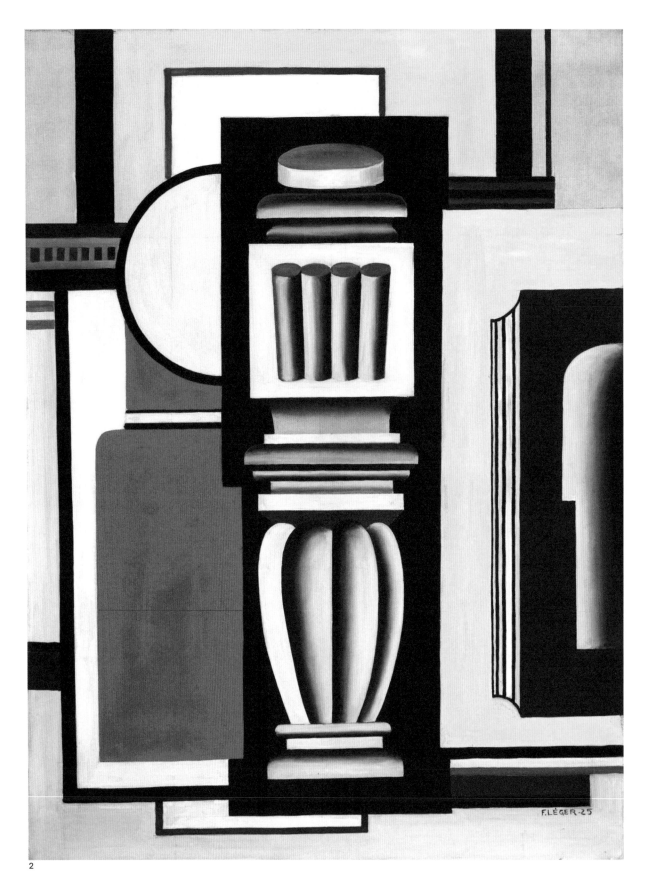

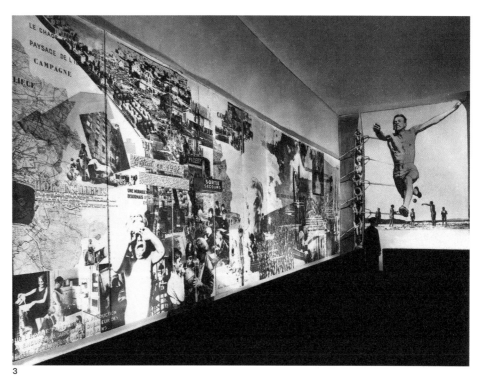

3

The year 1930 marked the centenary of the conquest of Algeria; in 1931, France's vast colonial enterprise was celebrated with the Exposition Coloniale Internationale, which projected an image of the conquered world at the Bois de Vincennes. African art—so-called *art nègre* or "Negro art"—first discovered by avant-garde artists like Pablo Picasso at the 1900 Exposition Universelle, had influenced movements such as cubism and Dada; it notably presented Picasso with the notion of a magical world of a "primitive," alternative civilization and, above all, suggested that representation in painting or sculpture could be conceptual, rather than realistic. By the 1920s, materials from the colonies—mahogany, ebony, ivory, shagreen, inlaid mother-of-pearl, and precious metals—together with an exotic iconography made up of indigenous peoples, animals, birds, jungles, and oceans in art deco style abounded, in conjunction with geometric, syncopated "modern" motifs. The same fusion was at work in jazz music in Paris, and in the dances of Josephine Baker*: contemporary syncopated rhythms and a fantasized figure of the "negro" blended exotic Africa with the sophistication of the African-American culture of the day.

Anti-colonialist writers such as André Malraux were joined by the voices of the Paris-based surrealists. Inspired by the Freudian notion of the unconscious, they were receptive to theories about the "primitive mind."[5] While they enthusiastically explored both African and Oceanian art, colonial capitalism and its cruelty disgusted them. They were already engaged with the French Communist Party, and changed the title of their journal, *La Révolution surréaliste*, to *Le Surréalisme au service de la révolution* in 1930. In 1931, in the reconstructed Melnikov pavilion, they staged an anti-colonial protest exhibition in conjunction with the Communist International (Comintern) and issued a leaflet, *Ne visitez pas l'Exposition Coloniale!* (Don't Visit the Colonial Exhibition!).[6]

As the 1930s progressed, the working-class population within Paris experienced great poverty. Ilya Ehrenburg, a go-between for the capitals Paris and Moscow, photographed the most squalid slums, the destitute, and the homeless with his Leica camera. El Lissitzky gave these images a visual urgency in his design for the book *Moi Parizh* (My Paris), which the writer published in Moscow.[7] Photomontage—a technique invented by Dada artists like John Heartfield in postwar Germany—was used in the Soviet Union to represent both the energy and dynamism of Lenin's Russian Revolution and the working masses themselves, in the works of Gustav Klucis, for example. International exhibitions had

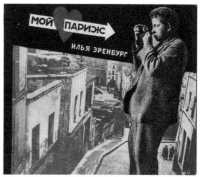

4

2 Fernand Léger, *Le Balustre (The Baluster)*, 1925. Oil on canvas.

3 Charlotte Perriand, *La Grande Misère de Paris (Deep Poverty in Paris)*. Photomontage exhibited at the Salon des Arts Ménagers home show, 1936.

4 Ilya Ehrenburg, *Moi Parizh* (My Paris), 1933. Cover by El Lissitzky.

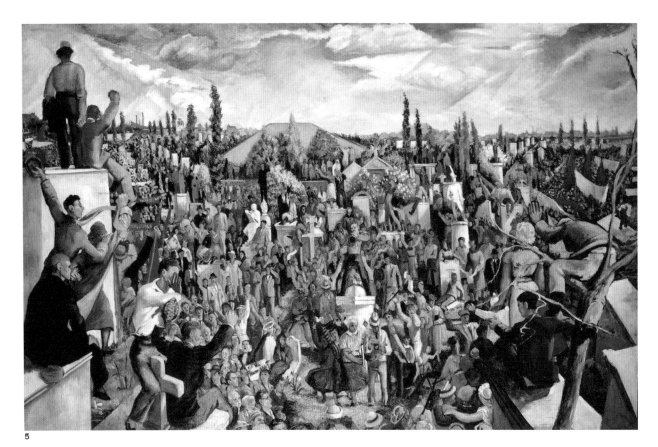

5

disseminated photomontage in Europe, notably *Pressa* (Cologne, 1928) and *Film und Foto* (Stuttgart, 1929), marked by the contribution of El Lissitzky. The grain of the black-and-white photography evoked the griminess of Parisian buildings blackened by smoke, in contrast with the dazzling modernity of bright, pure colors. In January 1936, Charlotte Perriand* displayed a huge photographic mural measuring 52 1/2 feet (16 m) long, *La Grande Misère de Paris* (*Deep Poverty in Paris*), at the Salon des Arts Ménagers "ideal home" show. Slogans pointed out poor-quality, overcrowded housing, illness, and called for work for all. The Salon itself promoted hygiene, the removal of dirt with new appliances, and the streamlining of labor—in particular, the invisible, unacknowledged female labor that kept Paris sparkling. The dangers of dirt and of the rebellious working masses were elided.

After Hitler's rise to power, German intellectuals fled to Paris; the persecution of German Communists in Berlin resulted in Soviet Comintern operations with impressive cultural budgets being moved to Paris in 1933. The Association des Écrivains et Artistes Révolutionnaires and its Maison de la Culture, based on Soviet models, was directed by the former surrrealist, now communist poet Louis Aragon.* The young Russian-Jewish artist Boris Taslitzky would become his secretary. Talitzky's painting of the 1935 commemoration of the Paris Commune at Père-Lachaise cemetery was exhibited at the Galerie Billiet-Worms, whose exhibition *Le Réalisme et la Peinture* (Realism and Painting) accompanied the *Querelle du Réalisme* (The Dispute about Realism): three tumultuous debates about style held in May and June 1936.[8]

The Popular Front came to power in May 1936. The Matignon Agreements introduced a forty-hour work week, leisure time, and paid vacations, which were met with an explosion of joy after the wave of national strikes. Taslitzky, who had been trained academically at the École des Beaux-Arts, was a romantic, as responsive to Aragon's equation between socialist realism and "revolutionary romanticism" as he was inspired by John Heartfield's photomontages and their "revolutionary beauty."[9] He organized a show at the Théâtre du Peuple et de la République, the former Alhambra music hall, where young artists mixed democratically with the great names

of their times, such as Picasso or Léger. Here, Picasso created a huge stage curtain for Romain Rolland's revolutionary play *Le Quatorze Juillet* (*The Fourteenth of July*); a variation on his bullfighter theme, with warrior, horse, vanquished Minotaur, and strong, eagle-headed antagonist, it was an immediate response to Nazi intervention in the Spanish Civil War.

Intensified Stylistic Confrontations

The whole of Paris and the international art world were now gearing up for the great Exposition Internationale des Arts et des Techniques Appliqués à la Vie Moderne of 1937, which once again transformed important parts of Paris's cityscape: the Palais de Chaillot and the Palais de Tokyo still remain today. History has retained one major work from this exhibition: Picasso's *Guernica*, which was created for the Spanish pavilion. The canvas's screen-like size, its static/dynamic, black-and-white flickering images, dramatically confirmed the specifics of painting versus cinema. Action, pain, and death, filmed and particularized in time, contrasted with Picasso's trans-historical statement condemning civilian bombing.

The exhibition witnessed a confrontation of architectural styles. Due to its "revolutionary" character, the Soviet constructivist model was adapted by José Luis Sert and Luis Lacasa in the Spanish pavilion, whose façade was composed of large photomontages. And nothing could make a more striking contrast than the comparison between Alfred Janniot's art deco nymphs on the façade of the Palais de Tokyo and Julio González's *La Monserrat*, standing outside the Spanish pavilion—a work in iron depicting a terrified woman and her child during a bombing raid. In contrast to these "revolutionary" artistic messages and metaphors, the immense and solemn pavilions by Nazi architect Albert Speer and Soviet architect Boris Iofan seemed to flank Paris's Eiffel Tower. The Nazi pavilion, topped with an eagle, stood like a bulwark against the more dynamic assault of Iofan's building, which served as a giant pedestal for Vera Mukhina's iconic sculpture *The Worker and the Kolkhoz Woman*, brandishing hammer and sickle. This became the emblem of the Soviet Union, symbolising the coming together of industry and agriculture. Inside the pavilion, while the photomontage by Gustav Klucis—who was executed a year

6

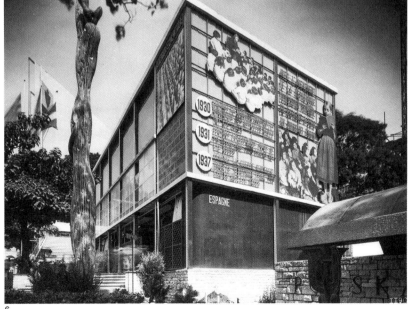

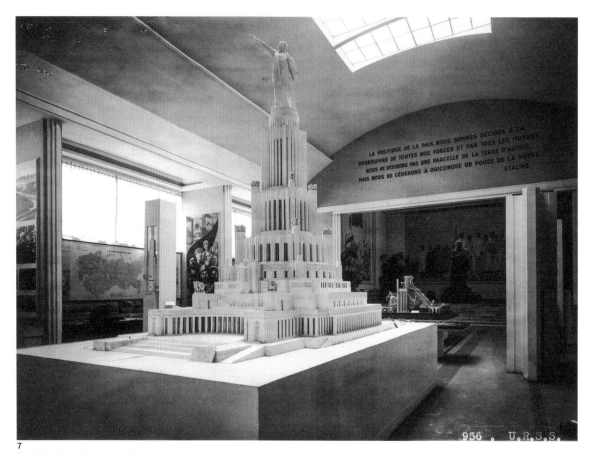

7

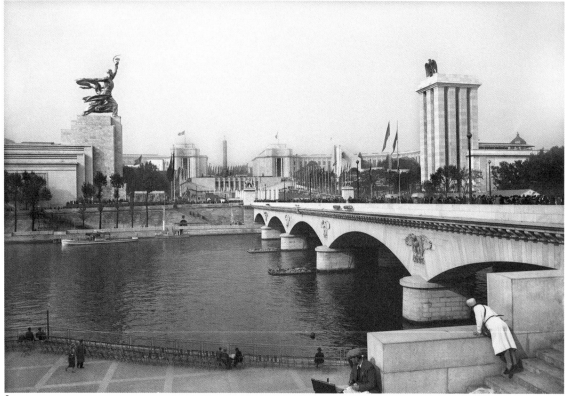

8

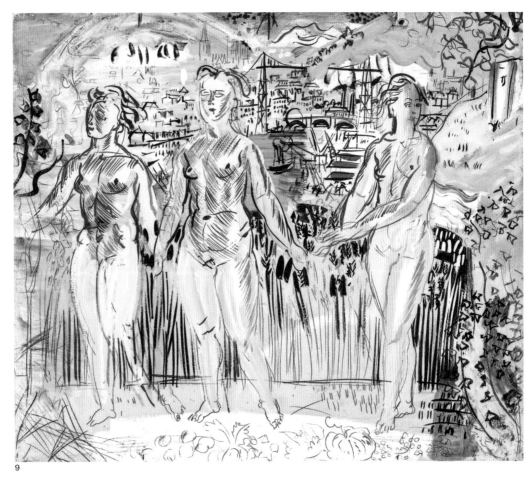

9

7 Boris Iofan, Soviet pavilion at
the 1937 Exposition Internationale.
Interior with the model of the
Soviet palace designed by Iofan,
Vladimir Gelfreikh, and Vladimir
Shchuko. Photograph by H. Baranger.

8 The face-off at the 1937
Exposition Internationale between
Boris Iofan's Soviet pavilion
and Albert Speer's Nazi Germany
pavilion, adjudicated by the Palais
de Chaillot.

9 Raoul Dufy, La Seine entre l'Oise
et la Marne (The Seine between the
Oise and Marne Rivers), 1938. Oil on
canvas.

later—could still be seen, paintings such as Aleksandr Mikhailovich Gerasimov's *Stalin at a Meeting with His Commanders*, depicting military generals (with faces personalized from photographs) in a large hall ornamented with neoclassical chandeliers, revealed how Soviet socialist realism had been turned into an instrument of state manipulation and propaganda.

To focus on just the Spanish, Soviet, and Nazi pavilions (which showed academic paintings and a turn toward medieval Germanic themes) would be misleading, for not only were there pavilions from all over the world, but there could also be a clash of styles even within the same pavilion. France itself organized numerous contrasting displays. Its *Chefs-d'œuvre de l'art français* (Masterpieces of French Art) held at the Palais National des Arts brought together historical works from many different museums, prompting Louis Aragon's speech "réalisme socialiste, réalisme français"—an attempt to "nationalize" the realism movement.[10] At the Petit Palais, the French School contrasted with *Origines*

et développement de l'art international indépendant (Origins and Development of International Independent Art), held at the Musée du Jeu de Paume. While some artists exhibited in both sites, this demonstrated an unease with the internationalism of the so-called "School of Paris," at a time when antisemitism in the arts was on the increase. Raoul Dufy's plump, naked river goddesses of *La Seine entre l'Oise et la Marne*, painted for the Palais de Chaillot's bar-smoking room, looked back in time, and stood in sharp contrast with the entirely contemporary, multicolored, dynamic abstractions of the murals by Auguste Herbin and Georges Valmier for the Palais des Chemins de Fer. Both artists had exhibited with the internal abstract group Abstraction-Création, which was based in Paris throughout the 1930s.

In the Palais de l'Air, Robert Delaunay's circular rhythms of pure color and form complemented a polychrome walkway, from which visitors could see colored satellite rings of rhodoid acrylic encircling a suspended Caudron-Renault airplane.

10

The story comes full circle: we recall Delaunay's biplane painted in 1912 and Sonia Delaunay's abstract *Prismes Électriques* of 1914.

Toward Disaster

It is extraordinary that the clash of styles between abstract and figurative art could have had such powerful ideological significance. Christian Zervos's* journal *Cahiers d'art* knew what was at stake. The German Nazi Party advocated eugenic selection in conjunction with their ideology of Aryan purity. With this came the fear of "degeneracy," which was extended to the concept of "degenerate art": African "Negro" works and artists of Jewish origin were particularly targeted. In 1937, the *Degenerate Art* exhibition held in Munich was reported in France: the greatest works of abstraction, Dada, and German expressionism, including

works by Paul Klee, Wassily Kandinsky, Max Ernst, and Emil Nolde, were derided and defiled by vicious labels. Aragon's Maison de la Culture produced an important journal whose fifth issue in May 1938 was devoted to these works, with the headline "L'art dégenéré. La liberté de l'esprit sous le régime fasciste" (Degenerate Art: Freedom of the Spirit under the Fascist Regime). The exhibition *Freie Deutsche Kunst* (Free German Art), organized for the Galerie d'Anjou at the Maison de la Culture, echoed the one held previously in London: seventy artists under threat from Germany and Austria, including expressionists, surrealists, or figures such as Oskar Kokoschka, were exhibited.

The year 1938 marked a strange hiatus, as the Exposition Internationale was dismantled and the political climate deteriorated. The Exposition Internationale du Surréalisme was held at the start of the year, organized by the group's leader, André Breton, at the Galerie des Beaux-Arts on the smart Rue du Faubourg-Saint-Honoré. This event was significant as a pioneering "installation," with coal sacks suspended from the ceiling by the notorious Marcel Duchamp* (just back from New York), and a taxi containing two store mannequins, live snails, and dripping rain conceived by Salvador Dalí. It was a menacing environment, presaging horrors to come.

Paris was occupied by the Nazis in June 1940. France, subsequently divided into a Free Zone and an Occupied Zone, was led by the aged Marshal Pétain, a World War I hero. Pro-German propaganda masked the defeat. Hundreds of people were interned in camps across the country for being Resistance fighters, Jews, Communists, or "enemies from without," including the German artists Max Ernst, Hans Bellmer, and Wols. Many were sent to certain death, notably the abstract painter Otto Freundlich, who died at the Sobibor extermination camp in Poland. Among the thousands of Jews deported from France who perished during World War II, sixty-four artists are known to have been gassed.[11]

In this context, the former Dadaist painter Francis Picabia—who lived on the French Riviera, where the beaches were lined with barbed wire—mocked the obscene Opération Vent Printanier (Operation Spring Wind, the code name for the rounding up and deporting of Jewish populations in July 1942) with "realist" paintings such as *Portrait d'un couple (le cerisier)* (Portrait

10 Francis Picabia, *Portrait d'un couple (le cerisier)* (*Portrait of a Couple*), 1943. Oil on canvas.

11 Georges Braque, *Vanitas*, 1939. Oil on canvas.

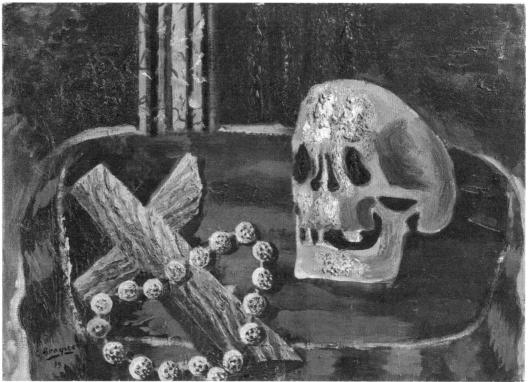

11

of a Couple), depicting a smiling couple next to a cherry tree in bloom; the painting's kitsch style alone was a critique of Vichy propaganda.

During the Occupation of Paris and its surrounding area, the period of waiting and mourning was represented in paintings such as Georges Braque's *Vanitas* of 1939—a still life with skull and crucifix— or in sculpture, notably in Picasso's brutal decapitated skull in bronze from 1943. The patriotic—and mostly Catholic— group known as the "Young Painters in the French Tradition" managed to escape the active censorship of the times with brightly colored semi-abstract works.[12] But the School of Paris, which had once been France's glory, existed no more. The richer and more privileged artists left the country.

It is tragically ironic that the greatest Soviet sculpture shown at the 1937 Exposition Internationale, by Vera Mukhina, and the most exaggerated Nazi sculptures by Arno Breker,* which dominated Occupied Paris's art scene when they were exhibited in 1942 at the Musée de l'Orangerie—while the world was engaged in bloody battle—displayed the very styles and techniques that their creators had learned in Montparnasse in the 1920s. S W

1. See the well-known diagram on the dust jacket of Alfred Barr's book *Cubism and Abstract Art* (New York: Museum of Modern Art, 1936).
2. Blaise Cendrars, *La Fin du monde filmée par l'ange N-D*, illustrated by Fernand Léger (Paris: La Sirène, 1919).
3. "Orphism," which takes its name from a poem by Guillaume Apollinaire,* is essentially defined by the work of Robert and Sonia Delaunay, and František Kupka from 1912 to 1914.
4. Jean Cocteau, *Le Rappel à l'ordre* (Paris: Stock, 1926). Published in English as *A Call to Order*, trans. Rollo H. Myers (London: Faber and Gwyer, 1926).
5. The works of Freud were translated progressively into French from 1920 onward. See also Lucien Lévy-Bruhl, *Les fonctions mentales dans les sociétés inférieures* (Paris: Librarie Félix Alcan, 1910) and *La mentalité primitive* (Paris: Librarie Félix Alcan, 1922). Published in English as *How Natives Think*, trans. Lilian A. Clare (New York: Alfred A. Knopf, 1926) and *Primitive Mentality*, trans. Lilian A. Clare (New York: The Macmillan Company, 1923).
6. *La Vérité sur les colonies*, September 1931–February 1932, Soviet pavilion, 12 Avenue Mathurin-Moreau, Paris.
7. Ilya Ehrenburg, *Moi Parizh* (Moscow: Izogiz, 1933).
8. Louis Aragon et al., *La Querelle du réalisme* (Paris: Éditions Sociales Internationales, 1936).
9. Louis Aragon, "John Heartfield et la beauté révolutionnaire" and "Le retour à la réalité," in *Pour un réalisme socialiste* (Paris: Denoël & Steel, 1935), 35–57, 85–86.
10. See the catalog *Chefs-d'œuvre de l'art français* (Paris: Palais National des Arts, 1937); and Louis Aragon, "Réalisme socialiste, réalisme français," *Europe*, no. 183 (March 15, 1938): 289–303.
11. See Hersh Fenster, *Undzere Farpainikte Kinstler* [Our Martyred Artists], preface by Marc Chagall. In Yiddish. Published in Paris in 1951 at the author's expense; published in French as *Nos artistes martrys* (Paris: Hazan, 2021).
12. *Vingt jeunes peintres de tradition française* (Twenty Young Painters in the French Tradition), Galerie Braun, Paris, May 10, 1941. Among them, Jean Bazaine, Maurice Estève, and Charles Lapicque became well-known after World War II.

Jean Patou

1887, Paris
1936, Paris

In 1912, Jean Patou opened his Maison Parry, where his avant-garde vision of fashion at more affordable prices than elsewhere earned him a clientele of prominent actresses. In 1914, after early commercial success in the United States, he set up Jean Patou & Cie. on Rue Saint-Florentin, not far from the Place de la Concorde. During World War I, he served as captain of the Zouaves in the Dardanelles, and he returned to France with a collection of oriental designs and an international address book.

A conscientious employer, he surrounded himself with members of his family and incorporated leading society figures into his team. He was more of an artistic director than a couturier, and it was not long before he began attracting attention. Close to Louis Süe and André Mare, who together decorated and furnished his apartment and his fashion house, Patou organized spectacular fashion shows that showcased sumptuous evening gowns as well as sporty designs that were perfectly adapted to his customers' new lifestyles. Advised by his muse, tennis champion Suzanne Lenglen, he was the originator of sportswear and the almost systematic use of logos. In 1926, he invented the first sunscreen product, Huile de Chaldée (Chaldea Oil), and he was a skilled perfumer: in the middle of the economic crisis of 1930, he had no qualms about launching Joy, the most expensive perfume in the world.

Sophisticated, seductive, and living on an equal footing with his clients, he helped elevate the status of the couturier. In 1936, a fatal stroke brought to a close an intrepid life that reflected his era. C Ö

Emmanuelle Polle. *Jean Patou: A Fashionable Life*. Paris: Flammarion, 2013.

Tennis star Suzanne Lenglen sporting a daywear ensemble, c. 1930. Photograph by Laure Albin-Guillot.

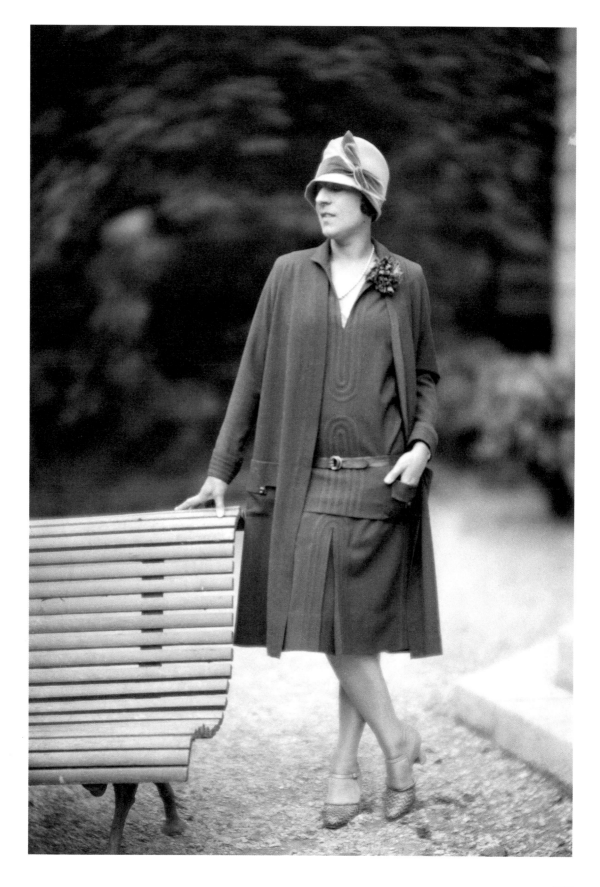

Charles Peignot

1897, Paris
1983, Paris

Charles Peignot succeeded his father, Georges Peignot, as artistic director and then general manager of the Peignot foundry, which had produced such widely used typefaces as Grasset and Auriol—the latter was a source of inspiration for Hector Guimard's metro signage. Located on Rue de Fleurus, in the sixth arrondissement, the firm became Deberny et Peignot following a merger in 1923 and was a major player on the typographic market until its liquidation in 1973. Charles Peignot added new alphabets matching the spirit of the age to the already rich catalog: between the wars, he commissioned Cassandre* to create Bifur, Acier, and Peignot and Marcel Jacno to design Film. In 1929, he acquired the rights to Paul Renner's Futura from the German foundry Bauer, which he distributed in France under the name Europe.

Peignot developed the company commercially, encouraging the use of these typefaces in printing, but also for signs and epigraphs. In addition to using customary advertising methods to ensure the name of the foundry appeared in magazines and periodicals, in the form of press advertisements, as well as on the Parisian streets on the sides and back of vehicles, he also relied on sophisticated editorial publications, and founded *Divertissements typographiques* (Typographical Amusements), which ran from 1928 to 1936, with his collaborator Maximilien Vox, and, most importantly, the luxury magazine *Arts et métiers graphiques* (Graphic Arts and Crafts), which existed from 1927 to 1939. C d S

Maximilien Vox. "Charles Peignot et son temps." *Communication et langage*, no. 14 (1972): 45–61.
Michel Wlassikoff. *The Story of Graphic Design in France*. Berkeley, CA: Gingko Press, 2006.

↓ Advertisement for the Deberny et Peignot foundry on a van, 1929.

→ Publicity brochure for the launch of the typeface Film, designed by Marcel Jacno, 1934.

LE GRAPHISME DANS LA RUE

NOS NOUVELLES VOITURES DE LIVRAISON

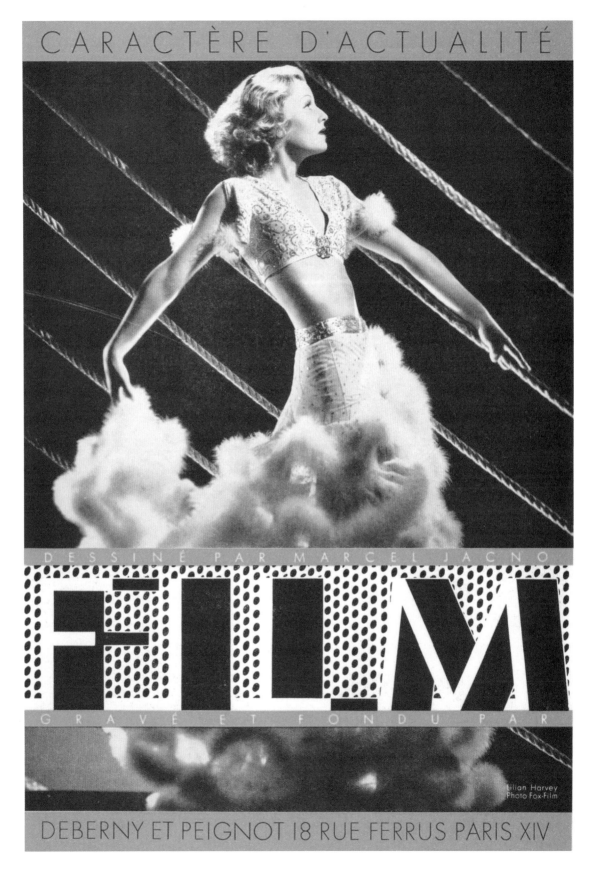

CARACTÈRE D'ACTUALITÉ

DESSINÉ PAR MARCEL JACNO

FILM

GRAVÉ ET FONDU PAR

Lilian Harvey
Photo Fox-Film

DEBERNY ET PEIGNOT 18 RUE FERRUS PARIS XIV

257

Auguste Perret

1874, Ixelles (Belgium)
1954, Paris

The years following World War I were decisive for Auguste Perret. Although the fierce controversy triggered in 1913 by his Théâtre des Champs-Élysées had aroused suspicions of him being a German agent, he fulfilled his patriotic duties by designing airship shelters in concrete—a material to which he lent prestige earlier in the century.

After completing the church of Notre-Dame-de-la-Consolation (1922) in Le Raincy, in the eastern suburbs of Paris—its colored glass façades, thin vaults, and exposed posts led to its nickname the "Sainte-Chapelle of Reinforced Concrete"—he created the theater for the Exposition Internationale des Arts

Décoratifs et Modernes Industriels in 1925, giving it a three-part stage that followed on from his earlier experiments. For the concert hall of the École Normale de Musique on Rue Cardinet, he designed upward, in a very compressed volume, succeeding, in the words of the school's founder, the pianist Alfred Cortot, in creating a hall that "sounded like a Stradivarius."

In contrast, he looked to the extended horizons of greater Paris for his "tower block" project. Theoretical at first, and associated in his drawings with the kind of docklands found in New York, the vertiginous skyscrapers first designed in 1920 were meant to be installed along the Voie Triomphale from La Défense to Saint-Germain, in a project that was featured in the magazine *L'Illustration*.

Remaining firmly in Paris, Perret built private mansions and apartment buildings, notably the block on Rue Raynouard, with his studio at the base and his apartment on the top floor. The tectonic treatment of his façades used concrete in a variety of finishes—exposed, washed,

↓ The master at work in his studio on Rue Raynouard, c. 1932. Photograph by Albert Harlingue.

→ The École Normale de Musique (Salle Cortot), Rue Cardinet, 1928-29. View of the concert hall, 1929. Photograph by Studio Chevojon.

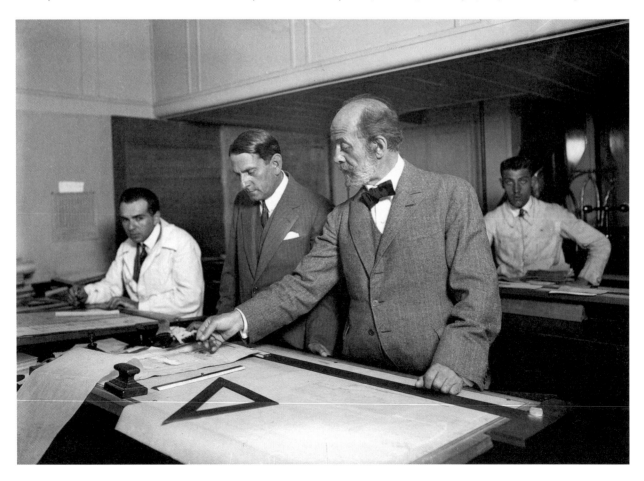

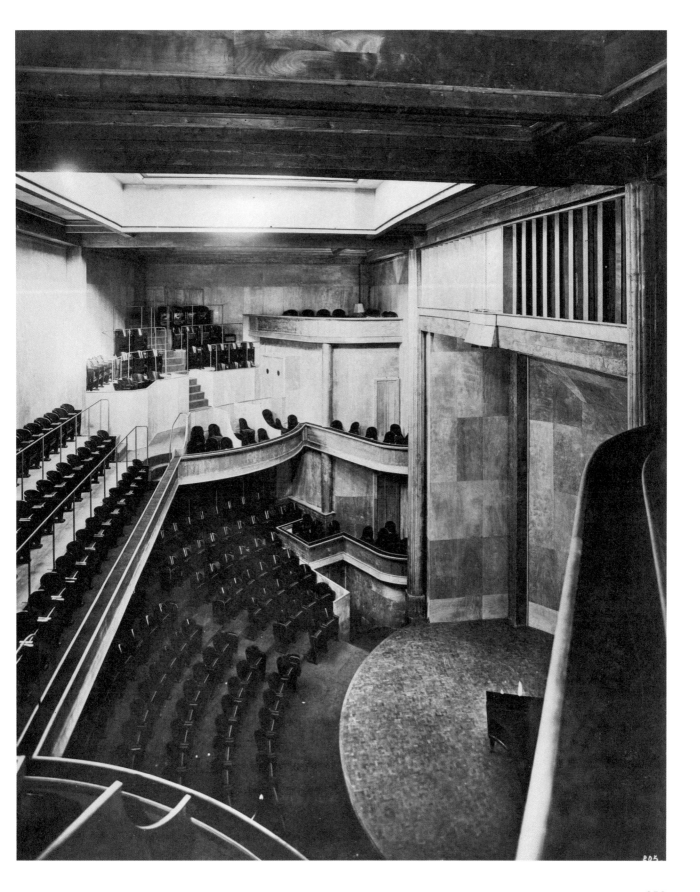

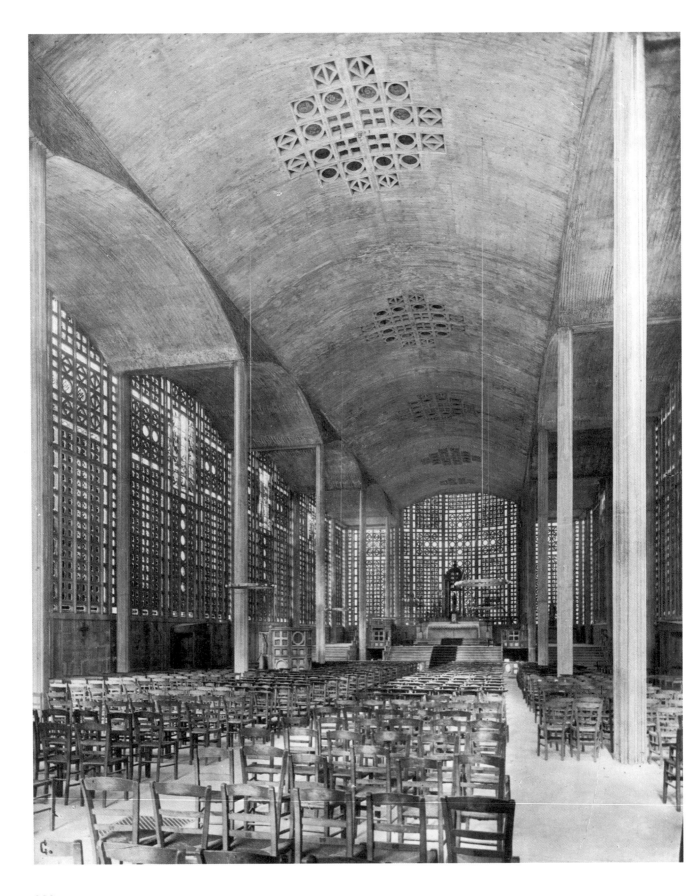

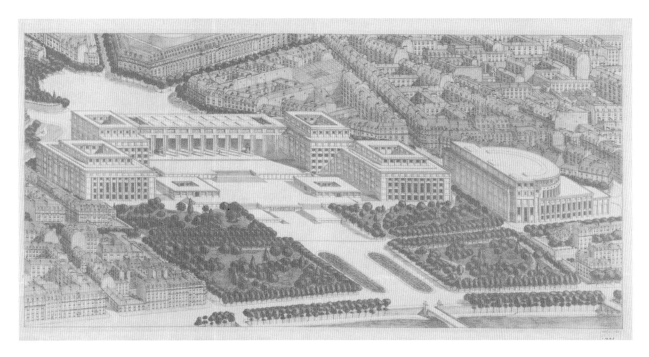

bush-hammered—and thus introduced a vocabulary he would put to use in several public buildings such as the Mobilier National and the Musée des Travaux Publics (Museum of Public Works), the jewel in his Parisian crown and now home to the Conseil Économique, Social et Environnemental (Economic, Social, and Environmental Council.) For the only completed section of the project conceived in response to education minister Anatole de Monzie's request for the creation of a "Colline des Musées" at Chaillot, he combined two architectural orders nestled one inside the other. Their columns have tapered capitals whose surface reveals the hidden reinforcements, and Perret's double-revolution staircase demonstrates a rare virtuosity.

Perret became a public figure, always quick to express his theory of architecture in the form of sententious aphorisms, and an influential teacher with his creation of the Atelier du Palais de Bois in 1924 on the former fortifications. Ernö Goldfinger, Denis Honegger, Paul Nelson,* and Oscar Nitzchké* were among his disciples. Later, he ran an atelier at the École Spéciale d'Architecture, and finally, in 1942, obtained a worthy chair at the École des Beaux-Arts in Paris.

During World War II, he developed a project for a national Olympic stadium located on several sites in the Paris region, while playing an active role in establishing the Order of Architects and within the bodies responsible for rebuilding France.　J-L C

Karla Britton. *Auguste Perret*. London: Phaidon, 2000.
Jean-Louis Cohen, Joseph Abram, and Guy Lambert, eds. *Encyclopédie Perret*. Paris: Éditions du Patrimoine/Institut Français d'Architecture/Éditions Le Moniteur, 2002.
Maurice Culot, David Peyceré, and Gilles Ragot. *Les Frères Perret: L'œuvre complète*. Paris: Institut Français d'Architecture/Norma, 2000.
Paul Jamot. *A.G. Perret et l'architecture du béton armé*. Brussels: Vanoest, 1927.

← The church of Notre-Dame-de-la-Consolation, Le Raincy, 1922-23. View of the nave. Photograph by Studio Chevojon.

↑ Project for the Cité des Musées on the Colline de Chaillot, 1933. Axonometric view of the site. Heliographic print on paper.

Charlotte Perriand

1903, Paris
1999, Paris

In 1925, Charlotte Perriand—who had just graduated from the École de l'Union Centrale des Arts Décoratifs in Paris—exhibited her work at the Exposition Internationale des Arts Décoratifs et Industriels Modernes. However, she first made a name for herself with her "Bar sous le toit," located in the attic of her own apartment on Place Saint-Sulpice, which was shown at the 1927 Salon d'Automne.

Armed with this initial success and marked by the reading of *Vers une Architecture* (*Toward an Architecture*), she immediately offered her services to Le Corbusier* and Pierre Jeanneret and collaborated with them regularly until World War II. Together, they left an indelible mark on the modern design landscape at the 1929 Salon d'Automne, where they presented a now famous series of tubular metal-framed furniture described as "the interior equipment of a home" and which, a century later, still represents a paradigm of modernity. That same year, Perriand participated in the founding of the Union des Artistes Modernes along with other artists with whom she had worked, including René Herbst,* Djo-Bourgeois, and Robert Mallet-Stevens.* Closely acquainted with Fernand Léger,* since their meeting in 1930, she joined him in producing spectacular photomontages for various pavilions at the 1937 Exposition Internationale. She had already used this technique the previous year in *La Grande Misère de Paris* (*Deep Poverty in Paris*), presented at the Salon des Arts Ménagers home show. These works, which illustrated the policies of the Popular Front, were evidence of her leftist commitment.

In 1940, she embarked for Japan and was enduringly influenced by the pared-down way of living she discovered there. After World War II, she continued to work with Le Corbusier, for whom she designed the rational kitchen layout for the apartments in the Unité d'Habitation in Marseille. She also collaborated regularly with Jean Prouvé.* G MJ

Jacques Barsac. *Charlotte Perriand: Complete Works. Vol. 1: 1903–1940*. Zurich: Scheidegger & Spiess, 2014.
Jacques Barsac, Sébastien Cherruet, and Pernette Perriand, eds. *Charlotte Perriand: Inventing a New World*. Paris: Gallimard, 2019.
Charlotte Perriand: Un art de vivre. Paris: Musée des Arts Décoratifs/Flammarion, 1985. Exhibition catalog.

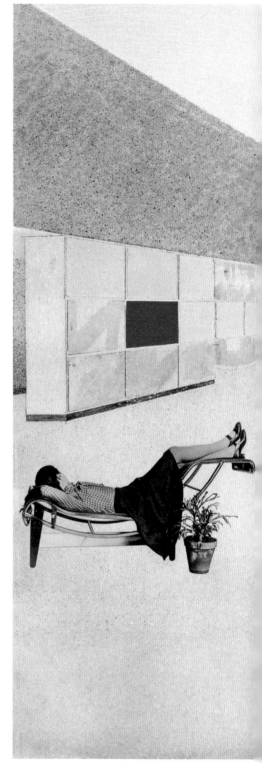

Indoor Furnishings for the Home, installation at the Salon d'Automne, 1929, with Le Corbusier and Pierre Jeanneret. Photomontage published in *L'Architecture vivante*, 1930.

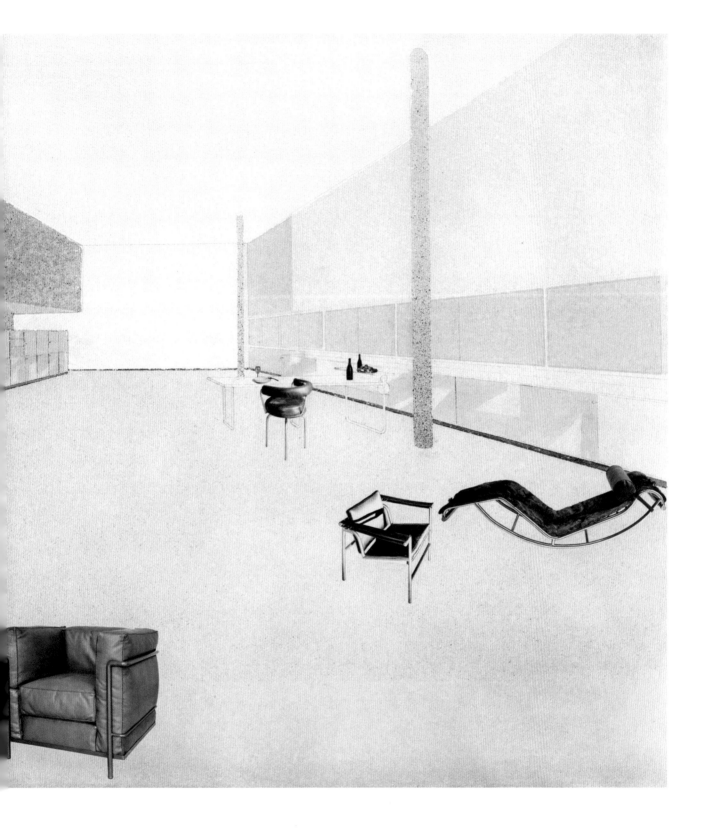

Pablo Picasso

1881, Málaga
1973, Mougins (France)

Picasso was very young when he moved to Paris from Spain in 1904, and he initially settled in the Bateau-Lavoir artists' colony in Montmartre, where he became close friends with Guillaume Apollinaire* and numerous emerging artists of his generation. The man who was to dominate the art of the twentieth century worked for nearly fifty years in various districts of Paris, moving from Montmartre to Montparnasse, to Rue La Boétie and then to Rue des Grands-Augustins, before settling in the South of France after World War II. It was in Paris that he founded cubism with Georges Braque, painting *Les Demoiselles d'Avignon* in 1907, and where, after World War I, he explored many other artistic paths—including primitivism and surrealism—as well as a wide range of varied techniques, including drawing, painting, collage, engraving, illustration, ceramics, and sculpture. He was no stranger to success, after the initial lean years—Gertrude Stein* was one of his first clients and friends, followed by Marie Cuttoli,* Helena Rubinstein,* and many others—with numerous commissions and ever-larger exhibitions fueled by his incredible productivity. As early as 1932, publisher Christian Zervos* embarked with him on the adventure of issuing the catalogue raisonné of his paintings.

His major work from the interwar period, *Guernica*, which he saw as "an instrument of offensive and defensive war against the enemy," was painted for the Spanish Republic's pavilion at the 1937 Exposition Internationale. A rare occurrence in the history of art, every stage in the process of creating the painting was documented by his companion at the time, the photographer Dora Maar.* G MJ

Émilie Bouvard, ed. *Guernica.* Paris: Musée Picasso/ Gallimard, 2018. Exhibition catalog.
Pierre Daix. *Picasso.* Paris: Tallandier, 2007.

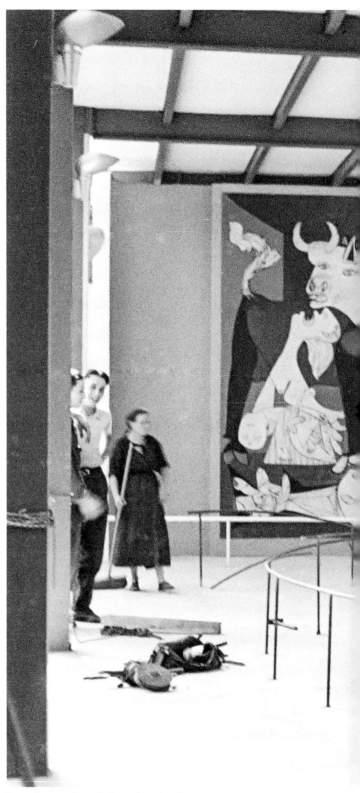

Dora Maar, view of *Guernica* in the Spanish pavilion of the Exposition Internationale of 1937, with Alexander Calder's *Mercury Fountain* in the foreground.

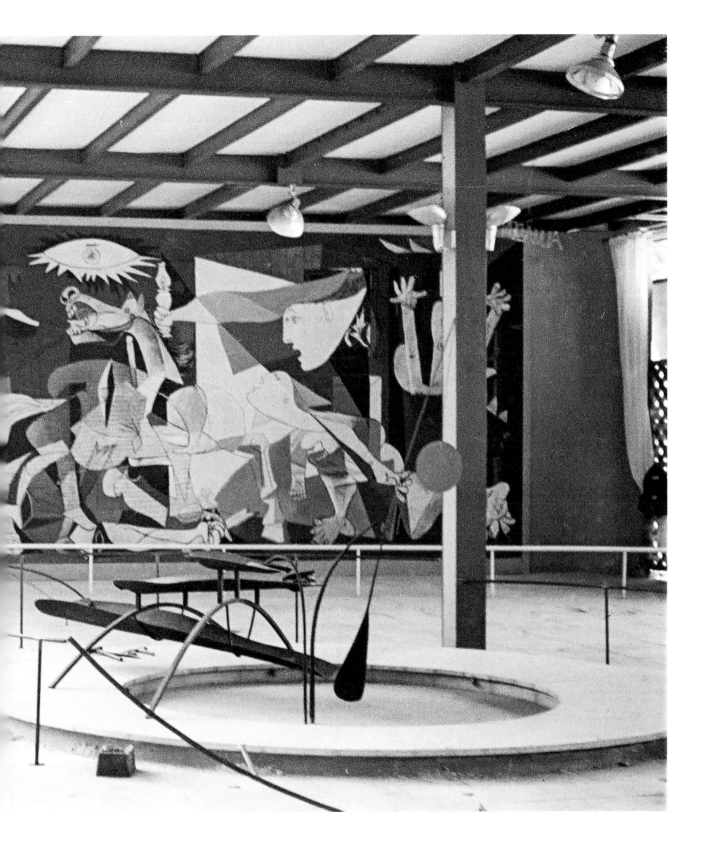

Paul Poiret

1879, Paris
1944, Paris

Trained by Charles Frederick Worth and Jacques Doucet,* Paul Poiret opened his couture house in 1903. His corsetless dresses, launched in 1906, made him famous, and his creations were marked by his taste for the exotic and a vivid palette borrowed from the Ballets Russes. He opened the way for artistic collaborations of all kinds: with Raoul Dufy, he breathed new life into the textile design repertoire, and in 1921–22 he commissioned Robert Mallet-Stevens* to build a house in Mézy-sur-Seine, which remained uncompleted due to a lack of funds. He also financially supported the production of Marcel L'Herbier's* film *L'Inhumaine* (*The Inhuman Woman*).

The first couturier to diversify his design activities, Poiret founded the Martine ateliers in 1911, where young girls drew naïve motifs, which were then transposed into embroidery and fabrics for fashion and home decoration. He was also the first designer to establish licenses abroad, to invent a perfume and design its packaging, and to open a glassworks and packaging factory.

After World War I, Poiret was no longer in tune with the times. Bankrupted by his extravagant contribution to the Exposition Internationale des Arts Décoratifs et Industriels Modernes and by the Crash of 1929, he nevertheless broke new ground in 1933 by designing collections under his name for the Printemps department store. An omnipotent creator, Poiret was extremely involved in the artistic and social scenes in Paris. He wrote his memoirs as well as a cookbook, and was a significant collector and patron of the arts. C Ö

Paul Poiret. *En habillant l'Époque*. Paris: Grasset, 1930.
———.*King of Fashion: The Autobiography of Paul Poiret*. London: V&A Publishing, 2019.
Paul Poiret et Nicole Groult: Maîtres de la mode Art déco. Paris: Musée de la Mode et du Costume, Palais Galliera/Paris-Musées, 1986. Exhibition catalog.
Palmer White. *Poiret*. London: C. N. Potter, 1973.

↓ House built by Robert Mallet-Stevens for Paul Poiret, Mézy-sur-Seine, 1921–23. View of the construction site.

→ Fitting session in the atelier, 1925. Photograph by Boris Lipnitzki.

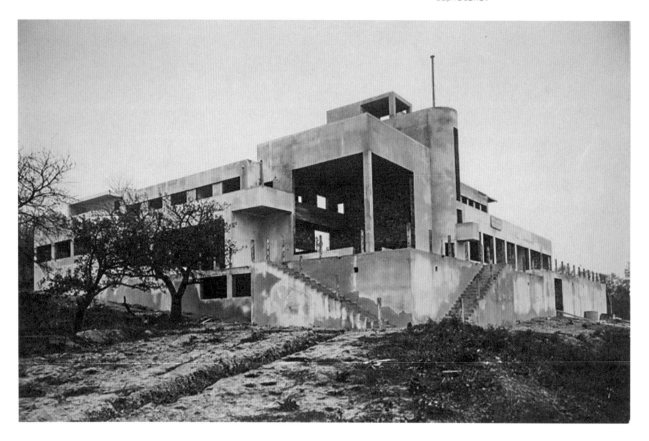

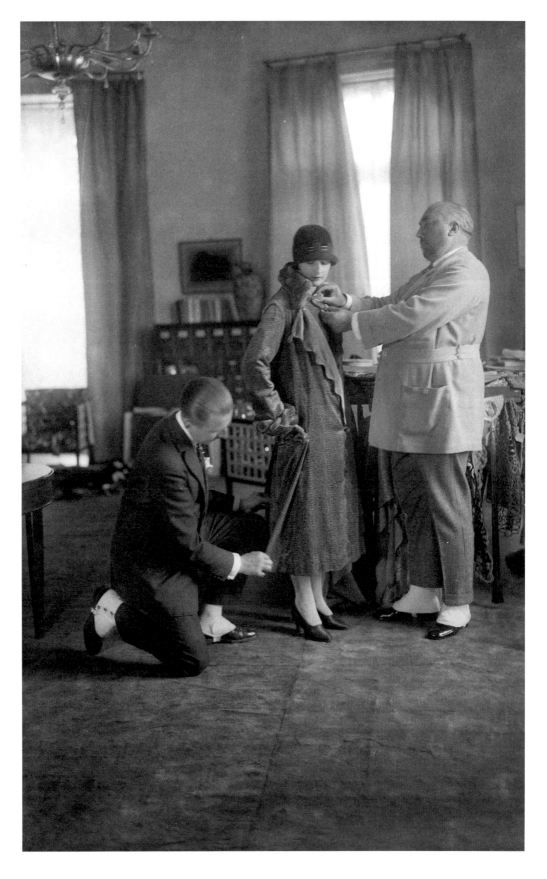

267

Henri Prost

1874, Paris
1959, Paris

Henri Prost, who was awarded the prestigious Grand Prix de Rome for architecture in 1902, had made extraordinary measured drawings of Hagia Sophia in Istanbul. His interest in the new discipline of urban planning and his experience of the Orient led him to be commissioned by Hubert Lyautey* in 1914 to create the Town Planning Department of Morocco. He then drew up the regional plan for the coastline of the Var département on France's Riviera (1922–26)—the first French planning document to go beyond the individual city to encompass an inter-municipal entity.

From 1928 onward, Prost worked on the general plan for the Paris region, with the support of Raoul Dautry* and under the authority of the Comité Supérieur de l'Aménagement et de l'Organisation Générale de la Région (Regional Development and Organization Committee). Completed in 1934, this plan was the result of a careful study of the real conditions of urbanization. Its objective was to "organize Greater Paris and not to extend it further" and to "perfect this enormous area that the law has circumscribed within a radius of thirty-five kilometers [twenty-two miles], with Notre-Dame de Paris as its center," while avoiding the fantasies of "urban planning theorists" such as linear cities or satellite towns. Prost wished to regulate the pace of growth according to the land potential of the various communes; to this end, he devised an extensive freeway scheme connected to a still-virtual national network, whose major elements were large radial roads allowing the "exit" from Paris, such as the Western autoroute, linking Paris to Caen, which was begun in 1939.

In 1936, Prost returned to his youthful concerns, when he was called on by Mustafa Kemal Atatürk to draw up plans for Bursa and Istanbul. J-L C

Joseph Marrast, ed. *L'Œuvre de Henri Prost: Architecture et urbanisme*. Paris: Académie d'Architecture, 1960.
Henri Prost. "L'urbanisme au point de vue technique." *Les Cahiers du Redressement français*, no. 16 (1927): 1–17.
Henri Prost. "Plan d'aménagement de la région parisienne." *Urbanisme*, no. 41 (December 1935).

↓ Robert Danis. Roquencourt Triangle freeway interchange, 1939-40. View of the model.

→ Development plan for the Paris region, 1934. Aerial view of the route from Place de l'Étoile to Saint-Germain. Heliographic print on paper, with added ink and gouache.

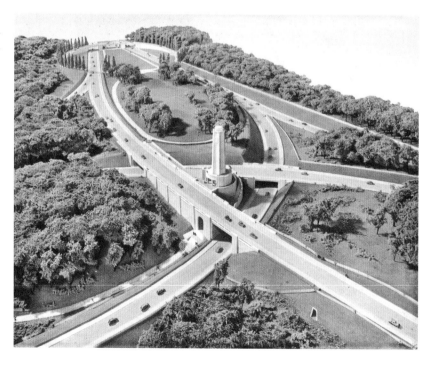

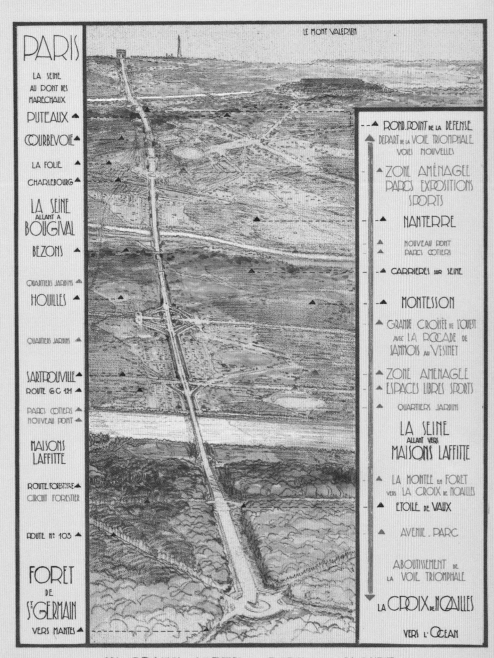

LE MONT VALERIEN

PARIS

LA SEINE
AU PONT DES
MARÉCHAUX

PUTEAUX ▲

COURBEVOIE ▲

LA FOLIE ▲

CHARLEBOURG ▲

LA SEINE
ALLANT A
BOUGIVAL

BEZONS ▲

QUARTIERS JARDINS ▲

HOUILLES ▲

QUARTIERS JARDINS ▲

SARTROUVILLE ▲
ROUTE G C 121 ▲

PARCS COTIERS
NOUVEAU PONT ▲

MAISONS
LAFFITTE

ROUTE FORESTIÈRE ▲
CIRCUIT FORESTIER

ROUTE N° 103 ▲

FORET
DE
S† GERMAIN

VERS MANTES ▲

---- ▲ ROND-POINT DE LA DEFENSE
DEPART DE LA VOIE TRIOMPHALE
VOIES NOUVELLES

▲ ZONE AMÉNAGÉE
PARCS EXPOSITIONS
SPORTS

▲ NANTERRE

NOUVEAU PONT
PARCS COTIERS ▲

CARRIERES SUR SEINE

▲ MONTESSON

▲ GRANDE CROISÉE DE L'OUEST
AVEC LA ROCADE DE
SANNOIS AU VESINET

▲ ZONE AMÉNAGÉE
ESPACES LIBRES SPORTS

▲ QUARTIERS JARDINS

LA SEINE
ALLANT VERS
MAISONS LAFFITTE

▲ LA MONTEE EN FORET
VERS LA CROIX DE NOAILLES

▲ ETOILE DE VAUX

▲ AVENUE - PARC

ABOUTISSEMENT DE
LA VOIE TRIOMPHALE

LA CROIX DE NOAILLES

VERS L'OCEAN

LES GRANDES SORTIES DE PARIS VERS L'OUEST
LA VOIE TRIOMPHALE DE PARIS A S† GERMAIN
VERS LES PROVINCES OCCIDENTALES DE FRANCE

N°DC3-2/G.1

Jean Prouvé

1901, Paris
1984, Nancy

It was not until 1930 that Jean Prouvé—a self-taught member of a long line of artists from Nancy —replaced "ironsmith" with "constructor" on his letterhead. He had already designed and built elements for several Parisian buildings: two wrought-iron doors for the Nancy and the East pavilion at the Exposition Internationale des Arts Décoratifs et Industriels Modernes, and several railings, banisters, and other doors in the constructions realized in 1927 by Robert Mallet-Stevens* in the street that bears his name—notably the townhouse-studio of the Martel brothers, Jan and Joël.* In addition, in 1929, he created the balustrades and glass façade of Albert Laprade's Citroën garage on Rue Marbeuf.

This change of designation had a significance that went beyond mere professional status: the craftsman had become a full-fledged contributor to modern architecture. His membership in the Union des Artistes Modernes in 1930, and his collaborations with Eugène Beaudouin* and Marcel Lods* in the Paris region—the Cité de la Muette in Drancy, the air club in Buc, and the Maison du Peuple in Clichy—bear witness to this. With his ingenious and elegant solutions, he became the master of folded steel sheet, which he would use from the beginning of World War II in multiple types of temporary shelters that were entirely prefabricated and dry-mounted.

During his lifetime, Prouvé was a respected contractor but was little known by the general public. By contrast, the furniture designs he created, either personally or in collaboration with Charlotte Perriand,* are today much sought after by auction houses and collectors, despite the fact that his tables, chairs, and shelves were originally intended to be mass-produced, economical items that were accessible to all. G M J

Laurence Allégret and Valérie Vaudou, eds. *Jean Prouvé à Paris*. Paris: Pavillon de l'Arsenal/Picard, 2001. Exhibition catalog.
Catherine Dumont d'Ayot and Bruno Reichlin, eds. *Jean Prouvé: The Poetics of the Technical Object*. Weil am Rhein: Vitra Design Museum, 2004. Exhibition catalog.
Peter Sulzer. *Jean Prouvé: Complete Works*. 4 vols. Basel: Birkhaüser, 2008.

↓ CB 22 chair, 1947.

→ Maison du Peuple, Clichy-la-Garenne, with Eugène Beaudouin, Marcel Lods, and Vladimir Bodiansky, 1936–39. Study for the supporting structure. Charcoal on tracing paper.

↘ Maison du Peuple, general view with the sliding roof open. Plate from *L'Encyclopédie de l'architecture*, vol. 12 (1939).

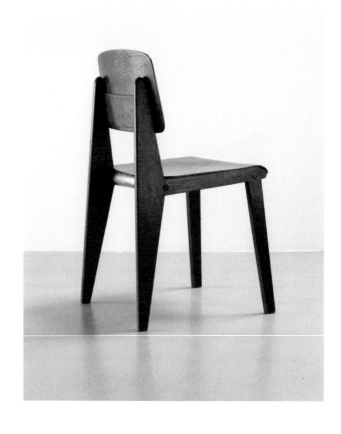

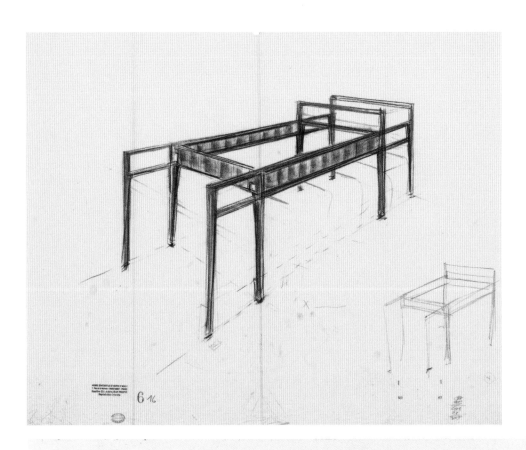

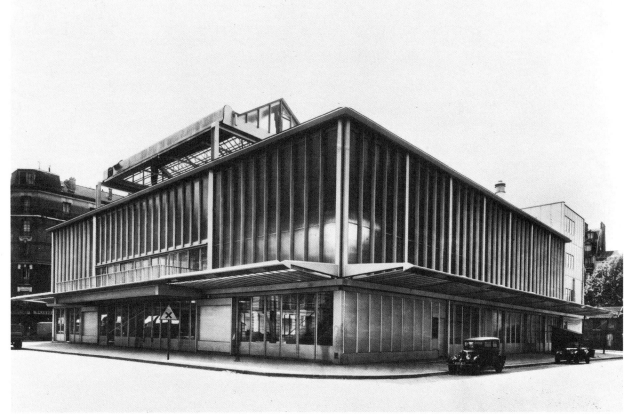

R S T U V Z

Man Ray

(b. Emmanuel Radnitzky)

1890, Philadelphia
1976, Paris

After studying drawing in New York, Man Ray moved to Paris in 1921. Welcomed by Marcel Duchamp,* he mingled with the European avant-garde, and learned the art of photography. In Paris, he met Kiki de Montparnasse, who became his companion and the model for such works as *Le Violon d'Ingres* (1924) and *Black and White* (1926). His talents as a portraitist made him the well-paid darling of the Paris social scene, which in turn led to publication in various magazines (*Vanity Fair*, *Vogue* from 1924, then *VU*) and guaranteed him a living while leaving him free to pursue personal projects, which included the discovery of the rayograph. His involvement in the surrealist movement, his reputation, his publications, and the exhibitions in which he featured earned him numerous commissions for the burgeoning fashion and advertising industries. From this creative environment came enduringly famous images such as *Tears* (1932), which was originally intended for a brand of mascara.

In 1929, Man Ray shot his major film, *Les Mystères du château du Dé* (The Mysteries of the Château of the Dice) in the Villa Noailles,* designed by architect Robert Mallet-Stevens,* and met Lee Miller, who would become his muse, assistant, and companion until 1932. Together, they discovered solarization. Hired by *Harper's Bazaar* in 1933, he gave free rein to his imagination in his work for the magazine for nearly seven years, using his gift for technical innovation to bring a dreamlike, poetic dimension to haute couture.

Man Ray sought recognition as an artist, rather than as a photographer, as evidenced by the title of his 1937 book *La Photographie n'est pas l'art* (Photography Is Not Art), which opened with a foreword by André Breton.* Yet, thanks to his technical mastery and his ability to step back from reality, he helped make fashion photography an artistic discipline in its own right. C Ö

Man Ray. *Self-Portrait*. Boston: Atlantic–Little, Brown, 1963.
Man Ray and Fashion. Paris: Réunion des Musées Nationaux/Grand Palais, 2019. Exhibition catalog.

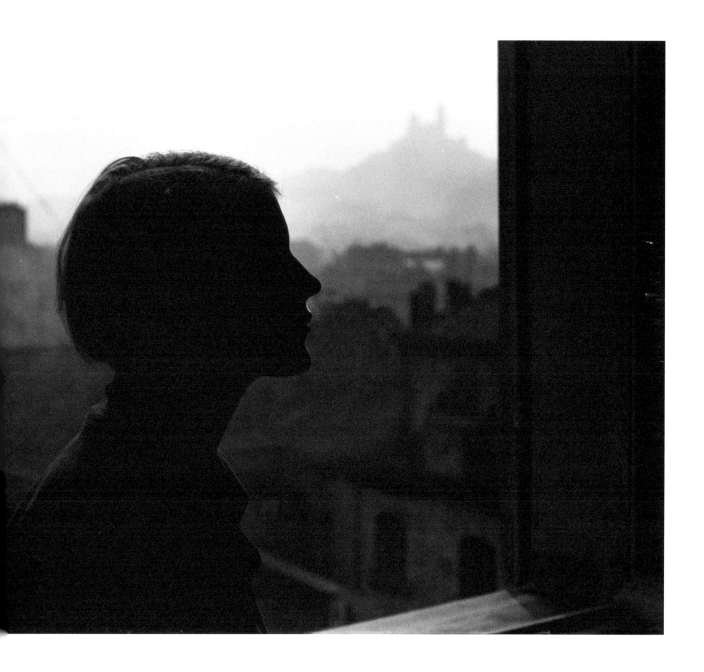

Silhouette of Lee Miller at the
window, c. 1930. In the background
can be seen the Sacré-Cœur basilica.

Jean Renoir

1894, Paris
1979, Beverly Hills

Jean Renoir began his career as a ceramist, but, thanks to an inheritance from his father—painter Auguste Renoir—he turned his hand to cinema, promoting the film career of his wife, Catherine Hessling, who was previously Auguste's model. Following *La Fille de l'eau* (*The Whirlpool of Fate*) in 1924, which was shot outdoors at Marlotte, near the forest of Fontainebleau, *Nana* (1926) was the movie that made the filmmaker's name, despite the fact that it was a resounding commercial flop. This adaptation of Émile Zola's novel, codirected by Renoir with his screenwriter and friend Pierre Lestringuez, evoked the Paris of the Second Empire through the character of a much-courted actress who becomes a courtesan and dies of syphilis just as the Franco-Prussian War of 1870 breaks out:

faced with social unrest, Napoleon III, had seen the war as an outlet. The film required large sets—designed by Claude Autant-Lara* and Robert Jules Garnier—but did not include views of Paris. It was later, for *Marquitta* (1927), that Renoir had a miniature reproduction of the Barbès metro station made, within which his actors played their roles as if they were living puppets. After the arrival of talkies, Renoir made several films that were set in Paris but mostly shot in the studio: *La Chienne* (*The Bitch*) in 1931; *La Nuit du carrefour* (*Night at the Crossroads*) in 1932; *Boudu sauvé des eaux* (*Boudu Saved from Drowning*) in 1932; *Le Crime de M. Lange* (*The Crime of Monsieur Lange*) in 1935; and *La Vie est à nous* (*Life Belongs to Us*) in 1936. Conversely, *Partie de campagne* (*A Day in the Country*) of 1936 was shot near Marlotte and Montigny-sur-Loing (Seine-et-Marne), *La Marseillaise* of 1938 was filmed between Marseille and Paris, and *La Bête humaine* (*The Human Beast*) of 1938 was shot between Paris and Le Havre. *La Vie est à nous*—a propaganda film for the

French Communist Party, for which Renoir coordinated the filmmaking collective—includes several exterior scenes, one showing a new vertical housing scheme erected in the suburbs. F A

André Bazin and François Truffaut. *Jean Renoir*. New York: Little, Brown, 1992.
Raymond Durgnat. *Jean Renoir*. London: Studio Vista, 1975.
Jean Renoir. *My Life and My Films*. New York: Atheneum, 1971.
———. *Écrits, 1926–1971*. Paris: Pierre Belfond, 1974.

↓ Still from *La Vie est à nous* (*Life Belongs to Us*), 1936. In the background, a low-cost housing complex in Gentilly is visible.

→ Stills from *Boudu sauvé des eaux* (*Boudu Saved from Drowning*), 1932.

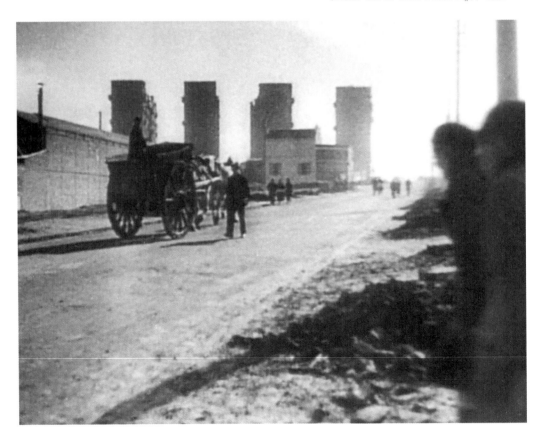

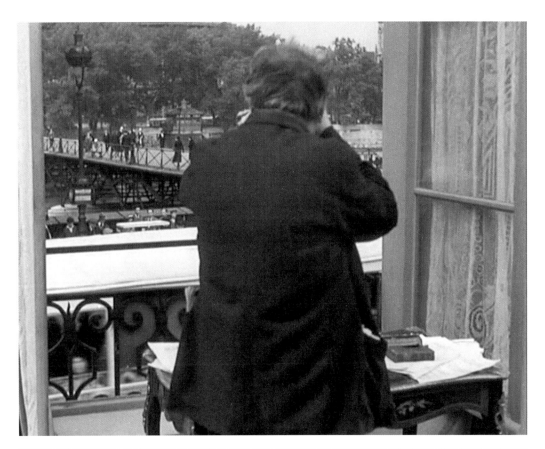

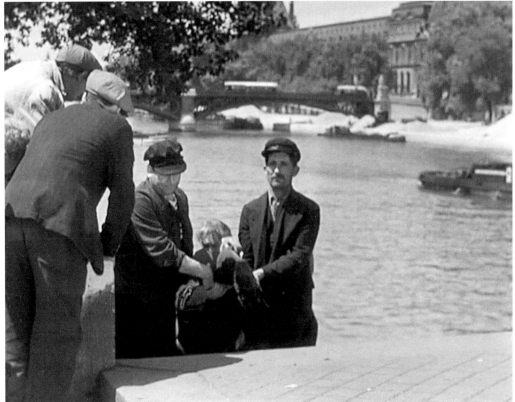

Michel
Roux-Spitz

1888, Lyon
1957, Dinard

Roux-Spitz is the epitome of the temperate modern architect. Awarded the First Grand Prix de Rome in 1920, he was sufficiently classical to appeal to both the state and private clients, making him a prolific constructor, in Paris and in the provinces.

This recognition led him to hold various positions successively: editor in chief of the magazine *L'Architecte* from 1925 to 1932, then of *L'Architecture française* from 1943 to 1950, and professor of theory at the École des Beaux-Arts in 1940. He left his mark on the Parisian landscape with a dozen private apartment buildings in the capital's upscale neighborhoods; they are characterized by stone veneer façades arranged around bow windows that illuminate the salons of large bourgeois apartments and, sometimes, oculi reminiscent of ocean-liner portholes. Built in the second half of the 1920s, they can still be seen today, notably on Rue Guynemer and Rue Cognac-Jay in Paris, and Boulevard d'Inkermann in Neuilly-sur-Seine. Facing Parc Montsouris, the ground floor of his building on Rue de la Cité Universitaire was home to the boutique of art deco lighting designer Jean Perzel, whose services the architect called upon for several of his constructions.

Roux-Spitz was also involved in one of the most controversial programs in Paris during the Occupation: the renovation of the "insalubrious block" no. 16 in the Marais, on which he worked from 1942 onward, along with Albert Laprade and Robert Danis. G MJ

Michel Raynaud. *Michel Roux-Spitz, architecte, 1888– 1957*. Brussels: Mardaga, 1984.
Michel Roux-Spitz: Réalisations. 3 vols. Paris: Vincent, Fréal & Cie, 1933–59.

↓ Apartment building, Rue Guynemer, 1925-28. General view. Photograph by Albin Salaün.

→ The architect's office, Avenue Henri-Martin, 1931. Plate from *L'Architecte*, June 1931.

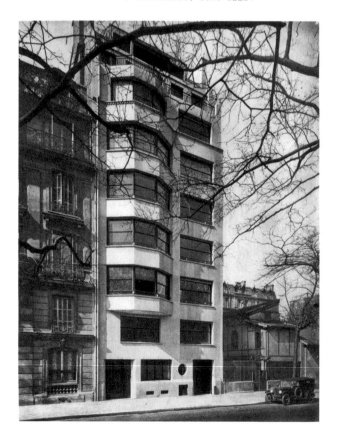

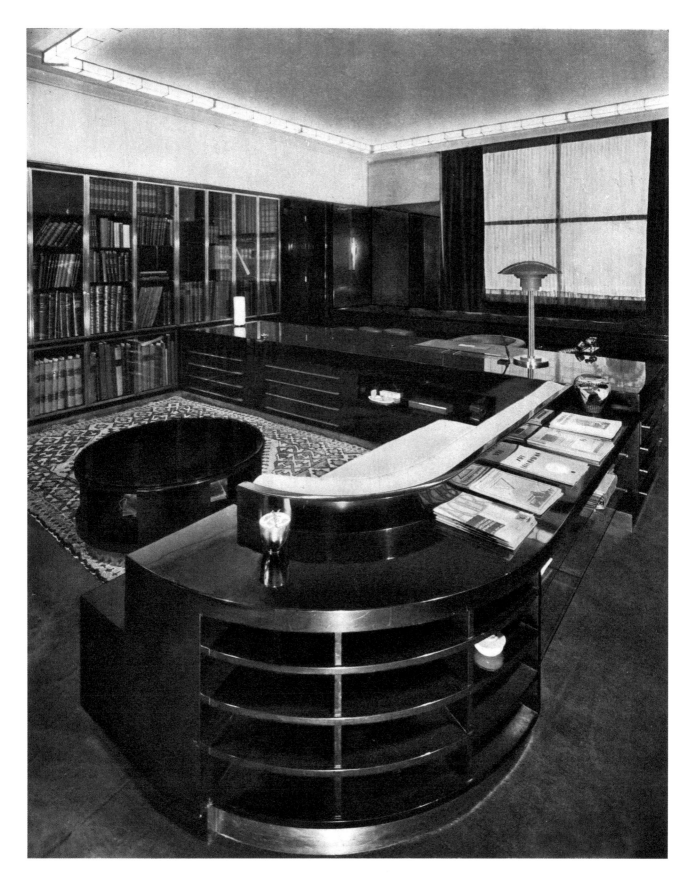

Helena Rubinstein

1872, Krakow (Austro-Hungarian Empire)
1965, New York

Helena Rubinstein, the creator of modern cosmetics, lived and worked in many cities, in Hungary, the United States, Australia, Great Britain, and Israel, but the French capital—after New York—was one of her main ports of call. She stayed in Paris for extended periods from 1905 onwards, and soon began purchasing "primitive" art at the Drouot auction house. She opened her first beauty salon on Rue du Faubourg-Saint-Honoré just before World War I, and had production laboratories built in Saint-Cloud, to the west of Paris, in 1913 and 1930. She commissioned Bruno Elkouken

↓ The founder visiting one of the Helena Rubinstein production laboratories in Saint-Cloud, 1930.

→ Helena Rubinstein with Marie Cuttoli in her apartment on Boulevard Raspail, presenting her collection of African art, 1934. Photograph by Boris Lipnitzki.

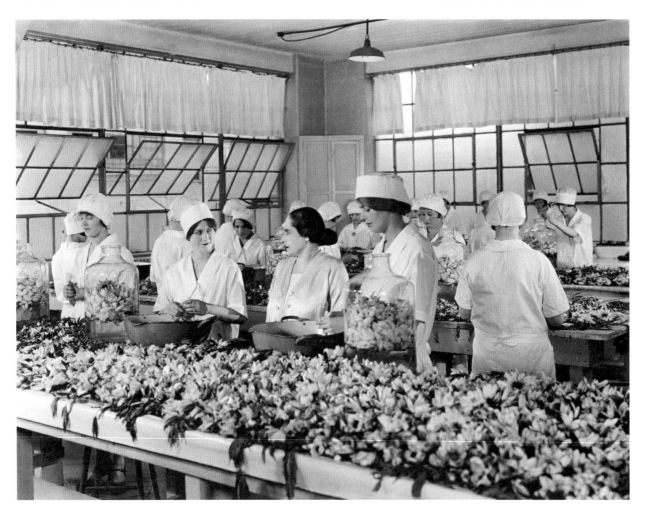

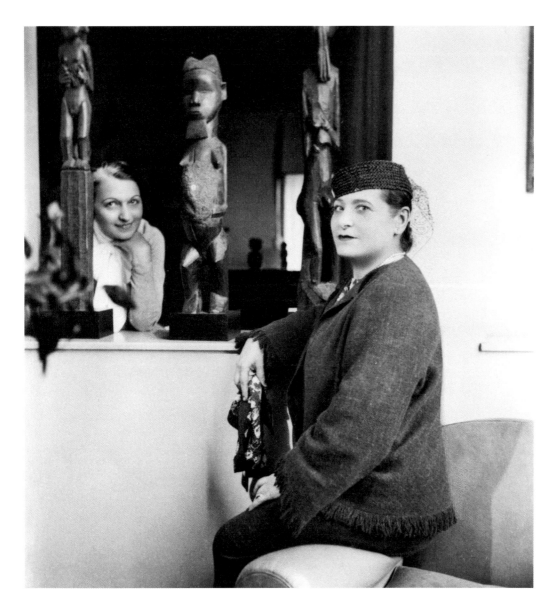

to construct a building at 216 Boulevard Raspail; in 1934, she moved into the penthouse there, which was decorated by the Hungarian-born architect Ernö Goldfinger. She later moved into her luxurious townhouse on Quai de Béthune, in 1937.

When not working, this compulsive collector, dressed by Doucet,* Poiret,* Chanel,* and Schiaparelli*, entertained her guests in the midst of the works she had acquired: African and Oceanian art, crockery, dollhouses, and artworks by contemporary artists—including Raoul Dufy, Chana Orloff,* Louis Marcoussis, Salvador Dalí, Fernand Léger,* and Pablo Picasso*—from whom she sometimes commissioned her portrait. When she acquired the 1928 statue *Négresse blanche II*

(*White Negress II*) by Constantin Brancusi, which was perhaps inspired by Josephine Baker,* she achieved a synthesis between the two poles of her immense collection. A shrewd businesswoman, she often used her personal collections and apartments for publicity purposes. G MJ

Michèle Fitoussi. *Helena Rubinstein: The Woman Who Invented Beauty*. London: Gallic Books, 2014.
———. *Helena Rubinstein: The Adventure of Beauty*. Paris: Flammarion, 2021.
Hélène Joubert. *Helena Rubinstein: Madame's Collection*. Paris: Skira, 2021.

Émile-Jacques Ruhlmann

1879, Paris
1933, Paris

In 1908, twenty-nine-year-old Émile-Jacques Ruhlmann took the reins of the family wallpaper and mirror business created in Paris in 1870. In fewer than twenty years, he turned it into a company that exported not only furniture but a strikingly distinctive style around the world.

Between 1912 and 1920, the young self-taught Ruhlmann learned the craft of cabinetmaking by designing sleek furniture for friends and family, made of rare, exotic woods, both inside and out. Reflecting the great tradition of Parisian cabinetmaking, his creations met with great success, which allowed the company to move into serial production.

In 1925, Ruhlmann created a sensation at the Exposition Internationale des Arts Décoratifs et Industriels Modernes with his designs for the interior of the Hôtel du Collectionneur, conceived by his army friend, architect Pierre Patout. Ruhlmann designed the furniture and carefully selected all of the decorative elements: wallpaper, curtains, lighting, and artworks. This marked one of the main breakthroughs for the art deco style in France and around the globe, from Rio de Janeiro to New York and Shanghai. Ruhlmann's furniture found its place in Paris's handsomest townhouses, such as the Hôtel Potocki, as well as on board the liner *Île de France* (1927), and it also featured in official contexts, including the Musée Permanent des Colonies (Permanent Museum of the Colonies) in 1931, the Palais de l'Élysée, the National Assembly, and several city halls. Among his private clients from the Parisian elite were the Rothschilds, Gabriel Voisin, Colette, and Jacques Doucet.* Stricken by an incurable disease, Ruhlmann had made sure, thanks to ad hoc legal provisions, that his company would not outlive him. It duly disappeared in the mid-1930s. P M

Emmanuel Bréon. *Jacques-Emile Ruhlmann: The Designer's Archives*. Paris: Flammarion, 2004.
———, ed. *Ruhlmann: Genius of Art Deco*. Paris: Somogy, 2001.
Florence Camard. *Ruhlmann*. New York: Rizzoli, 2011.

↗ Study for a boudoir, 1922. Plate from *Harmonies: Intérieurs de Ruhlmann* by Jean Badovici and Émile-Jacques Ruhlmann, 1924.

→ Sideboard known as "the cart," 1922.

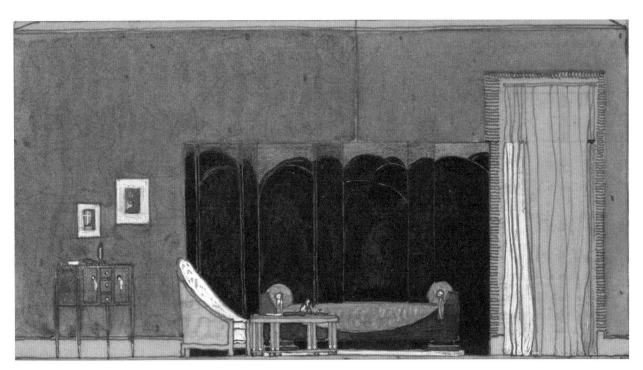

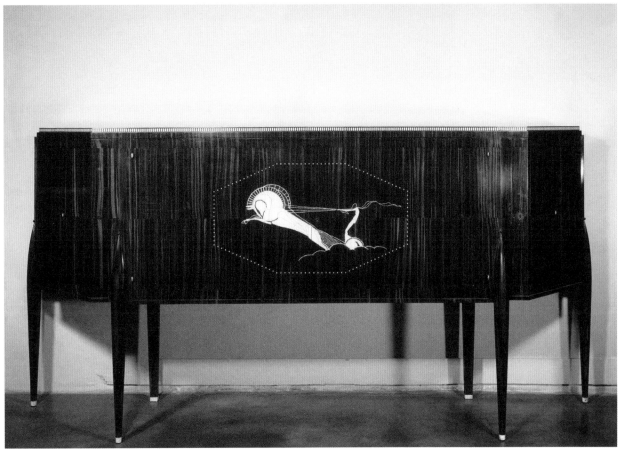

André Sauvage

1891, Bordeaux
1975, Boutigny-Prouais (France)

André Sauvage, who was a friend of Max Jacob and Robert Desnos, and was close to the Prévert brothers and Man Ray,* made just a few films. In 1928, he shot *Études sur Paris* (Studies of Paris), the first relatively systematic feature-length documentary about the city. Extending from the Tour Saint-Jacques to the Montagne Sainte-Geneviève, the film focused on the Paris port, the Nord-Sud metro line, Paris's islands, and the Petite Ceinture railway. The camera traveled by barge on the Canal Saint-Denis to the Bassin de la Villette, then took the Canal Saint-Martin through the tunnel to the Bastille, reached the Île Saint-Louis, boarded the Petite Ceinture train, and followed the workers' gardens to the old fortifications. Finally, it reached the Latin Quarter, with the Luxembourg Gardens and its strollers. The contrast between neighborhoods in terms of populations—workers here, dalliers there—and the monuments that characterized them thus emerged from these various paths along urban, river, rail, and land routes.

Now largely forgotten, Sauvage abandoned his filmmaking career after a number of setbacks, notably his removal from the documentary *La Croisière jaune* in 1931–32, following the demand of André Citroën,* who sponsored the expedition. F A

Isabelle Marinone. *André Sauvage, un cinéaste oublié: De la traversée du Guépon à la Croisière jaune*. Paris: L'Harmattan, 2008.

Stills from *Études sur Paris* (Studies of Paris), 1928.

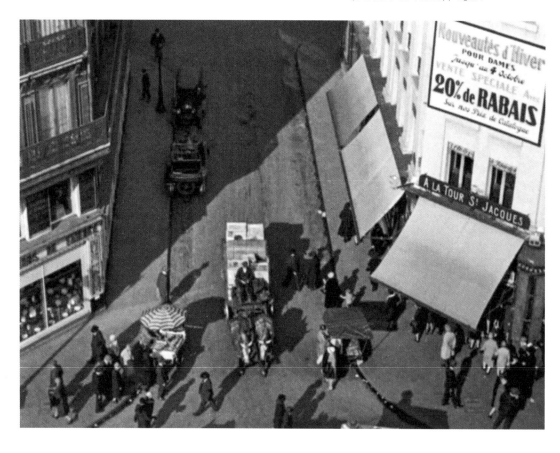

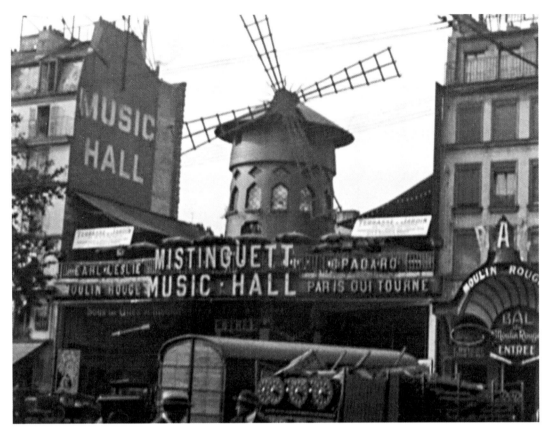

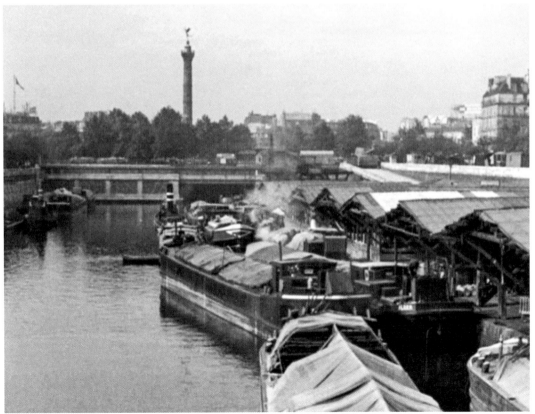

Henri Sauvage

1873, Rouen
1932, Paris

After attending the École des Beaux-Arts in Paris without graduating, Henri Sauvage began his career as a decorator. He then used reinforced concrete in several low-cost housing blocks built in Paris before World War I, and in 1912 he patented a construction system with set-back façades that improved domestic ventilation and lighting. His building on Rue Vavin, which is entirely covered with enameled terra-cotta tiles, bears witness to this. Based on this same model, the group of low-cost housing units on Rue des Amiraux, completed in 1927, justified its pyramidal cross-section with a spectacular swimming pool underneath the units, overlooked by two levels of changing cubicles.

Sauvage was also interested in the industrialization of building and new materials: he registered several patents in this domain, and in 1925 he devised numerous projects for small, mass-produced houses, which were never built. Undeterred, he continued his research into set-back construction with increasingly vast projects, such as the Metropolis building, envisaged for

Low-cost housing, Rue des Amiraux, 1921–25:

↙ Cross-section of the building and pool. Ink on tracing paper.

↓ View of the side façade.

→ Project for the Metropolis Building, Quai de Passy, 1928. Gouache on paper.

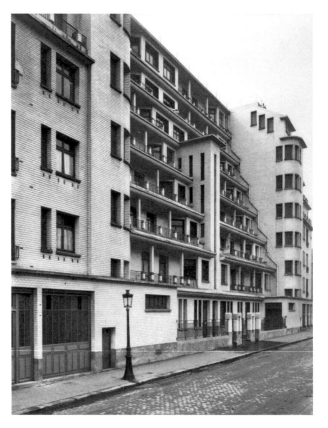

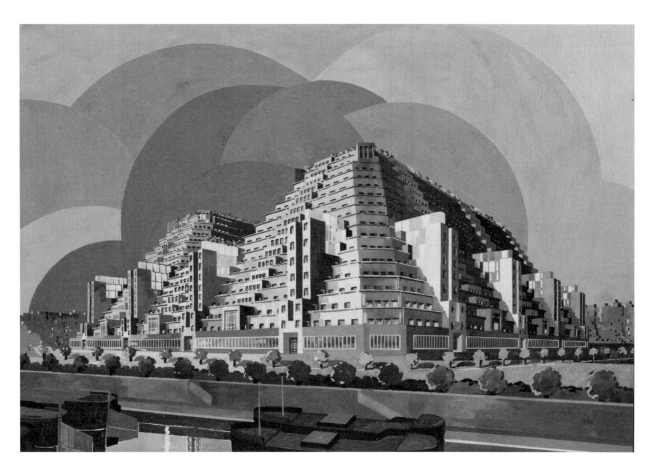

the Seine embankment in 1928, and the design proposed in 1930 in the Rosenthal competition for the Porte Maillot. In 1928, he collaborated with Frantz Jourdain* on the new Samaritaine department store.

Sauvage's personality was complex, fluctuating between his commitment to low-cost programs and his taste for new industrial techniques, a vocabulary that varied from art nouveau to art deco, and even a structural rationalism. Standing between tradition and the modern tabula rasa, he dreamed, as he wrote in 1931 in the journal *L'Architecture d'aujourd'hui*, of "a happy era when, finally reconciled, Reason and Sentiment will bring to Art, the former a *solid foundation*, the latter *emotion*, without which no work can endure." G MJ

Maurice Culot and Lise Grenier, eds. *Henri Sauvage (1873–1932)*. Brussels/Paris: Archives d'Architecture Moderne/SADG, 1976.
Jean-Baptiste Minnaert. *Henri Sauvage, ou l'exercice du renouvellement*. Paris: Éditions Norma, 2002.
———. *Henri Sauvage, le rationaliste*. Paris: Éditions du Patrimoine, 2011.

Elsa Schiaparelli

1890, Rome
1973, Paris

Elsa Schiaparelli was a legendary fashion
designer, despite never making anything
with her own two hands. Raised in Italy, she
broke with her aristocratic family, married,
went to the United States, and came back
to Europe in 1922 with a child to support.

Paul Poiret* introduced her to the Paris
social scene where she cut a brilliantly
extravagant figure and grew close to the
Dadaists. In 1927, her fitted sweaters
with trompe-l'œil motifs brought her to
the attention of an American department
store aware of the Parisian scene. Having
begun her business working out of her
apartment, she opened her first boutique,
Pour le Sport (For Sport); she designed
and sold daywear, then evening wear, and
finally perfumes, before opening her haute
couture house on Place Vendôme in 1935.
Henceforth, she expressed her true iden-
tity, giving free rein to her imagination and
expanding her range of perfumes.

Surrounded by artists—Jean Cocteau,
Marcel Vertès, Salvador Dalí, Man Ray*—
"Schiap," as she was known, shook up the
concept of fashion by introducing a dose
of surrealism. More artistic director than
dressmaker, she attributed themes to her
collections—the circus in 1938, music in
1939—which allowed her to unify and stim-
ulate her creative team (Albert Lesage for
the embroidery, Jean Schlumberger for the
jewelry), and effectively communicate her
creative vision.

Her colors, including "shocking" pink,
her subverting of materials, objects, and
functions, her "drawer" pockets and shoe-
shaped hat all put an end to the classicism
that prevailed until the mid-1930s. Adored
by a chic clientele, she became the great
rival of Coco Chanel.* C Ö

Dilys E. Blum. *Shocking! The Art and Fashion of Elsa
Schiaparelli.* New Haven, CT: Yale University Press, 2003.

↓ Zodiac jacket, winter 1938-39.
→ Wool hat, fall-winter 1937-38.

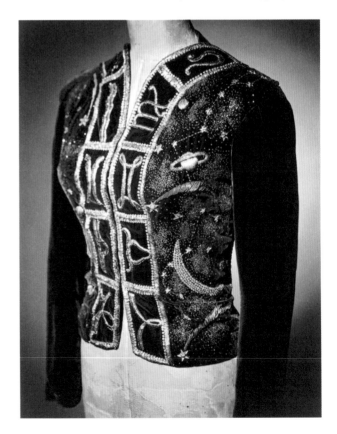

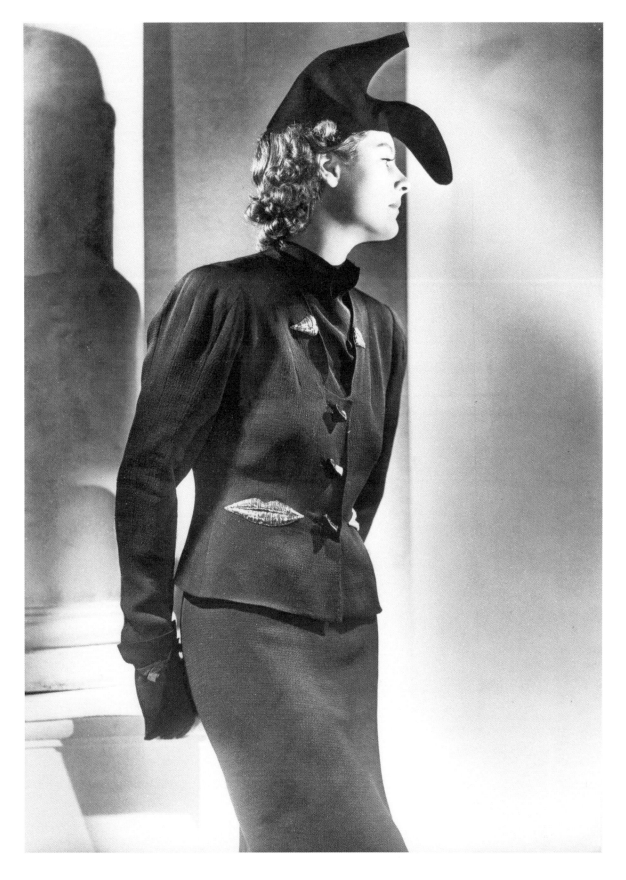

Henri Sellier

1883, Bourges
1943, Suresnes

Henri Sellier was a tireless contributor to the modernization of the Paris region, as a political activist, elected official, and administrative office-holder. A former student of the prestigious business school HEC Paris and a law graduate, he became involved in socialist organizations in 1898 and remained a member of the SFIO (French Section of the Workers' International, which became the Socialist Party) throughout his life. Mayor of Suresnes from 1919 to 1941, he was a senator and minister of public health in the Léon Blum government of 1936–37.

Well informed on the subject of European cities, he and Marcel Poëte founded the École des Hautes Études Urbaines in 1919, which became the Institut d'Urbanisme de l'Université de Paris in 1924, and he coedited its journal *La Vie urbaine* (Urban Life). At the same time, he became president of the Office Public d'Habitations à Bon Marché (Public Authority for Affordable Housing)—whose function was to create new, inexpensive apartment blocks while managing those already built by the city—for the Seine département, of which he had been a director since 1916.

As head of the Office, Sellier proceeded to build eleven garden cities: the first two, in Gennevilliers and Stains, were close to the picturesque English models, while the later ones, in Châtenay-Malabry and Drancy-La Muette, prefigured the large-scale projects of the postwar period. In Suresnes, Sellier built an experimental outdoor school designed by Eugène Beaudouin* and Marcel Lods,* and chaired the housing section of the committee responsible for the development and organization of the Paris region, while supervising the enactment of Henri Prost's* regional plan (1928–34). Despite being dismissed from his position as mayor by the Vichy government, he continued to develop his thinking about municipal policy at the beginning of the Occupation. J-L C

Roger-Henri Guerrand and Christine Moissinac. *Henri Sellier, urbaniste et réformateur social.* Paris: La Découverte, 2005.
Henri Sellier. *Les Banlieues urbaines et la réorganisation administrative du département de la Seine.* Paris: Marcel Rivière, 1920.
———. *Une cité pour tous.* Paris: Éditions du Linteau, 1998.

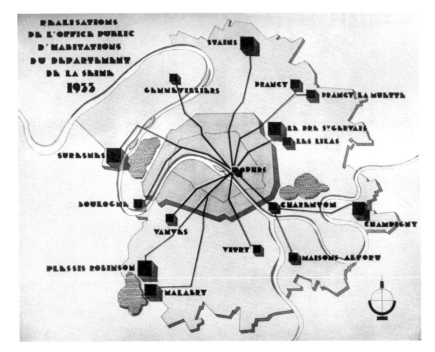

← The garden cities built by the Office Public d'Habitations à Bon Marché, directed by Sellier. Plate in *Réalisations de l'Office public d'habitations du département de la Seine*, 1933.

→ Henri Sellier, c. 1936.

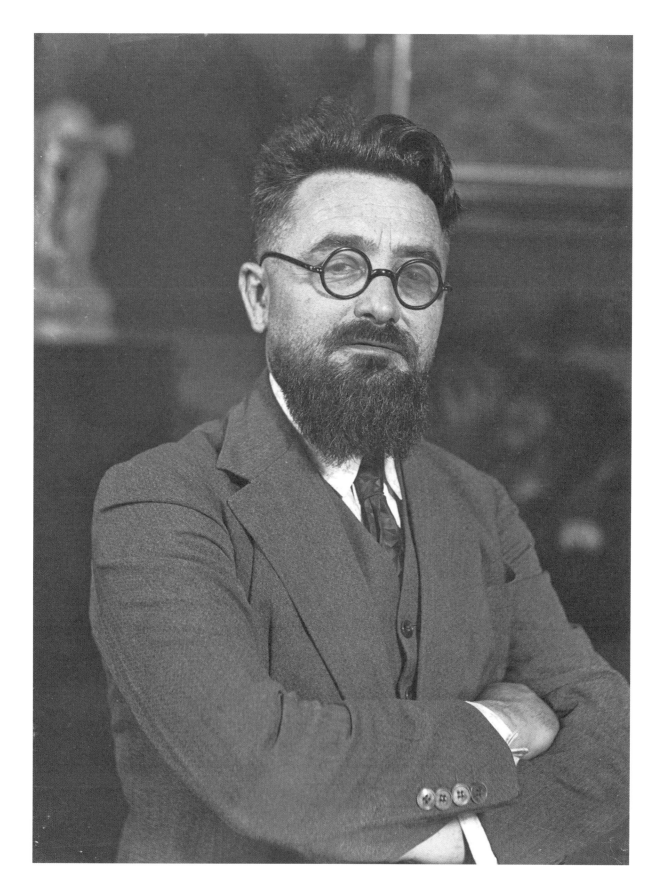

Gertrude Stein

1874, Pittsburgh
1946, Neuilly-sur-Seine

Gertrude Stein, who published the memoir *Paris France* in 1940, just as the Germans entered the capital, was no literary novice: her famous work *Autobiography of Alice B. Toklas* (the name of her companion) had been published in English in 1933 and translated into French the following year.

In addition to her literary output, she was known, together with her brother Leo, as a great collector of modern art. Furthermore, her reputation as the hostess of one of the most popular art salons in the capital meant that the greatest French and American artists and writers of the day—including Guillaume Apollinaire* and Ernest Hemingway—would flock to her apartment at 27 Rue de Fleurus, near the Luxembourg Gardens. Several of them painted her portrait: Félix Vallotton, Francis Picabia, Louis Marcoussis, Jacques Lipchitz,* and, especially, Pablo Picasso,* whom she particularly supported. Photographers such as Thérèse Bonney* and Man Ray* also endeavored to take her portrait, testifying to the importance of this central figure in Parisian artistic life, who acted as both a critic and an intermediary between creators. However, her interest in the modern arts does not seem to have included architecture, unlike her older brother, Michael, and his wife, Sarah, who commissioned Le Corbusier* to build them a villa in Garches, in the suburbs of Paris, in 1926. G MJ

Howard Greenfeld. *Gertrude Stein: A Biography*. New York: Crown Publishers, 1973.
Gertrude Stein. *Paris France*. New York: Charles Scribner's Sons, 1940.
———. *Picasso*. New York: Dover Publications, 1984.
The Steins Collect: Matisse, Picasso, and the Parisian Avant-Garde. New York: Metropolitan Museum of Art, 2011. Exhibition catalog.

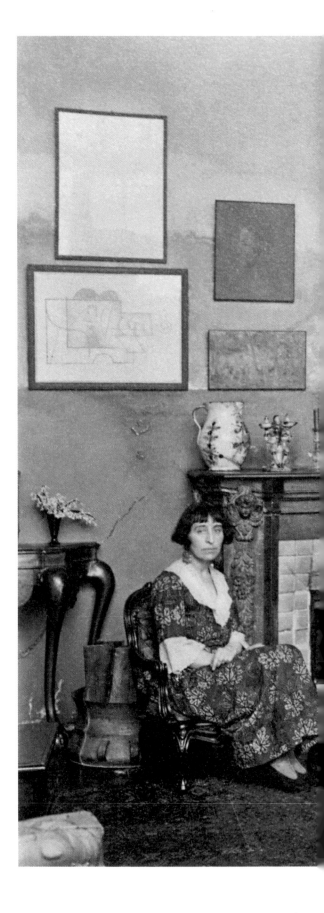

Alice B. Toklas and Gertrude Stein in the living room of their apartment, 27 Rue de Fleurus, 1923. Photograph by Man Ray.

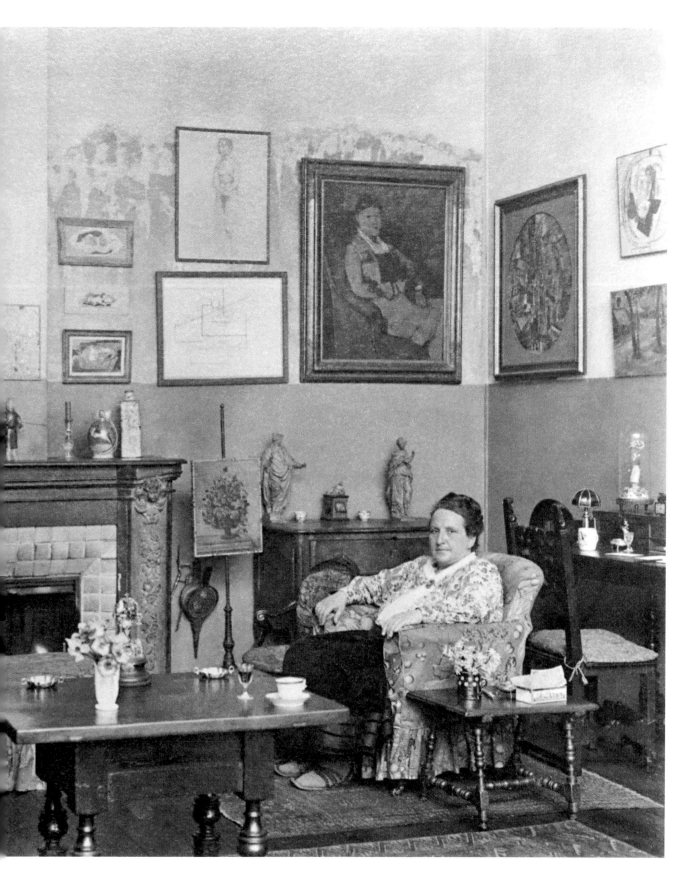

Sophie Taeuber-Arp

1889, Davos
1943, Zurich

Sophie Taeuber-Arp cofounded the Dada movement in Zurich in 1916 with, among others, her future husband—the painter Jean Arp*—the painter Marcel Janco, and the poet Tristan Tzara. She moved to Paris in 1925, on the occasion of the Exposition Internationale des Arts Décoratifs et Industriels Modernes. Her work perfectly embodies the ideal of the synthesis of the arts, as she practiced painting, sculpture, the applied arts (in two and three dimensions), and dance.

Between 1926 and 1928, together with her husband and the architect Theo van Doesburg,* she created the spectacular décor for L'Aubette, a brasserie-dance hall in Strasbourg, applying the aesthetic principles of the De Stijl group, with geometric figures that contrasted with the orthogonal arrangement of volumes. Her abstract and dynamic geometric compositions, which were in the main brightly colored and sometimes in relief, attracted the admiration of Wassily Kandinsky and made her one of the first women to adopt geometric abstraction.

Taeuber-Arp designed the house-studio in Clamart, outside Paris, where she and her husband settled in 1929. Their home became a meeting place for Parisian modern artists, especially those who had been exiled. This hospitable haven closed in 1939, when the couple was forced to take refuge in the South of France, not far from their friend Sonia Delaunay.*

After the artist's accidental death, her work, like that of many women artists of her generation, remained for a long time in the shadow of her husband's oeuvre. G MJ

Silvia Boadella. *Sophie Taeuber-Arp: A Life through Art*. Milan: Skira, 2021.
Sophie Taeuber: Rythmes plastiques, réalités architecturales. Clamart: Fondation Arp, 2007.
Anne Umland et al. *Sophie Taeuber-Arp: Living Abstraction*. New York: Museum of Modern Art, 2021. Exhibition catalog.

↓ Sophie Taeuber-Arp with her Dada head, 1920. Photograph by Nic Aluf.

→ Color scheme proposal for the foyer bar of the brasserie-dance hall L'Aubette, Strasbourg, 1927. Gouache on paper.

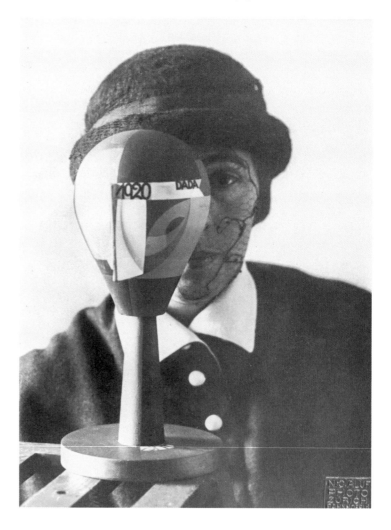

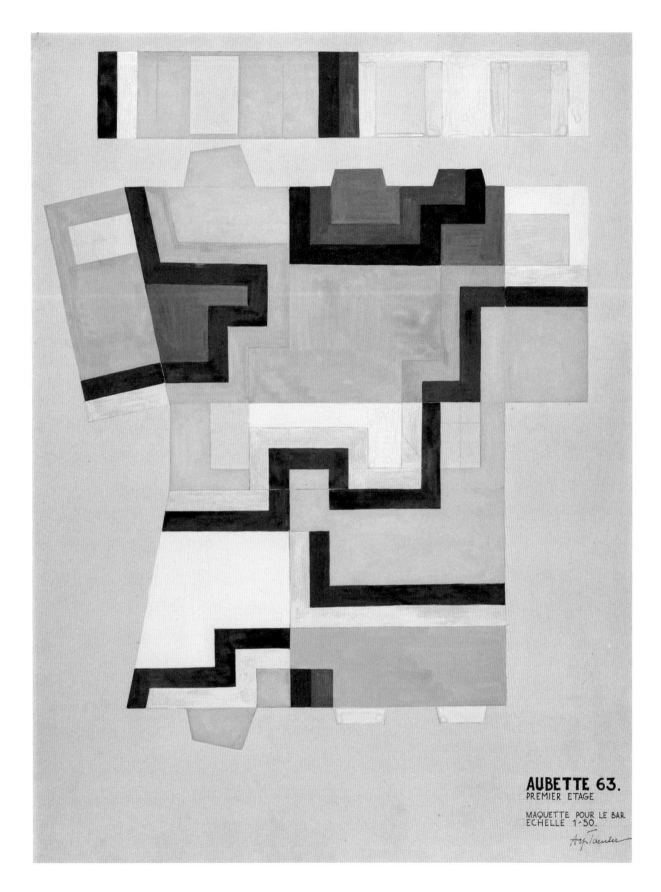

AUBETTE 63.
PREMIER ETAGE

MAQUETTE POUR LE BAR
ECHELLE 1·50.

Alexandre Trauner

1906, Budapest (Austro-Hungarian Empire)
1993 Omonville-la-Petite (France)

After graduating from the School of Fine Arts in his native Budapest, Alexandre Trauner left for Paris in 1929, as Miklós Horthy's dictatorship grew more extreme. During the six years he spent as an assistant to Lazare Meerson,* he learned his métier as a set designer. He became friends with Jacques Prévert and worked on a number of films for which the poet was the screen- or dialogue writer. Trauner created the sets for *Ciboulette* (directed by Claude Autant-Lara,* screenplay by Prévert) in 1933; the first maquette showed the airspace above Paris from its borders to the center, the church of Saint-Eustache, and Les Halles.

For *Hôtel du Nord* (1938), he reconstructed in the studio a fragment of the Canal Saint-Martin, its lock, and its movable bridge, as well as the hotel that gave the film its name. This feat made him French cinema's unrivaled painter of the people's Paris. In *Le Jour se lève* (*Daybreak*) of 1939, a narrow suburban apartment tower standing five stories high dominates, in its solitude, a square lined with low buildings, bistros, and shops, as a crowd of workers grows steadily larger amid mounting tension and a looming urban anguish on the eve of World War II. F A

Alexandre Trauner and Jean-Pierre Berthomé. *Alexandre Trauner: Décors de cinéma. Entretiens avec Jean-Pierre Berthomé.* Paris: Flammarion, 1988.

Sets for the film *Hôtel du Nord,* by Marcel Carné, 1938. Views of the set under construction and the shoot.

Tristan Tzara

(b. Samuel Rosenstock)

1886, Moineşti (Romania)
1963, Paris

Tristan Tzara left an enduring trace on the Parisian landscape, in the form of the house built for him by Adolf Loos* on the slopes of Montmartre—a trace as decisive as the literary imprint left by the poet after four decades spent in Paris.

After writing his first symbolist-inflected poems in Romania, Tzara left Bucharest for Zurich, where he opened the Cabaret Voltaire in 1916, together with the writers Hugo Ball, Emmy Hennings, and Richard Huelsenbeck, and the artists Jean Arp,* Marcel Janco, and Sophie Taeuber-Arp.* With them, he cofounded the avant-garde Dada movement, which he endowed with a European dimension, taking it beyond the borders of Germany and Switzerland.

He settled in Paris in 1919, and was introduced by Francis Picabia to Louis Aragon* and André Breton.* His parodic plays, such as *Le Cœur à gaz* (*The Gas Heart*) of 1921, *Le Cœur à barbe* (*The Bearded Heart*) of 1922—featuring costumes by Sonia Delaunay*—and *Mouchoir de nuages* (*Handkerchief of Clouds*) of 1924, performed by Serge Diaghilev's Ballets Russes, caused a scandal, as did his disputes with Breton and the surrealists. Having initially viewed them as imitators, he grew closer to the surrealists, and, in the late 1920s, he became an ardent practitioner of the surrealist "exquisite corpses": playful works created by multiple artists who each compose a section of a drawing without seeing the others, folding the paper over to hide their work.

Tzara's house on Avenue Junot also contained the studio of his wife, Swedish artist Greta Knutson. The main rooms, covered with Romanian carpets, were home to sculptures from his African art collection.

Under the Popular Front (1935–38), Tzara joined the Communist Party. He went to Spain to support the Republicans, and during World War II he was a member of the Resistance in south-western France. J-L C

Marius Hentea. *TaTa Dada: The Real Life and Celestial Adventures of Tristan Tzara*. Cambridge, MA: MIT Press, 2014.
René Lacôte. *Tristan Tzara*. Paris: Seghers, 1952.
Elmer Peterson. *Tristan Tzara: Dada and Surrational Theorist*. New Brunswick, NJ: Rutgers University Press, 1971.

↓ *Bulletin Dada*, no. 6 (1920), Paris.

→ Marcel Janco, *Portrait of Tzara*, 1920. Ink and gouache on burlap and cardboard.

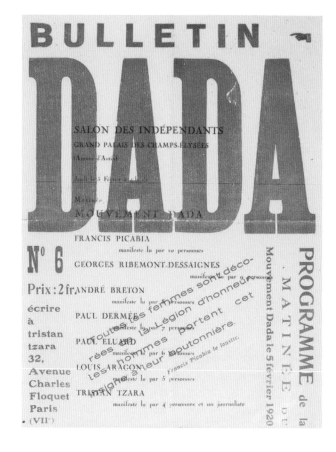

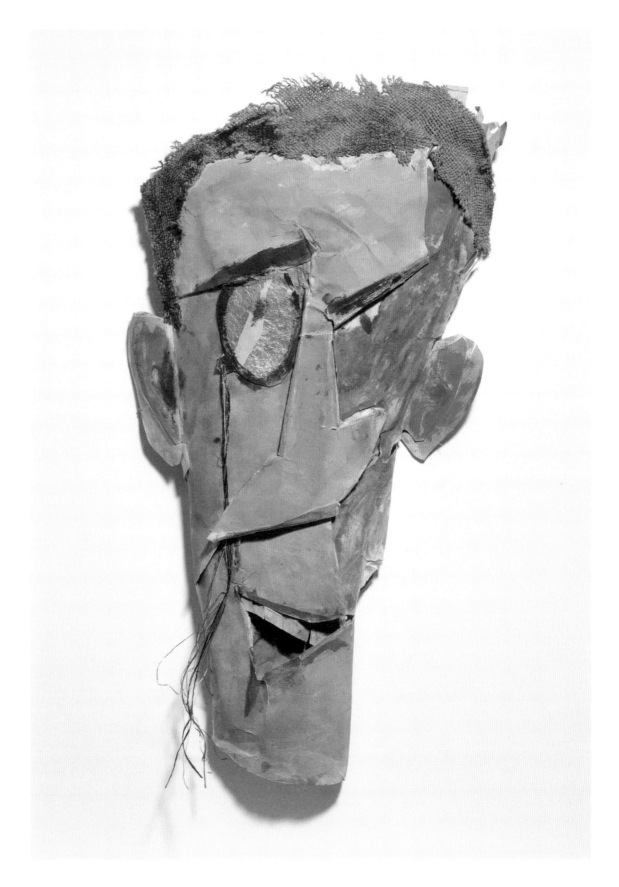

Urbanism

RESHAPING PARIS'S CENTER AND ITS SUBURBS

As World War I ended, the population of Paris reached its historical peak. However, the decline that began at that point was accompanied by a rapid increase in the number of inhabitants in the ring-shaped area surrounding the capital. Together, the city and these suburbs formed the département of the Seine. The département was run by an elected assembly: the Conseil Général (General Council). However, it held no authority over the center, which was governed by a state-appointed prefect. This territorial duality distinguished Paris from its European counterparts: the London County Council was established as early as 1889 and the Gross-Berlin in 1920. Although the hypothesis of a "Greater Paris" was considered in the interwar period, the political divide continued between a center dominated by the right and a periphery in which the left was hegemonic. This conflictual situation had repercussions in many fields of urban policy and on all levels of planning.[1]

Although successive elected assemblies and governments came and went, a certain continuity remained the general rule concerning the main issues facing Western Europe's largest metropolis. One such issue was the containment of the *ceinture rouge* or "red belt" of working-class municipalities, whose perceived "stranglehold" struck fear into the bourgeois elites, especially when the influence of the Communist Party became dominant from 1925 onward.

Toward a Regional Plan

It is enlightening to follow the common thread of the major policies of the late Third Republic and the short-lived French State that replaced it from 1940 to 1944, in the interconnectedness of objectives, from regional strategies to localized solutions, including the important issues of transportation, urban renewal, suburban transformation, and the development of the former fortification belt. Between the two wars, the city of Paris was governed by the right and the département of the Seine by the left, which was in power nationally from 1924 to 1926 and from 1936 to 1940. Marked parliamentary instability was the norm during those years.[2] However, the two world wars inevitably led to exceptional political situations, notably the all-party united front presented to the German enemy between 1914 and 1918, and the suspension of elected local bodies by the Vichy government during the Occupation.

After the Allied victory over Germany, a competition was organized in 1919 for an expansion plan for Paris, from which nationals of defeated Germany and its allies were excluded. Its program stipulated that "competitors should never lose sight of the fact that Paris and its suburban municipalities, whether adjacent or not, have a community of relations and interests such that practically no economic or social problem can be considered and solved for Paris alone, but for the metropolitan area at least partially or, if necessary, in its entirety. It is therefore recommended that competitors undertake the requested study in the most open-minded manner possible."[3] The winner, Léon Jaussely, an architect and pioneer in urban planning since 1900, reinforced the public transportation network, with a central underground station at Les Halles, and the creation of green corridors based on those proposed in Berlin in 1910. But further development of the plan was entrusted to Louis Bonnier, head of the Bureau de l'Extension (Expansion Office) at the Préfecture de la Seine and author of the 1902 Paris urban regulations, which would govern the construction of buildings in the capital for six decades.[4]

This was more than just a plan. In 1924, the Conseil Général de la Seine was intent on launching major projects, including a regional metro and two satellite cities, in La Courneuve to the north and Rungis to the south. A competition was organized for the development of the former. Four years later, things were taken up a level with the creation of the Comité Supérieur d'Aménagement et d'Organisation de la Région Parisienne (Higher Committee for the Development and Organization of the Paris Region), composed of elected officials and experts; drawing on his experience of expanding Moroccan cities, architect Henri Prost* drafted a plan for the committee that was approved in 1934.[5] Rather than creating new cities and extending the metropolitan area, this demographically conservative plan aimed to restructure it via a simplified form of zoning. Seen as "incomplete and flawed" by the Comité Supérieur, the Prost plan was nonetheless ambitious in terms of public roads. It abandoned Léon Jaussely's emphasis on rail transport in favor of a network of ring roads and radial freeways, while initiating the deindustrialization of the region.[6]

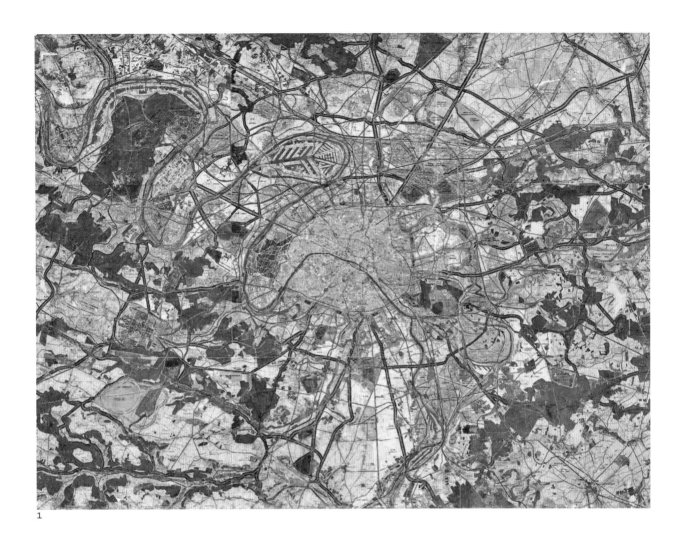

1

1 Léon Jaussely, project for the
expansion of Paris, 1919. Gouache,
watercolor, and ink on paper.

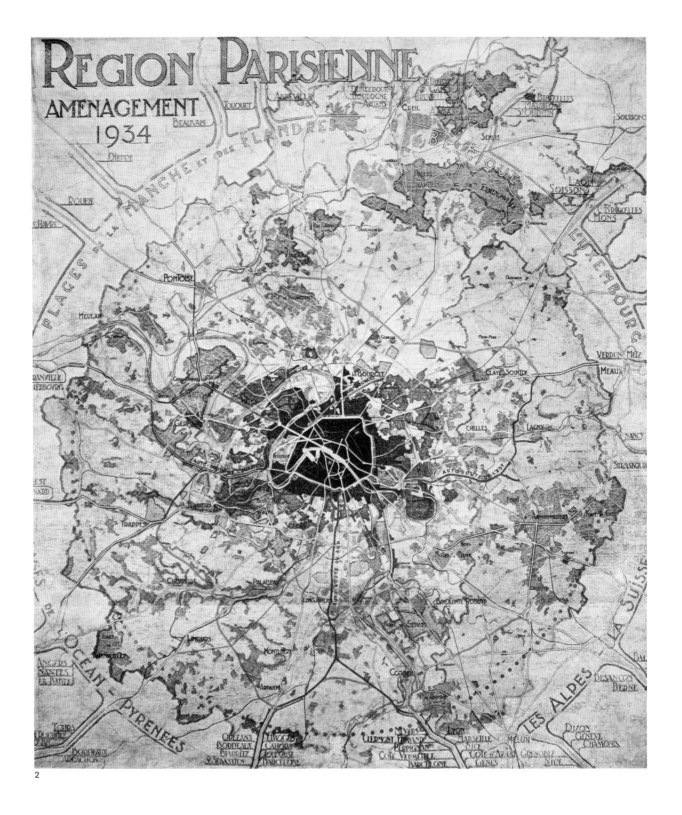

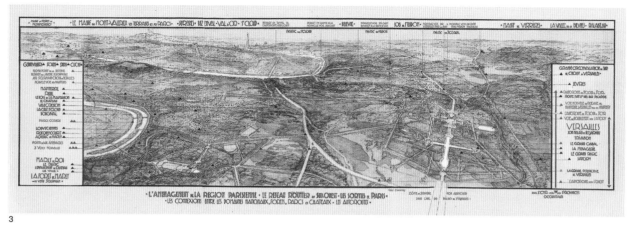

3

He also instigated the protection of extensive landscapes such as the park of Versailles. The elaboration of regulatory instruments and specific legislation for each commune continued into the 1930s and during World War II, the first months of which saw the launch of the construction of the Saint-Cloud tunnel and the Rocquencourt triangle interchange of the western freeway. While Jaussely endeavored to apply "large-scale Taylorization" to the Parisian economy, Prost conceived his plan under the banner of Fordism, based on an ambitious vision of the foreseeable evolution of the automobile.

A Ring of Housing

In the center of the overall map drawn up by Prost in 1934, a black area corresponds to the municipal boundaries of Paris's twenty arrondissements. It was not until 1943 that the engineer René Mestais completed a document providing the framework for road-building projects and construction operations. From 1919, the most significant Parisian undertaking of the first half of the twentieth century took place precisely where the "small" municipal Paris and the "large" regional Paris met: the 1845 fortifications were replaced by a double belt of housing and open spaces. Decommissioned by law after World War I, the twenty miles (33 km) of ramparts were acquired by the municipality, which sold them to public and semi-public housing authorities, whose cumulative production reached thirty-eight thousand units between 1921 and 1939. The western part of the ensemble, facing the Bois de Boulogne, was the site of more profitable residential schemes consisting of luxury buildings, such as the one designed by

Jean Walter at Porte de la Muette, and private mansions, like Auguste Perret's* design for Maurice Lange.[7]

This new rampart of red and beige bricks was surrounded by the "Zone"—a ring of land encumbered by thousands of precarious constructions; in 1924, Bonnier and the landscape architect Jean Claude Nicolas Forestier outlined a plan to transform it into a ring of parks and sports fields. Since the public authorities' official budget was insufficient to expropriate the fifteen thousand property owners in the area, the plan could only be implemented partially and led to the creation of just a handful of public gardens. The sole indisputable success was the Cité Universitaire designed by Forestier and Lucien Bechmann, where unbroken parkland linked two dozen national pavilions, including those built for the Swiss by Le Corbusier* and for the Dutch by Willem Marinus Dudok. Major facilities included the Parc des Expositions at the Porte de Versailles and the Parc des Princes and Jean-Bouin stadiums, built for the 1924 Paris Olympics, separated by buildings designed for the military, such as Perret's for the Navy's shipbuilding department.

While the completion of the last stretch of Boulevard Haussmann in 1926 concluded the program of the Second French Empire, the City of Paris still had to finish repaying loans it had taken out before 1870, which limited its investment capacity. Unable to successfully carry out large-scale projects in the center, it left the field open to private enterprise. The most spectacular project came from Le Corbusier, who obtained the sponsorship of car manufacturer Gabriel Voisin for a plan that was presented at the 1925 Exposition Internationale in the form of a diorama.

2 Henri Prost, development plan for the Paris region, 1934. General plan. Plate in *Urbanisme*, no. 41 (1935).

3 The southwest Paris road network. Heliographic print on paper, with added ink and gouache.

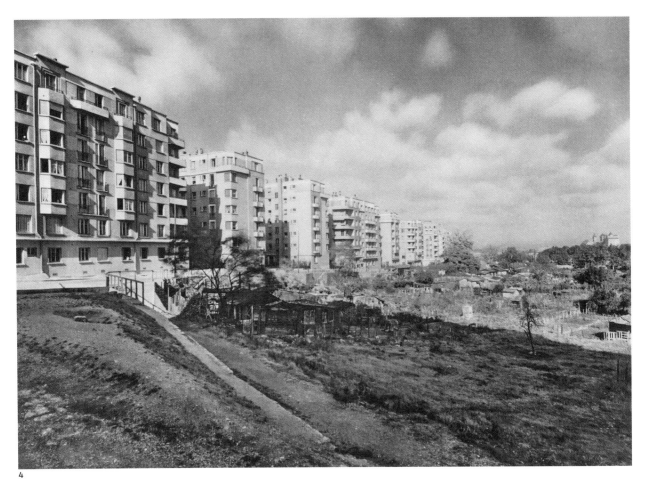

4

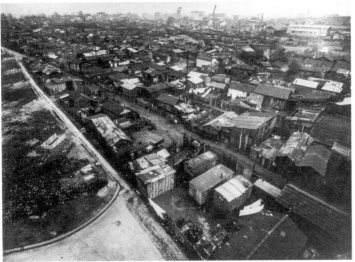

5

This provocative vision of a Paris that was "becoming Americanized," as the popular press claimed, caused a furor. It was the most radical expression of the drive for renovation that had long gripped the Paris authorities. Based on its data concerning mortality rates due to tuberculosis, the prefecture identified seventeen "insalubrious blocks" in 1921, classifying them according to their level of dangerousness, and their destruction and replacement with hygienic social housing was considered urgent.[8] Each block met with a different fate. Block no. 1—the most "deadly"—was demolished in the late 1930s, and the site remained vacant until the Centre Pompidou was built there forty years later. Block no. 9, in the eighteenth arrondissement, where cases of plague had been reported, was promptly rebuilt in the 1920s. The process was slower elsewhere, as with block no. 6 in the Faubourg Saint-Antoine, for which a competition was organized in 1935, and block no. 16 in the Marais, whose destruction became a major issue in the policy of the Vichy government, which proceeded to

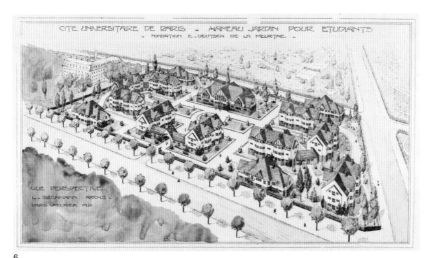

6

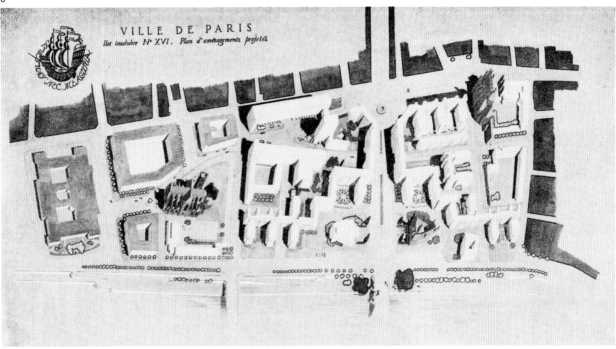

7

systematically expulse all Jews living there. In this block, the premise of totally destroying historic buildings was also abandoned, in favor of a more lenient scheme, which led to the conservation of several façades and some hôtels particuliers.[9]

Aside from the extensive overhaul carried out on the site of the former fortifications and the more limited works undertaken in the "insalubrious blocks," the authorities linked to the municipality embarked on numerous housing projects. Including those on the new belt, more than sixty thousand basic or "improved" low-cost housing units were built between 1920 and 1939, mostly in the working-class districts in the

north, east, and south. With their mineral courtyards, and their terraces and pergolas, these ensembles formed a distinctive landscape that contrasted with both the contemporary tenement buildings clad in stone and the wood and plaster constructions of the peripheral arrondissements.[10]

The City of Paris handed initiative over to the state on the occasion of the three major Expositions Internationales organized between the two wars. Whereas the 1925 Exposition Internationale des Arts Décoratifs et Industriels Modernes, whose pavilions were considered ephemeral from the outset, left no lasting mark on the landscape, the 1931 Exposition Coloniale

4 Low-cost housing complex facing the no-building zone, Boulevard Sérurier, 1935. Illustration in *L'Office public d'habitations de la Ville de Paris*, 1937.

5 The no-building zone to the right of the Porte de Malakoff, 1941.

6 Lucien Bechmann, project for the Cité Universitaire, Boulevard Jourdan, 1921. Watercolor and ink on paper.

7 André Hilt and Henri Bodecher, project for the development of "insalubrious block" no. 6, 1940. Illustration in *L'Architecture française*, no. 2 (1940).

Internationale, combined with the development of the new belt, allowed for the modernization of the Bois de Vincennes and the construction of the vast building for the Musée Permanent des Colonies (Permanent Museum of the Colonies). Various different locations were envisaged for the 1937 Exposition Internationale, which had long been in discussion and in preparation, by turns imagined at Bois de Vincennes or at La Défense. It led to the transformation of the Colline de Chaillot, where the Cité des Musées designed by Perret in 1933 provided the matrix for a procession of institutions leading from the Musée des Travaux Publics (Museum of Public Works) to the Musée de la Marine (Navy Museum) and the Musée de l'Homme (Museum of Man), via the city's and the state's two modern art museums, in a deliberate attempt to create a cultural hub in the west.

The transformation of the capital's geography was also extended to its economy, where a push in the same direction became apparent. With the extension of the axis of Avenue des Champs-Élysées, which had become a commercial artery in the 1920s thanks to the creation of several shopping arcades and automobile showrooms, two competitions allowed an architectural face to be given to this new vocation envisaged for the west of Paris.

In 1930, the pearl merchant and developer Léonard Rosenthal launched a private consultation at Porte Maillot, in which Perret, Robert Mallet-Stevens,* Henri Sauvage,* and Le Corbusier participated. Le Corbusier's proposal associated skyscrapers with a freeway interchange. The following year, the entire length of the so-called Voie Triomphale (it had been the site of the Victory Parade of July 14, 1919), extending from Place de l'Étoile to the La Défense crossroad, was the focus of a competition organized by the City of Paris and the département.[11] In addition to the development of Porte Maillot and the embellishment of the Neuilly bridge, the participants proposed plans for the creation of a business center at La Défense. Among the skyscrapers designed by the competitors, the most remarkable were those by Jacques Carlu and Jean Labatut, both of whom were familiar with the United States, where they taught. This "Americanism" was also evident in the construction of the Beaujon Hospital in Clichy, whose designers—Jean Walter, Louis Plousey, and Urbain Cassan—reproduced the vertical model of New York's medical centers.

Reflections on the development of La Défense were nourished in 1929 by L'Avenir de Paris (The Future of Paris), by Albert Guérard, a French historian living in the United States. He suggested the creation of a "government zone" situated away from dense Paris, in La Défense or Versailles, and a safe distance from the factories concentrated in the plains to the north of the capital.[12] Industrial production had indeed developed in the suburbs during World War I, when Renault colonized a large part of Billancourt on and around the Île Seguin. Subsequently, Citroën* created a network of factories in the southwest of Paris and in Levallois, while the aeronautics industry established itself along the lower reaches of the Seine. The entire region was involved in the production boom, which called for the modernization of river infrastructures and the development of new energy sources, such as large power stations—the plant in Vitry-sur-Seine is the most monumental example. The railway networks were modernized, beginning with the state's network, directed by the influential engineer Raoul Dautry.*

Modernizing Suburbia

Now more populated than the city of Paris, the closer suburbs continued to welcome workers from all over France, Italy, and the colonies, who lived in the precarious conditions of so-called "defective" housing estates. The Loucheur Law of 1928, named after the minister of labor, allocated significant budgetary resources to construction. It was intended to relocate a portion of those who were "poorly housed" by subsidizing the construction of permanent homes and grouping them into organized complexes. In the wake of the 1919 competition for the capital's expansion plan, in which a "garden city of Greater Paris" had been proposed for the southern suburbs, the Office Public d'Habitations (Public Housing Authority) for the département of the Seine, headed by the mayor of Suresnes, Henri Sellier,* undertook a comprehensive program to create autonomous residential estates.[13]

Those in Suresnes and Stains were among the first to be built, and were similar in their densest parts to the low-cost housing of the belt, while the picturesque arrangement of those in Gennevilliers,

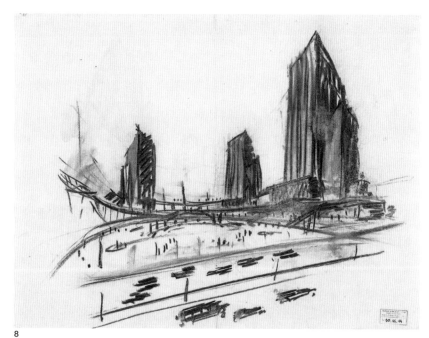

8

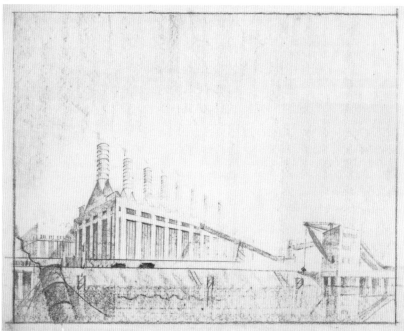

9

8 Auguste Perret, project for the development of Porte Maillot, 1930. Charcoal and watercolor on paper.

9 Georges-Henri Pingusson, Arrighi power station, Vitry-sur-Seine, 1929–31. Heliographic print on paper.

Drancy, and Champigny echoed the English garden cities of Raymond Unwin and Barry Parker. In the late 1920s, the funding provided by the Loucheur Law led to a significant change in the scale of the projects, which were then inspired by those implemented in the Netherlands, in Berlin, or in Frankfurt. The vast garden cities in Le Plessis-Robinson and in Châtenay-Malabry (Butte-Rouge) signaled a new direction, with collective buildings replacing single-family or semi-detached houses; the former was based on a relentless, monotonous serial logic, while the latter, designed by Joseph Bassompierre, Paul de Rutté, and Paul Sirvin, with the landscape architect André Riousse, subtly traced a network of lanes and skillfully diversified squares within a wooded site.[14]

A new feature of Sellier's program was a fourteen-story tower that dominated the Châtenay-Malabry complex. Neither a church steeple nor the belfry of a city hall, it symbolized the community of workers and intellectuals gathered between the center of the urban agglomeration and the countryside—a foreshadowing of the metropolis to come. This aspiration toward height was even more radical in the last ensemble built by the Office before public funding dried up: the Cité de la Muette in Drancy, designed by Eugène Beaudouin,* Marcel Lods,* and Vladimir Bodiansky, with the participation of Jean Prouvé.* The five towers erected in the middle of the fields, with steel frames on which a prefabricated concrete façade was dry-assembled, were presented as the "first skyscrapers in the Paris region." Too far out and poorly served by public transport, the only occupants they had were gendarmes.

In the 1930s, public facilities multiplied, as they intersected the network of housing developments and punctuated the subdivisions. City halls that were innovative in both their program and their form became the focal point of the suburban centers built by ambitious elected officials, who tried to connect them to the extensions of the Paris metro. In Boulogne-Billancourt, Lyon-based architect Tony Garnier built a double municipal palace for the mayor André Morizet, who was fascinated by the example of Haussmann, to whom he dedicated a book.[15] In the building's two adjacent volumes, he combined the monumentality of the reception and assembly spaces with the functionality of the services. For his part, Sellier entrusted Beaudouin and Lods with

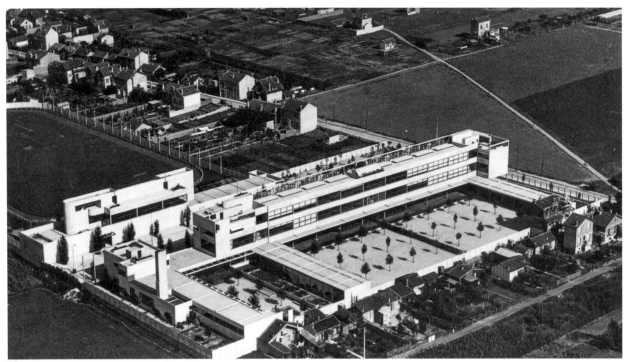

10

the construction of an open-air school in Suresnes, which was remarkable for its free standing, airy classrooms and sunny terraces. New civic monuments thus appeared to serve educational programs, such as the Jacques Debat-Ponsan School in Boulogne and, especially, the Karl Marx School complex by André Lurçat,* which allowed the Communist municipality of Villejuif to prefigure what a social and modern metropolis could look like. The cultural dimension was not neglected in municipal programs: it emerged through new interpretations of the "maisons du peuple" community centers—which first appeared before 1914—that often accompanied the creation of new housing complexes or the development of the existing suburbs. The "maisons du peuple" in Suresnes and Stains were the very heart of these garden cities. The theater in Gennevilliers, designed by Louis Brossard, and the Maison du Peuple in Clichy, designed by Beaudouin, Lods, Bodiansky, and Prouvé, were superimposed on covered markets, making them complex social spaces, and, in the second example, treated in the most technically and aesthetically advanced manner. The Catholic Church, meanwhile, was concerned about the de-Christianization of the suburbs and, left to fend for itself since the separation of the church and state forbade municipalities to build religious buildings, it responded

by multiplying the "Cardinal's projects" launched by the prelate Jean Verdier in 1931, leading to the construction of new churches in these areas.

These networks of housing and public buildings, which were being built simultaneously with little overall coordination, studded Paris and its periphery with islands of modernity, while the grand design of general development remained pure wishful thinking. The intense program of building slowed in the second half of the 1930s, when France began its rearmament in response to Germany's growing power. Although all construction operations were suspended, the Occupation was a key moment in the elaboration of the regional plan and in the conception of a general program of sports facilities intended to contribute to recovery. Economists and geographers from Vichy's Direction Générale à l'Équipement National (General Directorate for National Equipment) also advocated industrial decentralization, which would allow large factories to be moved away from Paris and its suburbs to be relocated in the "French desert," as geographer Jean-François Gravier stated in his 1947 bestseller.[16] It was not until ten years after the Liberation and the beginning of reconstruction that the fate of the Parisian metropolis once again became a government concern. J-L C

10 André Lurçat, Karl Marx School complex, Villejuif, 1931-33. Aerial view.

11 Charles Nicod and Paul Lebret, project for a school physical education center, Boulevard Bessières, 1943. Aerial perspective. In *L'Illustration*, February 20, 1943.

12 The shifting locations of the Boulogne city hall from 1791 to 1932. Illustration in *L'Hôtel de ville de Boulogne-Billancourt*, 1934.

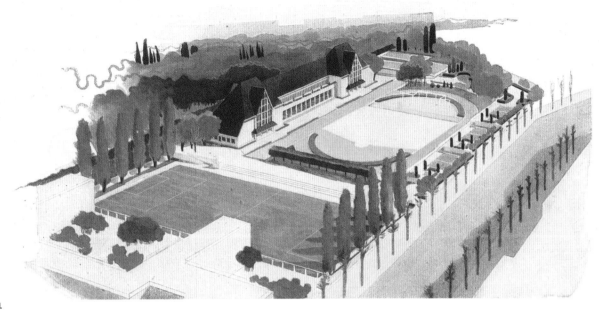

11

1. Annie Fourcaut, Emmanuel Bellanger, and Mathieu Flonneau, *Paris/banlieues: Conflits et solidarités* (Grane: Créaphis, 2007).

2. Jean-Pierre Azéma and Michel Winock, *La IIIᵉ République* (Paris: Calmann-Lévy, 1991).

3. Préfecture du Département de la Seine, Ville de Paris, *Programme du concours ouvert pour l'établissement du plan d'aménagement et d'extension de Paris* (Paris: Imprimerie Chaix, 1919), 4.

4. Florence Bourillon and Annie Fourcaut, eds., *Agrandir Paris, 1860-1970* (Paris: Publications de la Sorbonne/ Comité d'Histoire de la Ville de Paris, 2012).

5. Rémi Baudouï, *À l'assaut de la région parisienne: Les conditions de naissance d'une politique d'aménagement régional, 1919–1945* (Paris: Ministère de l'Équipement, du Logement, des Transports et de la Mer, 1990).

6. An overview of the plan can be found in *Urbanisme*, no. 40 (November 1935).

7. Jean-Louis Cohen and André Lortie, *Des fortifs au périf* (Paris: Pavillon de l'Arsenal, 2020).

8. Yankel Fijalkow, *La Construction des îlots insalubres, Paris, 1850–1945* (Paris: L'Harmattan, 1988).

9. Robert Auzelle, "Les îlots insalubres," in Bernard Champigneulle, ed., *Destinée de Paris* (Paris: Chêne, 1943), 112–20.

10. Paul Baroin and Christiane Blancot, *Les Habitations à bon marché de la ceinture de Paris: Étude historique* (Paris: Atelier Parisien d'Urbanisme, 2017).

11. Ville de Paris, Département de la Seine, *Concours pour l'aménagement de la voie triomphale allant de la place de l'Étoile au rond-point de La Défense* (Paris: Éditions d'Art Charles Moreau, undated [1932]).

12. Albert Guérard, *L'Avenir de Paris* (Paris: Payot, 1929).

13. Julie Corteville, ed., *Les Cités-jardins d'Île-de-France: Une certaine idée du bonheur* (Lyon: Lieux-Dits, 2018).

14. Élise Guillerm, *Une cité-jardin moderne: La Butte-Rouge à Châtenay-Malabry* (Marseille: Parenthèses, 2021).

15. André Morizet, *Du vieux Paris au Paris moderne: Haussmann et ses prédécesseurs* (Paris: Hachette, 1932).

16. Jean-François Gravier, *Paris et le désert français: Décentralisation, équipement, population* (Paris: Le Portulan, 1947).

LES MAIRIES SUCCESSIVES DE BOULOGNE-BILLANCOURT

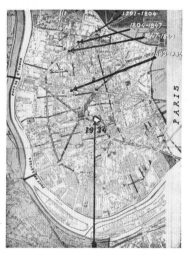

L'HOTEL DE VILLE EST PLACÉ AU CENTRE GÉOGRAPHIQUE DE LA CITÉ, SUR UNE DES GRANDES VOIES DU PLAN D'AMÉNAGEMENT DE LA RÉGION PARISIENNE. CETTE AVENUE RELIERA LA BANLIEUE SUD DE PARIS AU PONT DE ST-CLOUD POINT DE DÉPART DE L'AUTO-ROUTE DE L'OUEST.

12

Theo van Doesburg

(b. Christian Emil Marie Küpper)

1883, Utrecht
1931, Davos

Although he lived in Paris for less than ten years, Theo van Doesburg had a profound impact on the Parisian—and European—art scene. This is evidenced by his founding of the magazine *De Stijl* in 1917, the intensity of his networks within international avant-garde movements (notably Dada and the Bauhaus), his numerous collaborations with other artists and architects, and his prolific, protean oeuvre. He was at once a writer, publisher, architect, and painter. Although he was a close friend of Piet Mondrian (who had moved to Paris in 1919), their relationship soured during this time.

The key event that marked the arrival of the De Stijl movement in France was the exhibition in autumn 1923 of the group's architectural works at the Galerie L'Effort Moderne: a major cultural locus in Paris directed by Léonce Rosenberg. Van Doesburg's *Contra-Constructions* and three projects designed with the architect Cornelis van Eesteren were exhibited in two and three dimensions, including drawings—often axonometric—and maquettes. While modest in scale, this exhibition had a profound effect on Le Corbusier,* Eileen Gray,* and Robert Mallet-Stevens.*

With his wife Nelly, who was also an artist, Doesburg settled permanently in France, but the hoped-for architectural commissions failed to materialize. After working with Jean Arp* and Sophie Taueber-Arp* on the construction of the brasserie-dance hall L'Aubette in Strasbourg, the couple decided to build a house-studio in Meudon, which took the very simple form of two offset cubes. J-L C

Yve-Alain Bois and Bruno Reichlin, eds. *De Stijl et l'architecture en France*. Brussels: Mardaga, 1985.
Gladys Fabre, ed. *Theo van Doesburg: A New Expression of Life, Art and Technology*. Brussels: Mercatorfonds, 2016.
Evert van Straaten. *Theo van Doesburg: Painter and Architect*. The Hague: SDU Publishers, 1988.

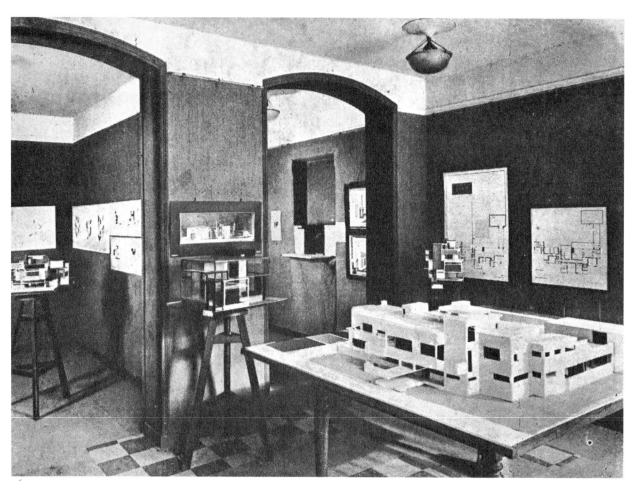

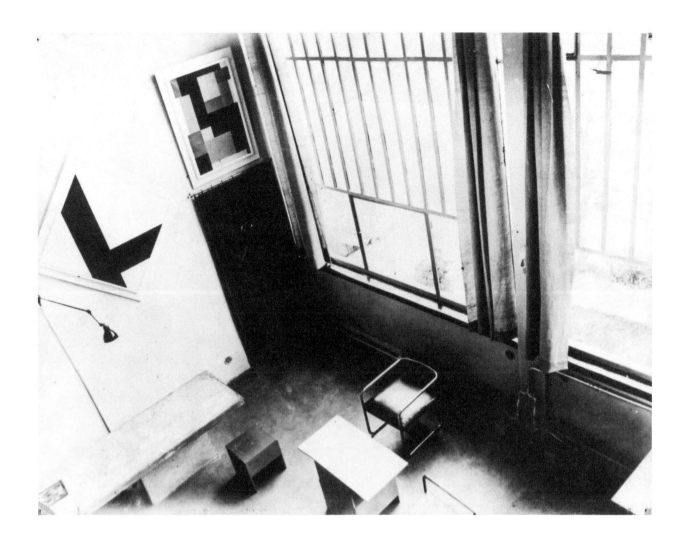

← Exhibition of the De Stijl
architects at the Galerie L'Effort
Moderne, 1923. View of the main room
with the model of the "townhouse."

↑ House-studio of Nelly and Theo
van Doesburg, Meudon, 1928–30. View
of the studio with its concrete
table, 1930.

Madeleine Vionnet

1876, Aubervilliers
1975, Paris

Apprentice at an early age, then seamstress, Madeleine Vionnet left France at eighteen for England, where she worked and trained with Kate Reily. Upon her return to Paris in 1900, she worked for Callot Sœurs, then for Jacques Doucet,* where she was able to create designs without corsets. She established her own fashion house in 1912.

Nicknamed the "Euclid of Fashion," Vionnet was a discreet personality who kept her distance from the hustle and bustle of the 1920s. Her designs were distinguished by skillful, geometrical cutting, inspired by the peplos of ancient Greece and best exemplified by the famous Four Handkerchiefs dress. Her silk crepe dresses were incredibly light. Resting on the shoulders, they floated on the body and allowed complete freedom of movement. Highly appreciated by the most demanding clientele, but weary of being copied, Vionnet was the first to register her designs systematically. However, innovation was her best defense: from 1926, she lengthened her dresses and made the bias cut her trademark. She preferred to work on her own, creating true masterpieces with each collection, and her designs immediately acquired a distinctly timeless character.

Vionnet was a pioneer with regards to social welfare policy within her company, providing well-lit premises, chairs instead of stools, an infirmary, a resident dentist, a canteen, and paid vacations before the legislation of 1936. The war forced her to close her couture house in August 1939. C Ö

Pamela Golbin, ed. *Madeleine Vionnet*. New York: Rizzoli, 2009.
Catherine Örmen, ed. *Madeleine Vionnet, 1876–1975: L'art de la couture*. Marseille: Musée de la Mode de la Ville de Marseille, 1991. Exhibition catalog.

The "Euclid of Fashion" at work on a mannequin doll, c. 1923.

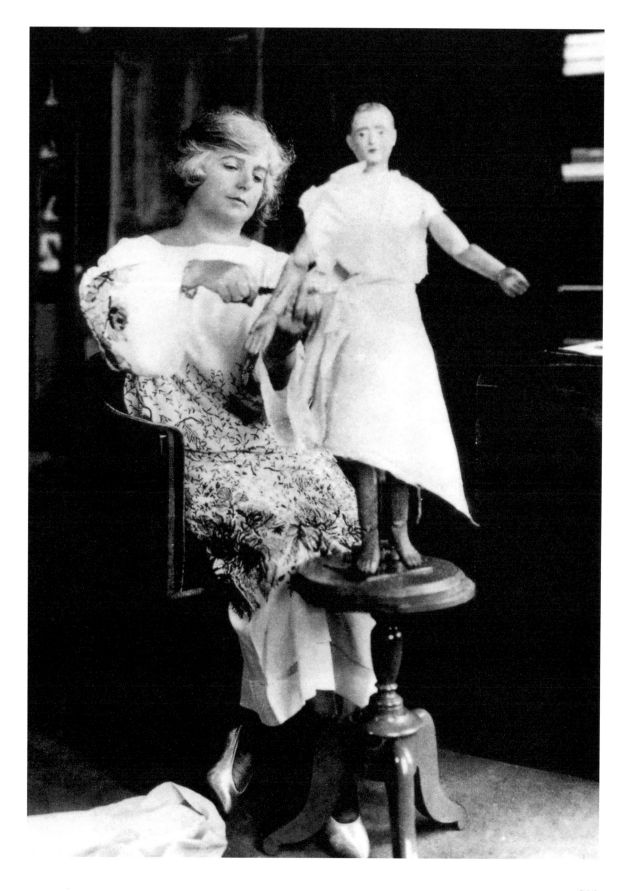

Christian Zervos

1889, Argostóli (Greece)
1970, Paris

Christian Zervos arrived in Paris with his family in 1907, and obtained his PhD in philosophy in 1918. Thanks to architect Jean Badovici,* he found his first job—and his vocation—with the art publisher Albert Morancé in 1923. From that moment on, his entire life would be devoted to publishing and to the art of his time, with regular forays into so-called primitive art. In 1926, he founded his own magazine, *Cahiers d'art*, which he published until 1960. He was responsible for everything, from editorial policy to layout, writing a large number of the articles himself, and even distributing the journal. Despite the lack of academic or commercial recognition, the magazine became an authoritative voice among modern artists and art dealers. In 1934, he and his wife, Yvonne, opened an art gallery: Zervos hoped that this activity would allow him to improve his cash flow, even if it meant selling pieces from his own collection.

A close friend of Paul Nelson,* Zervos had a keen interest in architecture, and in 1927 he published a special issue of *Cahiers d'art* defending Le Corbusier's* project for the League of Nations in Geneva. Later, in the 1930s, he featured a series of panoramas of contemporary architecture in various countries, with texts by Sigfried Giedion.

However, his great editorial undertaking remains the publication, from 1932, of the catalogue raisonné of the works of Pablo Picasso.* By the time of his death in 1970, he had completed the first twenty-two of what would ultimately be thirty-three volumes. For him, Picasso embodied "the art of painting pushed toward the great game of invention and adventure by which everything is renewed." G MJ

Christian Derouet. *Cahiers d'art. Musée Zervos à Vézelay*. Paris: Hazan, 2006.
Christian Zervos. *Pablo Picasso: Œuvres de 1912 à 1917*. Paris: Éditions Cahiers d'Art, 1942.

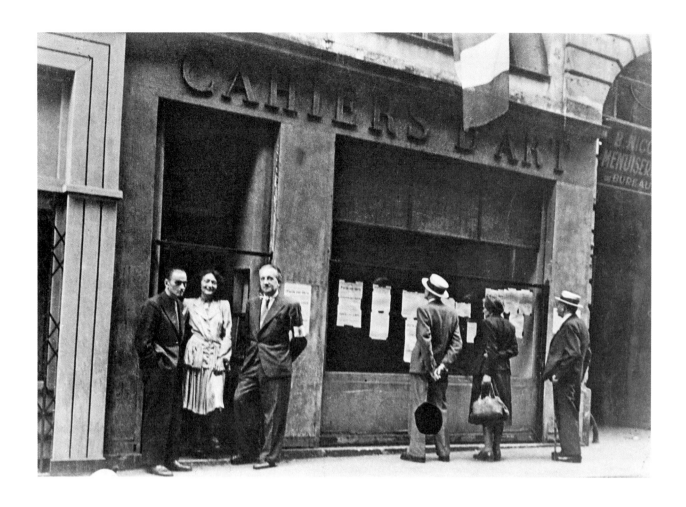

← Marcel Duchamp, *Cœurs volants*
(*Fluttering Hearts*) on the cover of
Cahiers d'art, nos. 1-2 (1936).

↑ The Galerie Cahiers d'Art, Rue du
Dragon, after the Liberation, summer
1944. On the left stand Christian
Zervos, and Nusch and Paul Éluard.

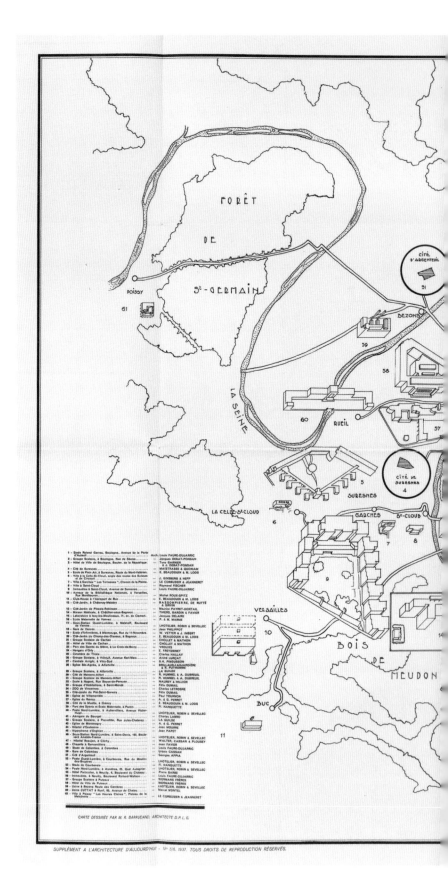

"Région parisienne 1937," map of buildings constructed outside Paris since 1918. Gatefold in *L'Architecture d'aujourd'hui*, 1937.

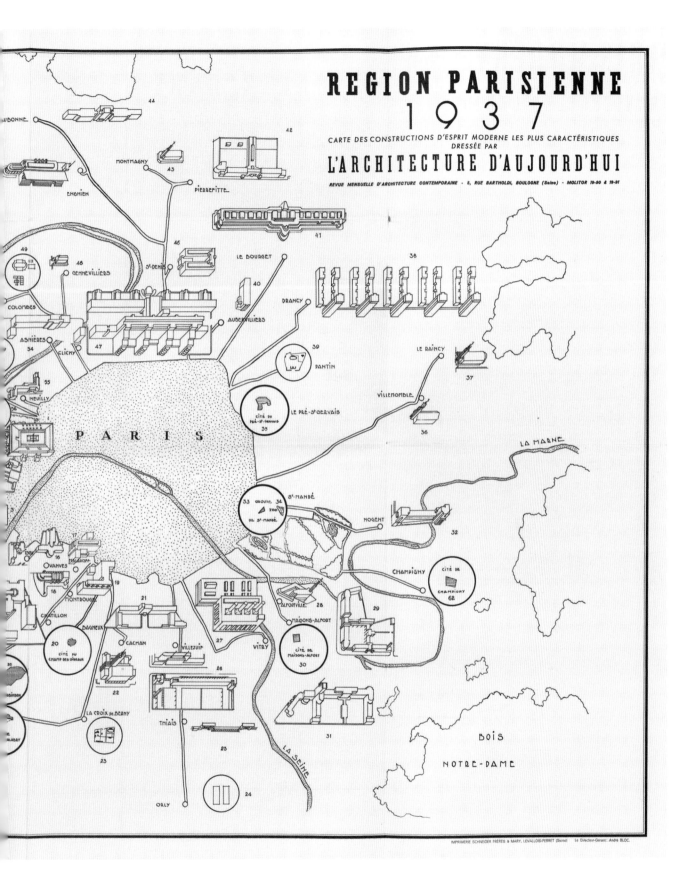

REGION PARISIENNE
1937

CARTE DES CONSTRUCTIONS D'ESPRIT MODERNE LES PLUS CARACTÉRISTIQUES
DRESSÉE PAR

L'ARCHITECTURE D'AUJOURD'HUI

REVUE MENSUELLE D'ARCHITECTURE CONTEMPORAINE - 5, RUE BARTHOLDI, BOULOGNE (Seine) - MOLITOR 19-90 & 19-91

PARIS

LA MARNE

LA SEINE

BOIS
NOTRE-DAME

IMPRIMERIE SCHNEIDER FRÈRES & MARY, LEVALLOIS-PERRET (Seine). Le Directeur-Gérant : André BLOC.

Antonio Martinelli

Contemporary Promenade

Paris *extra muros*

pp. 320-21: Auguste Perret, church of Notre-Dame-de-la-Consolation, Le Raincy, 1922-23. View of the nave.

pp. 322-23: Le Corbusier and Pierre Jeanneret, Villa Savoye, Poissy, 1929-31. General view.

p. 324: Louis Faure-Dujarric, housing complex, Rue du Calvaire, Saint-Cloud, 1934-36. Oblique view of the façade.

p. 325: Georges-Henri Pingusson, Ternisien apartment house, Rue Denfert-Rochereau, Boulogne-Billancourt, 1934-36. View of the corner, with the remains of Le Corbusier's previous construction.

p. 326: Alexandre Maistrasse, garden city, Suresnes, 1921-26. Views of the apartment buildings and the municipal theater.

p. 327: Joseph Bassompierre, Paul de Rutté, and Paul Sirvin, Butte-Rouge garden city, Châtenay-Malabry, 1931-34. View of the corner of Rue du Général-Duval and Avenue de la Division-Leclerc, and detail of the ground floor of a building.

p. 328: Eugène Beaudouin and Marcel Lods, École de Plein Air (Open-Air School), Suresnes, 1932-34. Views of a group of classrooms and the interior of one of them.

p. 329: André Lurçat, Karl Marx School complex, Villejuif, 1931-33. View of the elementary school and a covered walkway in the schoolyard.

pp. 330-31: Tony Garnier and Jacques Debat-Ponsan, City Hall, Boulogne-Billancourt, 1931-34. Views of the wedding hall and the public services hall.

pp. 332-33: Eugène Beaudouin, Marcel Lods, Vladimir Bodiansky, and Jean Prouvé, Maison du Peuple, Clichy, 1936-39. General view, view of the interior in 1990, and detail of the façade.

pp. 334-35: Jean Walter, Louis Plousey, and Urbain Cassan, Beaujon Hospital, Clichy, 1933-35. General view.

pp. 336-37: Georges Labro, Le Bourget Airport, 1935-37 (rebuilt after 1945). View of the departures and arrivals hall.

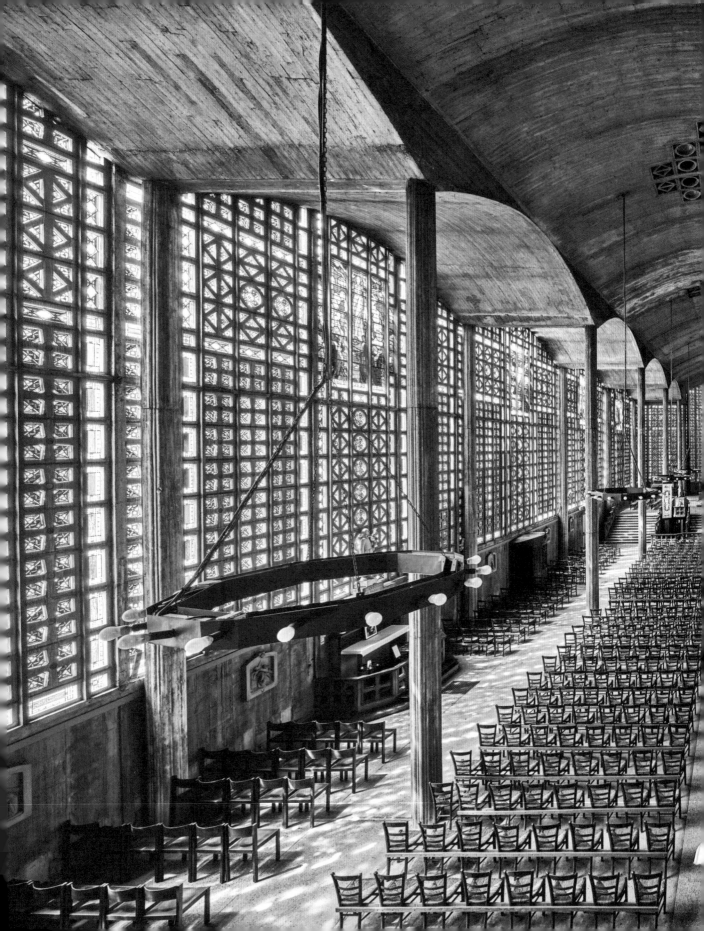

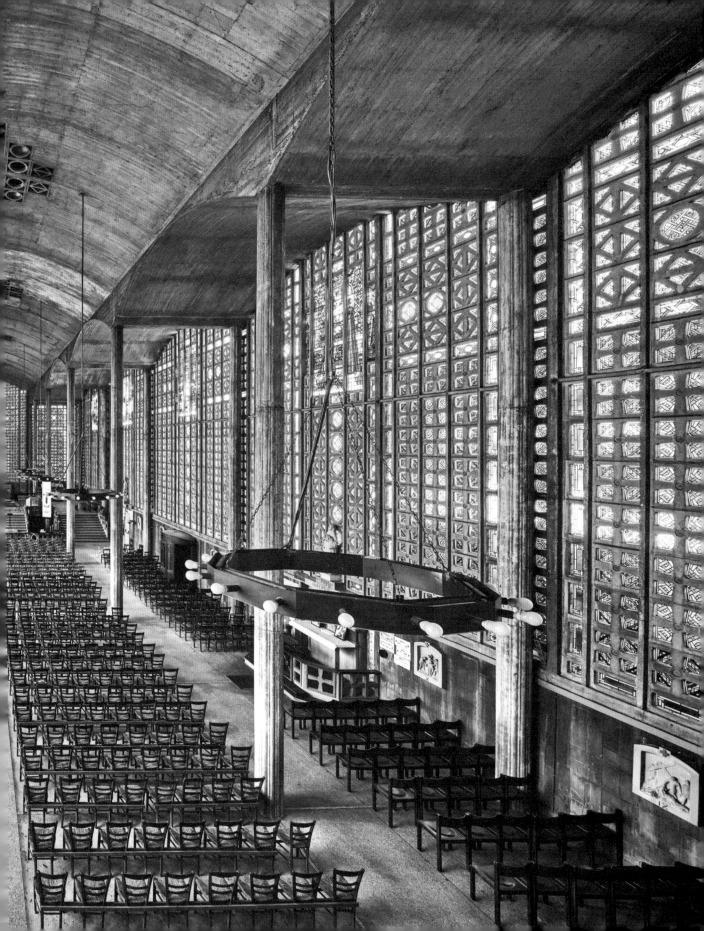

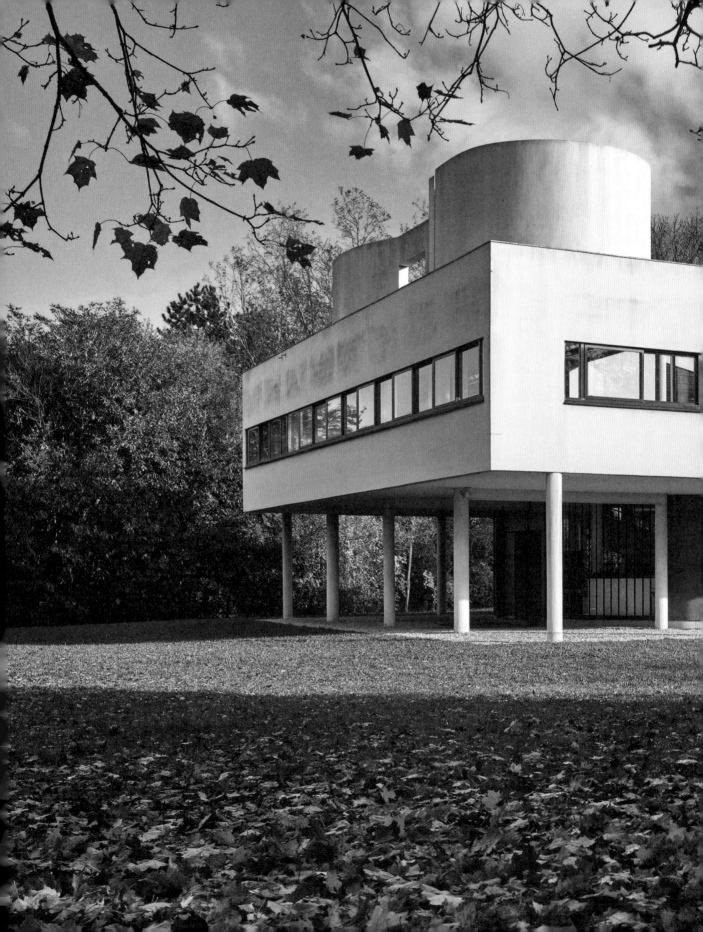

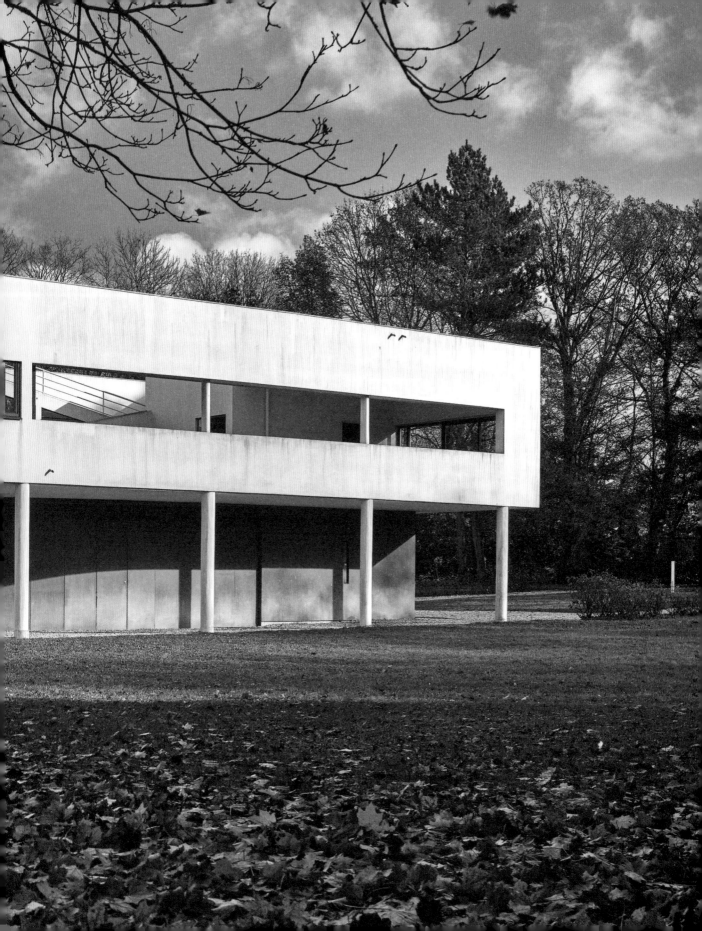

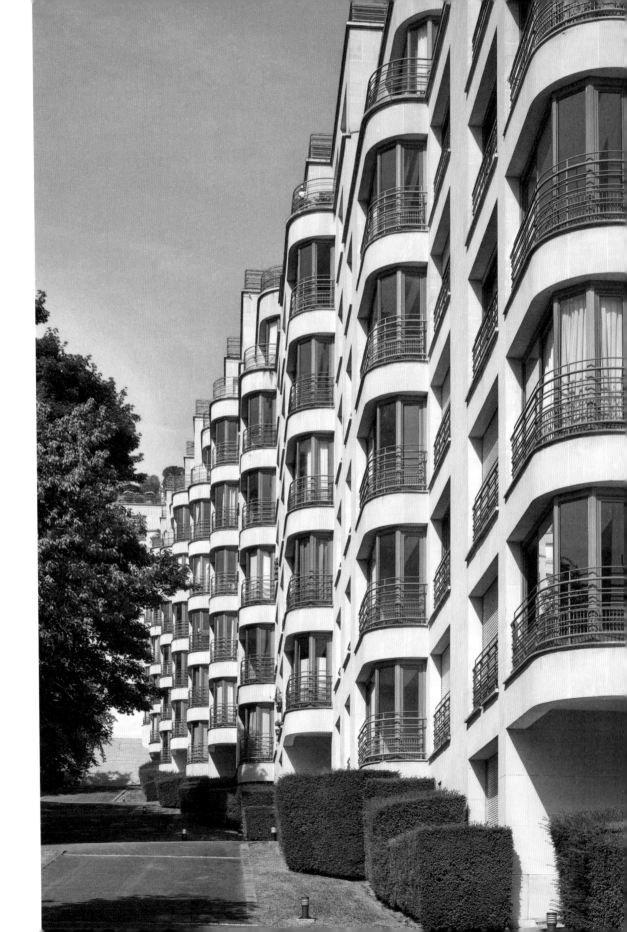

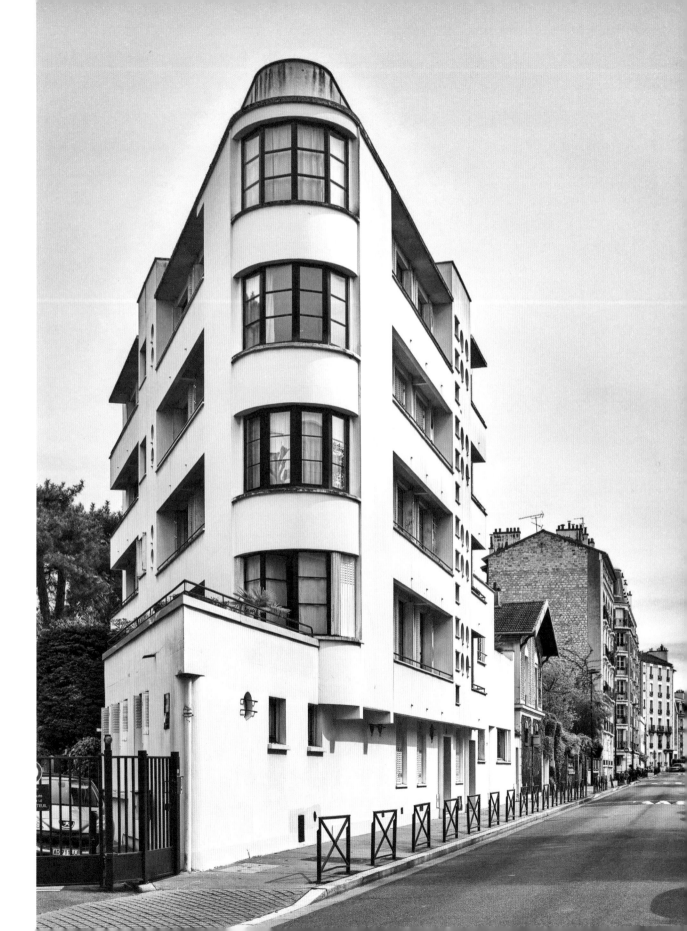

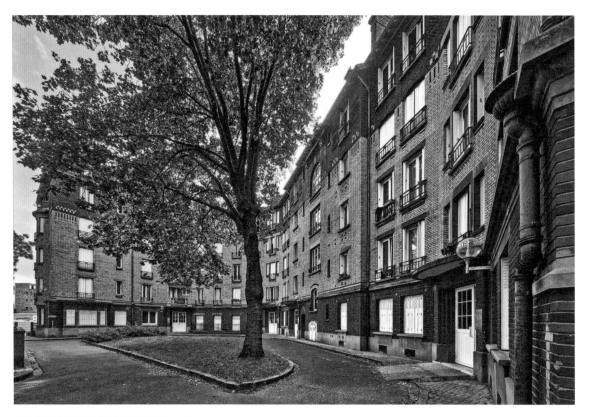

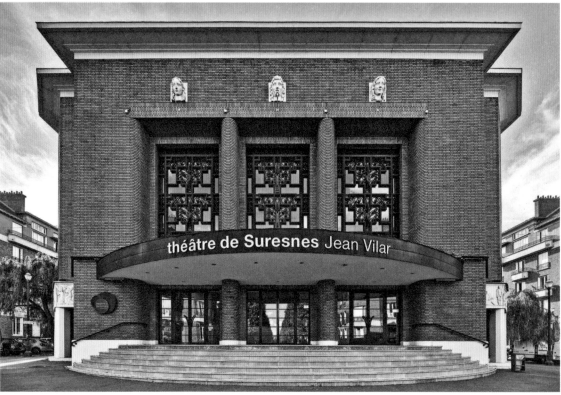

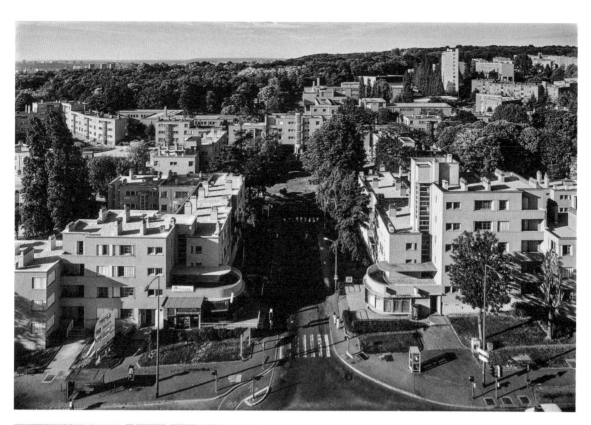

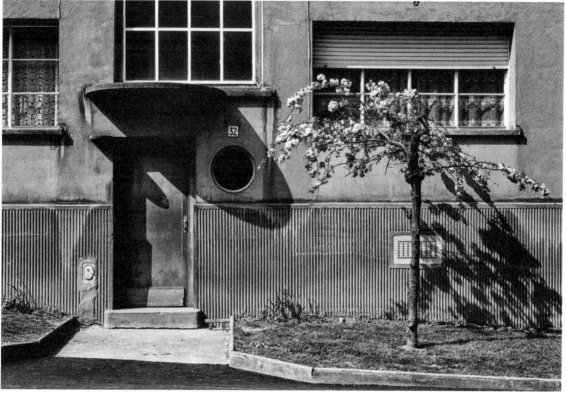

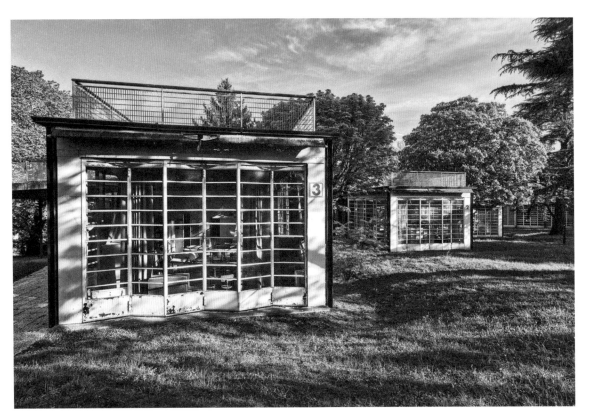

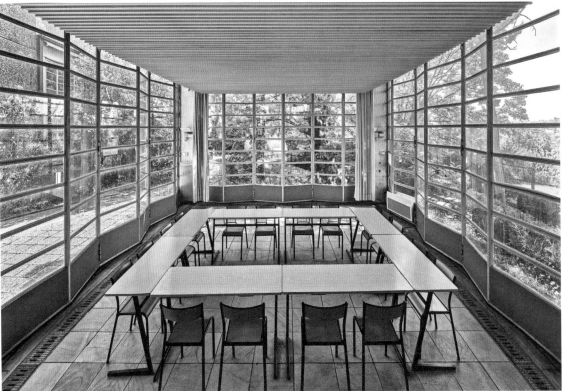

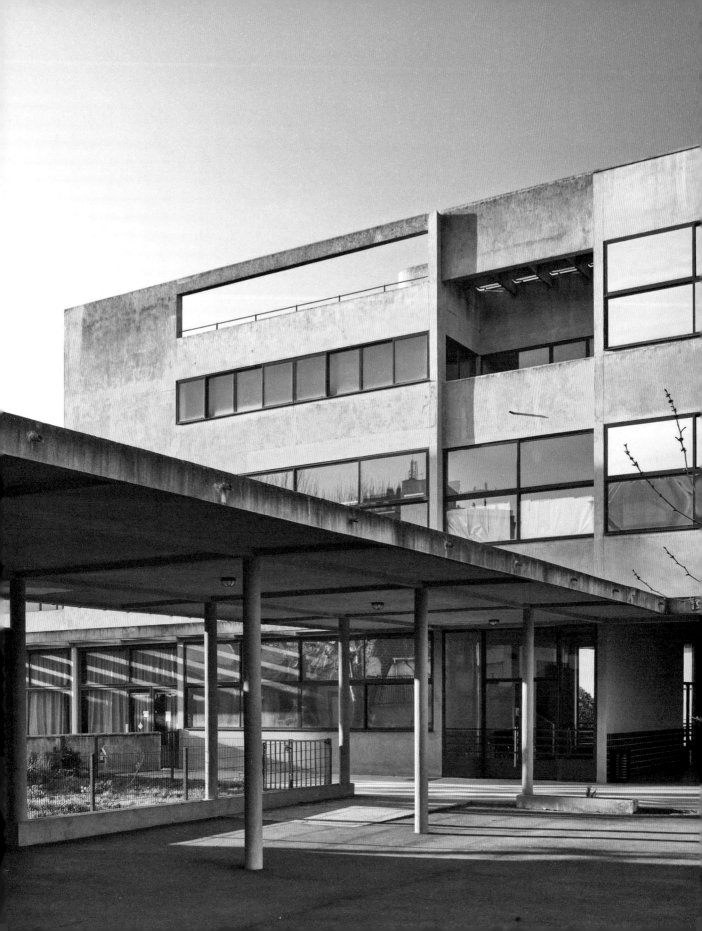

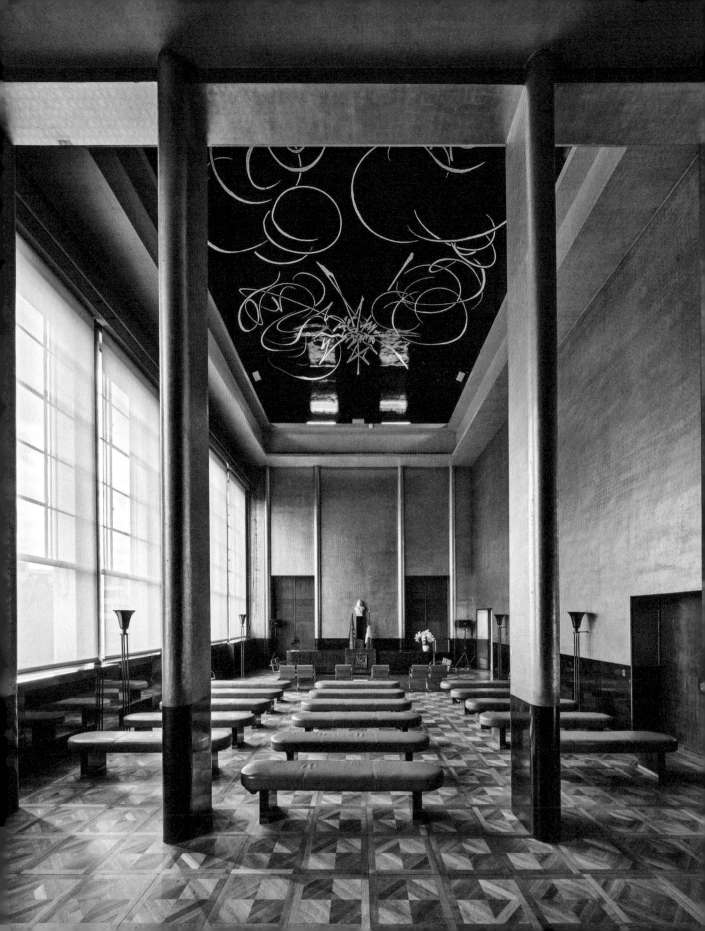

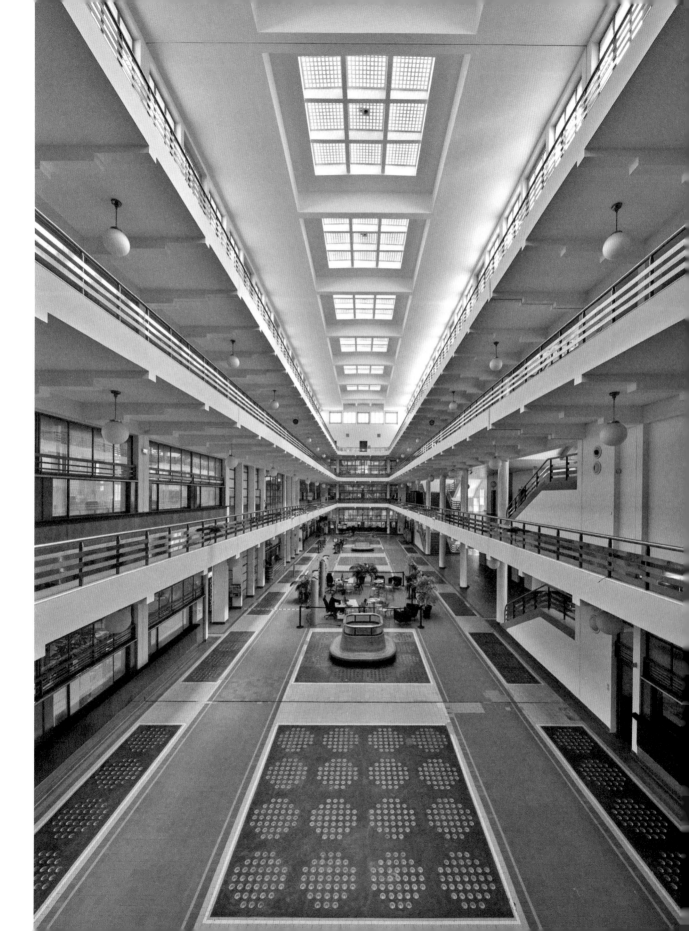

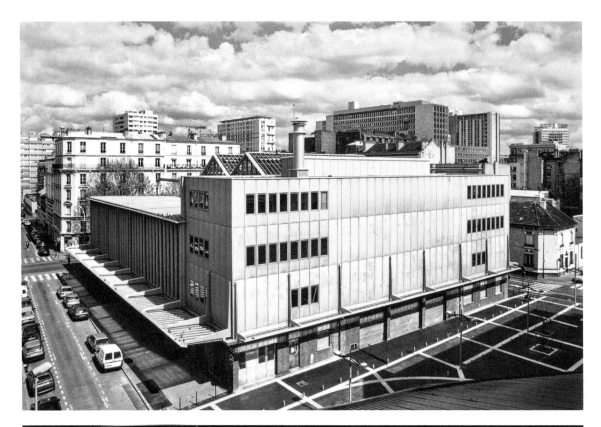

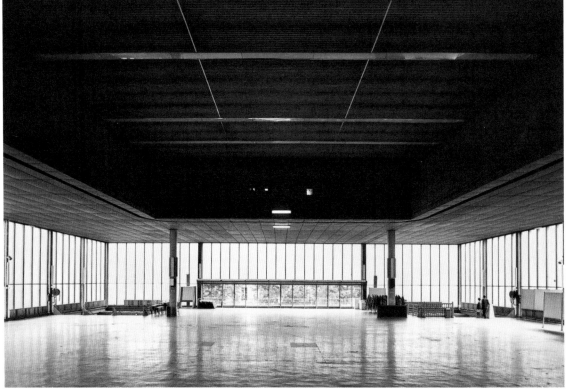

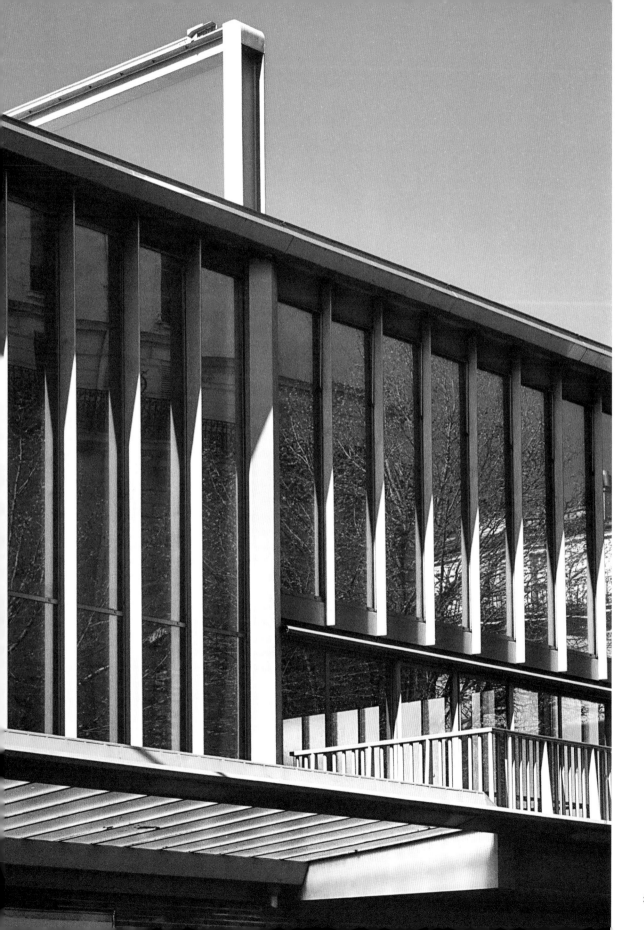

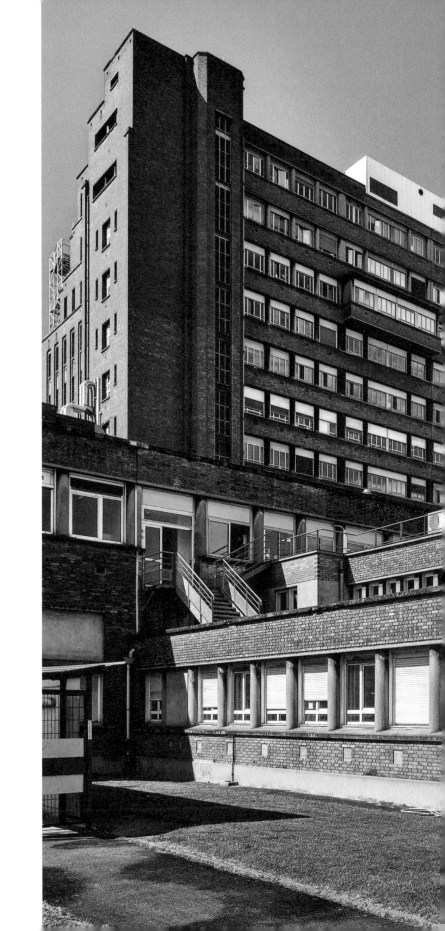

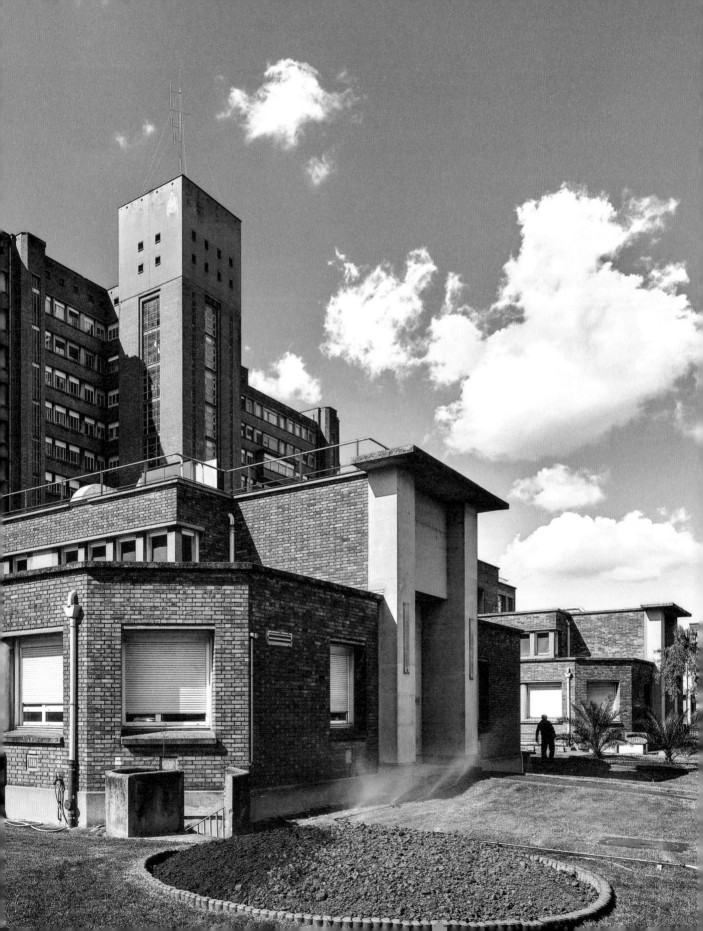

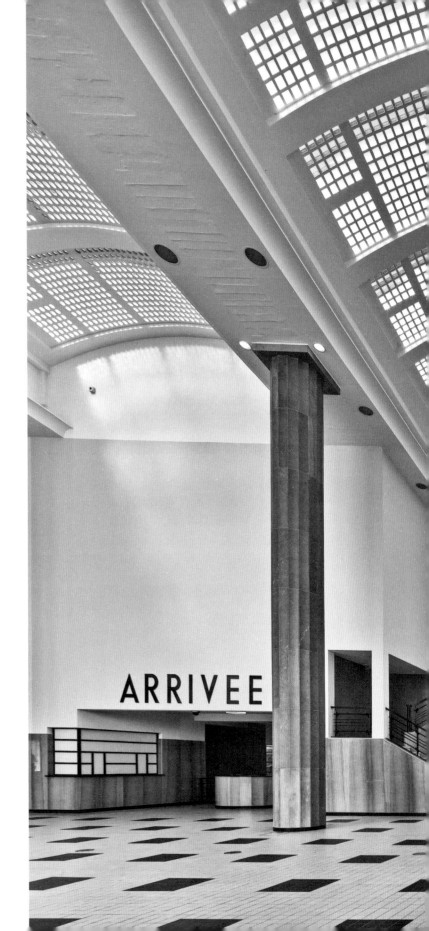

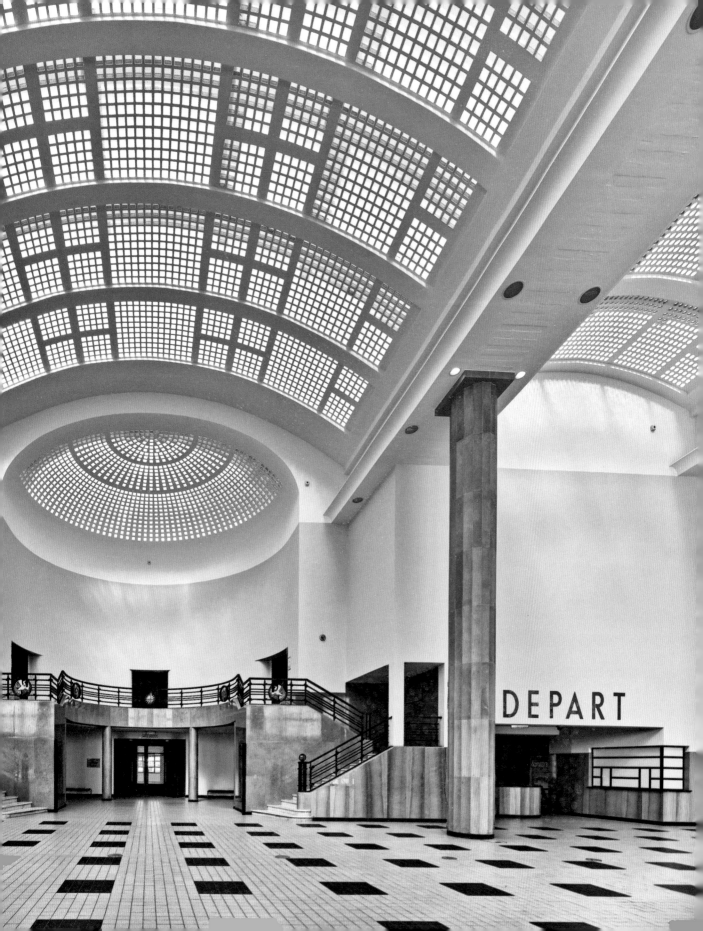

INDEX OF NAMES

Names in **boldface** designate individuals with their own dedicated entry in the book; other names refer to individuals who are mentioned in association with another entry. Page numbers in **_boldface italic_** refer to illustrations.

The featured individuals are often associated with a variety of creative activities; their primary fields are indicated with the following pictograms:

- 🏛 architecture
- ✎ art
- 🎬 cinema
- ◿ design/graphic design
- 👒 fashion/beauty
- 🏭 industry
- 📖 literature/philosophy/publishing
- 📷 photography
- 🌐 politics
- 🎭 theater/performance

D

E

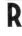

BIBLIOGRAPHY

Abel, Richard. *French Cinema: The First Wave (1915–1929)*. Princeton, NJ: Princeton University Press, 1984.

Aguilar, Anne-Sophie, and Éléonore Challine. *L'Enseigne: Une histoire visuelle et matérielle*. Paris: Citadelles & Mazenod, 2020.

Albera, François, and Jean Gili, eds. *Dictionnaire du cinéma français des années 1920*. Paris: AFRHC, 2001.

Baudin, Katia, ed. *Fernand Léger: Painting in Space*. Cologne/Munich: Museum Ludwig/Hirmer Verlag, 2016.

Bazin, André, and François Truffaut. *Jean Renoir*. New York: Little, Brown, 1992.

Benton, Tim, ed. *Art Deco 1910–1939*. London: V&A Publishing, 2003.

Benton, Tim. *The Villas of Le Corbusier and Pierre Jeanneret, 1920–1930*. Basel: Birkhäuser, 2007.

Berstein, Serge. *La France des années 30*. Paris: Armand Colin, 1988.

Bertaux, Françoise, and Nicole Ouvrard, eds. *Art & Publicité*. Paris: Éditions du Centre Pompidou, 1990.

Bertrand Dorléac, Laurence. *Art of the Defeat, 1940–1944*. Los Angeles, CA: Getty Research Institute, 2008.

Bizot, Chantal, Yvonne Brunhammer, and Suzanne Tise, eds. *Les Années UAM 1929–1958*. Paris: Musée des Arts Décoratifs, 1988.

Blum, Dilys E. *Shocking! The Art and Fashion of Elsa Schiaparelli*. New Haven, CT: Yale University Press, 2003.

Bony, Anne. *Les Années 30 d'Anne Bony*. Paris: Éditions du Regard, 2005.

Bréon, Emmanuel, ed. *Ruhlmann: Genius of Art Deco*. Paris: Somogy, 2001.

Bréon, Emmanuel, and Philippe Rivoirard, eds. *1925, quand l'Art déco séduit le monde*. Paris: Norma, 2013.

Briot, Marie-Odile, Gladys Fabre, and Barbara Rose. *Léger and the Modern Spirit: An Avant-Garde Alternative to Non-Objective Art (1918–1931)*. Houston, TX: Museum of Fine Arts, 1982.

Brunhammer, Yvonne. *1925*. Paris: Presses de la Connaissance, 1976.

Brunhammer, Yvonne, and Suzanne Tise. *French Decorative Art: The Société des Artistes Décorateurs 1900–1942*. Paris: Flammarion, 1991.

Brunius, Jacques-Bernard. *En marge du cinéma français*. Lausanne: L'Âge d'Homme, 1987. First published in 1954.

Camard, Florence. *Ruhlmann*. New York: Rizzoli, 2011.

Caws, Mary Ann. *Dora Maar, With and Without Picasso: A Biography*. London: Thames & Hudson, 2000.

Chemetov, Paul, Marie-Jeanne Dumont, and Bernard Marrey. *Paris-banlieue 1919–1939: Architectures domestiques*. Paris: Dunod, 1989.

Chéronnet, Louis. *La Publicité: Art du XXᵉ siècle*. Presented by Éric Dussert. Paris: Éditions La Bibliothèque, 2015.

Cinqualbre, Olivier, and Frédéric Migayrou, eds. *UAM: Une aventure moderne*. Paris: Éditions du Centre Pompidou, 2018.

Cocteau, Jean. *A Call to Order*. Translated by Rollo H. Myers. London: Faber and Gwyer, 1926.

Cohen, Évelyne. *Paris dans l'imaginaire national de l'entre-deux-guerres*. Paris: Publications de la Sorbonne, 1999.

Cohen, Jean-Louis. *France*, Modern Architectures in History, London: Reaktion Books, 2015.

Cohen, Jean-Louis, ed. *Les Années 30: L'architecture et les arts de l'espace entre industrie et nostalgie*. Paris: Éditions du Patrimoine, 1997.

Cohen, Jean-Louis, and André Lortie. *Des fortifs au périf*. Paris: Éditions du Pavillon de l'Arsenal, 2021.

Collomb, Michel. *Les Années folles*. Paris: Belfond, 1986.

Croix, Mathilde de. *Pionnières: Artistes dans le Paris des années folles*. Paris: Musée du Luxembourg, 2022.

Deslandres, Yvonne. *Mode des années 40*. Paris: Seuil/Éditions du Regard, 1987.

Dudley, Gus. *Oscar Nitzchke, Architect*. New York: The Cooper Union, 1985.

Dumont, Marie-Jeanne. *Le Logement social à Paris 1850–1930: Les habitations à bon marché*. Liège: Mardaga, 1991.

Durgnat, Raymond. *Jean Renoir*. London: Studio Vista, 1975.

Fabre, Gladys, ed. *Theo van Doesburg: A New Expression of Life, Art and Technology*. Brussels: Mercatorfonds, 2016.

Fenster, Hersh. *Nos artistes martyrs*. Paris: Musée d'Art et d'Histoire du Judaïsme/Hazan, 2021. First published in 1951.

Fitoussi, Michèle. *Helena Rubinstein: The Adventure of Beauty*. Paris: Flammarion, 2019.

Fitoussi, Michèle. *Helena Rubinstein: The Woman Who Invented Beauty*. London: Gallic Books, 2014.

Foucart, Bruno, and Jean-Louis Gaillemin. *Les Décorateurs des années 40*. Paris: Norma, 1998.

Fouché, Pascal. *L'Édition française sous l'Occupation, 1940–1944*. Paris: Bibliothèque de Littérature Française Contemporaine de l'Université Paris 7, 1987.

Fourcaut, Annie, ed. *Banlieue rouge, 1920–1960. Années Thorez, années Gabin: Banc d'essai des modernités*. Paris: Autrement, 1992.

Frizot, Michel. *Germaine Krull*. Paris: Hazan, 2015.

Frizot, Michel, and Anne-Laure Wanaverbecq, eds. *Kertész*. Paris: Hazan/Jeu de Paume, 2010.

Garnier, Guillaume, ed. *Paris-couture, années trente*. Paris: Paris-Musées/Société de l'Histoire du Costume, 1987.

Giedion, Sigfried. *Building in France, Building in Iron, Building in Ferroconcrete*. Los Angeles, CA: Getty Research Institute, 1995. First published in German in 1928.

Goissiord, Sophie. *Roman d'une garde-robe: Le chic d'une Parisienne de la Belle Époque aux années 1930*. Paris: Paris-Musées, 2013.

Goissiord, Sophie, ed. *Les Années folles 1919–1929*. Paris: Paris-Musées, 2007.

Golan, Romy. *Modernity and Nostalgia: Art and Politics in France between the Wars*. New Haven, CT and London: Yale University Press, 1995.

Green, Christopher. *Cubism and Its Enemies: Modern Movements and Reaction in French Art, 1916–1928*. New Haven, CT: Yale University Press, 1987.

Gronberg, Tag. *Designs on Modernity: Exhibiting the City in 1920s Paris*. Manchester/New York: Manchester University Press, 1998.

Grumbach, Didier. *Histoires de la mode*. Paris: Seuil, 1983.

Hattstein, Markus. *Art déco*. Cologne: Könemann, 2019.

Hentea, Marius. *TaTa Dada: The Real Life and Celestial Adventures of Tristan Tzara*. Cambridge, MA: MIT Press, 2014.

Herbert, James. *Paris 1937: Worlds on Exhibition*. Ithaca, NY: Cornell University Press, 1998.

Higonnet, Patrice. *Paris: Capital of the World*. Cambridge, MA: Belknap Press of Harvard University Press, 2022.

Hollis, Richard. *Graphic Design: A Concise History*. London: Thames & Hudson, 2001.

Jannière, Hélène. *Politiques éditoriales et architecture "moderne": L'émergence de nouvelles revues en France et en Italie (1923–1939)*. Paris: Arguments, 2002.

Joubert, Hélène. *Helena Rubinstein: Madame's Collection*. Paris: Skira, 2021.

Kinross, Robin. *Modern Typography: An Essay in Critical History*. London: Hyphen Press, 2004.

Kolboom, Ingo, Joachim Krause, and Hans Joachim Neyer, eds. *Absolut modern sein: Zwischen Fahrrad und Fließband—culture technique in Frankreich 1889–1937*. Berlin: Elefanten-Press, 1986.

Latimer, Tirza True. *Women Together, Women Apart: Portraits of Lesbian Paris*. New Brunswick, NJ: Rutgers University Press, 2005.

Lemoine, Bertrand, ed. *Cinquantenaire de l'Exposition internationale des arts et techniques dans la vie moderne*. Paris: Institut Français d'Architecture/Paris-Musées, 1987.

Lévy-Bruhl, Lucien. *How Natives Think*. Translated by Lilian A. Clare. New York: Alfred A. Knopf, 1926. Published in French in 1910.

Lévy-Bruhl, Lucien. *Primitive Mentality*. Translated by Lilian A. Clare. New York: The Macmillan Company, 1923. Published in French in 1922.

Lipchitz, Jacques. *My Life in Sculpture*. New York: Viking Press, 1972.

Lucan, Jacques, ed. *Eau et gaz à tous les étages: Paris, 100 ans de logement*. Paris: Pavillon de l'Arsenal, 1992.

Luo Zhi. "An Alternative Path: Architect Léon Hoa and His Career." PhD. diss., The University of Hong Kong, 2018.

Man Ray. *Self-Portrait*. Boston: Atlantic–Little, Brown, 1963.

Man Ray and Fashion. Paris: Réunion des Musées Nationaux/Grand Palais, 2019.

Monnier, Gérard. *Histoire critique de l'architecture en France, 1918–1950*. Paris: Philippe Sers, 1990.

Monnier, Gérard, ed. *L'Architecture moderne en France. Tome 1, 1889–1940*. Paris: Picard, 1997.

Montebello, Patrice. *Le Cinéma en France (à partir des années 1930)*. Paris: Armand Colin, 2005.

Morton, Patricia. *Hybrid Modernities: Architecture and Representation at the 1931 Colonial Exhibition*. Cambridge, MA: MIT Press, 2000.

Mundy, Jennifer, ed. *Surrealism: Desire Inbound*. London: Tate Modern, 2001.

The Neighborhood Unit. From the Regional Survey of New York and Its Environs. Volume 7, Neighborhood and Community Planning. New York: Regional Plan of New York, 1929.

Örmen, Catherine. *L'Art de la mode*. Paris: Citadelles & Mazenod, 2015.

Ory, Pascal. *La Belle Illusion: Culture et politique sous le signe du Front populaire (1935–1938)*. Paris: Plon, 1994.

Pagé, Suzanne, and Aline Vidal, eds. *Années 30 en Europe: Le temps menaçant*. Paris: Musée d'Art Moderne de la Ville de Paris, 1997.

Paris-Berlin: Rapports et contrastes France–Allemagne, 1900–1933. Paris: Centre Georges Pompidou, 1978.

Paris-Moscou 1900–1930. Paris: Centre Georges Pompidou, 1979.

Paris-New York. Paris: Centre Georges Pompidou, 1977.

Paris-Paris 1937–1957. Paris: Centre Georges Pompidou, 1981.

Paxton, Robert O. *Vichy France: Old Guard and New Order, 1940–1944*. New York: Knopf, 1972.

Poiret, Paul. *King of Fashion: The Autobiography of Paul Poiret*. London: V&A Publishing, 2019.

Polle, Emmanuelle. *Jean Patou: A Fashionable Life*. Paris: Flammarion, 2013.

Renoir, Jean. *My Life and My Films*. New York: Atheneum, 1971.

Riley, Terence, and Joseph Abram, eds. *The Filter of Reason: Work of Paul Nelson*. New York: Rizzoli, 1990.

Rioux, Jean-Pierre, ed. *La Vie culturelle sous Vichy*. Brussels: Éditions Complexe, 1990.

Sadoul, Georges. *Le Cinéma français (1890–1962)*. Paris: Flammarion, 1962.

Sadoul, Georges. *French Film*. London: Falcon Press, 1953.

Sadoul, Georges. *Histoire générale du cinéma. Tome 5, L'Art muet (1919–1929)*. Paris: Denoël, 1975.

Saillard, Olivier, and Anne Zazzo, eds. *Paris Haute Couture*. Paris: Flammarion, 2012.

Salvy, Gérard-Julien. *Mode des années 30*. Paris: Seuil/Éditions du Regard, 1987.

Sanouillet, Michel. *Dada à Paris*. Paris: CNRS Éditions, 2005.

Silver, Kenneth E. *Esprit de corps: The Art of the Paris Avant-Garde and the First World War*. Princeton, NJ: Princeton University Press, 1989.

Sirinelli, Jean-François. *Génération intellectuelle et normaliens dans l'entre-deux-guerres*. Paris: Fayard, 1988.

Spies, Werner. *La Révolution surréaliste*. Paris: Centre Georges Pompidou, 2002.

Steele, Valérie. *Paris Fashion: A Cultural History*. New York: Oxford University Press, 1988.

Stein, Gertrude. *Paris France*. New York: Liveright, 2013. First published in 1940.

Stein, Gertrude. *Picasso*. New York: Dover, 1984. First published in 1933.

Troy, Nancy J. *Modernism and the Decorative Arts in France: Art Nouveau to Le Corbusier*. New Haven, CT: Yale University Press, 1991.

Tschichold, Jan. *The New Typography*. Berkeley, CA: University of California Press, 2010. First published in 1928.

Van Straaten, Evert. *Theo van Doesburg: Painter and Architect*. The Hague: SDU Publishers, 1988.

Weber, Eugen. *The Hollow Years: France in the 1930s*. New York: Norton, 1984.

Weill, Alain. *The Poster: A Worldwide Survey and History*. Boston, MA: G. K. Hall, 1985.

White, Palmer. *Poiret*. London: C. N. Potter, 1973.

Wilson, Sarah, ed. *Paris: Capital of the Arts, 1900–1968*. London: Royal Academy of Arts, 2002.

Wilson, Sarah. *Picasso, Marx and Socialist Realism in France*. Liverpool: Liverpool University Press, 2013.

Wlassikoff, Michel. *The Story of Graphic Design in France*. Berkeley, CA: Gingko Press, 2006.

Ziebinska-Lewandowska, Karolina, et al., eds. *Dora Maar*. Los Angeles, CA: J. Paul Getty Museum, 2020.

CONTRIBUTORS

FA François Albera: film historian, emeritus professor at the University of Lausanne, director of the film history journal *1895*.

J-LC Jean-Louis Cohen: architectural historian, professor at the Institute of Fine Arts, University of New York.

CdS Catherine de Smet: art historian, professor at the University of Paris 8.

ME Monique Eleb: sociologist and psychologist, honorary professor at the École Nationale Supérieure d'Architecture Paris-Malaquais.

GMJ Guillemette Morel Journel: architectural historian, researcher at the École Nationale Supérieure d'Architecture Paris-Malaquais.

AM Antonio Martinelli: architect, photographer based in Paris.

PM Pascal Mory: architect, exhibition curator in Paris.

CO Catherine Örmen: fashion historian, exhibition curator in Paris.

M-PU Marie-Pierre Ulloa: historian, professor in the Paris program of Stanford Univeristy.

SW Sarah Wilson: art historian, professor at the Courtauld Institute of Art, London.

PHOTOGRAPHIC CREDITS

ARTISTS' COPYRIGHTS